W9-CAJ-195

WOMEN
IN THE MATERIAL WORLD

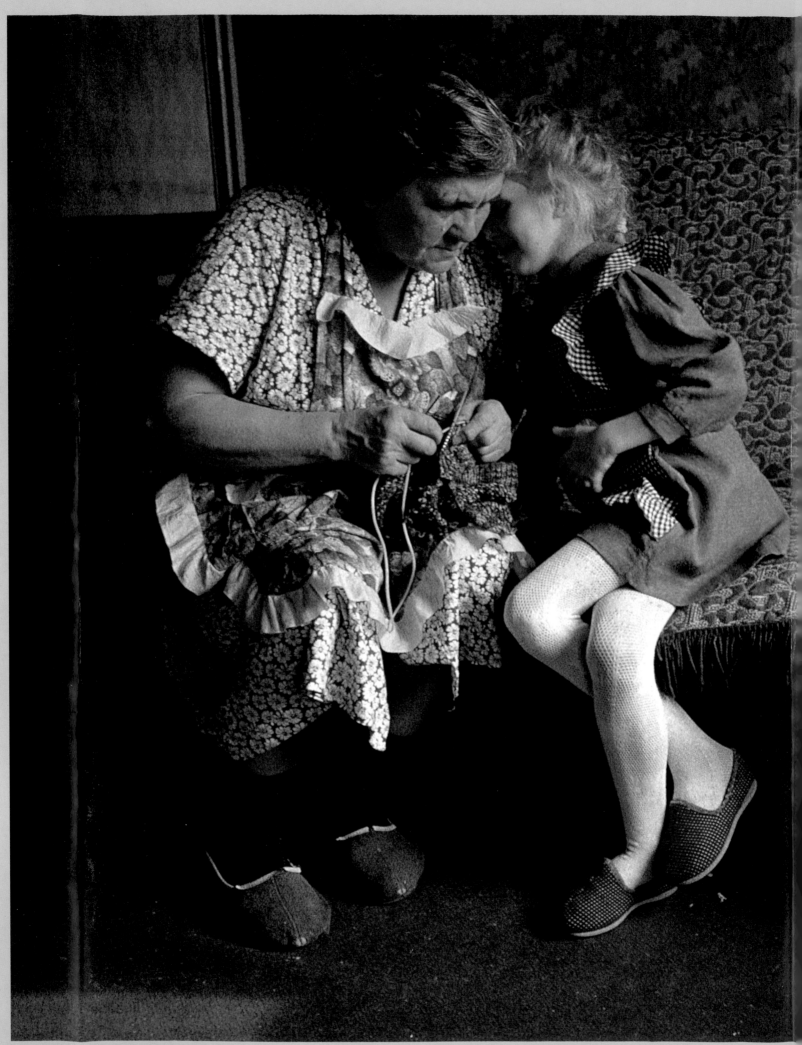

Suzdal, Russia: Anastasia Kapralova and her grandmother share a secret.

WOMEN
IN THE MATERIAL WORLD

By FAITH D'ALUISIO and PETER MENZEL

SIERRA CLUB BOOKS
SAN FRANCISCO

Photograph by Lynn Johnson

THE SIERRA CLUB, founded in 1892 by John Muir, has devoted itself to the study and protection of the earth's scenic and ecological resources—mountains, wetlands, woodlands, wild shores and rivers, deserts and plains. The publishing program of the Sierra Club offers books to the public as a nonprofit educational service in the hope that they may enlarge the public's understanding of the Club's basic concerns. The point of view expressed in each book, however, does not necessarily represent that of the Club.

The Sierra Club has some sixty chapters coast to coast, in Canada, Hawaii, and Alaska. For information about how you may participate in its programs to preserve wilderness and the quality of life, please address inquiries to:

Sierra Club
85 Second Street
San Francisco, CA 94105.

Published by Sierra Club Books,
85 Second Street, San Francisco, California 94105

First published in the United States, 1996

Text and photographs copyright © 1996 Material World

10 9 8 7 6 5 4 3 2 1

p. 256 cm.
ISBN 0-87156-398-3

All rights reserved under the International and Pan-American Copyright Convention. No part of this book may be reproduced in any form or by any electronic or mechanical means, including information storage and retrieval systems, without permission in writing from the publisher.

Portions of this work were originally published in different form in *GEO Magazin*, Germany; *Mother Jones Magazine*, United States; and *El Pais*, Spain.

WOMEN IN THE MATERIAL WORLD
is produced through Mandarin Offset. Printed in Hong Kong. Bound in China

Publisher's Cataloging in Publication

D'Aluisio, Faith.
 Women in the Material World: Faith D'Aluisio and Peter Menzel.

 p. cm.
 Includes bibliographical references and index.
 LCCN: 96-67640.
 ISBN 0-87156-398-3

 1. Women—Cross-cultural studies. 2. Women—Social conditions—Cross-cultural studies. 3. Sex role—Cross-cultural studies. 4. Material culture—Cross-cultural studies. I. Menzel, Peter, 1948- II. Title.
HQ1233.D35 1996 305.42
 QBI96-20368

This book is dedicated to our mothers, the memory of their mothers, and to our sons, Josh, Jack, Adam, and Evan, who are part of a generation which is beginning to understand that women have equal status as human beings.

—FDA and PJM

WOMEN
IN THE
MATERIAL
WORLD

" When you get into a tight place and everything goes
against you, till it seems as though you could
not hang on a minute longer, never give up then, for that
is just the place and time that the tide will turn. "

Harriet Beecher Stowe

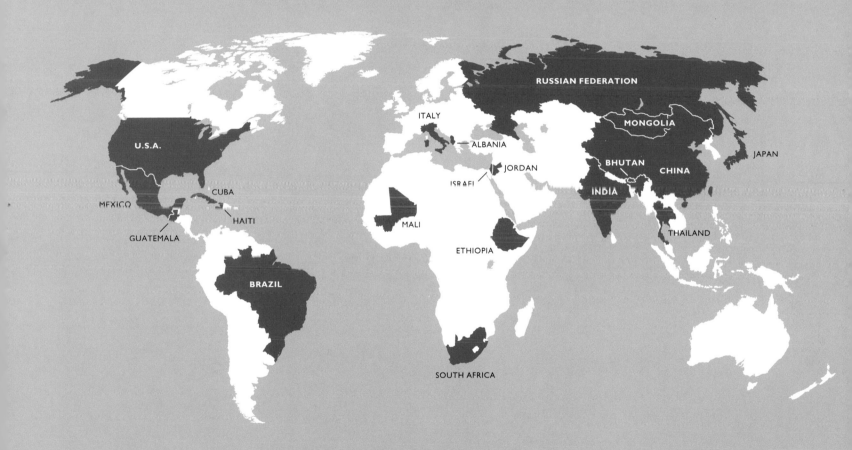

RUSSIAN FEDERATION

ITALY

ALBANIA

MONGOLIA

JAPAN

U.S.A.

JORDAN

ISRAEL

BHUTAN

CHINA

CUBA

INDIA

MEXICO

HAITI

MALI

THAILAND

GUATEMALA

ETHIOPIA

BRAZIL

SOUTH AFRICA

TEXT EDITORS
FAITH D'ALUISIO AND **CHARLES C. MANN**

DIRECTOR OF PHOTOGRAPHY
PETER MENZEL

PICTURE EDITOR
SANDRA EISERT

DESIGNER
DAVID GRIFFIN

Albania 12

Bhutan 24

Brazil 40

China 50

Cuba 62

Ethiopia 70

Guatemala 86

Haiti 94

India 108

Israel 116

Italy 130

Japan 140

Jordan 154

Mali 166

Mexico 184

Mongolia 194

Russia 206

South Africa 218

Thailand 228

United States 240

WOMEN
IN THE
MATERIAL
WORLD

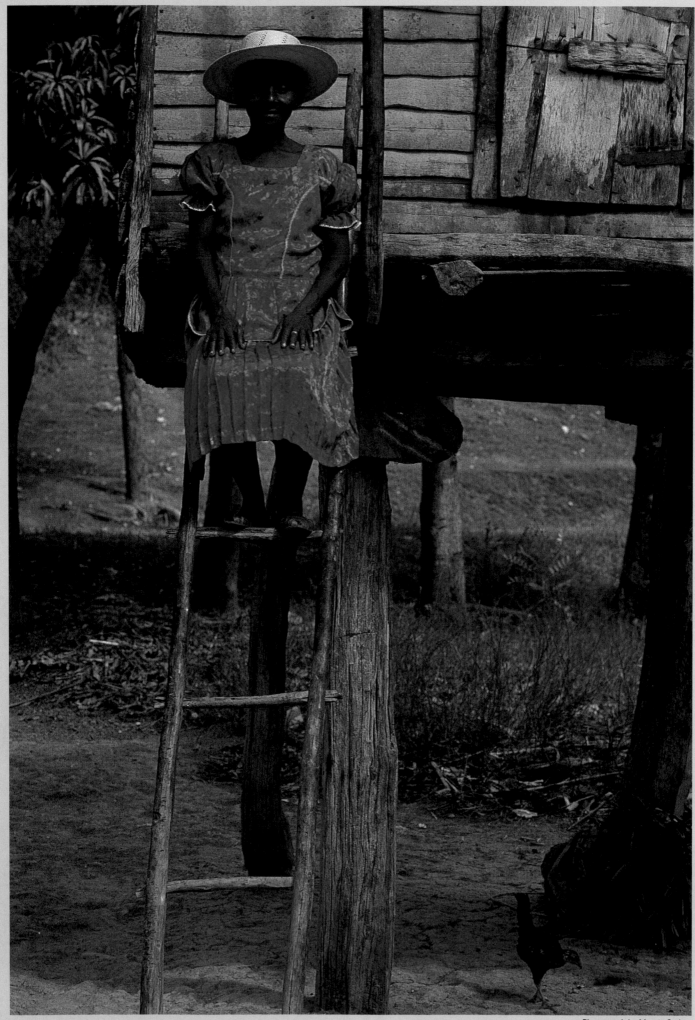

Haiti: Madame Delfoart in her Sunday dress, perched on the ladder of her elevated storage shed.

Photograph by Maggie Steber

Foreword

By NAOMI WOLF

ALL TOO OFTEN, THE PICTURE OF THE PLANET WE CARRY AROUND with us—a picture formed of our own experiences and the stream of information from the mass media—is at odds with what is real and important. The world is much more diverse, sorrowful, and splendid than the white-washed and overwhelmingly present stereotypes many of us have in our heads. And it is much more female—there's a whole half of the world that is waiting to be heard from. It's hard to know what a real portrait of what's out there would look like, hard to imagine what a symphony composed of all the world's voices would sound like. But this book may well be an indication.

What you have in your hands is nothing less than a template of a world that has long been invisible. Throughout history, the challenges, the courage, and the oppression of women—the majority of people on Earth—have been kept out of sight. Now, the hidden is coming into view: *Women in the Material World* begins to show what media and culture and consciousness could look like as this imbalance becomes balanced. It's a revelation to see.

Although the political and geographical scope of this inquiry is impressive, perhaps unique, I must confess that what is most striking to me is the beauty of its images. I don't wish to ignore the suffering and anguish that are all too apparent in the faces of some of these women. But I don't think the marvelous color and composition of the photographs are a trivial matter either. Fine aesthetics can engender good politics. The lush magnificence of these images makes it easy for outsiders to see and validate the subjects—something that in the long run, in an information empire, may help determine whether these communities thrive or suffer.

More importantly, the beauty on the page is a tribute to the inherent beauty of the subject: the female love, passion, and toil that invisibly undergird human societies everywhere. In shining such an ambient light on the lives of poor women in Brazil, Haiti, and Mali, for instance, *Women in the Material World* helps make immediate and undeniable many of the things that dominant classes in dominant countries tend to trivialize or take for granted. It reminds us forcefully of a lesson that can never be repeated enough: there is overwhelming drama and value in each and every human life, no matter how profoundly these lives are ignored. These are lives upon which the well-being of the world depends. They are justly celebrated here.

Preface

By PETER MENZEL

THIS BOOK IS THE OFFSPRING OF MY DOCUMENTARY photography project, *Material World: A Global Family Portrait*. The idea for the first book hit me while listening to a radio report on the marketing of Madonna's picture book about her sexual fantasies. I thought about the lyrics to one of her songs—we certainly are living in a Material World. In my twenty-five years as a photojournalist covering extremes all over the planet, I had witnessed warfare, starvation, environmental disasters, and the fruits of technology, science, and business. What the news often ignored were the ordinary folks and how they survived; preoccupied with hyped non-events like Madonna's book, it seemed to me that too many people had little idea of how their neighbors lived all over the world.

To counterbalance this overemphasis on extremes and hype, I came up with a crazy idea: find thirty statistically average families in thirty countries and photograph them with all their possessions in front of their homes. To pick the nations, I apportioned the selection along demographic lines, with Asia—home to the mass of humankind—getting the biggest share. From these rough guidelines, I chose idiosyncratically among nations that were in the news, undergoing rapid change, in timewarps, or had been enemies of my own country. To select the families, I determined what an average family was like in each nation, looking at family size, income, education, occupation, race, religion, and housing conditions, among other criteria. The task of finding and photographing these families was shared by a team of sixteen photographers who set out to accomplish this over the course of a year. I shot a dozen of the "Big Pictures" of the families and their possessions—in a snowy backyard in Iceland, in the desert sand of a vacant lot in Kuwait, on a rooftop in a mud village in Mali, in a narrow street under the scrutiny of officials in Cuba, and my favorite, in a garden in a tiny mountain village in Bhutan. It was truly a universal headache and a global backache. But I learned incredible things about our similarity and diversity.

Although the "Big Pictures" were the centerpiece of the project, most of the book itself was comprised of photos of daily life made during the course of the photographer's week with the family. But as I worked with our questionnaires and examined the photographs, I noticed that the women in nearly every family were eclipsed by the men. Part of this may have been because fourteen of the sixteen photographers were male; another part, because the cultural traditions in each country put the men up front in positions of power and leadership. In any case it was hard not to notice that the women were working longer hours than men for less or no pay while enjoying few of the benefits.

Working now with my partner, Faith D'Aluisio, I decided to go back to nineteen of the original thirty families (we added Jordan to round out our global coverage) to photograph the women of these families and to talk with them about their lives. We wanted to know how they see themselves and the world around them. We wanted to know about their daily routine, their thoughts about their children and their husbands; their hopes and dreams and their proudest accomplishments. And we wanted to ask their husbands some of the same questions.

Faith and I decided that we would eliminate the testosterone filter of the first book by assigning female photojournalists, interviewers, and translators to go back to the families. To get the intimate look at these women's lives we were hoping for, we thought success was more likely if women approached women. The results speak for themselves.

By FAITH D'ALUISIO

VISUALLY DOCUMENTING THE EXPERIENCES OF ORDINARY people—the small events that are the fabric of most human lives—is a uniquely difficult photographic task. Almost nothing "happens," and yet, of course, everything happens. To find the extraordinary in the ordinary, then make it real and vivid to an audience, photographers need a special kind of perseverance, awareness, and anticipation. Collectively, the photojournalists and journalists who took part in this project successfully captured the flavor of the lives of the twenty-one women presented in this book. From their fifty thousand pictures and the one hundred and sixty hours of interviews, we edited the book you now hold in your hands.

The field photographers and journalists were almost exclusively female. This was not a matter of ideology so much as practicality; time and time again, we encountered the reality that in many cultures women spoke more freely and honestly when the figures on the other side of the lens and microphone were female. This lesson was repeated again and again as we struggled across language barriers to disentangle the subtle cultural nuances and personal traits that made each woman different. Conversely, male translators often felt awkward around female subjects; even the excellent Tony Kadriu, our translator in Albania, did not want to ask certain questions of Hanke Cakoni.

In putting together the text, our goal was to represent these women in English the way they would sound if they spoke in English while trying to keep the flavor of their own language's idiosyncratic way of putting things. This proved to be troublesome. Translating in the field is an extremely difficult task—an art, really—especially when the translator must relay everything so that the conversational nature of the exchange can come through. Although in general our field translators did what can only be called a heroic job of interpreting these long, intimate conversations, it would be foolish to expect them to produce the exact yet colloquial text that we wanted. In consequence, the final text is adapted from both the translations we did in the field and further translations we did later on, in the Material World offices.

Occasionally the second translation corrected misimpressions that slipped through the first. For example, the initial translation of Melissa Farlow's interview with Fatoumata Toure, the second wife in Mali, led us to believe that Fatoumata was simply a terse, unreflective woman who didn't have much to say. When Kassim Kone, a Malian doctoral candidate in the United States, listened to her interview, he was able to give us a much fuller translation, which revealed that Fatoumata's way of speaking was thoughtful and sparely poetic.

For the most part the formal interviews became real conversations as one story led to another and we found ourselves sharing as much about ourselves as were the women being interviewed. Sometimes the conversations were intimate indeed. In Russia, Zhanna Kapralova, still recovering from the Christmastime murder of her husband in 1993, seemed to treat her conversation with interviewer Ludmilla Mekertycheva as a cathartic experience. In editing these very personal conversations, we tried to treat these women as we ourselves would wish to be treated were the tables turned. We wanted to balance their right to privacy against our journalistic desire to know and report absolutely everything. We tried, in short, to be accurate, kind, and fair.

Our conversations with these twenty-one women each have their own flavor, but it is possible to make some generalizations. From our experience it is evident that the educated women in developed countries spend more time thinking about their lives than women in poorer nations. They needed little prompting to express their feelings at length on a wide range of subjects. By contrast, our conversations with women in less developed countries tended to fall somewhat more into question-and-answer form, presumably because people in economically marginal situations are less often able to engage in the "luxury" of reflecting on their lives. Naturally, there are always exceptions to every rule. Despite her illiteracy and poverty, the Bhutanese family matriarch Nalim told us stories about her family and her life with considerable glee and verbal flourish. Nonetheless, Nalim was at a loss for words when we asked what made her happy, sad, or angry. Her emotional states are overwhelmingly determined by the quality of her crops and the weather that affects her farming.

Over and over again, we saw how these women negotiated through the range of social choices available to them. Zenebu Tulu in Ethiopia explained to interviewer Vivienne Walt how important it was for her to conform to her culture's expectations. Having regular, unwanted pregnancies is something that she cannot change; accepting them as an undesirable fact of life, she uses her considerable ingenuity to make the best of her situation. For a Western visitor, it was tempting to imagine that another woman might rebel, but this would be more apt to happen if the woman was able to see clearly that there was another path to follow. In Texas, by contrast, Pattie Skeen's daughter Julie, 12, is already making choices for herself and deciding between her options—a circumstance that will continue as she grows older. Alas, the opening of so many options is never accomplished without social turmoil; it would be difficult for Zenebu to have the choices provided to girls in Julie's culture without bringing along some of that culture's anomie and alienation as well.

As different as these women's lives are one from another, they all want more economic security for themselves and more education for their children, including their daughters. The biggest difference is that the women from developing countries usually saw education for their children as a way for the parents to be better off financially, whereas in more developed countries, the women viewed education as a future economic benefit for their children, not for themselves. Women in developed countries also spoke of education as having more than just purely economic benefits—personal

Bhutan: Namgay, Nalim, and family. Photograph by Peter Menzel

Bhutan: Nalim and her daughter Zekom. Photograph by Joanna Pinneo

growth was also important. Still, all the women wanted their children to have higher living standards. Because it is difficult to imagine how all the world could have more affluent lives without considerable economic growth, these simple, heartfelt wishes presage substantial environmental conflict in the future.

In speaking of these generalities, it's important to note that although the women profiled in this book are typical of their country, they don't speak for it. They speak only for themselves—not for their neighbors, not for their mothers, not for their best women friends. They are not activists working to make life better for women around the globe (though most hope to benefit from the actions of the exceptional women who are). They are not spokeswomen for feminism, or for a backlash against feminism—an important point in a world that compartmentalizes, oversimplifies and labels in order to define people. They are themselves, purely and simply; twenty-one of the almost three billion ways that human beings on this rapidly changing planet are inventing how to be women.

Albania
Hanke Cakoni

" When I haven't been attentive enough, I start getting upset. It seems to me that he's thinking, 'This is your fault—you brought me to life.' "

HANKE CAKONI WAS TOLD SOON AFTER her son Eli's birth that he was severely disabled. She wept uncontrollably. It was the lowest point of her life, she says, but she learned to care for the son whom the doctors said "Would never be happy." Seven years after his birth, he cannot walk or talk or feed himself.

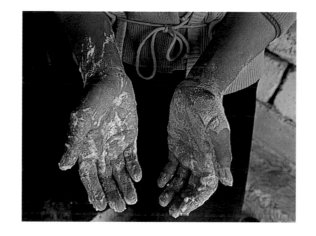

Hanke, her husband Hajdar, and their four children live in the Albanian countryside, three hours north of Albania's capital city of Tirana. Her days are filled with household tasks and the care of their disabled son and three healthy children. At first, Eli (*left*, watching his sister play) spent the day in a childcare center set up by the government. But by the time Albanian Communism collapsed in 1992, the center was gone. Hanke, 38, was able to stay at home to care for Eli, but for the unhappiest of reasons—she had lost her job when her company was privatized. Her schooling is not enough, she says, to obtain a good job in the post-Communist world.

Unsurprisingly, Hanke and Hajdar, 46, a school teacher, believe fervently in the value of education; they spend evenings working with the children on their homework. A comfort in a hard life, she says, is being able to share difficulties with her husband. Although Hanke does all the cooking (*inset*, her doughy hands), Hajdar is willing to help with what is traditionally viewed as women's work—an unusual attitude in a nation where a new bride's parents give the groom a bullet to symbolize the extent of his power over her.

Photographs and Interviews by CATHERINE KARNOW

Albania

Population: 3.5 million

Population Density: 312.6 per sq. mile

Urban/Rural: 37/63

Rank of Affluence among UN Members: 150 out of 185

Hanke Cakoni

Age: 38

Age at marriage: 22

Distance living from birthplace: 2-hour walk

Children: 4

Occupation: Homemaker

Religion: Islam

Education: High school and one year of technical school

Favorite subject in school: Russian

Monthly family income: 5,800 lek [US $64]; includes Hajdar's salary and government payment for Eli's disability

Cost of a pair of sneakers for oldest son: 600 lek [US $6.50]

House: 4 rooms (goats live in two of them)

Cost of home: Built by themselves for 40,000 lek [US $440 at current rate]

Fuel source: Wood gathered several times a week

Time spent gathering wood: 3 hours each time

Electricity: Yes, intermittent

Best life event: First child's birth

Worst life events: Parents' deaths and discovering son's disability

Favorite task: Caring for disabled son, Eli

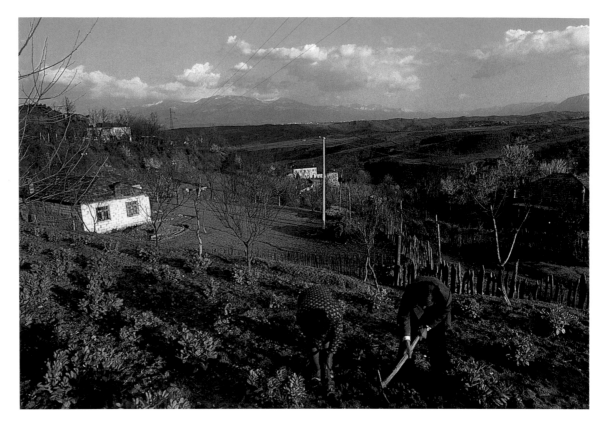

Of all the tasks Hanke performs, gardening (above) is her least favorite—though having her husband Hajdar joking beside her as they work makes the hoeing and weeding almost pleasurable. Thanks in part to the couple's constant diligence, life is slowly improving. Growing up, Hanke says, "I had just one blouse and I had to wash it during the night and hang it up to have it ready for the next day to go to school." By contrast, her daughter, Artila, 8, (right) has three or four blouses and two pairs of shoes. "She eats much better than I used to eat," Hanke says proudly.

Conversation with Hanke Cakoni

Catherine Karnow: I know you work at home now, but can you tell me about the job you used to have?

Hanke Cakoni: I was a topographical technician [surveyor] for 12 years. When I began I was paid 4,800 lek [US $53 at current rate]. By the time I left the job, I was paid 6,500 lek [US $72] per month and I had three months off every time I had a child. When democracy came and the country privatized, it became hard for me to keep my job in this field. It was difficult because I was in competition with people who graduated from university. I was fired. Almost everyone with my level of training was fired. There were a lot of people with university degrees. They got the jobs.

Do you wish you'd gone further in school?

I would really have loved to go further, but there were two obstacles. The first was that I had a low [grade] average. The second problem was that during Communism, not every child in every family was allowed to go to university. My older brother got the scholarship. Of the five children in the family, only one went to university.

Was life better for women under Communism?

Under Communism, women were given the right to speak out and were allowed to take part in every activity, but the problem was that neither men nor women were allowed to experience the rest of the world. We were closed in—the whole country was closed in. It was completely impossible to exchange thoughts with foreigners, so we could not compare where we lived to where others lived. And it was too difficult at that time to find material goods. Now it is easier to have such things, which is why I think it was probably worse under the communists. For example, it might be that here is an Albanian-made couch, let us say. Even if I had money during the communist rule, I could not buy a foreign-produced couch. Now there are a lot of people who can buy everything, who can buy a much better couch than this one. I could talk all day about this. At that time I could not even imagine what an electric stove would be, or what a gas stove would be, or what a very beautiful carpet on the floor would be, or anything else.

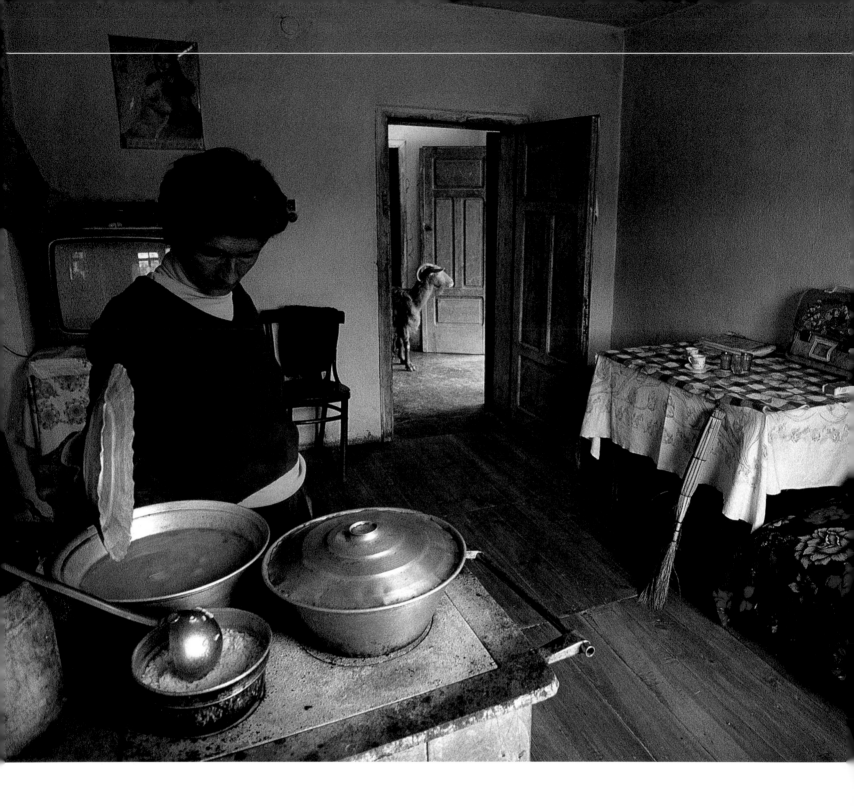

Ignored by one of the family's goats, which stands in the doorway, Hanke (above) finishes making lunch before Hajdar, daughter Artila, 8, and sons Armond, 14, and Ardian, 12, return from school. The Cakonis' house is divided between farm animals and people, with the goats and chickens occupying the two rooms on the right-hand side of the front door and the family using the two smaller rooms on the left.

Catherine: What do you do during a typical day?

Hanke: I wake up at 5:30 in the morning. I make the fire and I go to the children and say, "It is high time to go to school—time to get ready!" At 7 a.m., the children and Hajdar have breakfast and go to school. [Hajdar teaches in the school attended by the two older children—Ed]. Eli and I, we have breakfast afterward. Then it's time to wash the dishes and prepare lunch. At 10:30 a.m. I go out with the goats and chickens for 20 minutes. After this, the things I'm cooking for lunch might be ready. They are all boiled and I am expecting the children and

Hajdar to come from school. At 1 p.m. they come in, one after the other, and we sit and have lunch. In the afternoon we are freer, and sometimes we visit our friends. And then we come back and relax until 6 or 6:30 p.m. After that is the struggle to prepare for dinner. We have dinner, and I wash the dishes, and do other work. We watch television for two hours—it depends on the day and the program. And at 10 p.m., we go to bed.

What takes the most time?

The biggest part of my day is used up by washing laundry—I have a handicapped child, so his clothes have to be changed very often [he

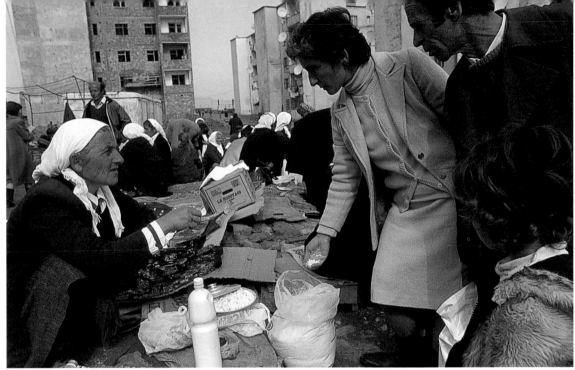

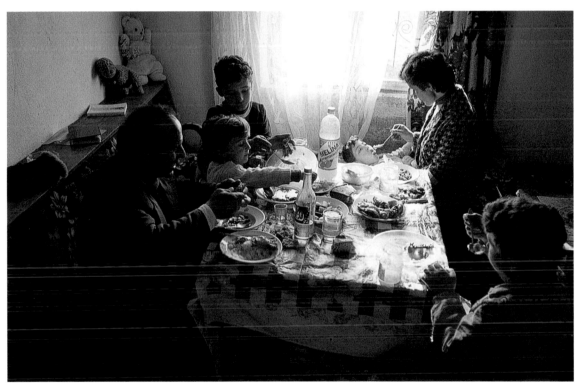

can't control his bowels—*Ed*]. And then I have to sweep all day because we have all the animals inside the house. I have to clean everything here. And sometimes I am busy with Eli—just helping him walk around the house or giving him some physical therapy. When we do the laundry, we do it all by hand. There are no machines, so it takes time. The fastest part of the day is getting the kids ready for school. I prepare breakfast in ten minutes, and then they are all gone. The rest of the day I sweep, do laundry, and take care of Eli.

What's your favorite time of day?

When I have finished everything and all the children and Hajdar are out of the house, then I can pay complete attention to Eli. It is the most beautiful time—I know that I am doing something good, emotionally and spiritually good. He spends the day waiting for me to pay attention to him. When I have not been attentive enough, I start getting upset. It seems to me that he is thinking, "This is *your* fault— *you* brought me to life." And in those moments, it seems to me that the most human thing I can do is to dedicate my whole life to this one child. At least I would like Eli to walk on his own. If I cannot help him do anything else, at least I want to make him able to walk.

Lunch at the Cakonis' (above) includes chicken, rice, leeks, turshi *(a type of pickle), and a nip of* raki *(a brandy-like liquor). Before eating, Hanke always feeds handicapped Eli, 7, who cannot feed himself. Supplies like rice come from Hanke and Hajdar's bimonthly trips to the market in Burrel, a 2-hour walk away. Hanke (top, bargaining for flour) controls the funds on these expeditions. "Men are a little bit unstable in making shopping decisions," she says.*

Women
in Albania

Medieval Albania was governed by an elaborate set of rules called the Kanun of Lek. Codified in the 19th century, the Kanun spelled out how Albania's many clans should live—from how to treat guests to rules for honor killings. "A woman is a sack made to endure," it said. The code subjugated women to male authority, allowing parents to choose a young girl's mate, and to forcibly hand her over to her fiance; if she tried to run away, he had the right to kill her.

After World War II, communists took power. Women became members of parliament and party officials, as well as lawyers, journalists, scientists, factory workers. But they still had to take care of their families—and in an officially atheist country—they also carried the burden of passing down ethical and moral values.

With the fall of Communism in 1992, many state-run factories were shut down, with women among the first to be laid off. As the puritanical socialist government lost power, prostitution and pornography burgeoned, along with a spate of violence against women.

Government and foreign aid organizations must now rebuild the country's decayed infrastructure: Health care facilities, roads, and schools have all fallen apart. Some Islamic countries have offered aid to largely Muslim Albania under specific conditions, like the veiling of women. But women's groups have successfully fought these initiatives, and are pressing for other changes, like the introduction of birth control and the legalization of abortion.

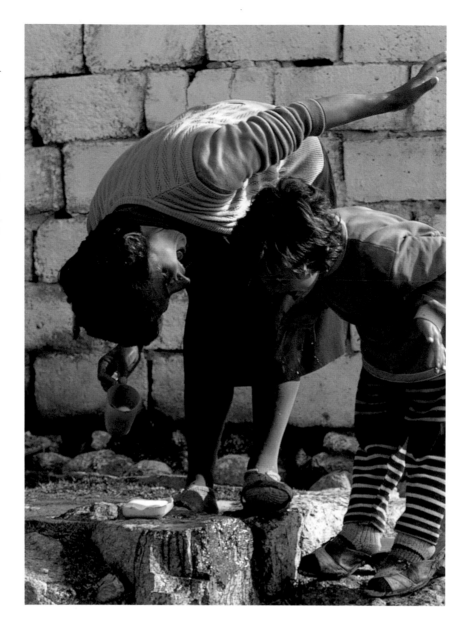

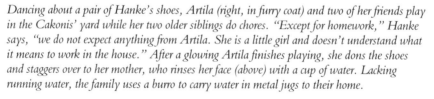
Dancing about a pair of Hanke's shoes, Artila (right, in furry coat) and two of her friends play in the Cakonis' yard while her two older siblings do chores. "Except for homework," Hanke says, "we do not expect anything from Artila. She is a little girl and doesn't understand what it means to work in the house." After a glowing Artila finishes playing, she dons the shoes and staggers over to her mother, who rinses her face (above) with a cup of water. Lacking running water, the family uses a burro to carry water in metal jugs to their home.

Catherine: Do you think women are treated fairly in Albania?
Hanke: In our country women are treated as one step beneath men. I can give you an example—for instance, women are not supposed to have the right to speak outside the home. In my family, Hajdar treats me completely differently from the way his brother treats his wife. In general, I would say this reflects the level of education—the higher the level of education, the better the family treats women.

Hajdar, do you think men and women are treated equally?

Hajdar Cakoni (husband): Personally, I think I have struck the right balance in my relationship with my wife. We have always been equal in this family. But in this area there are a lot of men who demand priority in the relationship.

What do you mean?
Hajdar: Even during a simple visit you can easily spot this kind of priority. The man always walks in front of the woman, and the woman walks just behind the man. And there are a lot of families where what the man says is the law.

Hanke, that's the custom, but are there actual laws protecting women?
Hanke: Yes, there are a lot of laws that

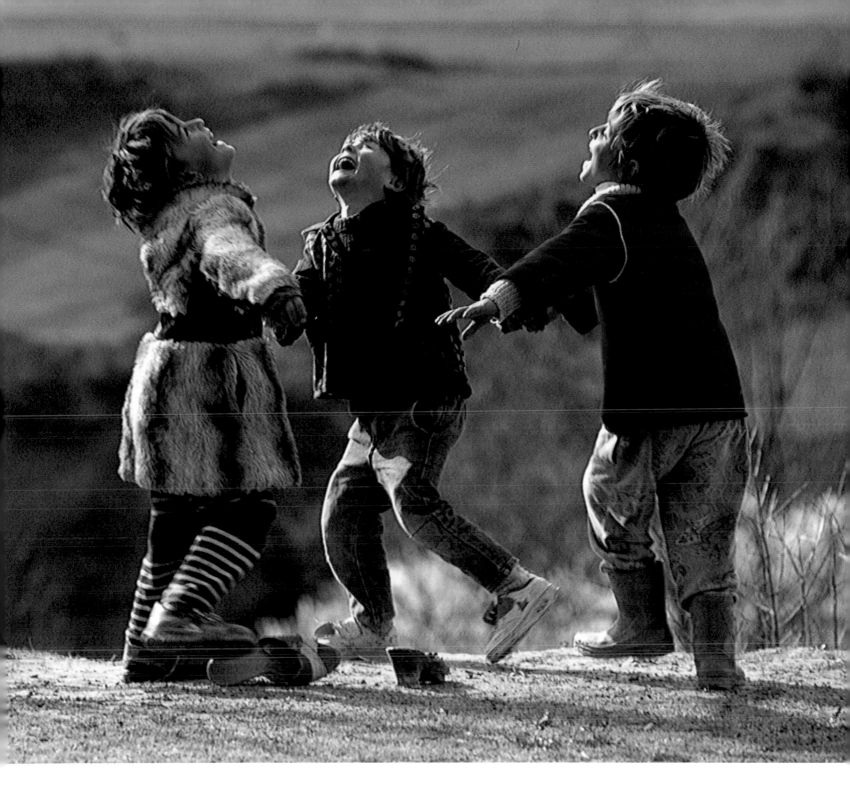

guarantee women equal rights. But people pay little attention to these laws.

How has life changed in recent decades?
Life for my generation is very different than for my mother's. In those days, women were supposed to do all the work inside the house, while everything outside the house was the men's responsibility. [Hanke's mother had a job, but this was unusual.—*Ed*] In my generation it is completely different—I have the right to go shoulder-to-shoulder with my husband. And there is a lot of difference between my generation and my daughter's generation, too. Simple things. She has this stove to get warm by, but when I was a child, the house was cold. And I did not have enough clothes, while she is growing up in a society where she has these things.

Are there things you like about the way women are treated here?
I do not like anything at all because women are treated as less than men. If somebody asked me, I really would like to completely change the way women are treated in this society, but I have never been given the opportunity to be involved in such activities.

FOLLOWING PAGES

Hajdar began helping Hanke with the wash some years ago, when she contracted hepatitis and couldn't do it alone. Realizing that it provided some rare private time with his wife, Hajdar has helped her ever since—a decision scoffed at by his neighbors. "Hajdar is not like other Albanian men," Hanke says. "[They said] it was shameful to go to the river and do laundry with your wife."

Surrounded by the family of Hajdar's brother Mustafa, Hanke is the center of attention (above), amusing the nieces and nephews while cradling Eli in her lap. Behind her, a reflective Hajdar sits and listens. They lived for many years with Hajdar's family in even more crowded circumstances than they are in now. Although the move into their new house was a major improvement, they remain painfully aware that they live in the poorest society in Europe, and that change will happen slowly. Meanwhile, Hanke says, she and her husband (left, enjoying a respite from gardening) have the considerable consolation of a happy, long-lasting marriage.

Catherine: Tell me about Hajdar.

Hanke: He has at all times been a good friend and a good partner. When I have been sick, he never lets me do the hard work and he does all the work that I cannot do.

The cooking, too?

No. Normally what happens—for example, when I was sick, someone from outside came to the house to cook. I started to train Hajdar how to cook and he tried so many times, but normally, no, it is me who does these things.

What do you expect from him?

When I ask him for help as my husband, he should give it to me. And if I ask him for help as my brother, he should give it to me, and as my friend, he should give it to me. And whatever kind of help he needs, I will give it to him. As a sister, as a friend, as a wife.

Is it unusual for a man to help his wife so much?

People generally say that if a man does everything his wife tells him, he is not a man. Everyone gossips about it. They say, "There is

no chairman in that house." It means he is not a man.

You were telling me you wanted a "normal" house. I'm not sure what you mean—what's a normal house like?

A normal house has a sitting room with two couches and a coffee table between them and a very beautiful rug in the middle or a carpet on the floor. I would like Hajdar and me to have a bedroom with all the usual furniture and another separate bedroom for the children. We have had a really difficult time. First we lived with the rest of Hajdar's family, all together in one house. Even after we left them and moved here, we had a lot of problems with the house and the land. But Hajdar and I have a very good marriage. We have never let our problems overwhelm us. The problems come and go. They pass, and we still have our lives.

Burrel feels like a rough place. The streets are full of men standing around as if on a break from work. In fact, they have no work and no chance of getting any. Dressed in jeans and leather, with longish hair and sideburns, they are like a bad '70s movie on late-night TV. All around are smashed factories and ruined buildings. The Cakonis' warmth is a relief.

They are a traditional family. Hanke loves her role as a caretaker. They'd be lost without her. Boys carry on the family name; girls are loved but inessential. They asked once if I wanted to have children. "Yes," I replied. Hajdar said, "Don't have girls, have boys!" This in front of Artila, his daughter.

One day, we went to the house Hanke grew up in. It was a huge house, compared to the little one she has now—a "proper" house. It's in disrepair; a couple of people were camped out upstairs. Hanke looked around at the chipped walls and wistfully said that once it had been a grand house where special visitors to Burrel always came for coffee. She sat down on an old wooden box, and I photographed her with a picture of her mother, whom Hanke misses terribly. It was very quiet, except for the distant sound of a rooster.

When we returned, she frenziedly busied herself with cooking to make up for all the work she had missed being with me. She didn't sit down to eat, but kept cooking and cleaning until long after everyone had finished. Even then she just nibbled on a piece of bread, though she hadn't eaten all day.

— CATHERINE KARNOW
JANUARY

Bhutan
Nalim

" If a woman plows, the ox will start to cry and will not work properly. "

STRUGGLING TO FEED A FAMILY OF 13 in the tiny Himalayan village of Shingkhey in western Bhutan, Nalim measures her own happiness by the size of the harvest. Because her husband, Namgay, has a club foot, Nalim, 49, (*right*, winnowing mustard) and her eldest daughter Sangay, 31, do most of the farm work in addition to fulfilling the roles of wives and mothers. (Like many Bhutanese, the family has no surname.) In the village, Namgay, 52, holds a revered position, divining the cause of illnesses by throwing dice and interpreting the results with religious texts. Payment is usually in the form of a betel nut, a mild narcotic common in South Asia. But betel is of little practical use to the family; to subsist, Nalim works other people's land, trading her labor for part of the yield.

Following the initiative of the King, the family dresses in traditional style (*inset*, part of Nalim's *koma*, a dress fastener). As is customary, Nalim, Namgay, and their children live in the second story of a three-story house, sharing the space with Nalim's brother and Sangay and her husband and five children. The grain is stored on the top level and the animals live on the ground floor. Because the animals attract disease, the government urges villagers to move them out of the house; Nalim says she would like to do it, but lacks the money for a barn. Such sanitation problems have caused each child to suffer at least one serious illness—dismaying to Nalim, whose brusque manner softens to an impish warmth in the company of her children.

Photographs by JOANNA PINNEO Interviews by FAITH D'ALUISIO

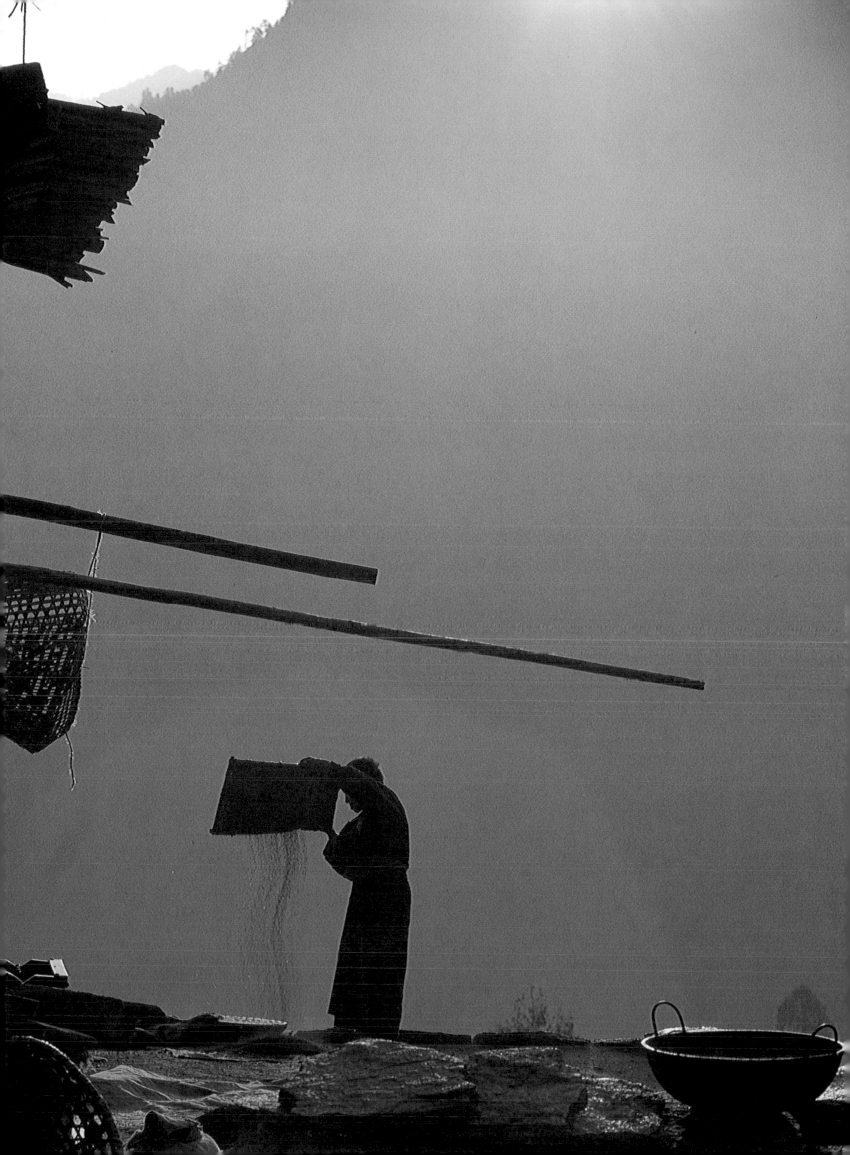

Family and Nation

Bhutan

Population: 800,000

Population Density: 44.1 per sq. mi

Urban/Rural: 8.5/91.5

Rank of Affluence among UN Members: 146 out of 185

Nalim

Age: 49 (but not sure)

Age at first marriage: Early twenties

Distance living from birthplace: Same village

Children: 5 (but 1 died)

Children living in house: 8

Number of people living in house: 13

Occupation: Farmer

Religion: Buddhism

Education: None

Family's monthly expenses: 344 ngultrum [US $11.50]. Money is spent for salt, sugar, tea leaves, clothes, and school supplies.

Cost of one pair of children's shoes: 50 ngultrum [US $1.70]

Number of children in Nalim's family who own a pair of shoes: 3

Amount of food consumed that is homegrown: 99%

Distance to nearest market: A 3-hour walk, each way

Would like to change: Her kitchen

Electricity: No, will come in 2 years

Personal dream: To travel to other countries

Conversation with Nalim

Faith D'Aluisio: Can you tell me what the important events have been in your life?
Nalim: None of real importance—just worrying about work and hoping that the harvest will be big enough.

Where were you born?
Here in Shingkhey. I've spent my whole life here. My old house was on this spot and I rebuilt it in the same place. When I was growing up, there were several of us living in the same house: myself; my brother Kinley Dorji, who still lives with me now; my mother; my uncle and aunt; and my husband.

Your husband Namgay?
No, Namgay is my second husband; we have been married for about 20 years. I was married to my first husband for six years. Just when our house was completed, he got sick and died. We do not know what he died of. He was the father of Sangay, my oldest daughter. Namgay is the father of Kinley, Bangum, and Zekom.

How old were you when you got married the first time?
In my early twenties, but I do not really know. He was from another village called Chungangkha. It was a love marriage. I met him when we worked in the fields.

Was your marriage to Namgay also a love marriage?
Yes.

Did you have a special ceremony for your wedding day?
On the day we married, he just came here and lived here.

So you didn't need any kind of legal papers?
We live together as married people, so we are married.

Is Namgay from this village?
Yes, his house is right up the hill—his family still lives there. I've known him all my life. After my first husband died, I did not marry again for six years. Namgay lived next door and I used to see him often. Maybe because of our previous lives we should be together. Our fate and our karma brought us together.

You said you all lived in your mother's house which is now yours. How long ago did your mother die?
I do not remember the age but it seems she died when I was in my thirties. My father died when I was very young.

Did your mother take care of the family when your father died?
I did. There was no one else strong enough to work. My mother was old and I had to put a lot of effort, myself, into rebuilding this house. But she expected me to have a strong household with a proper house—to get married and settle down so that I could look after the house.

I'm not sure what you mean by a "proper house."
I do not have a proper household. This is not a very good one. I do not have the jewelry and things that people should inherit from their mother. All I want to have someday is some chairs, some mattresses, and proper plates and cups so that when visitors come, I can offer them this. I do not have these things but I do have a *stupa*—a prayer house where we keep all the statues.

Do you have what is proper to make a good family?
In order to have a very good family, the main thing is to have trust and understanding among ourselves. Namgay, my second husband— Sangay thinks of him as her father—so whatever Namgay says, everyone in the family listens to him. We all listen to each other.

What do you expect from Namgay?
I do not expect anything of him. I married him because I loved him. He cannot do heavy work because of his leg—he is crippled—so even before we were married he did not do that kind of work. He is a seer, so he reads and tells the future for people. If you are sick, you go to him and he finds out what causes the sickness. During the monsoon, when the rest of the family works in the paddies, he stays at home and looks after the children.

What about your daughters? Do you want all of them to marry?
It is the tradition that when daughters marry, they stay with the mother. The husband comes and lives with them. So I do not want my daughters to marry, because we already have too many children in the house. We do not need more children, and if my daughters and granddaughters do not get married, they would lead a much easier life. There will be no children or husband to worry about. They can go where they want and they will not be stuck in one place like me. But, if they do not marry and we die, who will look after them?

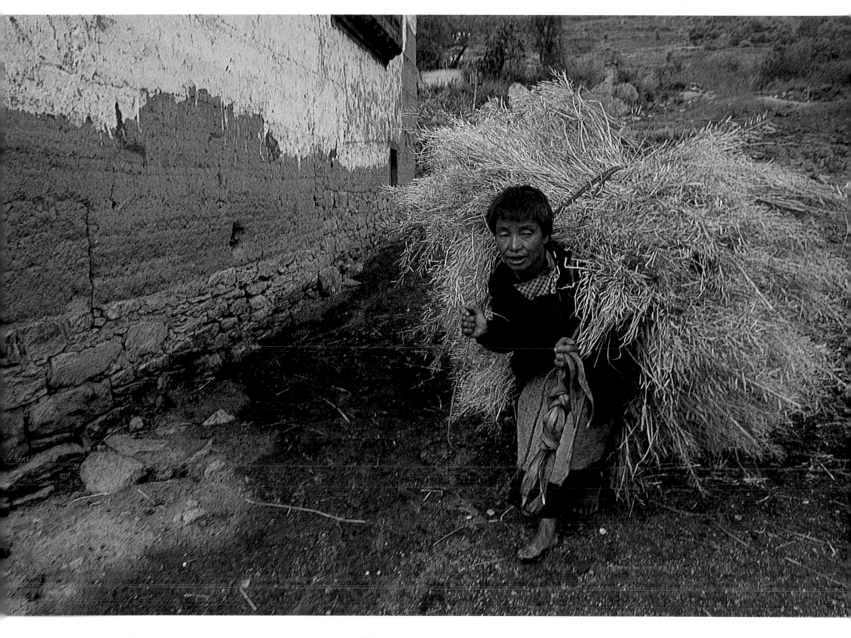

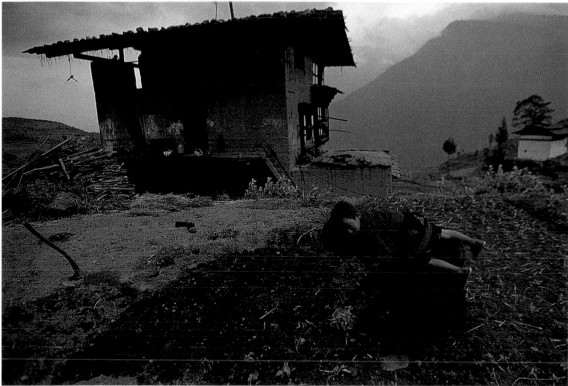

Because her husband, Namgay, walks with difficulty, Nalim and her daughter Sangay do almost all of the heavy work outside the house. Sometimes this involves lugging around 4-year-old Zekom (left) when Nalim plants chilies, a staple of the Bhutanese diet. A quietly indulgent mother, Nalim often acquiesces to her daughter's demand that she never be left behind. But carrying a child is not an option when the work is heavier, and Nalim must ignore Zekom's irate wails as she struggles to bring home a heavy load of wheat (above) from the terraced fields.

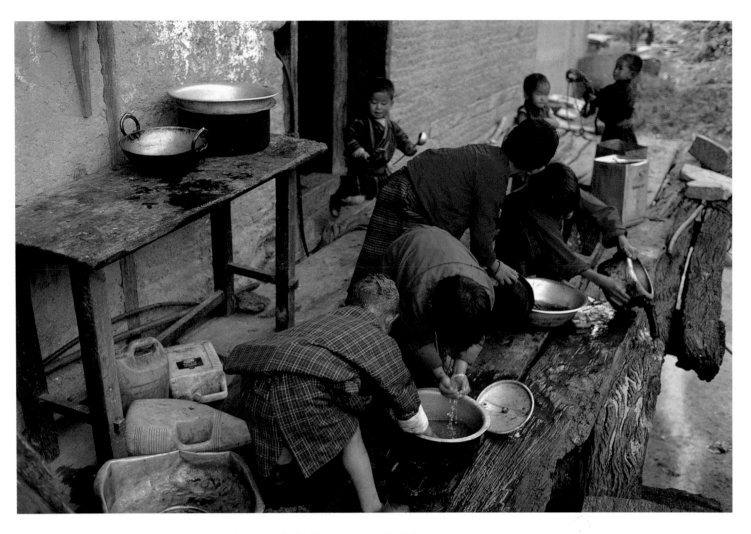

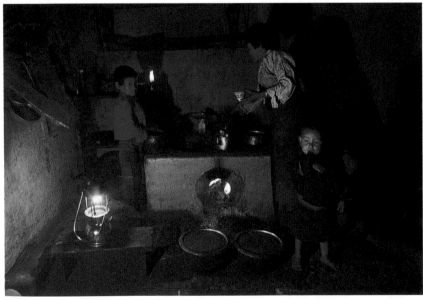

Seven young children can create chaos, but Nalim and her daughter, Sangay, run a tightly organized household. After breakfast, the children scrub the breakfast dishes (top). Because Nalim's middle daughter, Bangum, 16, is home from boarding school this morning, she takes the post of honor, holding baby sister Zekom after a chilly bath on the ledge of the house. Sangay's daughter Choden, 11, who usually gets to supervise Zekom, hovers jealously over the scene while Sangay's son Chato Gyeltshen, 4, inspects Choden's foot for a splinter. The silver chains of each girl's koma *(dress fastener) gleam in the morning light (right). In the evening, Sangay prepares a dinner of rice and curry on the earthen stove (above); her chief assistant is Choden, restored to her position of primacy by Bangum's return to boarding school.*

Faith: It seems as though you really enjoy your children.

Nalim: Yes, I love being with the children. When they are not at home, I miss all the naughty things they do. When they are naughty—I really love that. [Laughs] I will love it when they are grown up like Sangay and can do the housework for *me.*

Do you think you'll have any more?

I don't want to have any more. I do not have the strength to give birth again. I put all my effort into providing enough food for the children we have. Even my daughter Sangay is on birth control. We will not have any more children. The ones we have are sickly.

What kind of birth control does she use?

Injection. We thought to ask the health department because Sangay was having a child every year. For many years in a row she had children, so we decided to do this. For the last three years, Sangay has been on birth control. I decided it, and Sangay agreed to it.

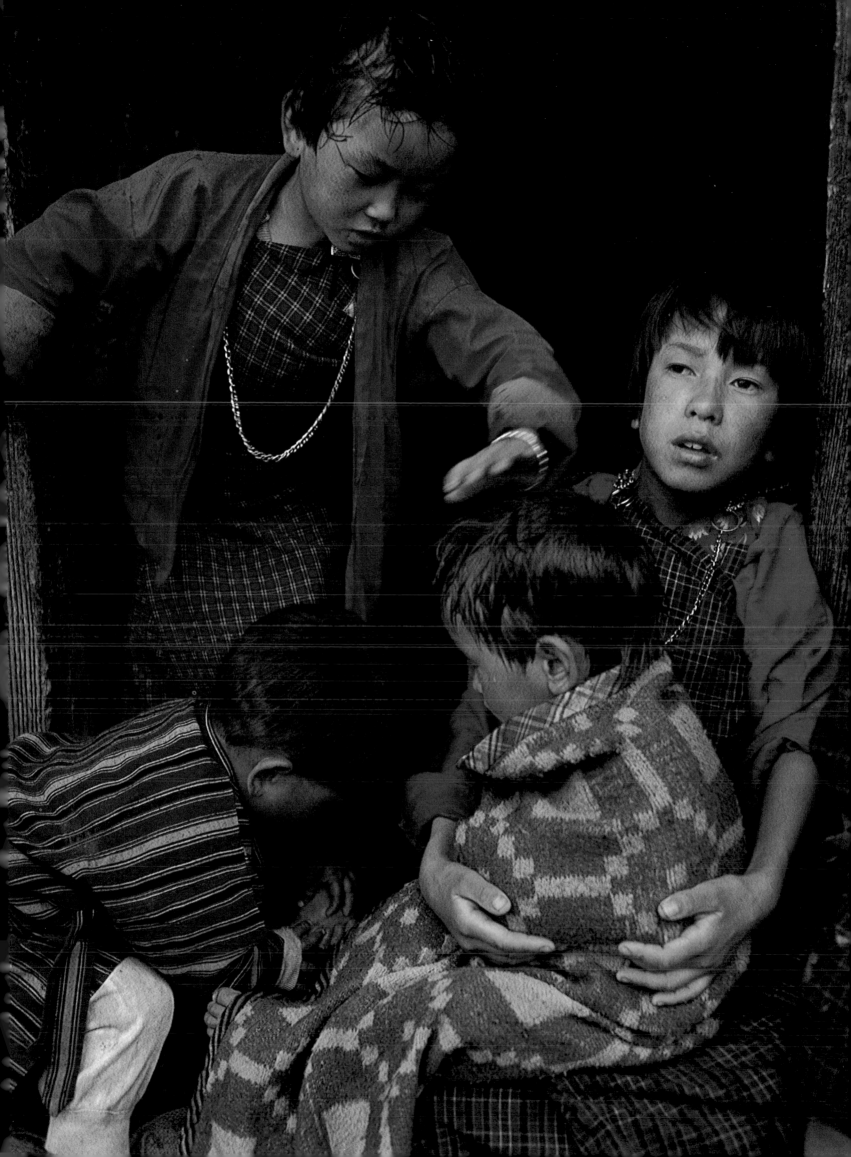

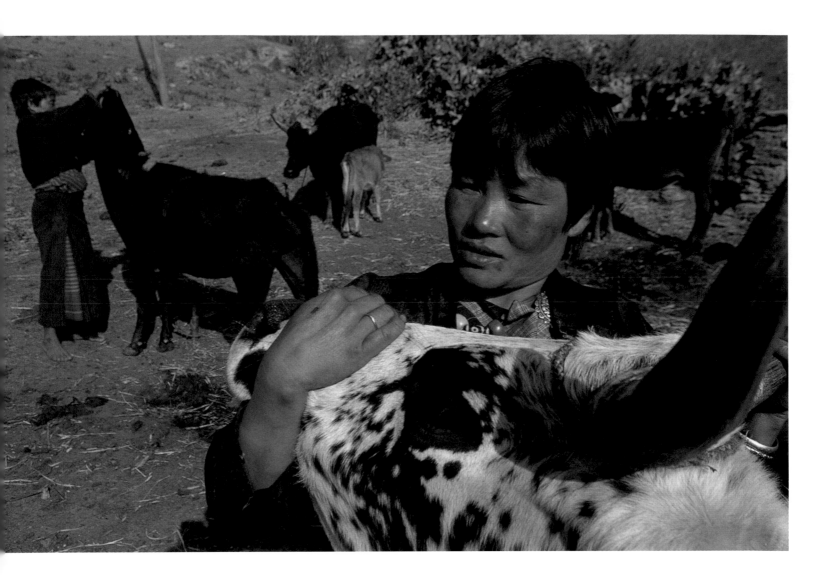

Wrapping her arms around a straining cow, Sangay (above) waits for Nalim to finish administering salt to another cow before they try to feed it to the particularly boisterous cow she is holding. Salt—one of the few items the family buys at the market three hours' walk away in the town of Wangdiphodrang—is used to increase milk production. Nalim and Sangay use the milk to make a soft white cheese, which they mix with chilies and wild asparagus to make a fiery vegetarian curry sauce that is eaten with red rice. As an accompaniment, the family drinks the runoff whey from the cheese.

Faith: Do the men help with the children?
Nalim: The only season when they take care of the children a lot is during the paddy time. Planting paddies is women's work, so at that time Namgay and Sangay's husband, Sangay Kandu, stay home and take care of the children and cook. Men's work is to plow the fields and make them ready to plant.

Have you ever wanted to do men's work?
Yes, I wanted to do men's work when there were not enough men. I thought about it but I never did it.

You seem to be a woman who does what she wants.
I wanted to, but I did not know how to plow.

Would the men teach you if you asked?
The men won't teach me. If a woman plows, the ox will start to cry and will not work properly.

Can men do women's work?
No, men never do women's things, like harvest wheat or plant the paddies.

What if a man wanted to plant rice?
But men don't know how to plant it. Even if they wanted to, they wouldn't know how. I

know a woman today who is going to plant the paddy. And in other parts of the village, there are people who want to plow and that family does not have men. They exchange the work. The men from this house go there and the women from the other house go to their house and plant.

Sangay, do you ever talk about how hard women work and how hard men work?
Sangay (oldest daughter): Yes, we do. When we have to take the dung down to the field—the men do not do that, so we say, "If we were men, we would not be doing this work."

Do you think men should do this work?
Yes, I think they should, but they do not.

Nalim, do you grow everything you need on the farm?
Nalim: I need money. I get it selling vegetables and when the wheat is ready, we make *ara* [a kind of ale] and sell it, too. This is our only way to get money. We buy salt, sugar, tea leaves, clothes, and school supplies and we need money for them.

How did you get the money to rebuild the house you inherited from your mother?
By borrowing money from friends. I paid them

back slowly. I worked for them and I paid partly in rice.

Do you and your family have everything you need to live?

It is difficult. I do not have enough money. This is why I cannot even build a proper kitchen in the house.

But if you were to say how your family stands economically, what would you say?

We are poor. But in this village we are average. Not rich. Some people are poorer than we are.

Who handles the money in your family?

I take care of the money, because I do the marketing and the money comes to me. I have to pay property tax of 100 ngultrums [US $3.22] a year and home insurance of 30 ngultrums [US $1.00].

Who makes the decision about how money is spent in your house?

I have the final decision in money. If anybody needs to buy something, they have to come to me for the money.

But your family mostly lives off the land, and I know rice season is coming up. Tell me what happens at rice-planting time?

Most of the time, we go almost every day to the fields to check if the rice is okay and see if there are any animals eating it. Especially when it has just been planted, the deer from the forest come down the mountain, so at night we have to stay in the fields.

You stay in the fields?

Only one or two people stay at home. The rest of the family stays in the fields. We build a sort of temporary hut. And then we stay there because the wild boars, the deer, and other animals come and eat the rice. All the families in the village go out. We build a fire and make noise to scare the animals. A man with a big torch goes around the field to see if there are any animals. Nobody gets proper sleep during rice time.

All the family sleeping outside with a big bonfire—it sounds fun!

[Laughs] Down in the paddies, whole families are out having parties. But it is hard, too.

Nalim piles mustard into her winnowing basket (above) while her brother, Kinley Dorji, and granddaughter Choden crush mustard stalks under their feet. This separates the pods from the stalks; Nalim then uses the basket to separate the seeds from the pods. Hand-fashioned leaf hats keep the workers cool.

FOLLOWING PAGES

After spending a tiring day chasing other villagers' animals out of her mustard fields, Nalim lost her temper at their owners. "People musn't let [animals] into the fields," she says, "because [the fields are] are our food supply for the year." Minutes later came an irate shout—Nalim's horse had wandered into a neighbor's wheat field. Chagrined, she leads her horse back home.

Women in Bhutan

The Bhutanese language has no distinct word for the act of getting married. After a boy has courted a girl, he will sleep over and eat breakfast with the family the next morning. This is called "going public," and afterward the couple is regarded as married.

In the extended family household, the grandmother holds great authority—cooking the food, and serving the evening meal in order of hierarchy. Most families pass down land through daughters, and husbands traditionally move to their wives' farms. These relationships are often unstable until the couple has children, keeping landless men on their toes lest their wives throw them out.

In this isolated mountain kingdom, 94 percent of people farm in rural areas, where wealthy landowners kept many in serfdom until the 1950s. Health care is an urgent problem: Bhutan has the world's second-highest maternal mortality rate. Many children die from dehydration due to severe diarrhea, although clean water programs and oral rehydration schemes have reduced infant mortality rates.

Few women serve in government, and those who enter the formal labor force—a recent development in a country which had no monetary system until the 1970s—earn less than men. Both sexes now have equal access to education, but girls account for only 40 percent of the school population. For generations, monastic schools educated only boys. Women can become nuns in this deeply religious Tibetan Buddhist culture, but the vast majority of important religious leaders—both monks and high lamas—are men.

Faith: Bangum, I can tell you're very close to your family. Do you like living here in the village?

Bangum (second daughter, 16): I want to leave. I will always be living a hard life like my mother here [if I stay] and I want a different life.

Even though your family has always lived here? Where would you want to live?

Bangum: I want to live in a town like Thimphu [the capital]. I've never been there but I want to go and live there.

Nalim, will Bangum's life be the same as your life and Sangay's life?

Nalim: No. I want her to continue in school and settle in the town and work in an office. I always wanted my children to go to school. Sometimes I want to know why my mother did not send me to school so I would not be having this hard life working in the fields with the animals.

Were other kids your age from the village going to school?

Yes, they did, but I was the only daughter so my mother did not send me to school.

If you'd gone to school, what kind of life would you have made for yourself?

I would move around if I were educated. If I had gone to school, I would not be living this kind of life—where I have to be out in the fields whether it is sunny or rainy.

So you make sure your kids go to the school?

My son, Kinley, wanted to go to school. My granddaughter Choden—Sangay's oldest daughter—was in school, but she always wanted to come home. Meanwhile, Bangum—my second daughter—was at home working. We sent her in Choden's place. Bangum had wanted to go to school before, but she knew that everyone could not go to school. She said if I wanted Choden to go, she would stay back.

Choden will never go back to school?

She will live the same life as me and look after the house once we are dead. Soon I will be old and will not be able to do this work. Choden will take care of us.

Sangay, if you could start again do you think you would have a different number of children?

Sangay (oldest daughter, 31): I only wanted three children but I did not know about birth control. By the time I learned about it, we already had five children.

When did you find out about birth control?

Sangay: I have a friend who lives in the next village. Her husband is a teacher. She told me about it. I told my mother and she told me to go and get the birth control. I agreed and went to Wangdiphodrang [nearest big town] for the injection.

Nalim, are you fairly satisfied with the way that your family lives?

Nalim: I like my life but, of course, I want to improve it. I think, oh, I wish I had some more land, or other things so I can have a proper household and have enough income so I would not have to worry about money.

Field Journal

Shingkhey is an idyllic location with horrible sanitary conditions. Flies and dung are everywhere. In the midst of all this is a nice family with real warmth.

Nalim and her daughter Sangay manage the household well. The women cook while the children gather the mismatched plastic and metal plates and bowls and set them on the floor of the main room of the house. Everyone sits on the floor to eat. The meals are lengthy affairs with lots of conversation. The adults listen with real interest to what the kids say—something you don't often see in our own frenetic techno-culture.

Most mornings, Nalim winnowed mustard seed outside. The sound of winnowing is like salt in a shaker but heavier, more rhythmic. Meanwhile, Sangay milked the cows. The little kids had the job of holding the calves away from the mother cows. The calves dragged the children all over the yard. Nalim watched with amusement, waiting to see what the outcome would be. The cows won and she laughed.

Choden's decision to stop going to school seems to reflect a desire to be the traditional "eldest daughter," which would end up putting her in charge of the household like Nalim and Sangay. Now Choden seems to regret staying home and not going to school, but the decision has been made. Choden will have to carry on and take care of the family. But the modern world is invading. Electricity is coming to Shingkhey in about two years, which could change everything. When that happens, will girls like Choden keep holding Bhutanese families together?

People from the village seem to move in and out of Nalim's house freely. It's a good thing she says she needs no privacy. She couldn't get it if she wanted it. Nalim says the house is always full of people because it's the last one before the trail leading to Gaselo. But we can see that's not the only reason.

— FAITH D'ALUISIO
AND JOANNA PINNEO
APRIL

While early morning light slants in through the second-floor windows, Nalim churns butter and contemplates the workday ahead (above). In a house without appliances, telephones, or television, the gentle sloshing of the milk is the only sound to be heard. Without electronic competition, family conversation is still the main means of entertainment. Moments before posing for this after-dinner portrait (left), children and adults were animatedly discussing a 4-year-old child in a neighboring village who has been identified as the reincarnation of a lama.

Marriage

Marriage, one of the most profound of human institutions, is practiced in ways that are as varied as humankind itself.

MALI

" *Even if Soumana were married to four women, I would be lucky, because I would always be the first wife.* "
— Pama Kondo. Soumana Natomo married his two wives, Pama Kondo (left) and Fatoumata Toure, within a month of each other; they have eight children between them.

HAITI

" *Yes, I married for love. We are getting older together.* "
—Madame Dentes Delfoart, who, as is customary in Haiti, took both the first and last names of her husband as her own when they married.

GUATEMALA

" *I have done as my mother did. I followed my husband, hiding for one week at his family's house. After one week, my husband's father's friends went to ask my hand of my father.* "
—Lucia Sicay Choguaj. Six months before this photograph was taken, Vicente Calabay Perez and Lucia were married in the Catholic church after living as a couple for several years; their three children attended the ceremony.

THAILAND

" *I married a different man than the one [my mother] wanted me to marry. I married the man I chose. I chose my own life.* "
—Buaphet Khuenkaew, who, in a small affront to tradition, settled near her parents, rather than the parents of her husband, Boontham, because she could not bear to be separated from her family.

CHINA

" *I admire my husband more than any other person. He is a workers' hero.* " —Guo Yuxian, standing for a portrait with her husband, Wu Bajiu, who displays his labor award from the local communist party. The couple has been married for 39 years during a turbulent time in China's history.

MALI

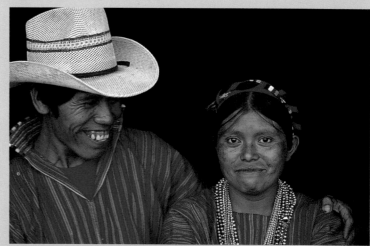

HAITI

GUATEMALA

THAILAND

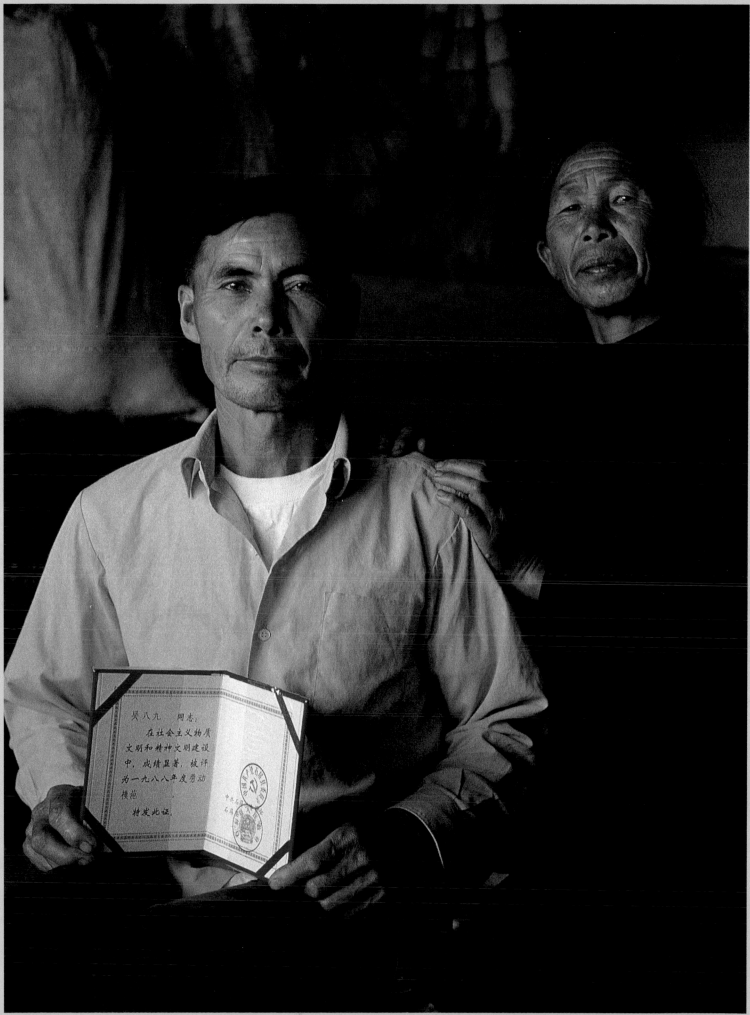

Marriage

BHUTAN: In a culture that has traditionally lacked formal marriage ceremonies, Nalim and her husband, Namgay, were considered married when he moved into her home; now they have been together for 20 years and have four children.

JORDAN: Haifa Khaled Shobi and Ali Nawafleh almost didn't get married when Haifa's father, a Palestinian living on the West Bank, wanted to withdraw his consent; he couldn't bear the thought of his daughter living so far away. Ultimately, they were allowed to marry—the couple has five children.

INDIA: Although Mishri Yadav's parents formally arranged her marriage when she was 10 years old, she did not actually meet her husband, Bachau, until she was 15, when she moved into his house.

MEXICO: Carmen Balderas de Castillo and Ambrosio Castillo Cerda did not marry until she was 18 years old. She became pregnant at 15 with their first child.

ISRAEL: After serving in the military, Ronit Zaks met her husband, Dany, on a blind date—a match between a romantic and a realist, the marriage complements both of their personalities.

ETHIOPIA: To his current shame, Getachew Mulleta married Zenebu Tulu by abducting her from a village street—automatically forcing her parents to concede the match.

ITALY: Although they believe that the formalities of state-sanctioned marriage have little meaning, Daniela and Fabio Pellegrini married after 20 years of living together because they wanted to give their daughter, Caterina, the legal recognition and protection afforded by a formal match.

SOUTH AFRICA: When Poppy Qampie became pregnant, she and her husband, Simon, got married—a source of some present-day ambivalence to Poppy, who feels that the early pregnancy interrupted many of the plans and hopes she had for her life.

ALBANIA: Although Albanian tradition awards Hajdar Cakoni near-absolute power over his wife, Hanke, he thinks it wrong to control her; the couple shares the household tasks more than is usual in their village.

UNITED STATES: After meeting at church, Pattie and Rick Skeen began dating when she was 16 years old; they married when she was 18 and still in college—earlier, she says now, than she will advise her daughter to do.

JAPAN: After her father died, Sayo Ukita realized that she would have to leave the family house, which was now the house of her older brother; perhaps as a result, she met and married her husband, Kazuo, within a year.

CUBA: In what is now a bittersweet image, Eulina Costa Aluis and Montecristi Garcia Moreira are captured on camera a few months before their divorce.

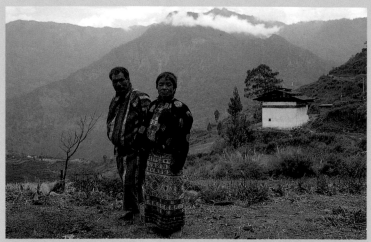

BHUTAN

JORDAN

INDIA

MEXICO

ISRAEL

ALBANIA

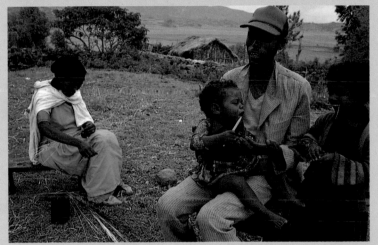

ETHIOPIA

UNITED STATES

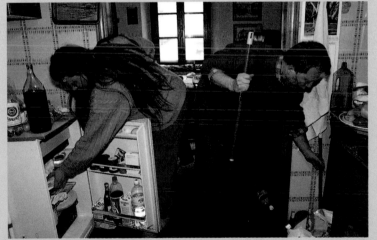

ITALY

JAPAN

SOUTH AFRICA

CUBA

Brazil
Maria dos Anjos Ferreira

*" I was abandoned by my mother.
I would not do this—if I had to live under a bridge,
my children would go with me. "*

WHEN MARIA DOS ANJOS FERREIRA was seven, her mother left the family, sending Maria and her six younger sisters to live with their grandparents in the farmlands of Minas Gerais, north of São Paulo, Brazil's capital. Her mother, Maria says, was fleeing domestic violence. Although the children were reunited with their mother in São Paulo five years later, the episode left Maria with a long-lasting sense of abandonment and anger. While living at her grandparents' home, she attended school although she had little interest in education. In the city, she found work as a nanny and never walked into another classroom. Since then she has held one low-paying job after another.

Like many poor Brazilians, Maria, 30, never married. The father of her first three children—twin boys and a girl, born 13 months apart—died from the effects of drug and alcohol abuse. By the time of his death, Maria was living with Sebastião de Goes, father of her youngest child, 2-year-old Priscila. Born with malformed legs, Priscila (*inset, and right,* with Maria) has twice had surgery, the last operation leaving her in a waist-to-ankle cast; the many trips to the doctor cost Maria her job as a bus ticket-seller. At about the same time, she left Sebastião and moved with the four children into the house of friend. Today Maria juggles childcare and job-hunting, taking pride in the tenacity that enabled her to enroll her children in one of the best public schools in her area. Her future hope is to have "a place of her own" for her children.

Photographs and Interviews by STEPHANIE MAZE

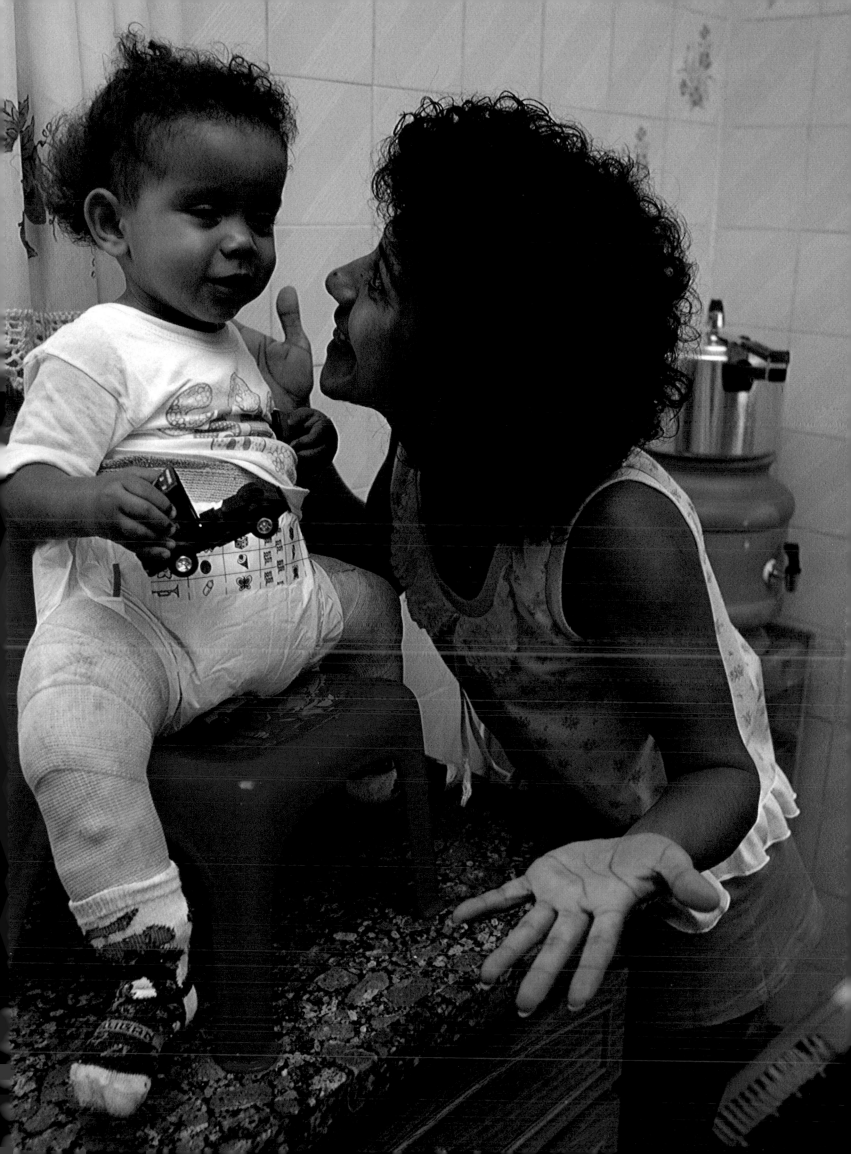

Family and Nation

Brazil

Population:
157.8 million

Population Density:
48.0 per sq. mile

Urban/Rural: 77/23

Rank of Affluence among UN Members:
55 out of 185

Maria dos Anjos Ferreira

Age: 30

Age at first marriage:
21 (common law)

Distance living from birthplace: 18 hours by bus

Children: 4

Number of children that were planned: 0

Number of children desired: 2

Occupation outside the home: Unemployed

Last job: Bus company ticket-seller

Reason for leaving: Fired for taking too much time off for daughter's doctor appointments

Religion: Baptised Catholic

Education: Primary school

Currently reading: *Marie Claire* magazine

Best woman friend: Does not believe that women can truly be friends

Most admired woman in the world: Madonna (the singer)

Worst life event: Being involved with physically abusive men

Happiest life event: Moving to São Paulo to rejoin her mother

Saddest thought: "Thinking about my pasts. All of them."

Conversation with Maria dos Anjos Ferreira

Stephanie Maze: What have been the important events in your life so far?
Maria dos Anjos Ferreira: The positive events were when I came to São Paulo by bus from the state of Minas Gerais in 1978 with my six sisters; when I got a job for the bus system in 1989; and when I met [my current boyfriend] Vavá in 1991. The negative events are my fights with my husbands and when I left my [parent's] house with my sisters at the age of 7. We went to live with my dying grandfather because my mother had decided to leave my abusive father. After my grandfather died, we lived with my mother's mother—my grandmother—on the farm until I was 12 years old.

And what happened then?
I went to São Paulo to be with my mother. She was working and living in the home of a family. I was not allowed to call her "Mother" because she was afraid of losing her job. Sometimes I would forget and she would hit me. I went to work for a family as a nanny at the age of 12.

How did you meet Elnildo, the first man you lived with?
We met on the street. We would joke around. We couldn't go out much. My mother would not let me go out, so I would sneak out. When I became pregnant by him, my mother threw me out, so I went to live with Elnildo's mother. My first husband was a drug addict and an alcoholic. He hit me a lot—there was a lot of abuse. He burned my face with a lighted cigarette. We had a very bad relationship.

Aren't there laws to protect women?
In some ways there are, in some ways not. There are laws about divorce but no laws against abuse. When I was beaten and I went to the police prefecture, I was told to hit back! There does not seem to be any protection of women, especially in violent situations.

Why did you live with him?
I wanted a place to live and [I wanted] him to help take care of the children. I lived with him only one year and had three children, the twins and Elaine, within 13 months. Then I'd had enough and left his mother's house. His mother never did anything about the abuse.

But you never formally married him?
Marriage is difficult in Brazil. [Many] couples prefer to live together. I do not know why.

Then you lived with Sebastião, the father of your youngest daughter, for five years before moving out?
Yes. When we separated, I wanted to stay in the house—me with four children, one of them sick. He should have been the one to leave, but he is too mean ever to do this. He is there sleeping in the house and I am here with the children.

And so what is your situation with your new boyfriend, Vavá?
He still keeps his own place, and there is a question now whether we are going to move in together. I would like to move in with him somewhere else, but I'm not sure yet where he stands on that. He has his own bar called the *Bar Marqués* and his little apartment is right above the bar.

Is Vavá supportive of you?
He admires the way women on my level live their lives. With all their troubles they are still getting up early in the morning, taking care of the children and the household, and dealing with the day-to-day crises.

Are there women whom you admire?
I admire the woman who drives a subway train. I admire female architects and journalists. I admire any woman who can do all she wants in life. That she can be herself and not wait for a man. I admire the women who do not wait for men, those who embrace the struggle. I like Luisa Erondina because she knows how to fight for things; she is a local politician. I also like Roberta Miranda, who is a singer. And Madonna. I like Madonna's style; she doesn't seem to care what other people think about her, and she does her own thing and lives her own life.

Is there love in your relationship with Vavá?
Very much on my part. I'm not quite sure about his part. In the past I did not want to get married, but I want very much to marry Vavá.

You want to get married to him?
[Nods her head yes] Can you imagine it? Will you come to my wedding?

If you invite me.
Certainly.

A *favela* wedding, with everybody in the neighborhood coming?
Nooo, a very chic wedding! Videotaped and everything else.

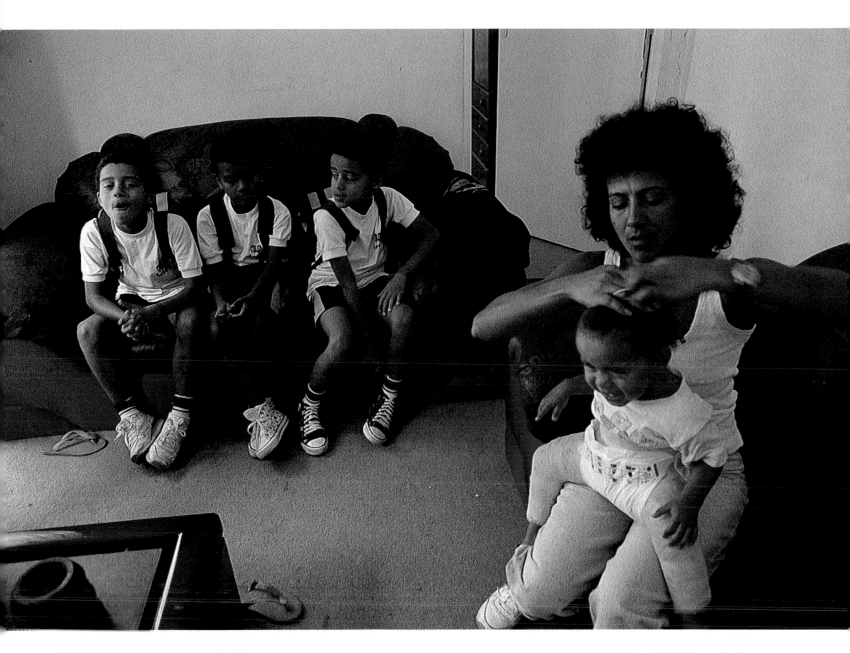

Packed into a single room, Maria, her four children, and her boyfriend, Vavá, settle down to sleep (left). The room is a spare bedroom in a friend's apartment; Maria's family has stayed in it since she left Sebastião, the father of Priscila, the squirming 2-year-old who is sharing Maria's bed. The next morning, Maria supervises the donning of school clothes and backpacks by the three older children —the twin 8-year-olds, Eric and Everton, and her daughter, 7-year-old Elaine (above, Elaine in middle of couch)—and untangles Priscila's hair. When all the children are presentable, she takes Eric, Everton, and Elaine to school.

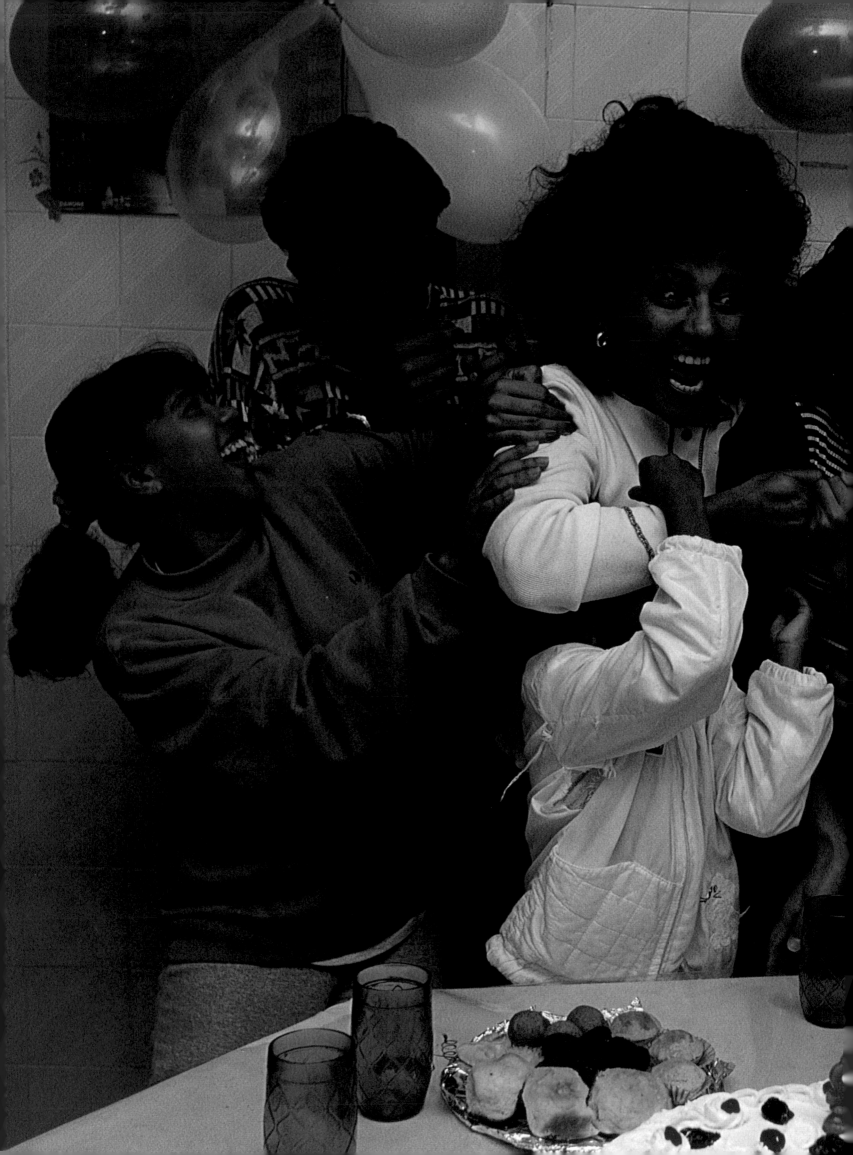

PRECEDING PAGES

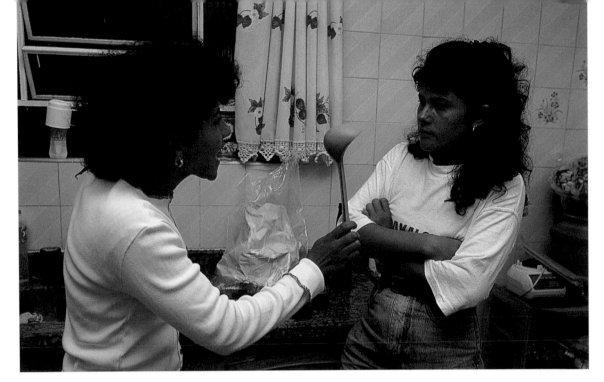

Discovering that her housemate Risomar has inexplicably left for the entire day on the 12th birthday of her daughter, Adriana, Maria arranges an impromptu party for the birthday girl (in striped dress). A rowdy group of friends and family celebrate the occasion with the traditional song "Tarabans para voce"— Portuguese for "good luck and all the best."

Later that evening, when Risomar returns, Maria angrily confronts her in the kitchen about her disappearance (right). A crying Risomar explains that she was trying to solve a family problem involving a bad loan. A few days later, Maria scrapes up the money to repay the loan and solve her friend's problem. Although Maria and Risomar are not related, their lives have been intertwined ever since Maria moved into Risomar's extra bedroom. They take care of each other's children, look out for each other's interests, and worry about each other's joblessness—a state of mutual involvement that sometimes exasperates them both.

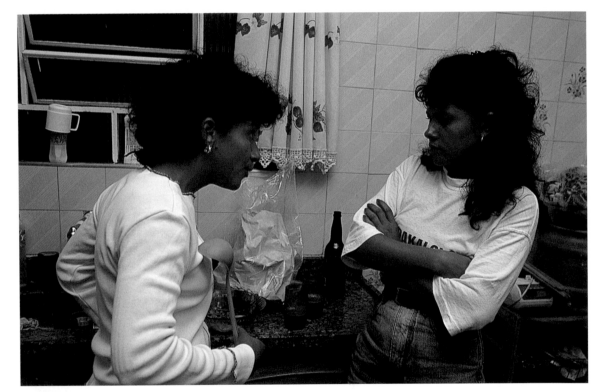

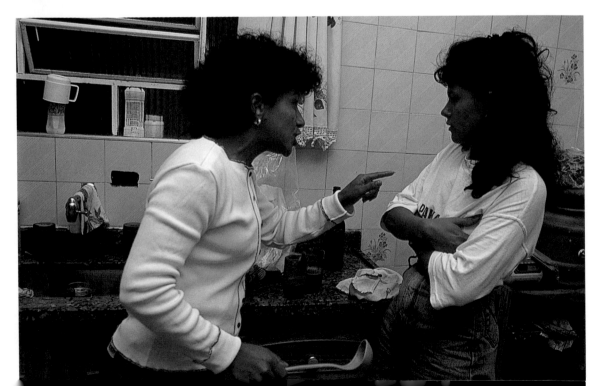

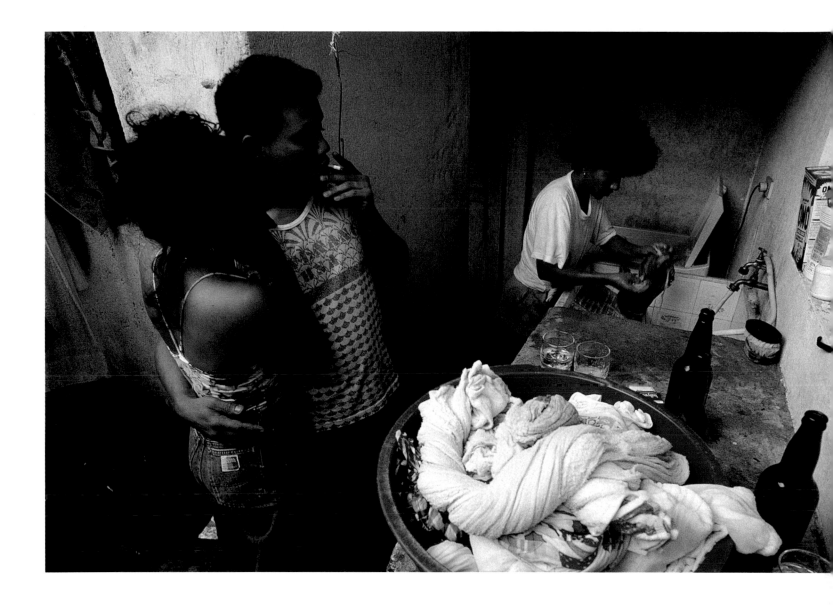

Stephanie: How far did you go in school?
Maria: My formal education went through elementary school 'til I was 12 years old—sixth grade.

Do you wish you'd gone further?
No. My favorite subject was recess because everybody got together and talked.

Do you feel the same way about your children's education?
No. They go to a very good school, about a half-hour away. [I take them] there on two buses.

Isn't there a closer school?
Not as good as this one. The reason I got the chance to put my children there is I have a friend who works in that school and helped me to enroll them. I was able to get Risomar's children in, too. I am very proud of that. I want the best education possible for them.

When do you think they will leave home?
Once they have a future career that's something better than being a day laborer. Actually, I don't want them to leave the house ever—at least not until they are 23 or 24.

Do they already talk about what they want to become?
Everton wants to be a mechanic. Eric wants to be an airplane pilot. Elaine wants to work on TV with Xuxa [the blond Brazilian superstar, who is accompanied by a group of blond backup dancers called Paquitas]. What taste!

Why not?
Oh yes, she could be the first black-haired Paquita! [Laughs]

Vavá, you told me that you didn't want your wife to work outside the home if you had children. But isn't Maria looking for a job?
José Valdenor "Vavá" da Silva (boyfriend): I don't want to be *machisto*, but if the woman has a house and children, she should stay in the house.

And what if she has someone to take care of the children?
Vavá: In that case I agree that she can work if she wants to. This is a better way to live; you are better off financially if she works, too.

On a hot afternoon, Maria stands on the patio (above), washing her children's clothes—a task that, surprisingly, she finds relaxing. Her housemate, Risomar, and Risomar's boyfriend, Geraldo, keep Maria company while she works away at the endless piles of laundry that four children produce.

São Paulo is a mass of buildings in various states of completion and disrepair. Flung together under the auspices of some half-baked urban plan, the pink and yellow remnants of the colonial era abut futuristic glass structures and crumbling greyish-brown *favelas*. Like most Latin American cities, it is extremely noisy and polluted. The air is filled with a thick blue smog. On the ground, a labyrinth of streets is choked by bumper-to-bumper traffic. It is one of the biggest cities in the world and one of the ugliest. But it has its own pulsating rhythm and agenda.

Everyone, even baby Priscila, called Maria "Du," a derivative of the family name "Dos Anjos." She had a tough, androgynous look and spoke with a raspy voice. But I soon realized how much the rough edges were a shield against the pain she felt since her mother left her. Her kids were polite, good-natured, smart—and rambunctious. As in many families in this ethnically diverse nation, skin color varied from child to child.

I could understand why Vavá was the first man Maria said she would consider marrying legally. He was shy, serious, sensitive, considerate and, above all, cared very much for Maria and her children. He was also familiar with her moods. He told me that Maria didn't know it yet, but that he wanted her to move in with him. After all these years, it seemed that her dream of a stable life with a good man might come true.

— STEPHANIE MAZE
APRIL

Stephanie: What do you think is the biggest difference between your life and your children's?

Maria: I was abandoned by my mother. I would not do this—if I had to live under a bridge, my children would go with me. I am not only a mother to them, I am a friend and a clown. I worry a lot about their futures. I do not want them to marry at an early age. I want them to take advantage of life. I want [my daughters] to study more than I did and not be dependent on a man. I want them to become people able to support themselves and the families that they will eventually have; to have their own proper houses; and to provide a better life for their children than I am doing for them.

You don't feel like you're providing well enough for them?

No, I never have enough money, even when I work. If I have money, I spend it on my children. Vavá helps a lot—he pays 200 reais [US $236] to Risomar for our rent. We pay approximately 300 reais [US $354] for food a month, but food gets used up very quickly. I do not have any luxury items. I bum cigarettes off people or Vavá gives them to me, but I am going to quit. I want my own apartment for my kids, so they feel good. I want a good education for my children; I think a lot about their future so they don't follow in my footsteps. If I had a formal education, I would not be stuck now. I would like to have work.

When you were working did you regard yourself as poor, too?

Yes. I will feel rich when I have my house.

Rich or middle-class?

To me it will be rich. If I had my house I would be a millionaire! [Laughs]

How do you spend your day?

I get up, I go to the bakery, I apply for jobs, wash clothes, clean house, help the children with their baths, and give them meals. I take them to school and back, and go to the doctor and dentist when necessary.

What takes up most of your time?

Priscila. She's had two operations on her legs. One was successful. The other was not. She has to be in a cast for four more months. I take Priscila to the doctor once a month to have her checked. The last time I went with Priscila was yesterday. We went because she was having some problems. Her urine irritated her skin and we may have to change the cast.

Is health care expensive?

It's covered by the government. Some drugs are paid for by the government, too. But some things, like contraception, we have to pay for ourselves.

How far away is Priscila's doctor?

A half-hour from the house on one bus.

Is it difficult to arrange care for your children as a single parent right now?

When I go out, my sister-in-law, Alba, takes care of them. I will only trust my children to her and sometimes my sister when it is absolutely needed.

Women in Brazil

Brazil's *favelas*, or shantytowns, ring most major cities, and house as much as one-third of the urban population. These squatter camps offer some measure of independence for women, who usually own the shacks and head the households, but often remain unmarried because the stresses of poverty and high male unemployment make relationships hard to maintain. Women also dominate grassroots social movements, and in some *favelas* have succeeded in obtaining running water, electricity, and health clinics.

Income inequality in Brazil is extreme: More than 40 percent of the population lives in poverty, while 10 percent of the people possess nearly half the wealth. Women are divided by class: Many upper-class women staged "marches of pots and pans" to support the dictatorship which ended in 1985, while many poorer women worked in opposition groups fighting for democracy.

The new civilian government has rewritten the constitution and changed laws which gave men legal status as heads of households. Women's representation in the federal government has increased from 1 to 7 percent. Women's high school enrollment rates equal men's, and more than 40 percent of university professors are women.

Brazil is the world's largest Catholic country, but a shortage of male priests means women take an important role in organizing church-based community movements. And despite Catholic injunctions against birth control, Brazilian women have far fewer children than they used to: The birthrate has dropped 40 percent since 1970.

But domestic violence is a problem: More than half of women murdered are killed by present or former partners. Courts have traditionally been reluctant to prosecute such crimes, but scores of women's groups have organized around this issue, and in the 1980s persuaded the government to set up dozens of police precincts run entirely by women. Now, more than 125 cities have special police offices to handle crimes against women.

Discovering that Priscila's cast—the result of two recent operations to correct her malformed legs—has created a severe diaper rash, Maria rushes to the local emergency room and waits for the physician on call (above). As a single mother, difficult days like these are part of the reason she longs for a secure relationship with her boyfriend, Vavá (left).

China
Guo Yuxian

" I am happy with my life the way it is now.
But I would like to have some more pigs.
They're very expensive. "

THE CHINESE CHARACTER FOR PEACE is a woman under a roof; that for trouble is three women under a roof. Despite such folkloric wisdom, Guo Yuxian (*right*) shares a household with her two daughters-in-law with few quarrels. Their harmonious life is partly due to the fact that boundaries are well demarcated. In the farmhouse in southern China's Yunnan province, Guo Yuxian, 58, and her husband, Wu Bajiu, 60, have their own kitchen (*inset*, preparing fish) and bedroom, as do their two sons' families. The courtyard and open living room are common space.

But the real reason that the Wu household is as placid as the fish pond outside their door is that "Great Auntie Wu," as Guo Yuxian is respectfully known, is a quiet power. Her reverence for the physical labor of fieldwork—the planting, irrigation, and harvesting of rice, vegetables, and fruit—inspires family members to work as hard as she does on their jointly farmed plots. During the years when her husband was a village commune official, the family prospered under her financial acumen—math was her favorite subject in primary school.

The household, like most in China, has no refrigerator or telephone. But the extended family does have a television set, a motorcycle, bicycle, gasoline-powered irrigation pump, and feed shredder for the pigs, whose quarters are in the household latrines. Much of the families' material success can be attributed to the matriarch's strength. At 85 pounds, she can balance a load heavier than she is and jump irrigation ditches more lightly than her daughters-in-law. She says, "Farm work is the most important thing in my life."

Photographs by LYNN JOHNSON Interviews by CLAUDIA GLENN DOWLING

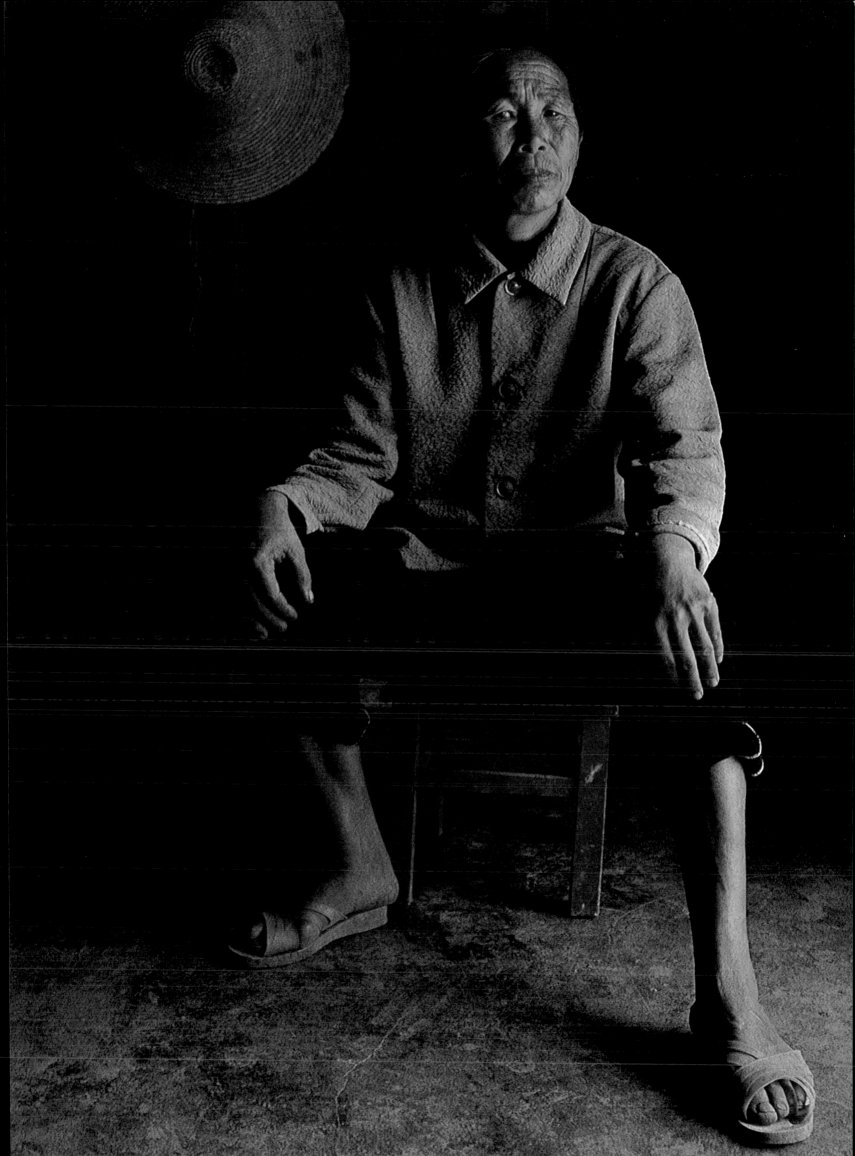

Family and Nation

China

Population:
1,218.8 million

Population Density:
329.8 per sq. mile

Urban/Rural: 28/72

Rank of Affluence among UN Members:
135 out of 185

Guo Yuxian

Age: 58

Age at marriage: 19

Children: 3

Number of children desired: 3

Number of days after giving birth that she returned to the fields: 8

Occupation:
Homemaker and farmer

Religion: None

Education:
Primary school

Literate: Yes. Husband is not

Favorite subject in school: Math

Family's monthly expenditures:
200 yuan [US $25]

Extended families' combined monthly income:
1824 yuan [US $228]

Main food sources:
Family garden and fish pond

Favorite task: Farming

Least favorite task:
Caring for grandchildren

Free time activities:
Watching television, playing cards, and knitting

Television programs watched: News, mostly

Most vivid childhood memory: Her mother's bound feet

Person who she says makes most family decisions: Herself (her husband says it is him)

Unfulfilled dream for daughter: That she attend university

Conversation with Guo Yuxian

Note: The interviews with Guo Yuxian and Wu Bajiu were difficult for both family and interviewers. The Wu family, though hospitable, clearly felt uncomfortable. Questions about topics such as birth control were particularly sticky, as were any questions dealing with politics. After their visit with the family, our staff was detained by the Chinese authorities and was permitted to leave the country only after hours of questioning.

Claudia Glenn Dowling: Great Auntie Wu, tell me about your childhood.

Guo Yuxian: I was born in another village, very far away from here—about ten miles. I do not know my birthday. My parents were farmers, too. Eight people lived in my household: my parents, four brothers, a sister-in-law and me. I was the fourth child, and the only daughter, so I got more affection than my brothers. I also had more education. I finished primary school and didn't begin to work in the fields until I was 17. Both of my parents wanted me to go as far in school as I could.

Was your mother's life different from yours?

My mother's life was harder. The family lands were too small to provide much comfort. We had enough food, but not much clothing. And my mother had bound feet. Because her feet were so short—about three inches long—she found it hard to work in the fields. She was always in pain from the wrappings that bent her toes under her foot, and could not do what she wanted to do. This tradition was not good, very cruel. When I was a young girl, I did nothing to help her. I didn't help her clean her feet. I just wanted to do farm work. I feel bad about that now.

How did you meet your husband?

A distant relative introduced us to each other. We married soon after, in 1956, when I was 19 and he was 20. As a dowry, my family gave us two sets of clothing and shoes. Some friends came to a dinner for a celebration. They asked us to sing a song. But my husband cannot sing, so I sang alone.

Was your marriage arranged by your families?

No, we married for love. And we are still in love.

How long was it before you had children?

I did not get pregnant with my oldest son until seven years after my marriage. We had no doctor, because of the weather—it was windy and rainy and cold. An old lady from the neighborhood who had midwifed many babies helped to deliver the child. There was a doctor for the other births—I went to the hospital. Five years later I had my second son, then my daughter four years later.

Did you use birth control?

We didn't do anything to prevent pregnancy, that's just how it worked out. At the time there was no law in China against having several children, as there is now. I was too embarrassed to talk to my mother about sex or birth control, and I never talked to my daughter about it, either.

Did your husband help you at the time of birth?

My husband was very happy, but he was too busy with his public duties to take care of me. My mother came to help for a few days. After two days I was walking, after a week or so, I was working in the fields again. When my daughter had her son, I stayed with her in town for five days. Her husband was away on business.

What were your hopes for your daughter?

Of course, I hoped she would get married and have a family. But I hoped that she would go to university first. I can read characters, but my husband cannot read or write. My eldest son had nine years of schooling, my second son, eight, and my daughter, twelve. She was the first person in our family to finish high school.

Wu Wenbo (daughter, 23): My greatest regret in life is that I did not go to university, as my parents hoped.

What happened?

I failed the entrance examination—I fell in love with my teacher.

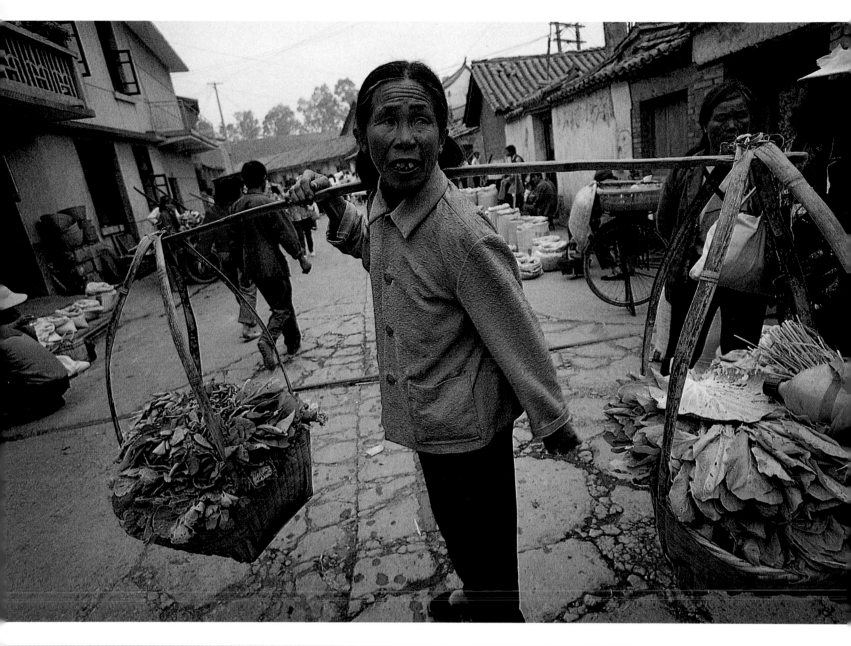

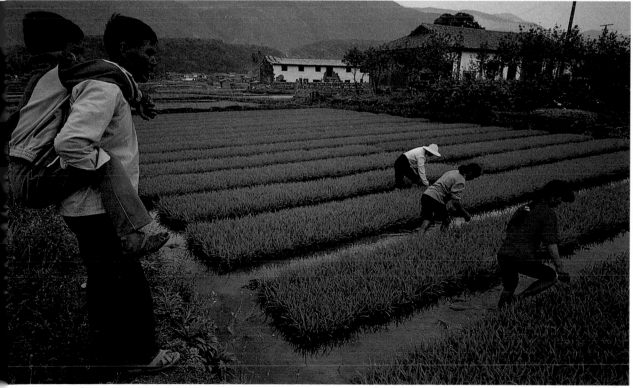

Market day gives the women of the family a chance to go to town. Once or twice a week, Guo Yuxian (above) harvests by flashlight, then walks the two miles to Shiping at dawn, balancing her baskets. She sits on the street in a line of women selling identical produce. She usually sells out, earning about 8 yuan [US$1], outselling her daughters-in-law. They laugh: "Customers think she looks honest." The Wus' staple crop is rice. They tend seedling beds (left), then bundle and transplant young plants into flooded paddies. Patriarch Wu Bajiu and grandson Wu Dong, 11, (on piggyback) let the women do the weeding. The men rent a water buffalo to do the plowing. And the whole family pitches in to plant.

Everyone watches out for the children, but bathtime is every woman for herself. Daughter-in-law, Li Jianchun, 31, tussles with daughter Wu Xi, 5, in the courtyard (right). She and her husband share their bedroom with their two children. The couple's happiest times together are when she helps him prepare their meals—both Wu sons are excellent cooks. The three families have separate kitchens and, except on special occasions (below), eat separately.

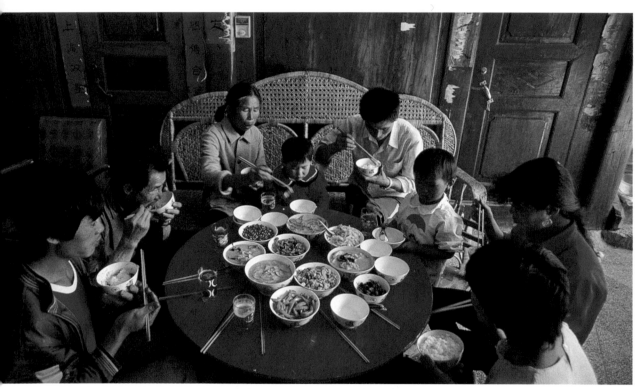

Daughter Wu Wenbo, 23, failed the university exam but married her tutor, a history teacher. Her family gave the couple a dowry of 5,000 yuan [US $625]. His family gave them an array of household goods. Wu Wenbo keeps the books at her in-laws' grain shop in town (right). She visits her own mother, Guo Yuxian, often, taking her baby to visit his cousins Wu Xi and Wu Xuexiao (top right). Her stature with both families has been assured since the child was born. She proudly opens the infant's split pants to display his sex: It's a boy!

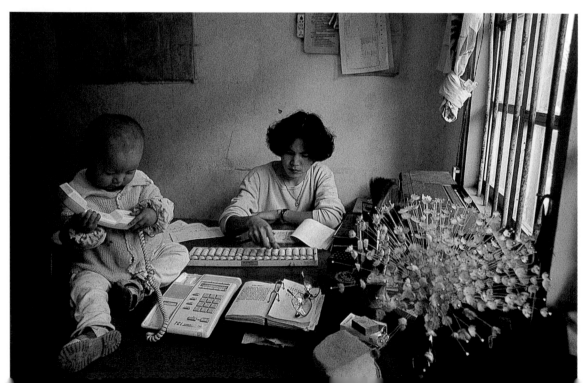

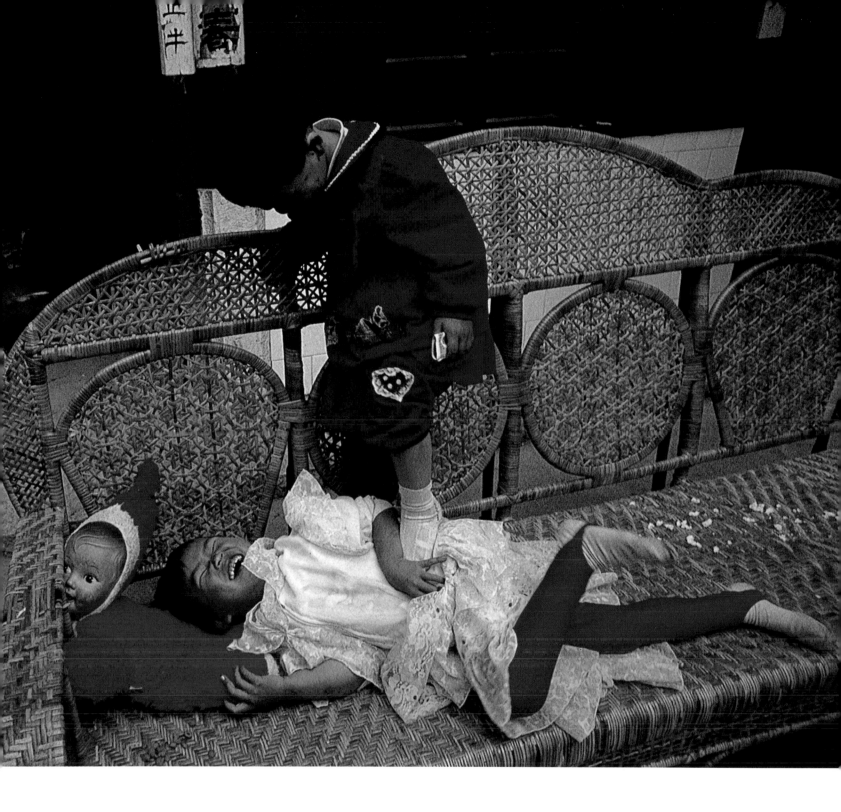

Claudia: Great Auntie Wu, do you have a role model?

Guo Yuxian: I admire my husband more than any other person. He is a workers' hero.

Uncle Wu, you were a village leader?

Wu Bajiu (husband): I was cadre for the commune, the chief of production, for 26 years. A few years ago they voted in a younger man. But I received many awards for my work. Five years ago an uncle visited me from Taiwan. He is a soldier in the Kuomingtang, and he was afraid that I would not welcome him. But we had a big party, and he stayed for several days.

Who makes family decisions?

Wu Bajiu: I make the major decisions, but sometimes my eldest son now makes them.

Who decides how money is spent?

Wu Bajiu: My wife takes care of finances. If I want money, I ask her.

Do you share household chores?

Wu Bajiu: Women work harder. They have two jobs—one outside the house, one inside. My wife does most of the housework and cooking. I hate to clean. I help take care of the grandchildren. The oldest is a boy, so he will inherit this house. We built it 13 years ago, when the commune distributed the land to individual families. We call my granddaughter, Wu Xi, "the Empress." (He taps his forehead.) She is very smart. The other, Wu Xuexiao, is loveable.

FOLLOWING PAGES

A decade apart in age, the two friends sitting toe-to-toe are a generation apart in experience. Guo Yuxian, 58, has functional feet. Her friend Chou Qingling, 70, had her feet bound as a child. Some years ago, she took off the wrappings to let her toes unfold, having decided to live through months of sharp agony rather than endure more years of aching bondage. The feet are still an inhuman five inches that hurt when she walks.

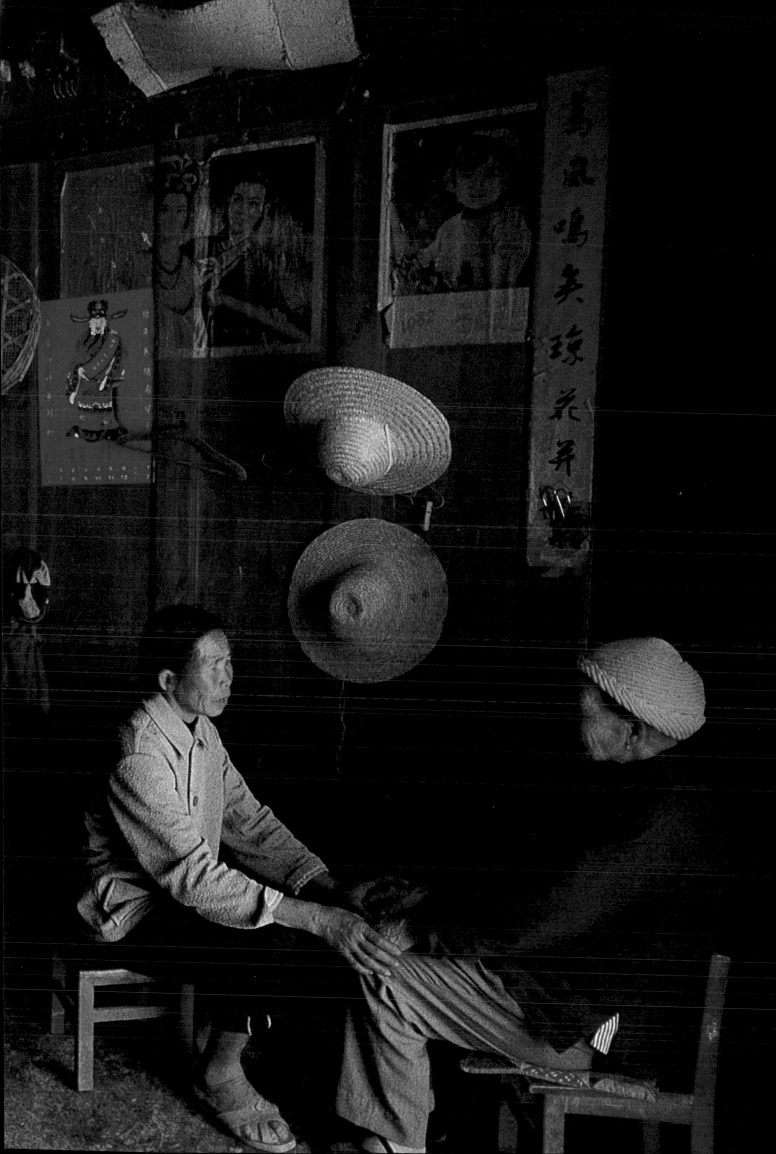

Field Journal

Compared to urban folks, the Wu family has a bountiful life. Spacious quarters, plentiful food, fresh air, etc. Of course, the work is tougher, the hours longer. The family was sweet and generous with us, but their mood changed when officials told us our "actions" were illegal. The next day we were interrogated and required to write two memos detailing our activities. Obviously, that was the end of working with the Wus. When we returned, the family was loading cabbage into a truck. In contrast to their previous cheer, they were cautious and formal. In the middle of the good-byes a security officer (one can always spot that too-clean shirt and slightly arrogant manner) slithered into the courtyard and hunkered down in a corner watching the scene. We really regretted that our visit ended on such a discordant note because we had had such a warm experience. To the extent that, culturally, they could open their hearts to us, they had. As we got into the car on the road outside their house, one of the women came up to us, tentatively took Claudia's hand and said, "You're welcome in my home any time."

— LYNN JOHNSON
APRIL

Seedlings slung across the back of his bicycle, son Wu Wende (above, right) gives his mother a ride to their rice paddies on Moon Dragon Lake. Using string to mark rows, the Wu family plants the seedlings in muddy knee-deep water. Guo Yuxian is faster than anyone, finishing her rows first and planting as neatly as a machine. She is proud of her prowess and readily admits that she vastly prefers fieldwork to babysitting for her granddaughters (above).

Claudia: Great Auntie Wu, how do you find any privacy?
Guo Yuxian: I don't really understand what you mean by privacy. Being alone? I don't like to be alone. I like to be surrounded by people.
Both family and friends?
I seldom visit my friends because the labor takes most of my time.
How do you get along with your daughters-in-law?
We help each other and forgive little fusses. We are satisfied with how we share the work.
Do you share your thoughts with them?
No. I don't really open my heart to anyone except one friend, Chou Qingling.
Have you known her a long time?

Not really. She just moved to the village perhaps nine years ago. Her garden plot was next to mine, so we began to talk while we worked. She is ten years older than I am. She reminds me of my mother, because she had bound feet, too. We gossip. When I have an hour of spare time, I go over to her house to help her wash clothes or plant her fields. Her husband is very old. She has a hard time because of her feet. I feel like I am making up for not helping my mother by helping my friend. And I can tell her anything. I can share the secrets of my heart with her.
What are your dreams for the future?
I am satisfied with my life the way it is now. But I would like to have some more pigs. They're very expensive.

Women in China

In pre-communist China, men controlled the social order, passing land down through sons and keeping a tight rein over family affairs. Women needed to marry for economic survival, but couldn't choose their husbands, initiate divorce, or remarry if they were widowed. And traditionally, they weren't valued until they bore sons.

Social upheavals began to shake the country in the early 19th century. In the 1850s, a peasant revolt against the Manchu dynasty led to reforms that allowed women to own land, join the army, and serve in the government, as well as banning child slavery, concubinage, and footbinding. The rebellion and its reforms were soon crushed. Footbinding, a long-standing custom that crippled women but gave families prestige by showing that they could afford to give up the women's labor, was banned in 1911, though some elderly women still suffer its painful effects.

Later, women's rights organizations began campaigning for suffrage, equal access to education, equal pay, and changes in marriage laws. The government met some of these demands, but also tried to revive Confucian rules requiring women to defer to husbands.

After 1949, the communists axed many discriminatory laws, and proclaimed women equal to men. Since then, women's literacy rates have doubled. One out of five government workers is female, and millions of women have entered the labor force. Still, this meant women's workload doubled—and in a culture that prizes sons, the incidence of female infanticide began to rise after the government propagated its "one-child policy." Ironically, some of the government's most progressive gender policies coincided with its periods of most intense repression—those in which thousands were exiled or killed.

Now China has rejected many former socialist policies, reorganized the economy, and introduced capitalism. One result: Some are arguing for greater sexual division of labor and for more women to stay home. Plus, multinational corporations, which are hiring women workers in droves, offer them lower pay, so the wage gap between the sexes has begun to increase.

Laundry

Although laundry is one of the myriad daily necessities that make up what has traditionally been called "women's work," it is, as anthropologists have noted, not merely a chore. Women often resent the routines of scrubbing, rinsing, drying, and folding, especially when they have no choice about doing it and no appliances to lighten the labor. But they have also celebrated such apparently mundane routines as acts, that in the most concrete way, help to take care of the people they love.

THAILAND: Working steadily at her least favorite job, Buaphet Khuenkaew wrings out the clothing that she or her daughter, Jeeraporn, will hang to dry on a line behind the family's house.

GUATEMALA: At the edge of Lake Atitlán, Lucia Sicay Choguaj rinses her husband Vicente's shirt. Her daughter Olga sleeps in a sling on Lucia's back.

MEXICO: Carmen Balderas de Castillo squeezes the water out of the clothes she is washing in her new electric washing machine. Because the machine is not connected to running water, she finishes the chore by hand in a cement washstand outside.

HAITI: At the Yofre River, three and a half miles from their house, some of the Delfoart children do the wash, kneading the clothes against rocks to clean them.

ETHIOPIA: Crouching at the mouth of a drainage pipe, Zenebu Tulu (at center), her daughter Mulu, and Zenebu's best friend, Dirribe, scrub clothes in water polluted by animals upstream.

CHINA: Laundry means a chance to chat for Guo Yuxian who visits with her best friend, Chou Qingling, and washes clothes for her.

MONGOLIA: Even though Lkhamsuren Oyuntsetseg lives in a new house, she still washes clothes in a tub of water on the floor because the house lacks plumbing.

SOUTH AFRICA: Irene Qampie brings the washtub into the backyard to gather the freshly dried clothes from the clothesline.

ISRAEL: Wrestling with a load of laundry, Ronit Zaks heads for the washer and dryer housed in a small room next to the kitchen.

JAPAN: In an energy- and water-saving practice, Sayo Ukita prepares to fill her washing machine with the family's bathwater—a custom that is less unhygienic than it may seem to Westerners, because the family members scrub down before their baths and use the bath itself primarily as a form of relaxation.

RUSSIA: Zhanna Kapralova, embraced by her youngest daughter, washes clothing by hand and will hang them to dry.

THAILAND

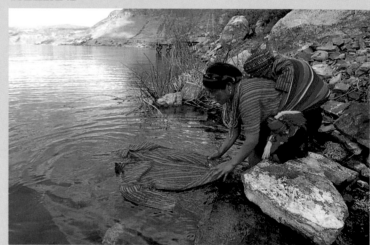

GUATEMALA

MEXICO

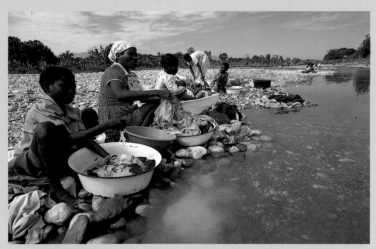

HAITI

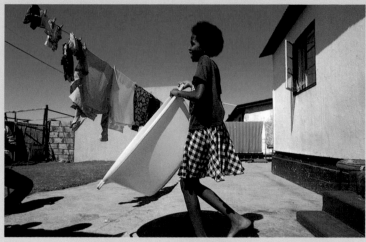

SOUTH AFRICA

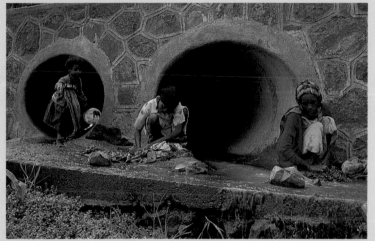

ETHIOPIA

ISRAEL

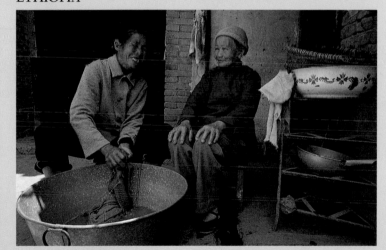

CHINA

JAPAN

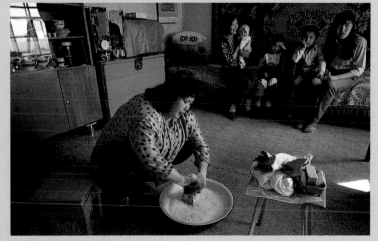

MONGOLIA

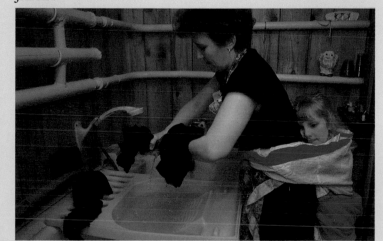

RUSSIA

Cuba
Eulina Costa Aluis

" I do not have a big dream.
They are only little dreams, and right now
I cannot think of one. "

ALTHOUGH EULINA COSTA ALUIS REMEMBERS her wedding fondly, she now realizes she married Montecristi Garcia Moreira mostly to conform to tradition. After ten years, tradition was not enough to hold the marriage together. The couple drifted apart, divorcing in 1995. Today Eulina, 37, and her two children, Javier, 9, and Iris, 8, (*right*, wincing) continue to live in an extended household in Havana with Eulina's parents; her youngest brother, Ramon; and his wife and children (*inset*, Ramon's son, Favio, 1). Montecristi, 41, lives with his mother in another part of the city and works as a civil engineer; the children, Eulina says, see him often.

During the "special period"—the economic austerity which befell Cuba after losing its main export markets in formerly communist eastern Europe—public transportation deteriorated and Eulina was unable to get to work. To earn money, she set up a beauty salon on the roof of her home. It quickly became successful. While she works on the roof, the rest of the family pitches in to help with chores and childcare. Eulina's father, a retired tobacconist, does the grocery shopping; her mother, to whom Eulina is very close, helps with the children. Eulina wants both children to attend university but says many things aren't possible in the current economic climate. She is reluctant to say more to outsiders, perhaps worrying that her remarks could be misinterpreted by the local communist party.

Photographs and Interviews by MAGGIE STEBER

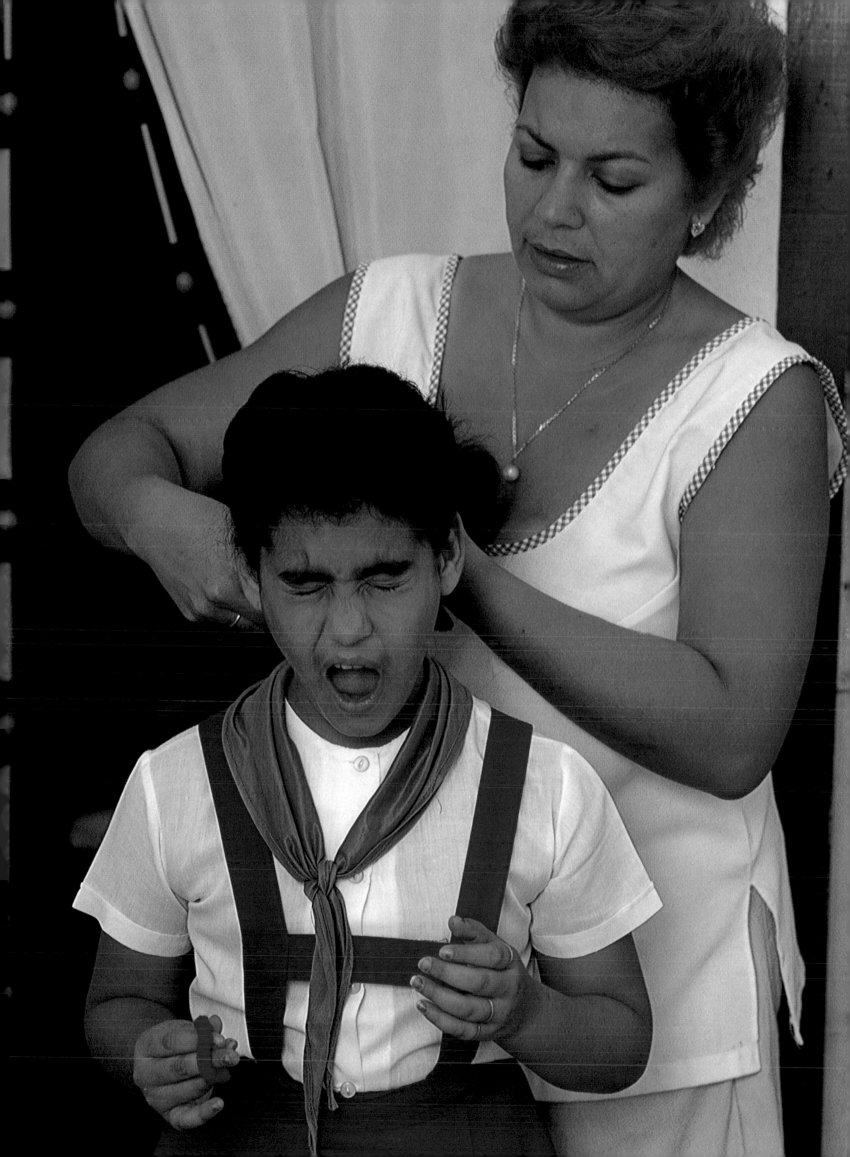

Family and Nation

Cuba

Population: 11.2 million
Population Density: 261.5 per sq. mile
Urban/Rural: 74/26
Rank of Affluence among UN Members: 98 out of 185

Eulina Costa Aluis

Age: 37
Age at marriage: 26
Years married: 10
Time it took to get divorced: 2 hours
Distance living from birthplace: Five blocks
Children: 2
Number of children desired: 2
Health care: Paid by government, some drugs not readily available
Method of contraception: IUD (for the past 7 years)
Occupation: Beauty salon owner
Religion: Baptised Catholic (non-practicing)
Education: 1 year of university
Favorite subject in school: Biology
Currently reading: Usually too tired to read
House: Owned by parents. It is divided in three parts for three families.
Laundry: Washed in sink in family courtyard
Favorite tasks: Sewing and working in the beauty salon
Least favorite tasks: Ironing and cooking
Personal dream: To become a doctor (unrealized)
Happiest life event: "I think that happiness does not exist, but there are many happy moments."

Conversation with Eulina Costa Aluis

Note: The text below is woven together from conversations before and after Eulina's divorce.

Maggie Steber: How do you spend your day?
Eulina Costa Aluis: In general I get up at 6 or 6:30 in the morning. I cook breakfast for the children and me. After I cook breakfast, I get my kids ready for school. I help them to dress; I comb my little girl's hair. Once they are gone, I start to do some housekeeping, putting the house into order again. And then I try to set up to start working before 9 a.m., when the beauty parlor opens.

Do you see a lot of clients?
Sometimes nine, eleven—sometimes two. It all depends if there is an anniversary or celebration—it's not constant. Usually I work from 9 a.m. to 4 p.m. at the beauty shop, but sometimes there are so many clients, and I feel bad telling them I don't have the time to take care of them. In those cases, since the kids get home from school at 5 p.m., my mother takes care of them so that I can just go on working, maybe until 6 p.m.

What happens then?
Usually the kids take their baths and do homework. We all have dinner. I watch TV for a while and then just go to rest until the next day. Some days, maybe, an occasional visit somewhere.

Who cooks dinner if you're working?
If I don't have too many clients, I will come down and start preparing it. On other days, my mother takes care of it.

Is it difficult to balance all these different parts of your life?
It is all well-organized. Each one of us has their own responsibilities, even though I receive the help of my parents.

Was having your own beauty salon a dream, or merely an economic necessity?
I never thought about it. I have enjoyed it but it was a necessity, the solution to problems, because I was so frightened of riding a bike through city traffic. I hope that if things change in the future, I will be able to go out again and work, in some other places.

What would you say is your biggest dream for yourself?
I do not have a big dream. They are only little dreams, and right now I cannot think of one.

You never had a dream for your life?
The real thing I wanted to do in my life was become a medical doctor. It was my dream and goal in life.

You would have had a great bedside manner as a doctor. When I look at you, I have confidence in you.
That's what my clients say. That's what keeps them coming. Even when they're afraid of doing something, they say, "I am in your hands."

What kept you from becoming a doctor?
When I decided that I wanted to become a doctor, there were too many people at that time finishing high school and trying to get into university. The state gave us a long list of different career options. The first I applied for was doctor, and then [I listed some] other professions. The last one was physics and that was the one they gave to me. I felt very, very bad and I told them this. They said, "You must study physics." I argued with them; I said I'd rather learn to become a [laboratory] technician, maybe a nurse—something related to medicine. I was told, "Well, you already are at a higher level than a nurse." So that's how I had to start studying physics. I didn't like it and I quit. It was a failure; it just wasn't what I wanted. This happened to many other students like me.

So you started working?
I worked from 1979 to 1991 in personnel management. I started working at Military Construction Enterprise No. 10, then at a fishing research center. Afterward [I worked] at the customs office of the José Martí International Airport, and finally at an import and export corporation. I was living then at Guanabacoa, a faraway town. I was facing many transportation difficulties. [Economic troubles have crippled public transportation, which meant that she would have to bicycle to her faraway job through city traffic.—*Ed*] So I decided to establish my own business at my parents' home [in Havana, and I moved there]. Now I do haircuts, bleaching, drying hair, cold waves, permanent waves, hairdressing—a little bit of everything.

Do you have any free time?
There is always leisure time, but transportation is very difficult. Sometimes we go to the beach on bikes, but [to go other places] I don't want to go through hassles on the streets—waiting hours and hours for transportation.

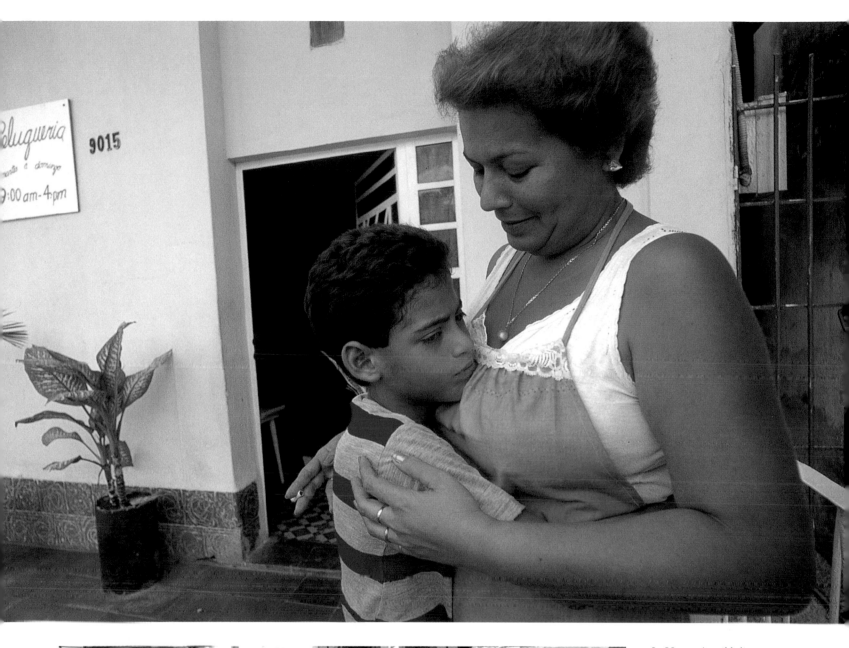

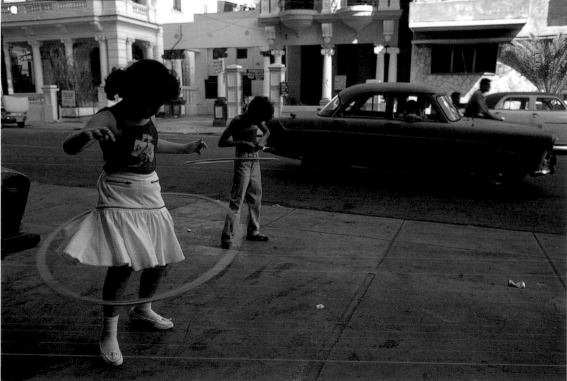

In Havana's mild climate, the extended Costa family spends much of the day outdoors. On the sidewalk in front of their home, Eulina gives 9-year-old Javier a quick hug between beauty salon appointments (above). Not far away on another sidewalk, her daughter, Iris, 8, (left, at left) and her niece Lisandra, 9, play with the Hula Hoops that Lisandra's mother bought for them at the "dollar store"—a store where Cubans can buy imported goods with hard currency. The "Hula Hulas," as they are called in Cuba, cost $1.20 each [8 pesos on the official market].

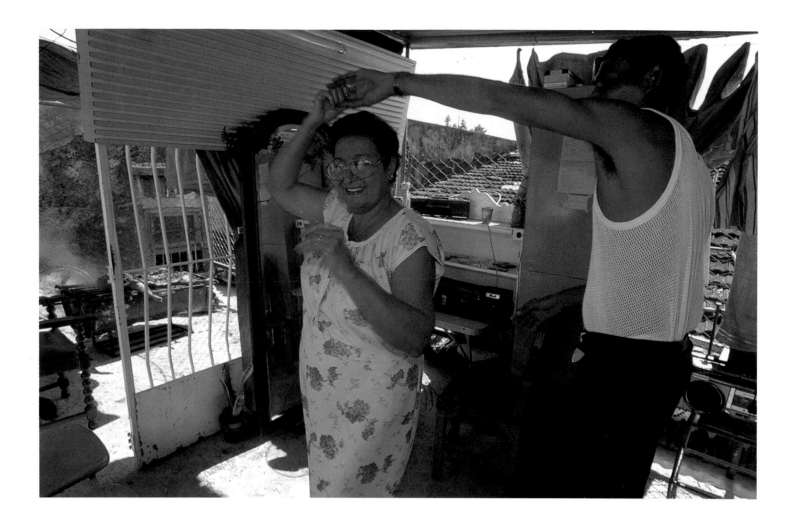

Temporarily taking over Eulina's rooftop beauty salon for a family celebration of Mother's Day, Eulina's mother, Angelina, 67, dances with Eulina's brother Orlando, 30 (above). Angelina is on the roof to supervise the grill, which is smoking furiously as it cooks half a pig for the feast (the family slaughtered the pig the night before). When the food is done and the family assembles in the courtyard (right), Eulina serves Iris a lunch of tamales, cucumber salad, fried plantains, sweet potatoes, rice, beans, and, of course, roast pork. Even on Mother's Day, it seems, the women do most of the work.

Maggie: How are women treated in Cuba?
Eulina: Women are not machines. They are a part of society and they have the right to speak freely and the right to become full participants in society. Women participate in all aspects of Cuban society.

Are you involved with any women's organizations?
The National Cuban Federation for Women [Federation of Cuban Women—*Ed*], that is all. I've been a member since I was 16 years old. Through that organization we are able to talk about the things that concern us. They give attention to women who need help. [They try] to help solve the problems of working women who need daycare for their children.

Has the treatment of women changed from your mother's generation to yours?
In those days women didn't have any responsibilities in society—they could not even vote. But now it is understood that there should be a feminine representation in every field.

Could your mother have worked outside the home?

She could have but she did not. She would not be allowed to [by the rest of the family]—that was the way she was raised. Women stayed at home and did sewing, cooking, and housekeeping.

What would you say is the proper role of a mother in a modern household?
I like to be the one who teaches the kids how they should behave. And in a way, I am the one who molds their personalities. If afterward they want to change, I do not mind. Above all, honesty is the main thing I teach them. I do not like lies. Even though we are all grown-ups, my brothers and I, my mother still gives us advice about our kids. She advises us and guides us as if we still were teenagers.

You sound like you are close to your parents.
We relate well, but my mother is not so young anymore and since I come from a different generation I have my own more modern point of view. But anyway, we talk together. In general, in our family, we help each other. I speak to my father; I consult him for advice. [In our family] if you have done something I do not like, we talk about it.

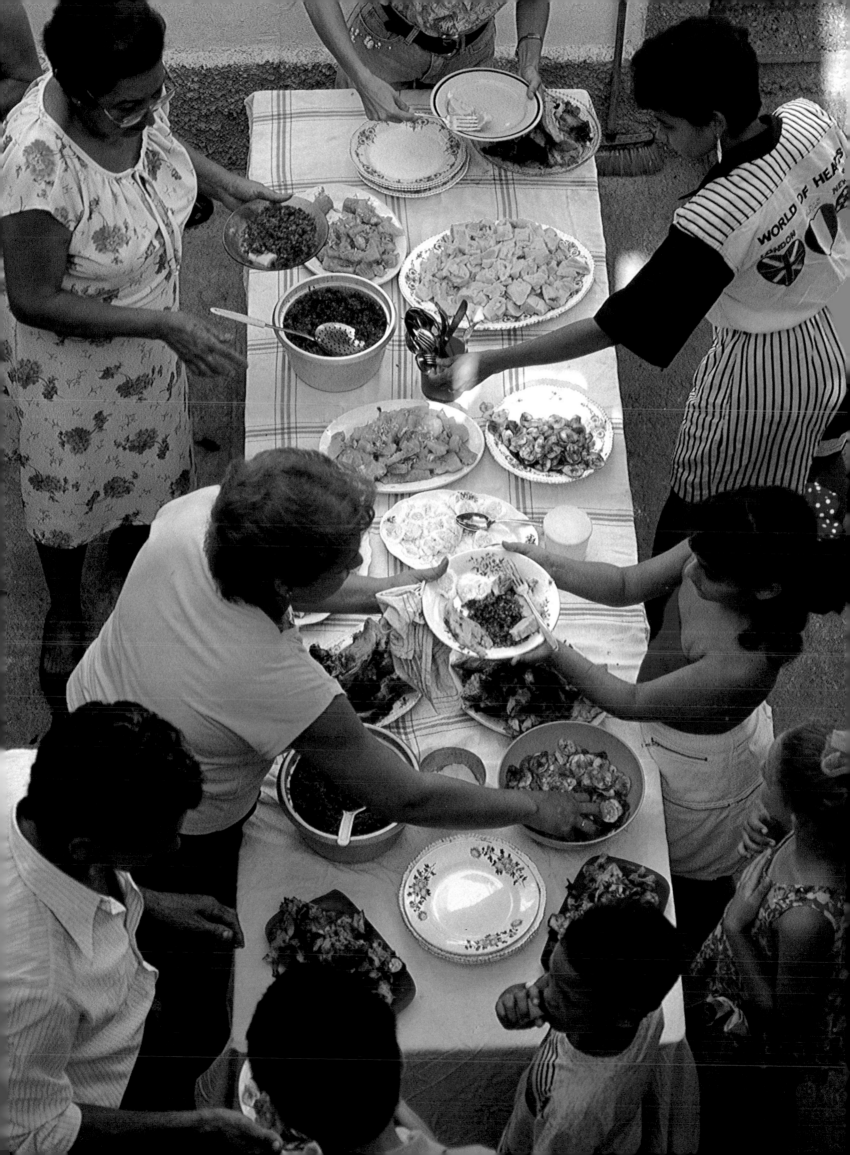

Women in Cuba

In 1907, only 12 of Cuba's doctors, lawyers, architects, and engineers were women; three out of four women workers were domestic servants. Today, women make up nearly half the country's doctors and university professors, and 60 percent of college students. Cuba has the third highest women's political representation in the developing world.

The biggest turning point for women was the 1959 socialist revolution, which prioritized social justice—including gender equality—and established the Federation of Cuban Women, which enlisted hundreds of women to teach in a national literacy campaign, and helped organize women's groups countrywide.

Better health care for expectant mothers has lowered maternal mortality rates, and child care centers helped triple the percentage of women in the labor force. Still women predominate in "feminine" sectors like health, education, and clerical work. They must also contend with a culture of *machismo*, in which they are expected to become wives and mothers, and to do most household work—despite an innovative, though largely unenforced, law that mandates the sharing of household chores.

Under Communism, the redistribution of goods meant most Cubans' standard of living was quite low. And since the Soviet Union withdrew economic support in the early 1990s, food and oil shortages have further complicated most people's lives; for women, this has meant harder struggles over everyday worries like getting to work and feeding their families.

Note: Repeated efforts to contact Montecristi after the couple's divorce failed. His responses are from our original conversation with him before he and Eulina divorced.

Maggie: Montecristi, how would you describe the economic situation of your family?

Montecristi Garcia Moreira (husband): I consider my situation a struggling one, and I base it on the economical situation my country is facing, due to the embargo.

Is there anything that you want that you do not have?

Montecristi: I would like to have an independent house, a house for ourselves. I would like to have a means of moving—that is, an automobile, a car—so that I could go out and make trips with my family, visit places for relaxation. Not just for my own pleasure, but for the enjoyment of my children. But this is difficult nowadays.

Do you have free time?

Montecristi: Because of my job, I do not have much free time left, but I go out with the children when I can. And there is a little time I spend reading. I read whatever is necessary to prepare myself for work. Among the activities that I prefer, my job is the first one and I also like to teach my children to research, to investigate, to get ready for life. Lack of activities for me is like dying.

What would you say is your proudest accomplishment?

Montecristi: Well, an accomplishment from a personal point-of-view is my job, but I am proudest of my children.

And what do you think Eulina would say about what she is proudest of?

Montecristi: I suppose it is our children's happiness.

What are your hopes for the future?

Montecristi: My hope for the future is that my children finish their careers, that they be happy, and they enjoy a happy marriage, as we do.

Eulina, how did you meet your husband?

Eulina: I met him when I started to work at Military Construction Enterprise No. 10. It all started very naturally. We were just looking at each other and we understood each other right away. We got along very well.

Did you always know that you would marry?

In our society girls used to dream of that day. At present, women do not feel the same way. It is not a goal anymore. [Now that I'm divorced,] I don't completely discount getting married again, although it would never be with the pomp and circumstance of the first time.

Why do you think that you changed your mind about the necessity of marriage?

I fulfilled what was traditionally correct in my family—I got married. The bad thing in my parents' view would have been not to get married and just live with somebody.

So you just did what was expected?

Yes, but times have changed. I think I always felt this way, actually, but in order to please my parents I did things their way.

So if you had had a choice earlier on, you might not have gotten married?

Maybe not.

What happened to your marriage?

We began seeing life in different ways. In view of the differences, I decided not to continue the relationship. I think it was a wise decision. We finally split up last June 30.

Divorce is difficult in many countries with a Catholic heritage. Is that the case in Cuba?

No, it's very simple. We both went to a state-run legal office where I presented the divorce petition, along with our marriage certificate and the birth certificates of our two children. I paid the taxes and fees—120 pesos [US $20 at unofficial rates]—and the divorce was granted. Since there was mutual consent, everything took about two hours. It included monthly child support by him to the children and my granting him full visitation rights. I did not ask for alimony.

How are you feeling?

I'm continuing my hair-dressing business. The children are leading their normal lives. The only difference is that Montecristi no longer lives with us.

You say that legally it's simple, but I know it's not all simple.

Although we're still on friendly terms, divorce always has emotional consequences. I'm trying to get through them. I'm taking special care with the children and working in my business. That's going to be my daily routine for a while.

And your family is supportive of you?

The divorce was my decision, accepted by my parents and relatives. Naturally it has also affected them emotionally. I am happy my parents both continue to appreciate Montecristi.

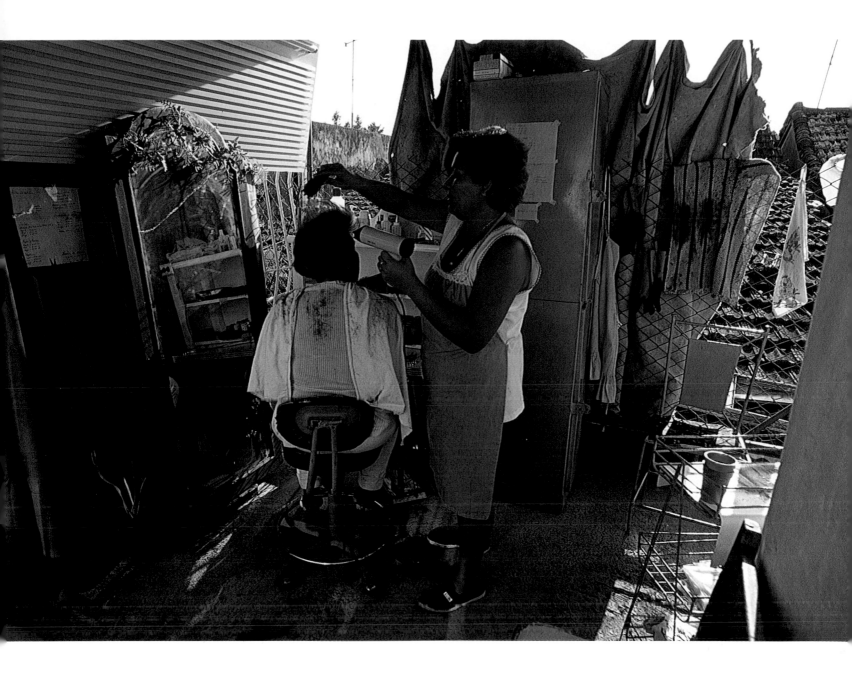

Field Journal

At first I had difficulty speaking with the Costa family because the local communist party told them that the first *Material World* book had slanderous stuff about Cuba in it (the "slander" amounted to the party not liking it when the book said that the family hadn't wanted to put a patriotic prop—a life-size bust of the national hero, José Martí—in their home to be photographed). But by talking with the Costas, I was able to straighten things out; we were focusing on them as people, I said, and not on Cuban politics. By the second day I was there, Eulina's mother was insisting that I share the family's wonderful lunch of pork (just a little), rice, black beans, cucumbers, fried sweet potatoes, and fried plantains.

Eulina was constantly busy in her hair salon. She would have made a great doctor for the same reason she makes a great beautician. She's got brains! And she has a real mind of her own and a strong, confident manner; Cuba lost something when it didn't have room for her in medical school.

After lunch, we bought the pig that would be slaughtered for the next day's Mother's Day party. The slaughtering, which took place in the courtyard, was hard to watch. But the men killed the pig well, with little suffering.

Mother's Day was terrific! We ate so much! The poor pig we killed Saturday was delicious! I have no family like this, so for me, at least for these five or six days, it's quite a treat.

Economically, though, I'm not sure this family is typical of most Cubans in these hard times. Maybe because they pool their resources, they seem to have more money than many people. Orlando, Eulina's youngest brother, is in the military—maybe that helps with privileges. And Eulina's shop is *very* popular and *very* busy; I'm sure that when I come back to Havana, she'll have customers lining up outside her door.

— MAGGIE STEBER
MAY

Eulina blow-dries a customer's hair in the beauty salon she opened on the roof of the family home. Five days of the week, 9 a.m. to 4 p.m., she attends to a steady stream of clients. The success of the business pleases her, but it also means that she has much less time for her family than she would like. Asked by photographer Maggie Steber what she did with her time, Eulina answered with a sigh, "All day long, I don't do anything but work at the beauty shop."

Ethiopia
Zenebu Tulu

"The others would laugh at Like when she goes to school if she were not circumcised. It is a humiliation, not circumcising a daughter. It is terrible not to."

AT THE AGE OF 18, ZENEBU TULU WAS kidnapped by her future husband, Getachew (Getu) Mulleta, and taken to his brother's home. Tradition forbade the tearful Zenebu from returning to her parents and the pair was married after negotiations between the two families. Such forced unions are not uncommon in

Ethiopia, where men often have near-total control over women's lives. For Zenebu, now 29, the abduction is a distant memory. For Getu, 32, it is a source of embarrassment—a reminder that he was "ignorant" as a young man.

The couple and their five children live in a family compound in the village of Moulo—a two-hour drive from Ethiopia's capital city of Addis Ababa—with Getu's parents, siblings, and grandmother. Their home is made of sticks cemented with mud and cattle dung; it leaks during the rainy season and needs constant work. Zenebu struggles to keep the yard clean and says her dream is to have "a very good yard and a garden." On Sundays, she attends services at an Ethiopian Orthodox church—a brief respite in a week of constant toil.

Zenebu's biggest help is her daughter Like (pronounced "*lee-kay*"), 10, who spends the day pounding grain and pressing fresh dung into the walls of their home (*inset*). Like dreams of going to school like her brother, Teshome, 12, an avid student who wants to become a teacher, but Zenebu says she needs the girl at home and that in any case the family can't pay her school fees. Asked if she thinks life will be better for her children, Zenebu, proud of her son's progress, says that she hopes it will, but is inclined to believe that not much will change.

Photographs by MELISSA FARLOW Interviews by VIVIENNE WALT

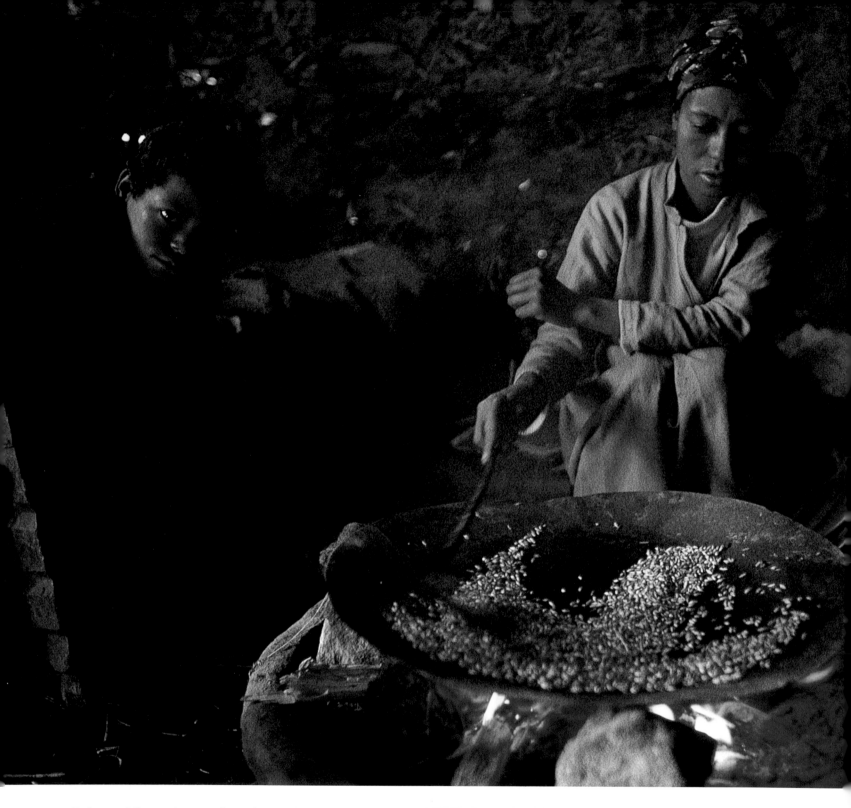

Early on a chilly morning, Zenebu rises, picks up the night's deposit of cow dung, lays it out to dry, fetches water from the spring, and makes the day's injera—flat, spongy Ethiopian bread (right). As the fresh scent permeates the household, Zenebu's daughter Mulu, 5, comes to watch. Zenebu spends much of her day around the fire, cooking meals and roasting grain and coffee. Like most Ethiopians, the family prefers injera made from teff, the poppyseed-sized grain unique to the country. But teff can be expensive, and so Zenebu often adds barley to the menu, roasting it (above, with son Teshome, 12) in the afternoon over the fire.

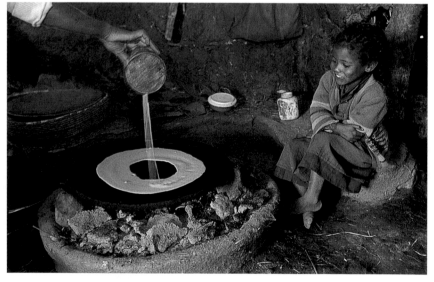

Conversation with Zenebu Tulu

Vivienne Walt: Do your children help with housework during the day?

Zenebu Tulu: Yes. They do help me. My daughter Like cleans the house, fetches water, and makes me coffee. My son, Teshome, mostly takes care of the animals, and sometimes he fetches water for me. Like makes coffee when I am busy, when I am weaving, or when I am making *injera*. Teshome also makes coffee.

What about Getu? Does he make coffee?
[Laughs] No, no. He does not make any coffee.

When you have some free time, what do you do?
It rarely happens. I do not do anything except cleaning, washing children, or combing hair.

And Getu? Does he have time when he can go out and just enjoy himself?
I cannot answer this question. You better ask Getu. He does not have much to do early in the morning and at night.

What do you hope for your daughters in the future?
I want them to have a good education and get married.

Do you know what your children hope for their own future?
I only know about Teshome. He is eager to become a teacher.

Does your daughter Like know what she wants to do when she is older?
I have no idea. She does not talk to me about it. We do not discuss it.

Will your children marry?
I have no idea about my son Teshome. My daughter Like does not even want husbands to be mentioned in front of her. If we make a joke about marriage, she cries. She does not want to get married. In our culture girls never mention marriage. It is parents who arrange the match.

Do you want to send Like to school? Only Teshome goes now.
We plan to send Like to a village school, but I want her to help me at home now.

How far do you expect your daughters to go in school?
I want them to go through the 12th grade so they can get a job.

You do not want them to take over running the farm when you are older?
No, I do not want them to be farmers. I do not want them to work as we are doing.

Will they live with you when they are grown up?
I do not want them to live with me. I want them to be free—to be educated and have their own life.

Do you want your children to look after you when you get older?
Definitely, that is my plan.

But what if they are far away?
The world is getting narrower and narrower. I feel like they can help me from wherever they are.

Family and Nation

Ethiopia

Population: 56 million

Population Density: 118.7 per sq. mile

Urban/Rural: 15/85

Rank of Affluence among UN Members: 182 out of 185

Zenebu Tulu

Age: 29

Age at marriage: 18

Dowry given by Getu's family to Zenebu: Decorative box with clothing, jewelry, and household utensils

Number of children: 5

Number of children desired: 1

Most important event in life: Having children

Occupation: Homemaker and farmer

Religion: Christian Orthodox

Education: Learned to read through national literacy campaign

Electricity: No

Water supply: Nearby stream

Cooking fuel source: Firewood gathered in the forest one hour's walk away

Price Zenebu charges for a small handwoven basket at the local market: 10 birr [US $1.60]

Other items Zenebu sells at market: Eggs, roosters, and butter; after harvest, cereals

Cost to grind cereal each month at grinding mill: 4 birr [US $0.60]

Favorite task: Washing clothes (in a drainage ditch a short walk from home)

Woman most admired: A woman she knows who has "only two children and a galloping horse."

Women in Ethiopia

Ethiopians speak more than 250 different dialects, evidence of the country's remarkable diversity. In the north, women could historically serve in the army and inherit property, wielding more power than in many societies. In other areas men controlled land but needed women's labor to maintain the household.

After the 1930s, moves toward modernization and Europeanization worsened women's position. The government, acting on British advice, barred women from the army and set up sex-segregated schools, as well as passing laws making women legal minors and restricting land inheritance. The socialist revolution of 1974 restored some rights, but widows, single women, and those in polygamous households still had to fight for access to land. And in coffee-producing areas, where men's and women's roles had been complementary, men's money from cash crops increased gender inequalities.

Several million women learned to read during the government's literacy campaign, but less than 40 percent of girls are currently enrolled in school. Two famines in the 1980s left thousands dispossessed, with economically vulnerable women hit the hardest. Many moved to cities, taking mostly low-paying, low-status jobs. In rural areas, women continue to do the bulk of the nation's work without getting paid for it, while men typically work less and are paid more.

Some groups still practice polygamy, using this arrangement as a means of controlling labor. Ninety percent of women undergo female circumcision, a cultural practice that some Ethiopians believe controls women's sexuality, but one that can lead to infection, severe complications, and even death. Malnutrition and infectious diseases are widespread, and maternal mortality is high. Dozens of women's groups focus on health care and environmental issues, but governmental restrictions on their operation restrict their effectiveness.

Vivienne: Getu, you told me that this is your second marriage. How old were you when you married Zenebu?

Getu Mulleta (husband): Twenty-three.

How did you meet her?

Getu: I kidnapped her.

What!? You stole her heart away, is that what you mean?

Getu: I saw her on the street. And I fell in love and wanted her to be my wife and that is why I kidnapped her.

Did you go to her parents and ask?

Getu: You do not need any prior arrangements to kidnap a girl. You just do it on your own and then people negotiate after.

How did you negotiate to marry her?

Getu: Traditionally, old men are selected to be sent to the [woman's] family to work this out.

Did you know her name when you married her or had you just seen her?

Getu: I knew her name. I'd seen her once or twice when she was coming to visit her sister.

What did Zenebu think about becoming your wife?

Getu: I loved her. I had no idea whether she loved me or not. It was my decision.

Do you want your daughters to have this kind of marriage?

Getu: I don't want any of my daughters to be kidnapped. I did that out of ignorance. I am an illiterate person. That is why I decided to do things without permission. But I want my daughters to be educated and to have an office job. I want them to get married to someone who has an office job. I don't want them to have the kind of life I am experiencing.

Zenebu, why did Getu's first marriage end?

Zenebu: She just left him. She wanted to visit her family and he refused to let her, so she left.

How did Getu abduct you?

I used to dance traditional dances and sing. I was selected by the farmers' association to be a member of the singing committee. I came to visit my sister [at the town where the dance was going to be] and I was kidnapped by Getu. I did not know him. That day was the first time I had even seen him. He might have seen me before, but I had not seen him. I was crying and

shouting. I wanted to go back home.

Where did he take you?

He brought me to his brother's home.

How did your parents feel?

They were humiliated. After the second or third day, elders were selected to negotiate with my parents. They settled on some amount of money and organized a marriage ceremony.

How do your parents feel now?

Now they are happy because I have my own children. I have my own life. They seem very happy for me now.

And you—are you happy now?

Yes, I am very happy. It's better to get married than to stay at home with no children.

[*Often a man kidnaps his intended bride so his family can avoid the high cost of giving a feast—which brings public recognition to a union in rural areas where marriage cannot be binding without firm agreement between both the bride's and the bride-groom's families. The man's family often knows of his plans well in advance, but the kidnapped woman may not, and has little or no say in the matter.—Ed*]

Zenebu's husband, Getu, watches her chop wood for the cooking fire (above left). The roles of husband and wife are strictly delineated: Zenebu does all the household chores, assisted by the children. Getu's primary responsibility is to plow the fields (above) to ready them for planting. Zenebu picks through the dirt clods for weeds.

FOLLOWING PAGES

Zenebu comforts her 2-year-old son Kebebe, as Getu and daughter Mulu sleep. The bed used by Getu and Zenebu has a hay mattress covered with animal skins and a blanket. The children sleep on a ledge of packed earth and cow dung covered with animal skins—unless, as here, they can take advantage of Zenebu's temporary absence to slip in bed with their father.

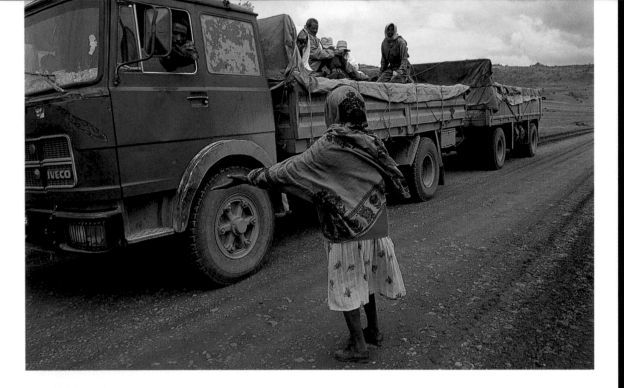

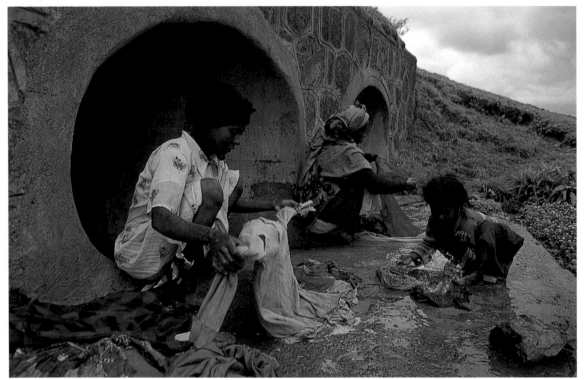

To go to Holeta, the nearest town with a sizable market, Zenebu must wait by the roadside for a ride from one of the trucks that lumber by (top). She pays 2 birr [US $0.32] for the 45-minute ride. For other trips, though, Zenebu must walk—as she does every time she washes the family clothing (above, with her daughter Mulu, 5, and her best friend Dirribe) at the drainage pipe a quarter-mile from her home.

Vivienne: Zenebu, how many times have you been pregnant?
Zenebu: Six times. One child miscarried. I was coming back from grinding meal and I fell down. I was five months pregnant. It was the second child, after Teshome. After that I always had problems giving birth.
Did you plan all your children?
I wanted to have children before I gave birth to Teshome, but after Teshome I did not want any more babies. Then I had the child who died at birth and I prayed to God not to give birth to another child. But it always accidentally happens. I don't want any more children. If I were

wealthy, if I had a better life and a better house, then I would want more.
Do you use contraceptives?
I do not use any family planning or any contraceptives or anything.
How come?
They teach us at the clinic how the family planning helps, but they do not give us any contraceptives. They teach us to use menstrual tabulation [the rhythm method—*Ed*].
Is that what you're using?
I have not menstruated since giving birth [to Kebebe, the youngest boy—*Ed*]. It has been two years. I am breast-feeding now and I do not expect to menstruate until I stop.

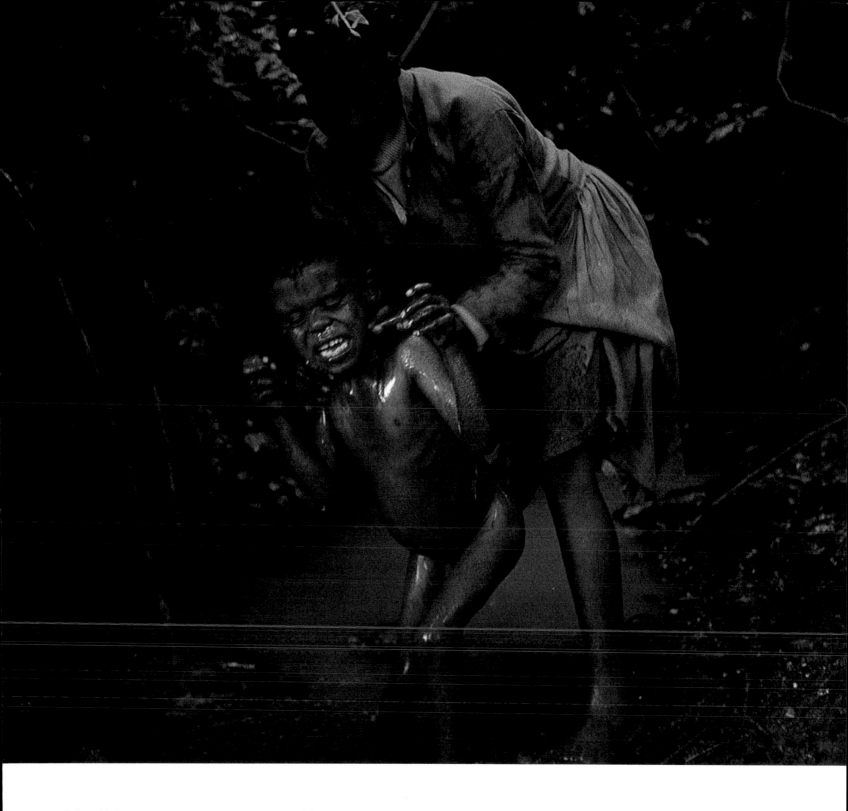

If the clinic gave you contraceptives would you use them?

Yes.

But are they too expensive at the moment to buy?

I do not know, but when there are missionaries here, they give them away.

What do you want for your daughter Like? Do you want her to have many children, or just one or two?

I want her to have two daughters and two sons only. In the future, I will advise her not to have many children.

Within the community here, are women respected as much as men?

No. When a girl is born, people are not very happy. They think it is much better when a woman gives birth to a son. When a girl is born, people do not celebrate like they do with a boy.

Is this also the way it was during your mother's time?

It is the same. I want women to be equal, but it is our culture [for them not to be] and I accept that.

Do you think it is different for women in other countries?

I've heard that women are treated as equals in many foreign countries, but I do not know it for a fact. For myself, I want to stay as I am. I want to fit in this society, with this culture.

Zenebu washes her son Mamoosh, 8, in a nearby spring (above) with icy water that is believed to have curative powers. The boy has an as-yet-undiagnosed mental disability that resembles autism. Zenebu believes that regular sessions in the spring are helping the boy, who otherwise is largely left to the care of his 93-year-old great-grandmother, Birri. He is ignored by the rest of the family.

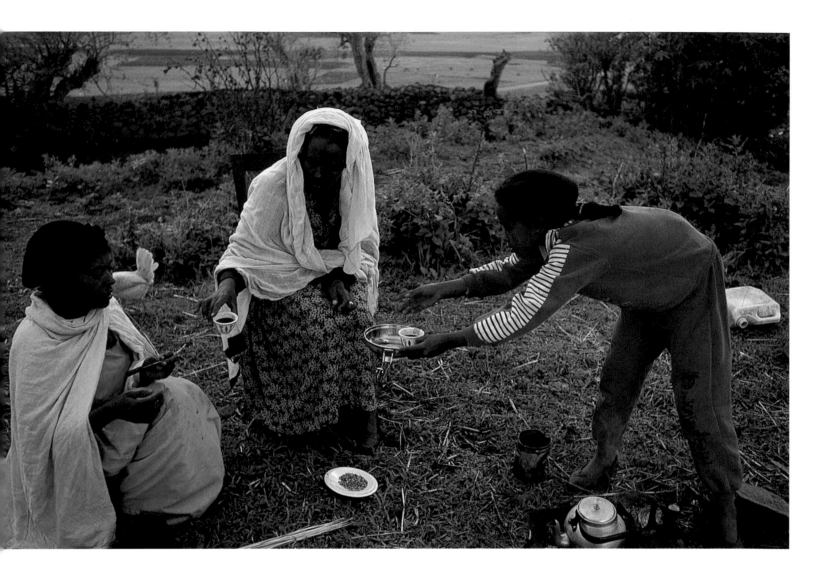

A respite from a busy afternoon, Zenebu (above, in green dress) takes a coffee break with her sister-in-law, Ayelech; her niece Zelalem, 10, does the brewing and serving. Zelalem is in the second year of school—one of only four girls in a class of 18. Zenebu's daughter Like, who is the same age, does not attend school, though she wants to. The reason, Zenebu says, is that the family cannot afford the required textbooks and clothing. In addition, Zenebu finds her daughter indispensible at home, where she helps to watch the younger children, grind grain, collect firewood, patch the house, and fetch water. Zenebu's son Teshome (above right), is an enthusiastic first-year student, here raptly listening to a lesson about human anatomy.

Vivienne: In our country, women are not circumcised. But here it is common. What did your family do?
Zenebu: My daughters are not circumcised, but [my son] Teshome is already circumcised and I am circumcised. Since last year I have begun planning for my daughters to be circumcised. But this year is a system year, which happens once in eight years, and we are not allowed to circumcise children during this time. So I will do it soon after the system year is over. [Zenebu, a member of the Oromo-speaking group, is referring to *gada*—a complicated age-grading system that dictates when an Oromo person can undergo certain ceremonial rituals.—*Ed*]
Why is it important to circumcise them?
It is a tradition—our tradition. I have no idea why, but it is a tradition.
Do you agree with the tradition?
The others would laugh at Like when she goes to school if she were not circumcised. It is a humiliation, not circumcising a daughter. It is terrible not to.

Have you talked about it with Like yet?
She keeps complaining that she is not circumcised. Like, herself, is complaining. She says, "Many of my friends are circumcised and you did not circumcise me."
Zenebu, at what age were you circumcised?
I've been told it was when I was a year and a half old.
When your daughters are circumcised, who will do the operation?
There are some people around here who do the circumcision.
Is it a traditional woman?
Yes, traditional. She comes here and we make porridge for her and give her butter to oil her hair and 2 birr [US $0.32].
What about something for the pain? Does she have medicines?
We buy a powder from private clinics. It is a Western medicine. I do not know what it is. We put it on the genitals.
Do the girls feel much pain, do you think?
Men suffer a lot. Not women.

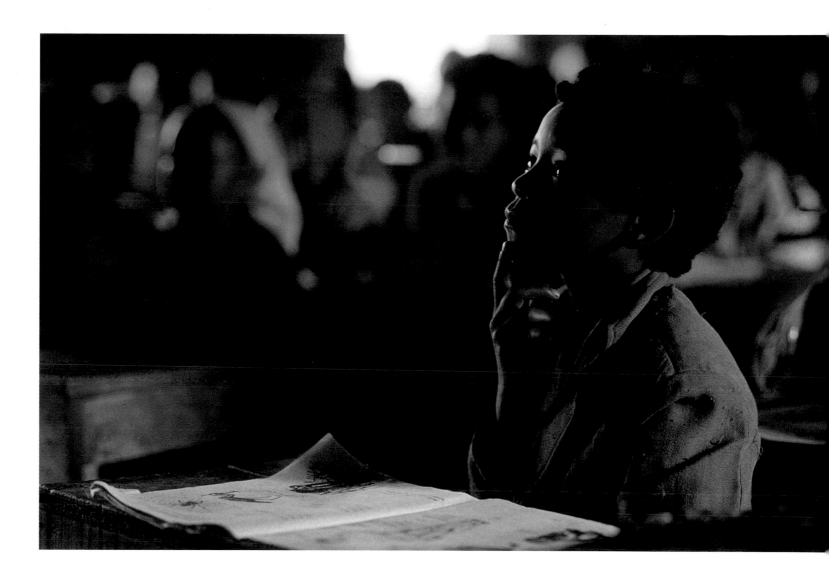

Why not have the operation in a clinic? For men—for Teshome, say—they do that. He was circumcised in Holeta at a private clinic. I do not think there is circumcision for women there.

Does the government allow this in the clinic?
For women it is not allowed. It is forbidden by the government.

Do you think there are health reasons why girls should not be circumcised?
In the clinic they complain about it. They say, "You lose all this blood and it always ends up infected." When a woman gives birth, the cervix will not relax sometimes, because of the infection. And they teach us that circumcised women can have problems in relations with a man.

What kind of problems?
They never tell us the details.

Field Journal

Hours before dawn, Zenebu leads a calf from the house to join its mother in the field. Smoke drifts out the doorway as she lights the fire to make coffee and flat injera bread. Shy 10-year-old Like appears with a yawn, scoops up handfuls of still-warm cow dung, and begins her day by patching the walls of their new home. Zenebu sharply calls Like, who responds by picking up a clay pot, and running to the nearby stream. Getu comes to the door, wiping sleep from his eyes. Like reappears with a small bowl of water for Getu to wash his face.

It is a difficult life for Zenebu and her family. They live in a one-room dwelling with a single piece of furniture—a crude wooden bed. On two walls are dung ledges for sitting around the cooking fire. At night the three oldest children wrap themselves in animal skins and sleep on the ledges. The thatched roof is terribly leaky—as I discovered on the day that the skies opened to the rain that had been threatening during the entire visit. I was in the house and the roof started leaking everywhere. About a dozen people huddled inside, many of them raising umbrellas against the gushing water.

When there's a break in the routine, Zenebu has coffee with her sister-in-law, Ayelech. The women roast beans in a metal pan, crush them, pour the powdery result into a pot of boiled water, and share secrets while waiting for the grounds to settle. The two women meet several times a day—a routine that is important to both of them.

The children work very hard, especially Like. Teshome does a lot of the plowing and Like does everything but cook. I never saw her play. She will never get to go to school, although I think she wants to. It's hard not to wonder what will happen to her in ten years—will her life be exactly like that of her mother?

— MELISSA FARLOW
APRIL

Work

In cultures where women work for income, they often work longer hours than men and almost always make less money; they are also more likely than men to work in the informal economy, where they have no guarantee of a paycheck or benefits. In addition, women who work in jobs outside the home usually do most of the work inside the home as well—a daunting, and unpaid, double burden. The "women's work" of cooking, cleaning, and childcare has always been the foundation of most households in every culture; indeed, all of human society has traditionally been held together by the invisible labor of countless women.

GUATEMALA

" I would like to get paid for work but I cannot because I have to take care of my children. I hope that when they grow up, I can get a job and get paid for it." —Lucia Sicay Choguaj, who creates small weavings at home when she has time away from her household chores, would like to have her own shop.

MONGOLIA

" I got three months off at full salary and three months without salary. I took some rest and looked after my baby until she was eight months old. My son, I looked after until he was one and a half years old, and then I went back to work." —Lkhamsuren Oyuntsetseg, pharmacist.

BHUTAN

" If I had gone to school and got some education, I would be working in an office and having a much easier life than I am having right now." —Sangay, Nalim's daughter, subsistence farmer.

ALBANIA

" The biggest part of my day is used up by washing laundry—I have a handicapped child, so his clothes have to be changed very often." —Hanke Cakoni, who starts her day early and works into the night, caring for son Eli and her three other children.

ETHIOPIA

" We plan to send Like to a village school, but I want her to help me at home now." —Zenebu Tulu. Like Getachew, 10, shoulders many of the work responsibilities at home such as pounding grain in the yard of her parents' home.

GUATEMALA

MONGOLIA

BHUTAN

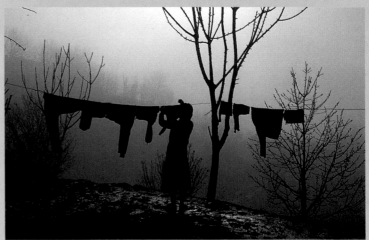

ALBANIA

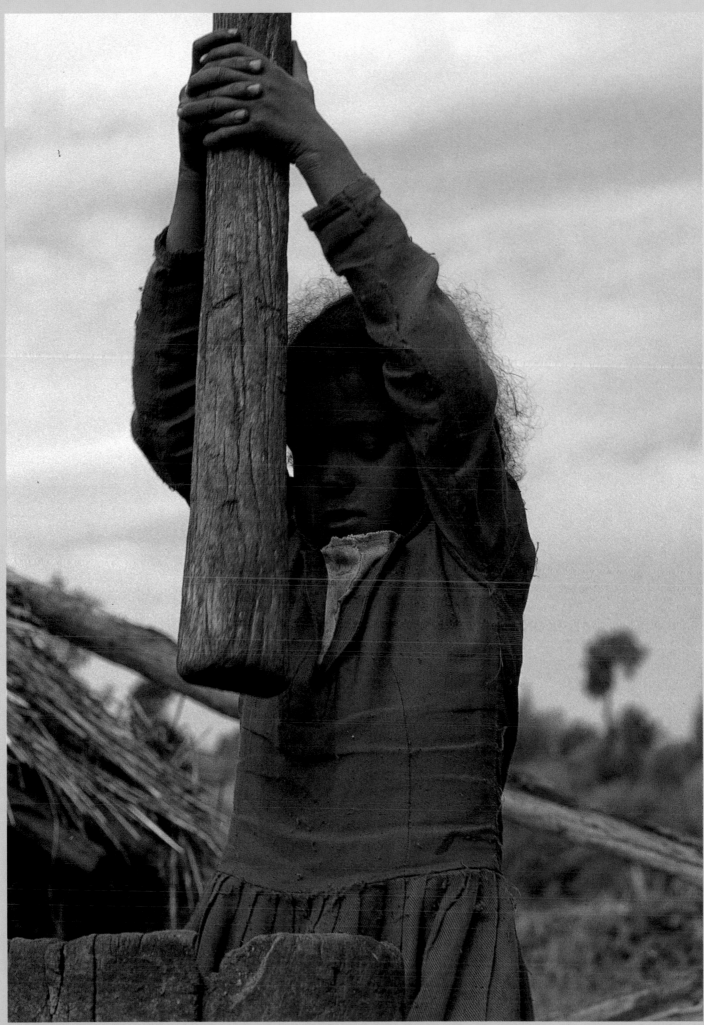

ETHIOPIA

Work

MALI

" *I want to have more [children] because they can help me to work.*" —Pama Kondo. Two of her children, Pai (on left) and Kontie, carry mangoes back from the families' orchard accompanied by their father, Soumana Natomo.

RUSSIA

" *I will not survive if I have only one job.*"
—Zhanna Kapralova, who has two jobs, practices a play in German with her students.

BRAZIL

" *I think the majority of the culture thinks that women should still stay at home—the machismo concept still exists, but a woman cannot [stay at home] because she has to work.*"
—Maria dos Anjos Ferreira. Filling out job applications (left in photo) with her friend, Risomar.

CHINA

" *Farm work is the most important thing in my life.*" —Guo Yuxian, walking on the levee with her irrigation tools.

USA

" *I was going to wait until I was out of college, and work for two years before I got married.*" —Pattie Skeen, with her students; she finished college after marrying at age 18.

MEXICO

" *Well, I was thinking about studying to be a secretary. I also like to travel very much. Airplanes have always appealed to me. I would have liked to have been a flight attendant.*"
—Carmen Balderas de Castillo, homemaker.

ISRAEL

" *I have a salary like a big secretary who is working eight hours a day and I'm only doing four hours a day! And when I want to work, nobody's standing on my head.*" —Ronit Zaks, who works as a typist from home but is weighing whether to take an outside job.

SOUTH AFRICA

" *It was very difficult for me when Simon was not working. I was working alone. I had installment accounts that I had to pay.*" —Poppy Qampie, settling accounts in her office in Johannesburg.

JORDAN

" *When I decided to retire, a lot of my friends told me I shouldn't and argued with me. I am convinced that I retired at the right time. It's a personal conviction.*" —Haifa Khaled Shobi, who quit her job as a teacher to spend more time with her five children.

JAPAN

" *My mother worked, I didn't want to work, because of my children.*" —Sayo Ukita, who is waiting until her children grow up to resume working outside her home.

HAITI

" *There are no set hours; people come day and night.*"
—Madame Dentes Delfoart, sweeping her yard between customer visits to the small store she runs from her house.

MALI

RUSSIA

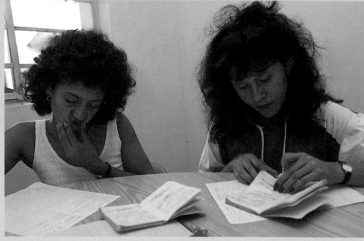

BRAZIL

CHINA

UNITED STATES

JORDAN

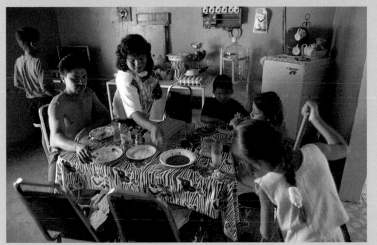

MEXICO

JAPAN

ISRAEL

SOUTH AFRICA

HAITI

Guatemala
Lucia Sicay Choguaj

> " Women wash clothes, make tortillas, clean the house, give baths to the children, and also weave. They do a lot of work. But men do just one thing and get paid. "

BY 5 A.M., HOURS BEFORE SUNRISE, Lucia Sicay Choguaj is already sweeping her house and making tortillas for her family's breakfast. She lives with her husband, Vicente Calabay Perez, and their three children on the shore of Lake Atitlán in a community that is almost entirely Maya (the family speaks Kaqchikel,

one of many Mayan dialects). Although the village of San Antonio de Palopó is quiet and rustic, it is transforming itself into a furiously active commercial enterprise, marketing textiles woven in bright Mayan patterns to tourists from Europe and North America. In addition to her housework, Lucia, 28, (*left* with daughters) weaves small, colorful bracelets and long eyeglass cords, selling them to a dealer who resells them in larger markets. Vicente, 29, used to farm and weave but now mostly works in the town cooperative, which sells villagers' textiles to tourists and exports them to faraway countries. Lucia would rather he did more farming, but he says he needs the money he earns to support his family.

A few months after photographer Annie Griffiths Belt stayed with the Calabay Sicay family, interviewer Faith D'Aluisio came back to San Antonio de Palopó to speak some more with Lucia. As a gift, she brought a photo album with some prints. Lucia thanked her, but said that it was painful to look at some of the pictures. A month after these photographs were taken, her fourth child, 7-month-old Olga (*inset*), came down with a sore throat. Although the doctor said that nothing was wrong, the baby died three days later.

Photographs by ANNIE GRIFFITHS BELT Interviews by FAITH D'ALUISIO

Guatemala

Population: 10.6 million

Population Density:
251.9 per sq. mile

Urban/Rural: 38/62

**Rank of Affluence
among UN Members:**
101 out of 185

Lucia Sicay
Choguaj

Age: 28

Age at marriage: 28
(Lucia lived with Vicente
from the age of 18. They
were married in the
Catholic church a short
time ago.)

**Distance living from
birthplace:** Same town

Children: 4 (but 1 died)

**Number of children
desired:** 4

Contraception used:
None

Religion: Catholic

Education: 2nd grade

Literate: Reads and
writes Kaqchikel with
difficulty

Occupation:
Homemaker and weaver

**Amount broker pays
Lucia for the bracelets
she weaves:** 3 quetzales
for a dozen [US $0.55]

**Number of bracelets
Lucia can make if she
works all day:** 24

**Price tourists pay
broker for bracelets:**
Lucia doesn't know

**Pounds of corn eaten
by the family daily:** 3

**Round-trip walk to
grind corn at a mill in
town:** A half-hour

Least favorite task:
Going to market by boat,
because the water can
be rough, the boats are
overloaded, and she
can't swim

Personal dream:
To have a shop for clothes
and weaving

Conversation
with Lucia Sicay Choguaj

Faith D'Aluisio: What do you do over the course of a day, Lucia?
Lucia Sicay Choguaj: At 5 a.m., I wake up and start working. I clean the house, I sweep the floor, and then I put together the fire and make food for my children—sometimes we have green vegetables, beans, sometimes eggs.

Does each child get an egg?
Sometimes yes, but when we do not have money, they get a piece of egg.

What did you make for breakfast today?
Eggs with a little salsa. The eggs, over easy. Sometimes we eat eggs in the way of the Maya—[cooked directly on the tortilla] without oil. It's good—I like them with and without oil. But when my daughter died, I couldn't eat oil with the eggs, I would get sick. After breakfast I make tortillas. If I need to grind my corn, I go to the mill. It takes 30 minutes to go there. When it is school time, I take my littlest daughter [who doesn't go to school]. When the [other two] children are home from school, like now, I leave them all and I go by myself. There are five places to grind corn, but all of them do not work all day. There is always a line of people waiting.

Do you go there with your friends?
All the time I find people on the street that I know and walk with to the mill. When I come back, I again make my tortillas, then sometimes I weave and sometimes I wash my clothes in the lake. When noon comes, I make lunch. In the afternoon, I weave again—sometimes I make bracelets. After that, it's getting late. I make dinner at 5 p.m. and we go to bed at 10 p.m. If the children go to bed too early, they will not go to sleep. They play in the evening until sometimes 9 p.m. Then they go to bed.

What do you make for lunch and dinner?
Sometimes I cook beans, sometimes fish. If we get some meat, I cook the meat. Red beans, black beans, potatoes. I make only one kind of food. If I make soup, we only have soup. If I make fish, we only have fish. I do not make combination food.

Does your husband like what you cook?
He likes everything. He eats everything I cook.

Does he think you are a good cook?
[Laughs] I think just that he is a nice man.

Are men and women equal in Guatemala?

I'm sure that we have equal abilities, but I believe that women have disadvantages because they get paid less than men. When men take off from work, they do not have to work. But women, they just do pieces [weavings] at home so they have to work all the time. We do a lot but we do not get paid well. Women wash clothes, make tortillas, clean the house, give baths to the children, and also weave. They do a lot of work. But men do just one thing and get paid.

What do you do in addition to your housework?
I tried to raise animals, but I lost my money because all the little pigs died. Now I have only chickens, but there was a sickness so many of them died also. I now have only three. Also I weave bracelets and the longer ones [eyeglass cords]. I get 3 quetzales [US $0.55] for a dozen bracelets. If I work all day, I can make 24 bracelets. Usually I make 6 quetzales a day [US $1.10] doing this. I sell them to the dealer and he takes them to Panajachel or Sololá or other places to sell for a higher price.

Vicente is a weaver also, isn't he?
He used to weave a lot but now there is no demand for it. Because so many people do the same kinds of work, we no longer sell the big weavings [bolts of cloth used for clothing].

You said he also farms?
Yes, he grows onions and other vegetables. He has to bring the water all the way from here to the fields, so he wakes up early, at 2 a.m. The men take turns bringing the water for the plants. That's why he doesn't grow as many onions as he used to, because carrying the water is so hard. Now he works in the artisan's cooperative.

I noticed lots of people in the village selling textiles—both large and small pieces.
Many people sell in the street [to tourists] and they sell the pieces much cheaper. There is a lot of competition. That's why we try to make the small bracelets and the longer ones [eyeglass cords] instead of the big weavings. Doing the big weavings takes more time and more work.

You make those bracelets fast.
Before, we did not make them. People started weaving them for the tourists about eight years ago. Myself, I started about two years ago. They aren't hard to make.

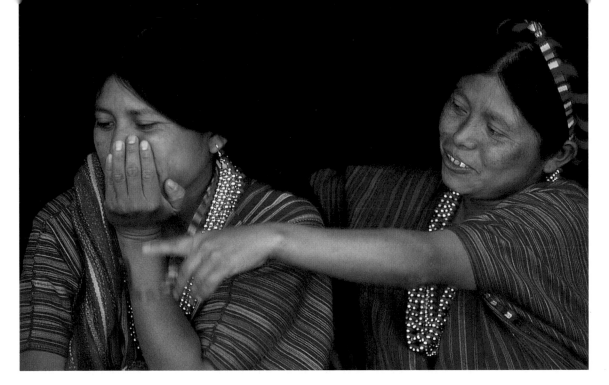

Women in Guatemala

Guatemala's civil war ripped through the country's families, leaving at least 125,000 orphans and 36,000 widows—in a nation of just 11 million. As a result, many women must support their families alone. And in a country with high levels of illiteracy, limited health services, and deep poverty, survival can be difficult. Both indigenous and *Ladina* (non-Indian) women who are employed outside the home usually work at low-wage, informal sector jobs like domestic work, in addition to cooking, cleaning, and caring for children at home.

Sixty percent of Guatemala's people are indigenous Mayas, who live mostly in rural areas. Here, the sense of family is strong, and women's skills in weaving and other manual work are highly prized. Although indigenous women may travel to market their handwoven textiles and other goods, in some areas they may be constrained by a patriarchal culture that requires them to ask their husband's permission before leaving the village.

Among Mayas, men and women traditionally had complementary spheres of influence: for women, the household and children; for men, the public realm. But with the advent of a cash economy, power has shifted more toward the men, whose contribution has more economic impact.

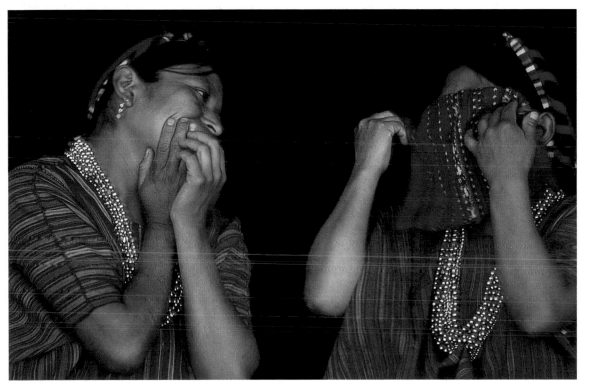

Lucia (on right) and her sister Juana are each other's best friends. "We're very close," Lucia says. "We talk about situations we can't share with anyone else. We keep secrets for each other—about our feelings or our husbands or our families."

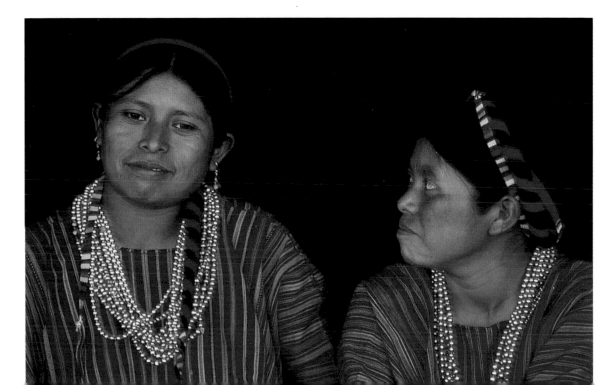

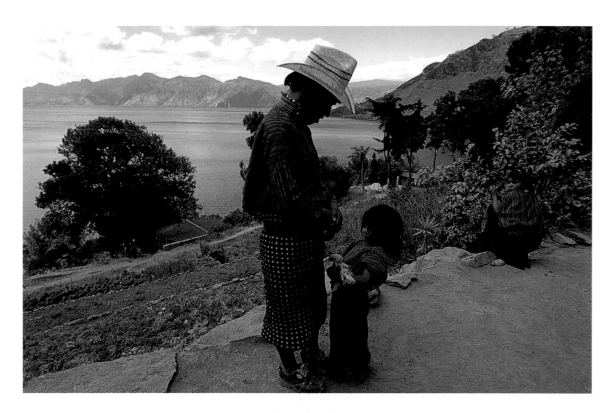

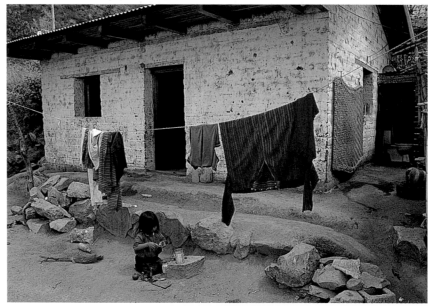

Carrying her baby in a traditional woven sling, Lucia's sister Juana does her family's wash on the shore of Lake Atitlán (below right); bent over her own laundry, Lucia kneels a few feet away. Afterward, as the clothes hang to dry (middle right) in front of their house, Maria, 5, plays with castoff kitchen items and waits for her brother Mario, 10, and sister, Olivia, 8, to come home from school. The brilliant colors of Mayan cloth have attracted attention across the world and created a growing export market. Indeed, Lucia's husband, Vicente (above, inspecting a chick held by Maria), wears the traditional fabric of their village which is wrapped, skirt-like, and belted at the waist.

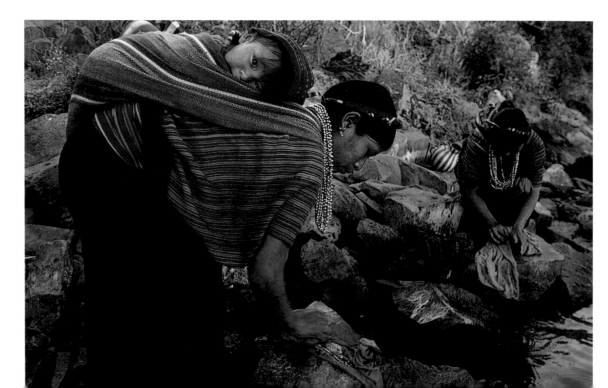

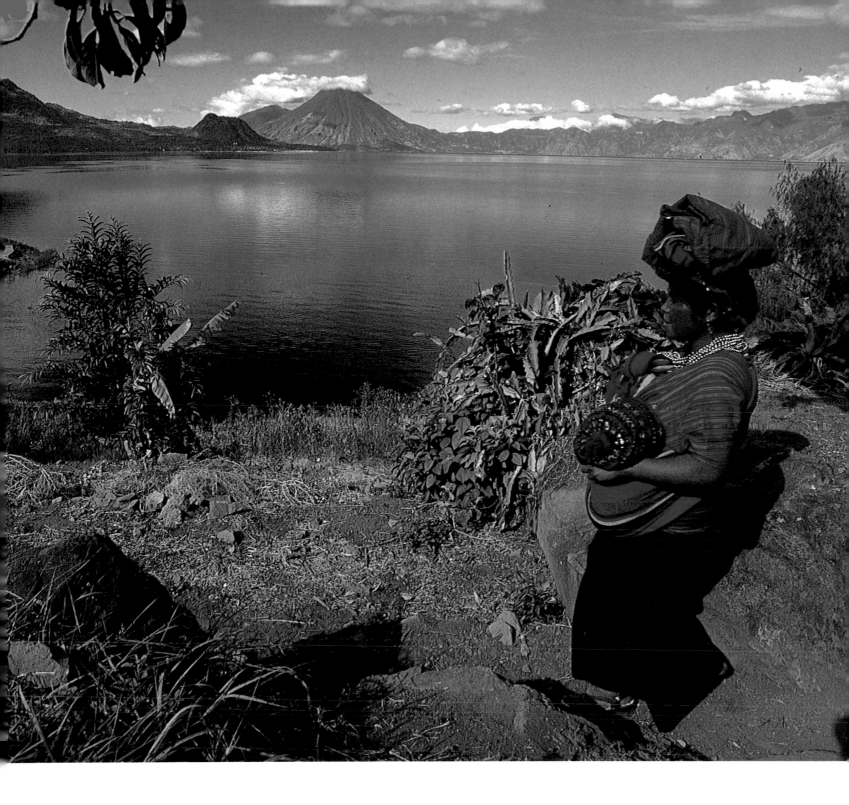

Faith: Vicente, how long have you been working in the artisans' cooperative?

Vicente Calabay Perez (husband): For two and a half years, selling material and thread and many pieces of clothing. There are 167 members of the cooperative. Most come from the town of San Antonio de Palopó. Most of the members of the cooperative are women because so many weave. We have a store here in the town and we also sell to the United States and to Germany.

Are you still farming?

Vicente: Yes. If I just depended on the money from the cooperative, I wouldn't make it.

Are you trying to give your children the opportunity to go to school?

Vicente: I am thinking they must go to school but it all depends on our economic situation because the school here only goes to the sixth grade. If I can find some money, they might continue at another place.

How far would you like them to go?

Vicente: I do not know yet what will happen. If I can get the money, I will send them to another place. It is my dream that even if they cannot continue, that they get a good job and they survive.

You don't want them to work on the farm? What would you want them to be?

Vicente: Employees of a company, workers in a market or store—anything else.

Carrying her goods wrapped in a cloth on her head and her baby in her arms, Lucia (above) walks along the path at the edge of Lake Atitlán in her town of San Antonio de Palopó. Maria's clothes identify where she lives, for each Mayan community has its own specific pattern and colors, and communities are known by the colors they wear. As Lucia negotiates the tricky path, Volcán Tolimán looms in the background.

Field Journal

When I got to the village I had no idea that Lucia's baby had died just after Annie had photographed the family. When I was giving out small presents I had brought the family, I suddenly realized that the number of children I was greeting wasn't right. Because of the language barrier, it took a while to figure out why the baby wasn't there. I quickly hid her present from Lucia and tried to figure out how to ask what had happened. My view is, you have to deal with these things as a person first and a journalist later.

It was lucky I was a woman, for Lucia is painfully shy and hardly talks to men other than her husband. At one point she told me about where the women take their baths. The men and boys all go down to Lake Atitlán, but the women have adobe huts where they bathe themselves privately. She was walking to show me the hut when the men came in and Lucia just shut down — she stopped walking and wouldn't talk.

But she would tell me things if I told her things in return. We exchanged our total life stories— children, relationships, family, everything. When I left I gave her a photo album of Annie's pictures, many of which were of the baby. I think Lucia was happy to get the album, despite all the photos of the baby. She went through the book, and I could tell she was both smiling and wanting to cry.

— FAITH D'ALUISIO
DECEMBER

Faith: How did you and Vicente meet?
Lucia Sicay Choguaj: It is customary here on Sundays that the young men paddle in their boats on the lake. I met Vicente when he was paddling his canoe. I was washing clothes in the lake and I met him there.

Did you know Vicente's family?
No, because he lived on this side and I lived on the other side of the town. For more than one year, he was courting me. There were three more boys who were around me also.

What was it about Vicente that made you choose him?
Maybe because he is not a drinking man, and he was not seeing any other women.

So then you married?
No, I did as my mother did—*xek' ule'* [Kaqchikel for cohabitating—*Ed*]. I met Vicente near my home in the evening and went with him to his home to live. People do this. When they get to the home of the man, the parents of the young man have to go to the woman's house to tell the parents that she has made an agreement with the boy to live with him.

How did your parents react when you went to live with Vicente?
My mother, she was so angry because she had been very happy when my sisters and I were around her. When I got there with Vicente and his family, she asked me why I left her. I told her why I went with him and finally she accepted it.

Did your parents publicly treat your running away as *xeleq'ex e'l* [an abduction in which men steal their brides—*Ed*]?
Yes, to keep their pride before the town.

Did this happen with any of your sisters?
One sister, Felicita, she got married in the way of the old customs—in the good way—the man went and asked for her hand. Another sister, Juana, she went like I did and Paulina, my younger sister, is not yet married.

How is your life with Vicente?
Okay. Sometimes we are arguing but we live a very tranquil life.

He seems like a very nice man. Are other Guatemalan men like he is?
Actually, some men, they want to live a few months with a woman, and then they find another woman and go with her. My husband, he is with me only.

You said that your mother was angry when you left her to be with Vicente. Will you feel the same way when your daughters leave your house?

I tell my children, "If you grow up and go to school, maybe you can get a job and work." If they marry, they are free to marry anybody. If they want, they can do it, but I would like to have my daughter be like you [Faith]. You have your job, your work. But many girls here, they get a job but they don't really want to work. They want to marry only. I don't want that for my daughters.

How much schooling do you want them to get?
Some people here, when the children finish [elementary] school, they send them to another place to go to school. If God helps us to get the money we will send them anywhere, but it is very hard for us because it is hard to get money.

How much schooling did you have?
I passed the second grade. I got sick with measles and did not go back to school. If I had not gotten sick, I would have stayed in school. I was in bed for a long time with the sickness.

You couldn't go the next year?
I was also treated badly by the other children in the school. So after I got sick, I did not want to go back. When I realized that it was important to complete my education, it was too late.

There's no way for you to go back now?
Yes, I would like to but I'm too busy, and it is too late. There are too many things to do.

Are you trying to make sure this doesn't happen with your daughters?
My hope is that they keep going to school. I want them to continue their studies, because learning will make it possible for them to go anywhere they want. Myself, I cannot go anywhere because I have limitations. I didn't learn enough Spanish in school to communicate outside of this one town.

So speaking only Kaqchikel holds you back.
That's right.

What is important to you in your life?
Just being together with my husband and having a very tranquil life. My children, they have a good life, even if we lost my one child [7-month-old Olga].

I know it must have been hard for you. What happened?
I was beginning to see that she was sick with a sore throat. I really do not know any more. We took her to the doctor and he gave her medicine. The doctor said that the baby was fine. There was no problem with her. My baby was sick for three days. Two days after we saw the doctor, Olga died at 3 in the afternoon.

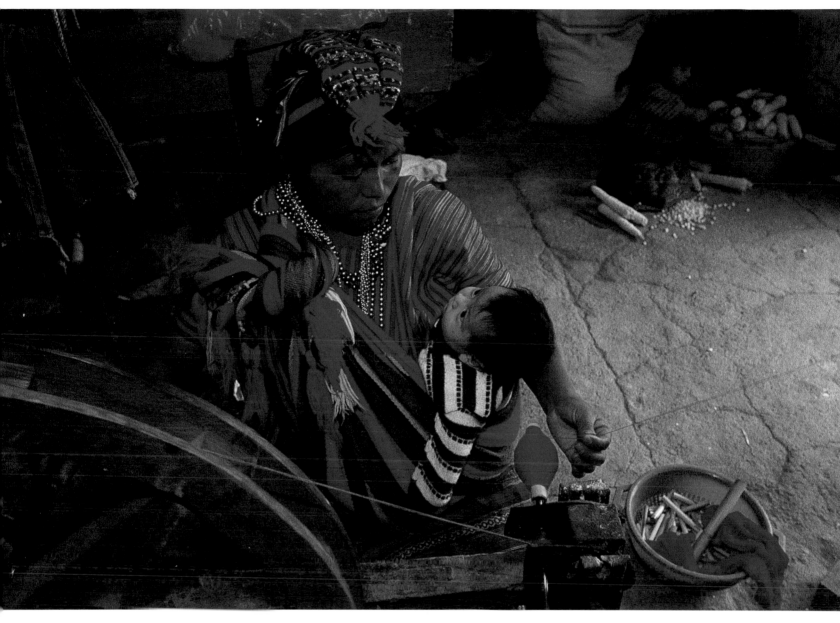

At 4 p.m. on the same day, we buried her.

Was the doctor here in the village?

He was living here but now there is no doctor. That doctor left the village two months after the baby died.

Was it difficult for you to talk about Olga's death with the other children?

Yes. They cry because they remember their sister. I cried too, for two months. My husband also cried. I have not forgotten.

Do you go to the place where she rests to remember her?

Only in November, on the Day of the Dead, we went to see her at the cemetery. We did not bury her in a tomb. We buried her directly in the Mother Earth.

Lucia carries baby Olga close to her body in the traditional Mayan cloth sling, which allows Lucia (above) to work spooling thread and still be close if her baby needs her. A month after the photograph was taken, the baby became ill and died. Lucia and Vicente buried her in the town cemetery (left). "My whole family is close and we are together all the time," Lucia says. "We all miss her."

Haiti
Madame Dentes Delfoart

" Our family is not poor—not really poor.
When we are fine, we are fine;
when we are not fine, we are not. "

BORN AND RAISED IN THE PROVINCE OF Maissade, northwest of Port-au-Prince, Madame Dentes Delfoart followed rural tradition and replaced her name with that of her husband, Dentes, along with the honorific "Madame." Like her mother, she provides much of her family's income by doing what she calls "a little selling"—which means operating a sort of local convenience store out of her storage shed (*right*). Dentes, 55, takes care of the goats, pigs, donkeys, and the family bull; he also plants millet, sugar cane, and potatoes in the family plot. He told photographer Maggie Steber that he loves to work hard, he loves his animals, and he loves his wife—a declaration that Madame answered with an affectionate laugh.

Mme. Delfoart, 41, seems to never stop moving. Busy days become busy nights, and throughout, her house draws a steady stream of visitors—both family and friends. Food isn't plentiful, but she is able to scrape together enough to feed anyone who happens to be present at mealtime (*inset*, sorting beans). Madame's daughter Fifi—and Lucianne, a niece who lives with the family—are expected to help with household tasks. Her oldest daughter lives nearby with her husband and four children, but they spend much of their time at the Delfoart's home. Madame's son Soifette—and a nephew who also lives with them—pound rice, clean the yard, and help Dentes forage for animal feed. Having joined the neighborhood Pentecostal church in 1985, both Dentes and Mme. Delfoart now attend services regularly and consider themselves deeply religious.

Photographs and Interviews by MAGGIE STEBER

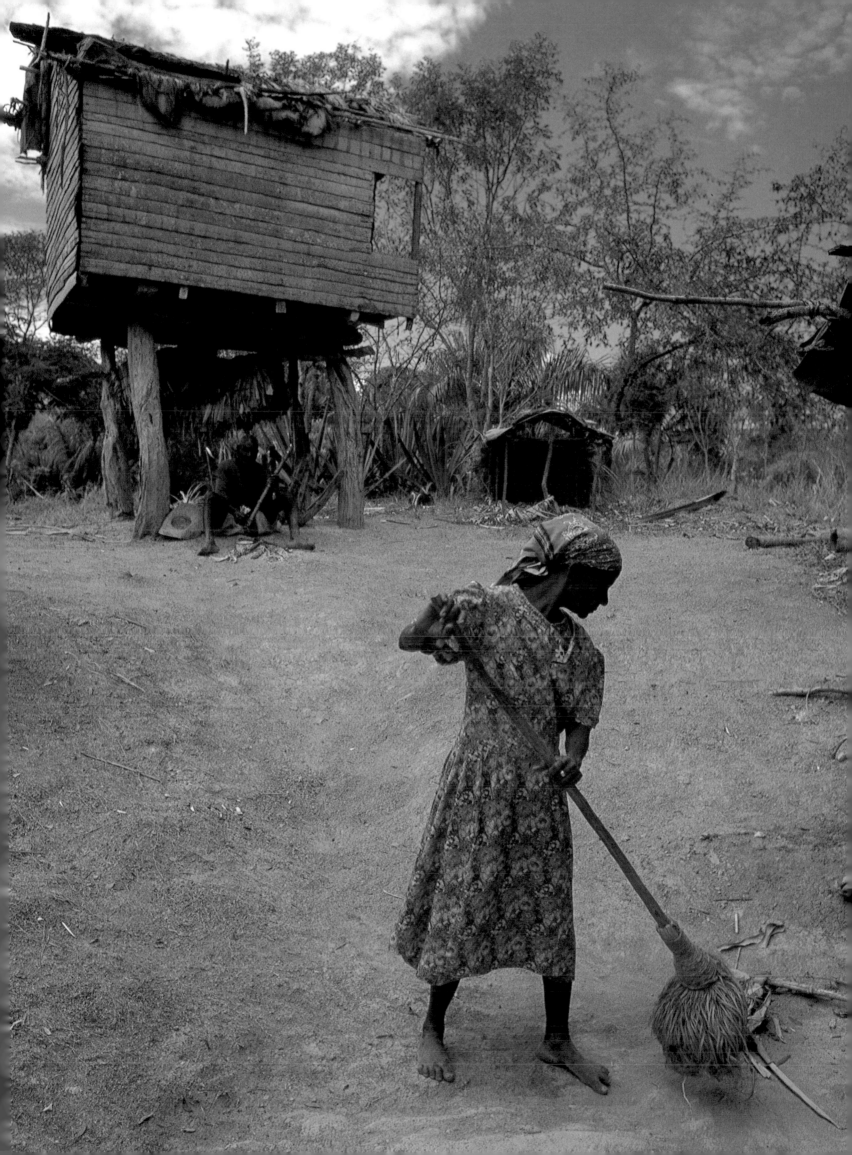

Family and Nation

Haiti

Population: 7.2 million

Population Density: 666.0 per sq. mile

Urban/Rural: 31/69

Rank of Affluence among UN Members: 171 out of 185

Madame Dentes Delfoart

Age: 41 (but not sure)

Age at marriage: Mme. Delfoart doesn't know how old she was when she started living with Dentes, but they had a church marriage in 1985.

Children: 6 (but 2 died as young children)

Number of children desired: She does not want any more, but says, "God will decide."

Occupation: Food seller

Price negotiated for a bunch of spring onions at the Hinche market: 9 gourdes [US $0.90]

Religion: Pentecostal

Literate: No (no formal education). Neither is Dentes

Informal education: Taught by her mother to do housework and run a small market

Number of meals family eats per day: 1

Drinking water supply: A spring which is a 15-minute walk away. Each day several trips are made with a 5-gallon bucket.

Distance to nearest doctor: 20 km

Worst life events: Being robbed 4 times

Treasured possession: Family Bible (now stolen)

Woman most admired: Her best friend, Madame Akseus Joseph (the minister's wife)

Conversation with Madame Dentes Delfoart

Maggie Steber: How do you spend your day?

Mme. Dentes Delfoart: When I wake up, I wash and make coffee. My husband goes to the garden and brings in some bananas or potatoes, and I make food for the day. I give beans to Fifi and Lucianne to put in the fire and they cook the food. Fifi and Lucianne are the ones who wash the clothes. Before, I used to do it.

What takes up most of your time?

My business. What I do most of the day after I feed the children is go out for many hours into Hinche [the nearest town] to buy things for my business—for my selling from my home. If I have nothing else to do, I take a rest.

With the business, does your family have enough money?

Oh, my God! I do not have money to take care of my life. Just yesterday I was trying to find someone to lend me money to go to Hinche to buy things for my business. But our family is not poor—not *really* poor. When we are fine, we are fine; when we are not fine, we are not.

A lot of your income comes from your business, right?

Yes. I've always done a little small selling from my house. I sell food from the storage shed. I go to markets in Maissade and Hinche to get supplies for my business. Then neighbors come and buy small amounts of salt, onions, boullion cubes, and other things. There are no set hours. People come day and night.

Who is most responsible for care of the children and the house?

I am, and the children help me. My husband helps, but it is the children and I who do the work. It is work for women, especially when [the man] is working in the fields.

Did you ever go to school?

I have no formal education. My mother could not afford to send me to school, but she taught me to sew and cook and clean the house, and how to go to the river for water and tend the garden.

When you look back at your life since that time, what's your proudest accomplishment?

That I joined the church and regularly pray to God.

Do you have a specific hope for the future?

That Jesus will come.

What makes you happy?

It makes me happy when I go to church. We do not have a nice church, but we are praying to God for a better one.

What makes you sad?

What does not make me happy is that sometimes I want to change something and I cannot.

What would you change about your life if you could?

I cannot change my life.

As Pastor Akseus Joseph holds her hand encouragingly, Mme. Delfoart stands in her Pentecostal church (above) to chastize the relatives and neighbors who were jealous of the visit by photographer Maggie Steber. In this case, the problem is resolved quickly, and the spirited discussion ends with her son Soifette, 12, singing a high, ethereal hymn about God's love for all people.

Among Mme. Delfoart's least favorite activities is haggling with merchants (left) at the market in Hinche, the nearest town. Nonetheless, she makes the 15-mile donkey trek to Hinche frequently, because that is where she buys the vegetables, grain, and canned goods that she sells in her store.

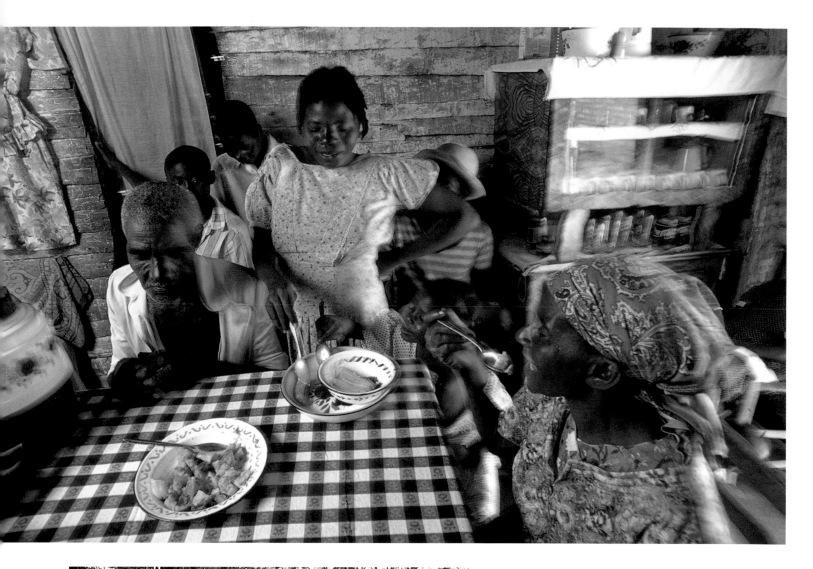

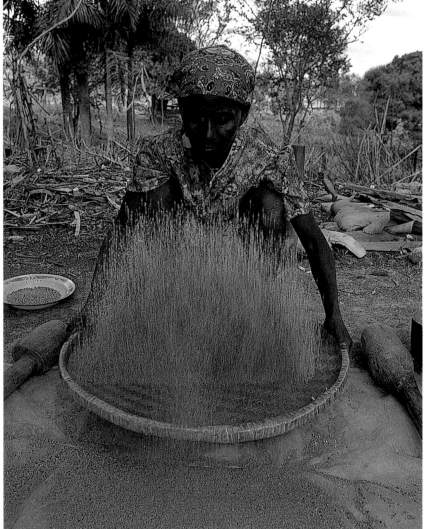

Maggie: How many people were in your home when you were growing up?
Mme. Delfoart: My mother had six children. She lost three. I was the oldest and helped raise the boys.

What did your parents do to earn a living?
My father worked in the fields. He was killed cutting sugar cane. My mother did some small selling.

Would you say your mother's life was different from yours?
Oh, the life of my mother was a much better time than my time. When my mother was alive, things were not so expensive. Corn was one or two cents. Rice was three cents.

Do you treat Fifi and Lucianne differently than your two sons?
I teach them different things—the girls to cook and sew—but I want them to have an education just like the boys. My husband treats the children equally, but they have different jobs. He teaches the boys about farming and animals.

Have you taught them about how to prevent getting pregnant?

We do not know [about] that.

How many times were you pregnant?

I had six babies and lost two. I do not want any more.

Looking back at it, do you think you had the right number of children?

It is God who gives children, so God decides.

You had all your babies in your house. Did you have any help?

Sometimes I had my babies by myself. Sometimes my mother helped. I never had a doctor or anybody—only my mother.

What about Dentes? Was he a help?

Oh, he doesn't know anything! He just stayed outside and prayed for me.

Dentes, can you describe your marriage for me?

Dentes Delfoart (husband): I love the way she makes love to me. We have a good life.

What do you expect from each other?

Dentes: She helps me to do work, and she loves me. That is a gift from her.

Do you also help take care of the children?

Dentes: Because of the job that I do, my wife takes care of the children more.

What is your relationship with your children like?

Dentes: We never argue or fight and we pray together. I am the provider for food and school.

You never argue?

Dentes: You know kids—they always argue. Afterward they apologize. They treat me like a father—with respect. When I come back home, I find my water and my food on the table. So they take care of me well.

What are your hopes for the future?

Dentes: Tomorrow I could be dead. Whatever I find tomorrow, I will take it but I cannot hope for anything.

Life for Mme. Delfoart passes by with a constant, sociable stream of visits among the members of the extended family. Often Madame's oldest daughter, Timenne, 20—who is now called Mme. Rene Louis, after her husband— and her children drop by to share supper with the Delfoarts (top left). On the weekends, the whole family frequently congregates in front of the Delfoarts' house, the adults sitting in front and conversing while the children play in the yard— sometimes scuffling (above) out of sight of their parents. The visits are an enjoyable break from the daily round of chores (bottom left, Madame winnows grain, a task she detests).

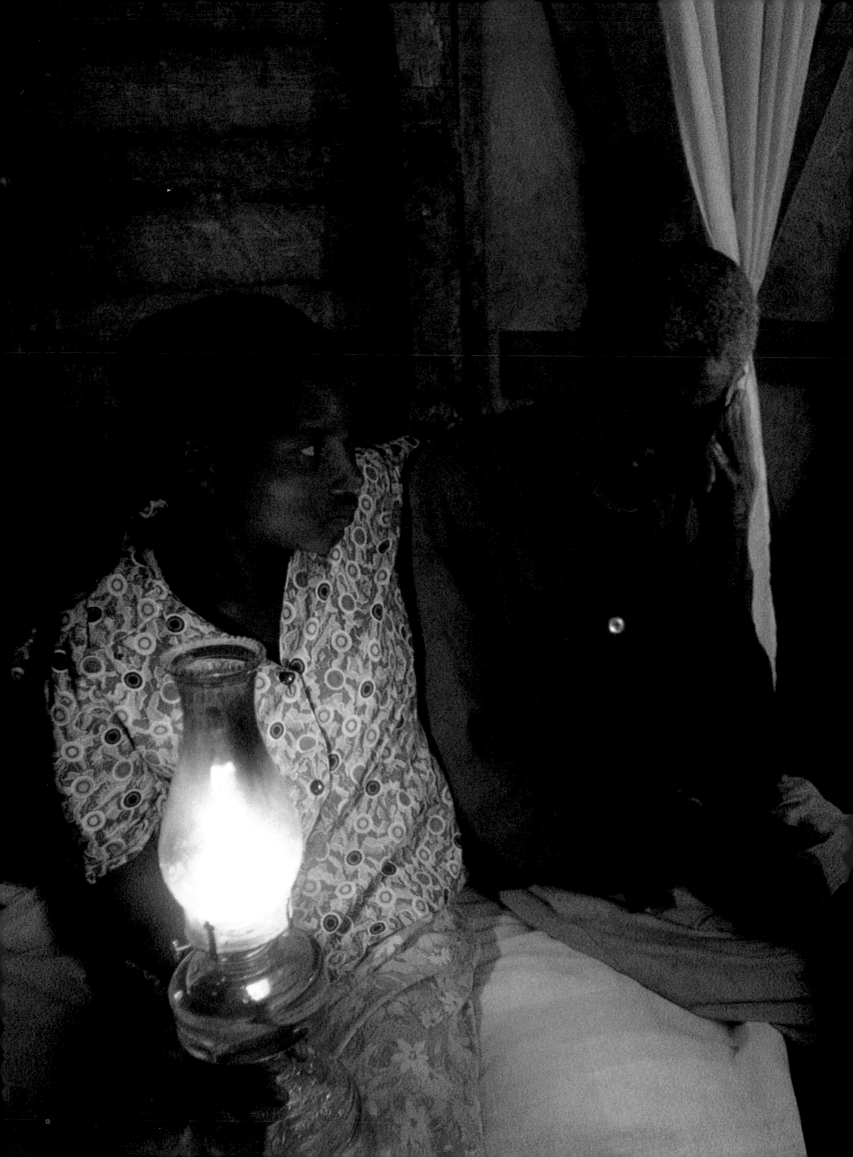

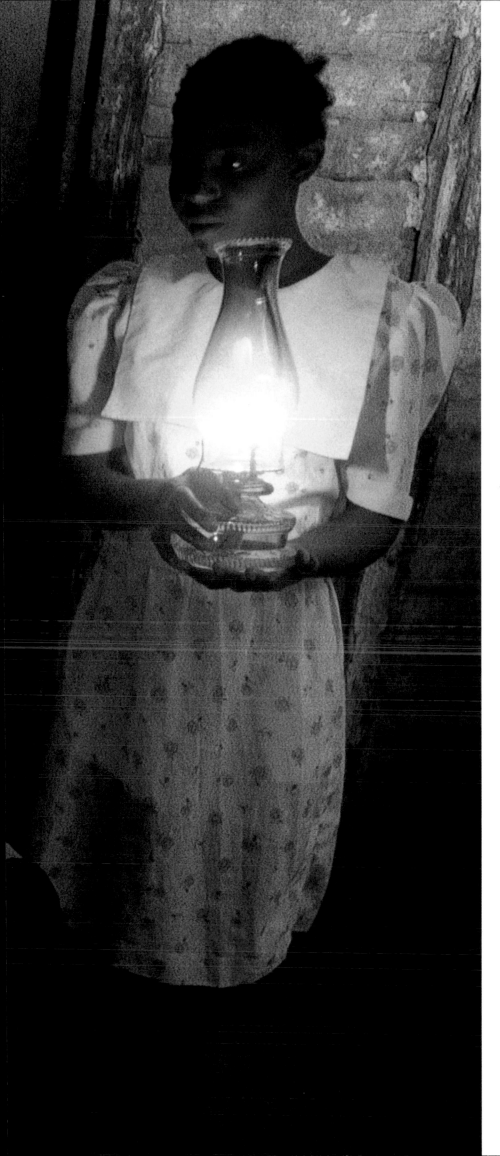

A dreadful day—one of Dentes's animals escaped, raising the possibility of a serious financial loss. Hours of frantic looking later, he finally found the stray. After tying it up, he collapses in exhaustion onto the bed, comforted by his niece Lucianne, 16, and his daughter Fifi, 15 (left, on right). Fifi is Mme. Delfoart's principal assistant around the home—a position that sometimes earns her sharp reprimands (below, weeping after a lecture from her mother).

Women in Haiti

Voodoo priestesses, traditional healers, midwives: Women fill some powerful roles in Haitian society—though men hold most political power. Women provide primary health care to much of the population, and deliver 80 percent of the babies.

Giving birth is a marker of adulthood for women, and new mothers are often waited on hand and foot for weeks. Having children is seen as so important that women with trouble conceiving are often said to have a folk illness unique to Haiti—a woman in *pedisyon* is believed to have an arrested pregnancy, or a fetus that has stopped growing inside her. The illness is considered cured when she has a child.

Haiti is incredibly poor. More than 40 percent of couples don't get legally married; they simply can't afford the wedding expenses. A scarcity of jobs has left many men unemployed, and since household duties are defined as women's province, women do the bulk of the work, including small-scale marketing of produce. Although low-wage manufacturing is dominated by women workers, Haitian law does give pregnant women the right to three-months of company-subsidized maternity leave.

Posing for a portrait in front of their home, a mischievous Mme. Delfoart suddenly leans over and kisses her surprised husband, then bursts into laughter.

Field Journal

I began my work by following the girls, who were going to the river to wash clothes. They sang beautiful songs from the church, except for Fifi, who never seems to talk. They pooled their money and sent someone to town to buy a snack of bread and peanut butter for them. Two fishermen passed by and then a man carrying bamboo poles on his head who sang out to the girls "You are my Sunshine"—in English—from the opposite bank.

At church a few days later, Mme. Delfoart told the small congregation that some family members were jealous of our visit. Then she went over to one cousin—a church leader—and said he was jealous because he saw us driving her to market in our rented jeep. He and another female cousin thought we were going to give the jeep to the Delfoarts. In the sweetest but firmest way, Mme. Delfoart said yes, the jeep was for them, but only while we were here. And at a certain point I stood up and told the congregation that we loved everyone there, and did not want to show favoritism. We wished we could spend time with all of the people. After some other speeches Mme. D's son, Soifette, stood up and

sang a wonderful song about how God loved all people, no matter their color or nationality. That seemed to be the perfect end to the trouble.

Later Mme. D. told us the congregation praised God that we had come. That's Haiti for you. The problem of jealousy is a profound one in a country where so many have so little. Any time one person gets ahead, it causes resentment and sometimes violence. It divides communities, distracting them from organizing together to achieve a better life for all.

— MAGGIE STEBER
FEBRUARY

Maggie: You lived with Mr. Delfoart for a long time before marrying him.
Mme. Delfoart: Yes. I didn't think that I would get married.
Why?
It is the man who decides to marry the woman. If a man does ask for her hand, she can accept. I wanted to be married, but as long as Dentes didn't ask to marry me, I couldn't get married, because a woman never asks a man to marry.
Is your life now with Mr. Delfoart what you expected at the time of your wedding?
I thought I would marry this man, and that we would love each other for life and die together. My life is in his hands.
Is your marriage happy?
Yes, I am happy. I love him very much.

Education

Among the world's 900-million illiterate people, women outnumber men two to one. Of the 21 women interviewed for this book, 15 are literate, but only 10 have more than a primary school education. When questioned, all said they wanted equal education for their sons and their daughters, but in practice, families from poorer nations, facing more pressing choices, often regard it as necessary to keep daughters at home to help with household chores and farm work.

ETHIOPIA

"*If my daughter is uneducated, she cannot decide what she wants to do. If she is not attending any school, I will insist she get married.*" —Zenebu Tulu. Her niece, Zelelem Abera, 12, who wants to become a doctor, answers a question in class. Zenebu's daughter, Like, 10, does not attend school because of the expense and because she is needed at home.

RUSSIA

"*I am really crazy on literacy. I think that all people should know their native languages well.*" —Zhanna Kapralova, reading a fairy tale to her daughter.

BHUTAN

"*In school I have a much easier life. I don't have to go in the fields or look after the cows.*" —Bangum, age 16, in her fifth grade class.

USA

"*I think I'll go all the way through to college. I'm not sure exactly what I want to study.*" —Julie Skeen, age 12, getting ready for an inter-school competition with her classmates.

MONGOLIA

"*I worry about what might happen to me before my children get a higher education. I am afraid of dying before they can be successful.*" —Lkhamsuren Oyuntsetseg. Her daughter, Khorloo, works on a math problem at the blackboard.

ETHIOPIA

RUSSIA

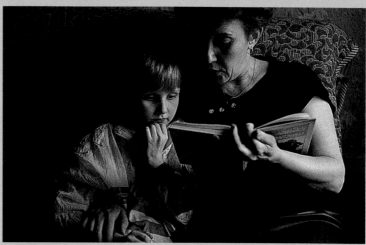

BHUTAN

UNITED STATES

MONGOLIA

Education

BRAZIL: Helping with the homework, Maria dos Anjos Ferreira and her housemate Risomar (both on left), supervise the older children as they cut out letters and paste them into their school workbooks; Maria's youngest child (in cast after surgery) watches this important business with the envy of all children who are still too young to attend school.

GUATEMALA: Following the directions of the teacher, first-year students Olivia Calabay Sicay (on left) and her deskmate cut plastic straws into pieces.

ITALY: Seizing the moment when her daughter is absorbed by her drawing, Daniela Pellegrini has a rare chance to practice one of her favorite activities—immersing herself in the printed word.

MALI: Pai Natomo (on left) works out math problems in her class.

ALBANIA: Ever the teacher, Hajdar Cakoni makes sure that his daughter, Artila, is progressing with her schoolwork.

MONGOLIA: Members of Lkhamsuren Oyuntsetseg's extended family read the newspaper together with the children.

ISRAEL: Raptly attentive, Noa Zaks listens to the bedtime story that her mother, Ronit, reads to her each and every night.

CUBA: Eulina Aluis Costa's children, Iris and Javier, linger with a group of children before school.

JAPAN: Oblivious to the baseball game that captivates her father, Maya Ukita puzzles over her homework at the family's living room table.

JORDAN: Trying to teach her lessons that will guide her life, Haifa Khaled Shobi reads the words of the Koran to her daughter Salam.

MEXICO: Even the Easter holiday must stop for homework as Carmen Balderas de Castillo helps two of her children, Cruz (on left) and Marco Antonio, with their lessons.

Adult Literacy
(%), female / male

Country	F / M	Country	F / M
Albania	**99 / 99**	**Italy**	**96 / 98**
Bhutan	25 / 51	Japan	99 / 99
Brazil	**80 / 83**	**Jordan**	**70 / 89**
China	62 / 84	Mali	24 / 41
Cuba	**93 / 95**	**Mexico**	**85 / 90**
Ethiopia	16 / 33	Mongolia	86 / 93
Guatemala	**47 / 63**	**Russian Fed.**	**98 / 100**
Haiti	47 / 59	South Africa	75 / 78
India	**34 / 62**	**Thailand**	**90 / 96**
Israel	89 / 95	United States	95 / 96

Table shows the percentage of people over the age of 15 who can, with understanding, both read and write a short, simple statement about their everyday life—a standard test of literacy. The actual definitions of adult literacy are not strictly comparable among countries. (1988-90 data)

Source: *World Resources, 1994-95*, World Resources Institute.

BRAZIL

GUATEMALA

ITALY

MALI

ALBANIA

JAPAN

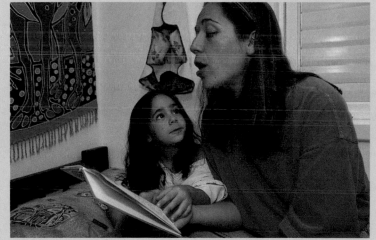

MONGOLIA

JORDAN

ISRAEL

CUBA

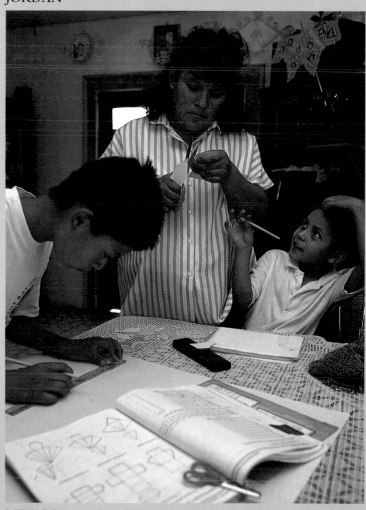

MEXICO

India
Mishri Yadav

"I do not want more children, but if God wishes, what can I do?"

MISHRI YADAV SPENDS MOST OF HER life within the walled courtyard of her family's home in Ahraura village, in the northeastern state of Uttar Pradesh. (Yadav, a caste name, refers to the caste's historic role as cowherds.) As do many Hindu women in this Muslim-influenced region, Mishri, 27, practices the Islamic custom of *purdah*—living in seclusion, away from prying eyes. When male visitors enter her home, she shields her face with her sari.

In her enclosed world, Mishri tends to the needs of her extended family— her husband, Bachau; their five children; and Bachau's father and cousin, who live with them. The work keeps her busy from sunup to sundown, except for a brief rest during the hottest part of the day when friends might visit to talk and decorate their hands and feet (*inset*). Her oldest daughter, Sunita ("Guddi"), 9, is her biggest help with the household chores. In the courtyard is a waterpump where Mishri bathes herself and the children, draws drinking and cooking water, and scrubs the family clothing. Bachau, 32, spends his time working his small field and making wooden toys for sale—a job he dislikes but needs to feed the family. The three oldest children go to school near their home. Classes are held outside because the school building is too small. Mishri, who never attended school, cannot read; living in a world without clocks or calendars, she doesn't know her own birthday or those of her children.

Photographs and Interviews by SARAH LEEN

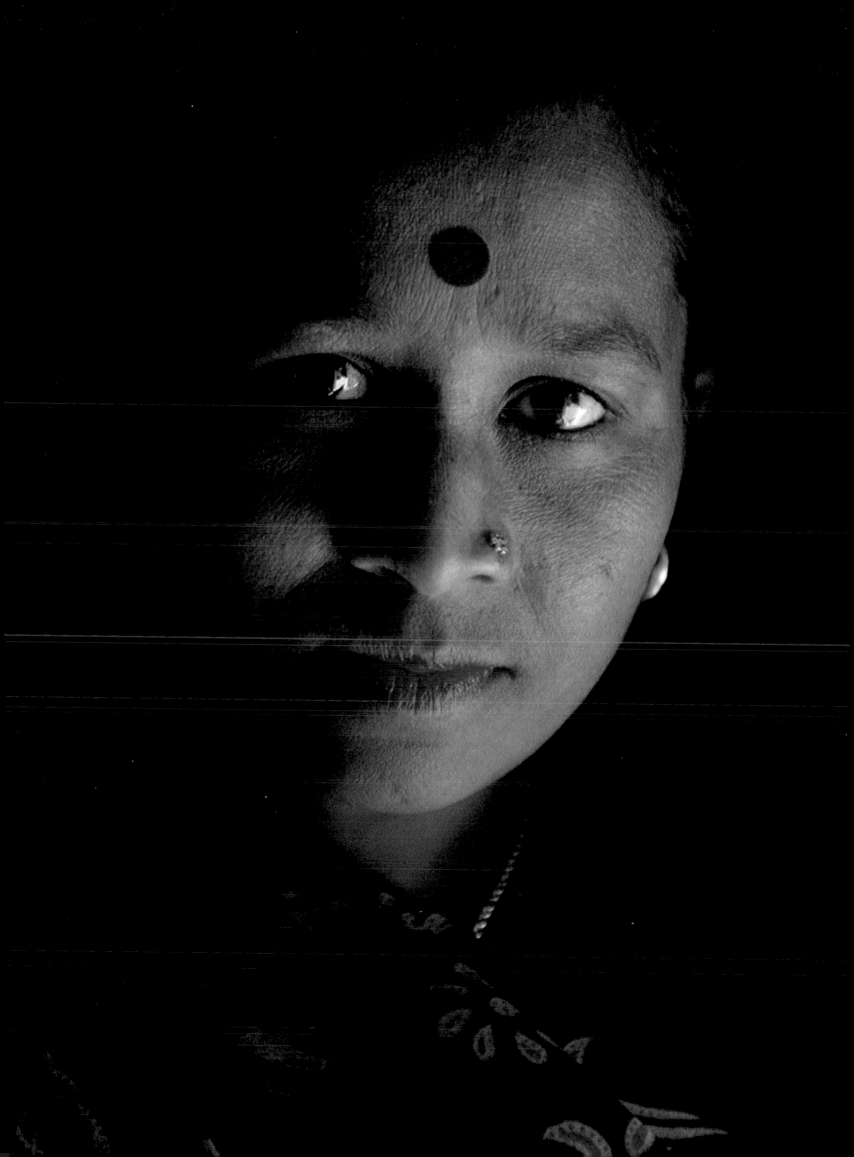

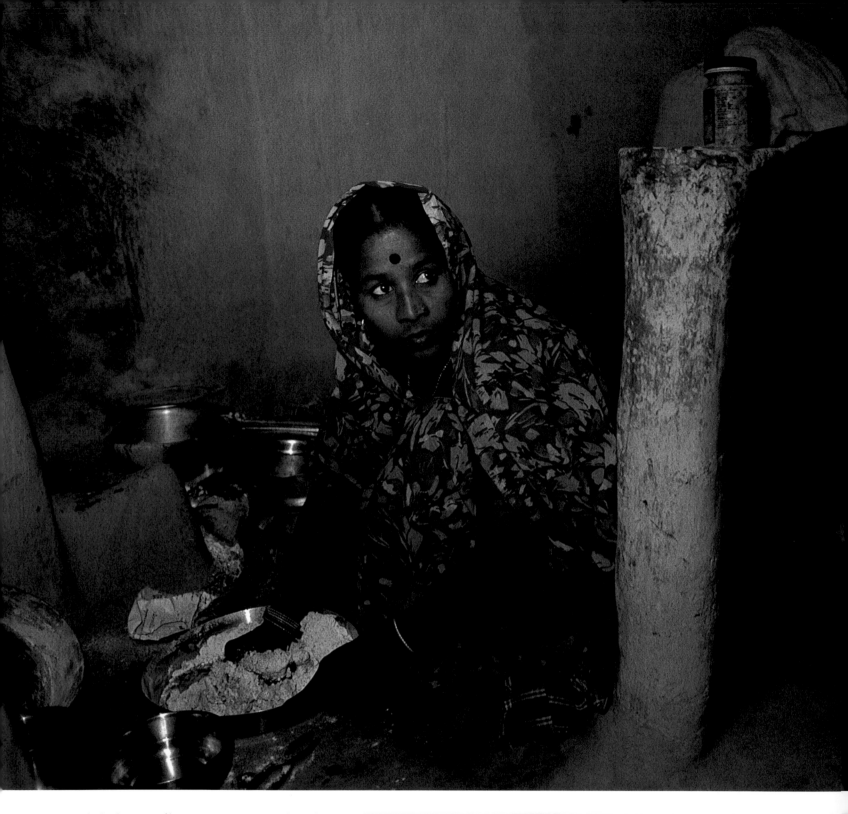

In the kitchen area of her home, Mishri kneads dough in a pan (above), her sindur—red powder put in the hair—gleaming in the dusky light of the small cooking space. Like a wedding band in western cultures, the sindur indicates her married status. A pot gently steams on the stove beside her. While her family's dinner cooks, Mishri will sweep the dust and debris from her hard-packed dung and mud floors.

Stooping over the tender new shoots of rice, Bachau weeds his fields (right). Although he spends much of the day making wooden toys to earn money for his family, he derives much more pleasure from working the land.

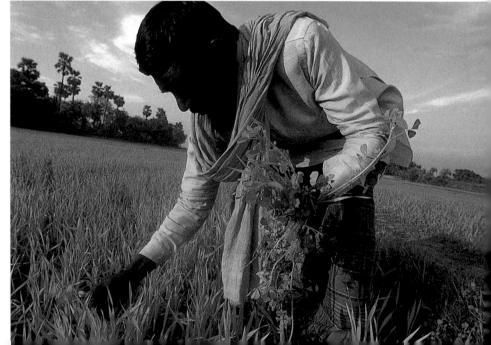

Conversation with Mishri Yadav

Note: Unlike most other women in this book, Mishri Yadav was interviewed in the presence of her husband, who attempted to answer questions for her.

Mishri Yadav: My father was a farmer, and my mother helped in the field and was a housewife. I had four sisters and four brothers. I was the eldest child.

Sarah Leen: Was your mother's life different from yours?

It is the same.

At what age were you betrothed?

Ten. My uncles found my husband for me.

Did you marry for love?

No.

Is there love in your relationship now?

Certainly. A lot of it.

You were betrothed at ten. When did you actually meet your husband?

I met him [five years later at the wedding] when I came to move in, to stay in his house.

What was your wedding like?

I put color on my hands—not henna but red dye. When the *pandit* [village priest] came, they called me outside. I was asked to sit in front of my husband. They said all the prayers and then my brother put rice in my hands and into the fire [Hindu custom that symbolizes life and prosperity—*Ed*]. There was eating—they fed all the men. And then my husband and I went and saw a nice movie.

Was there a dowry?

Yes. My father gave him 500 rupees [US $17 at current rate], a bicycle, a watch, and other things.

Did you ever consider not getting married?

No, I always wanted to get married. I like being married to my husband. It is a very good life.

What do you expect from each other?

I want my husband to earn money so that we can have a nice big house and everything inside the house. That would be nice.

Would you say you are of equal standing with your husband in your home?

My husband is higher.

Who makes the big decisions?

We both make decisions.

Would it be okay for your daughter, Guddi, to remain unmarried?

It won't happen. I want her to marry.

How old do you expect your daughter, Guddi, to be when she marries?

I want her to be ten years old.

Is it an option for her not to have children?

I want my daughter to have children.

What if she were unable to?

It is understood as a bad thing. The women who are unable to give birth are considered—we call it *banjh* [barren]. She would be considered bad for the village and maybe would be expelled.

Will your children live with you when they are grown?

If my sons live other places, then we will be alone. If not, we will be together. My daughters will have gone to live with their in-laws by that time.

Family and Nation

India

Population:
930.6 million

Population Density:
733.0 per sq. mile

Urban/Rural: 26/74

Rank of Affluence among UN Members:
157 out of 185

Mishri Yadav

Age: 27

Age at Marriage: 10
(began living with Bachau at age 15)

Distance living from birthplace: 20 km

Children: 6 (but first baby died)

Number of children desired: "I do not want more children, but if God wishes, what can I do?"

Contraception used:
None. Would use if available

Occupation:
Homemaker

Religion: Hinduism

Education: None

Literate: No. Bachau is literate

Favorite task: Combing hair

Least favorite task:
Going to the market

Food source:
Marketplace and family's field

Number of saris Mishri owns: 2

Electricity: Yes, but not used often

Cost of electricity per month:
30 rupees [US $1]

Biggest life event:
Having her children

What Bachau says is Mishri's proudest accomplishment:
"She has had kids, and she has the strength to fight with me."

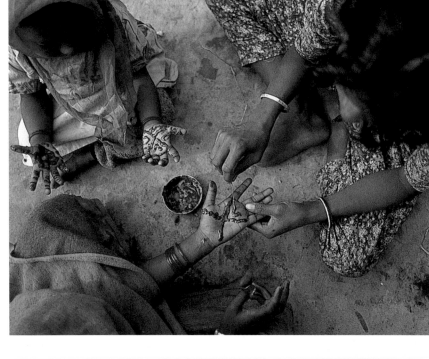

Friends of Mishri and her 9-year-old daughter, Sunita (Guddi), crowd the Yadav family courtyard (bottom) as they talk and adorn their hands and feet with nail polish and dye— a common communal activity for women. As Mishri (bottom, at center right, in red sari) colors her toes, Guddi combs the hair of her 3-year-old sister, Arti. The gathering is entirely female; should a man appear, the women will veil their faces. At a similar session on another day, Guddi (top) has her hand adorned with henna—a dye made from the crushed leaves and branches of the henna shrub, which leaves a long-lasting orangey-red stain. Meanwhile, Arti patiently waits for her hands to dry. In a traditional practice, Mishri massages the skin of 6-month-old Guddu (right, middle) with coconut oil every day. The massage, she believes, is good for his health.

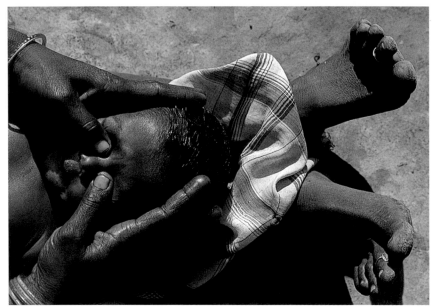

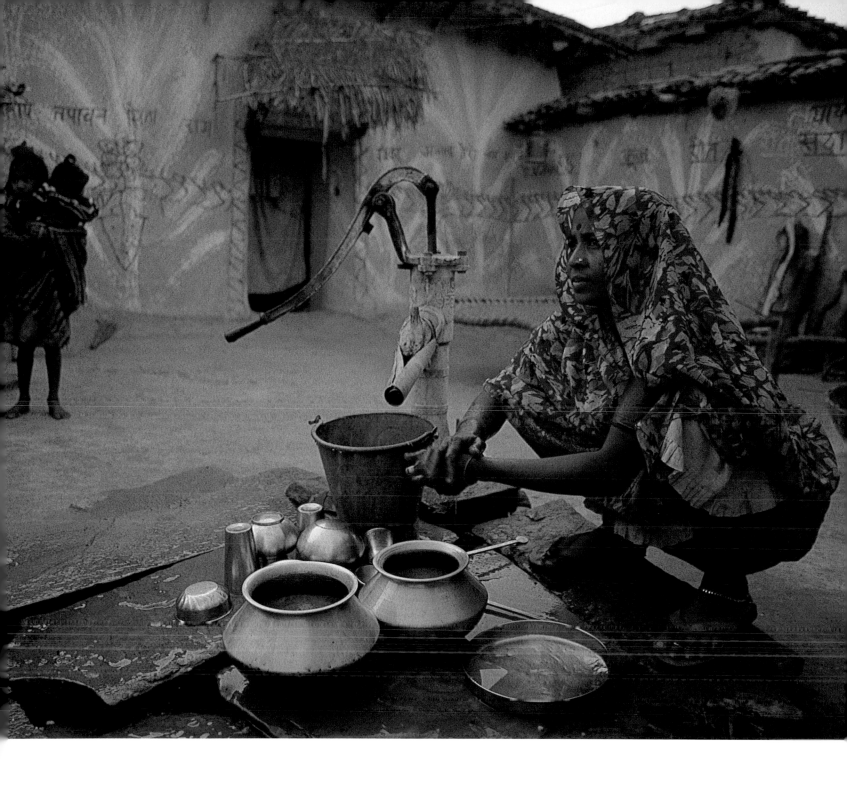

Sarah: Mishri, how do you spend your day?
Mishri: I do all the housework. I massage the baby, clean the dishes and the house, and put everything in order, and I cook.

What takes up most of your time?
Making food.

What takes the least time?
Sweeping the house.

Do you have a favorite activity?
Combing my hair.

How do you and your husband spend time together?
If we get the chance, we sit and talk together. We don't have much time to do this.

What about the family as a whole? How much time do you all spend together?

About two hours a day. My husband goes out to work, and that takes time.

Do you have much time to yourself?
About two hours a day between 11 a.m. and 1 p.m. This time is for sleeping, for going out [to visit friends], and for putting color on my hands.

Is there anything you like to do that you wish you could do more often?
We could go to watch a movie.

Is there anything that you would like to do that you don't do now?
I would like to sleep more.

Are you satisfied with your life?
I feel happy if the farming goes well.

As Mishri washes her hands after cleaning the pots and dishes at the waterpump in the courtyard (above), Bachau sits with the children. Guddi, 9, is most responsible—after her mother—for her younger siblings and holds her youngest brother, Guddu. Most family activities take place in the courtyard, because the house, which Mishri and her husband, Bachau, built themselves, is windowless and often hot.

Women in India

In a country once led by Indira Gandhi, the first woman head of state in modern Asian history, the majority of women still marry early, bear many children, and obtain little, if any schooling. The few who become doctors or engineers are mostly urban and upper-caste. Most of India's 450 million women live in the countryside, where they rarely own land and have little economic power.

Women face intense pressure to bear sons, and daughters are sometimes neglected. Some experts say this explains India's skewed sex ratio: Just 94 women for every 100 men. But Indian culture focuses more on families than individuals, so women's role as mothers gives them status. Women of high caste are often secluded in their homes, while lower-caste women may be servants or field-workers—and surprisingly, have more freedom of movement.

Access to education is increasing for both men and women, and as men gain more education they often demand educated wives—an incentive for parents to send their daughters to school. One negative result is the new phenomenon of "dowry deaths"—murders of brides when the husband's kin don't receive the high payments they've demanded.

Thousands of women helped push for Indian independence starting in the 1920s, and in recent years, scores of women's groups have sprung up, working to protect the environment, increase women's access to credit, and prevent violence against women. Despite some small-scale changes, many Indian women live much like their grandmothers did.

Sarah: Do you own your house?

Mishri: Yes, we own it. We bought the land to build the house. My husband carried the soil on his shoulders and I smoothed the walls with my hands.

What are your monthly household expenses for food, clothing, and household goods now?

How am I supposed to know? I have never been to school.

Do you know what you pay for fuel?

It is 30 rupees [US $1] a month for electricity. We buy firewood, but I don't know how much it costs. The dung [for fuel] I have to buy, too.

Do you have any money to spend on yourself personally?

About 25 rupees [US $0.85] a month.

What do you spend it on?

Bindis [small round red marks traditionally used to indicate that a woman is married] and *sindur*. But most of the money goes into buying coconut oil, which is 20 or 30 rupees [US $0.65-$1] for 230 grams [8 oz.]. [The family uses the oil on their skin.—*Ed*]

Is there anything you would like to own that would make your life better?

It would be good if there was a television.

Would you like more children?

I don't want more children, but if God wishes, what can I do?

Did you see a doctor when you were pregnant?

I went to a doctor about my [last] pregnancy when it was two or three months before the baby was due. But I had all of my children at home, not in the hospital. The village midwife helps me. In the room there's me, my mother, and a woman to cut the umbilical cord. There are also village women in the house. My husband takes a walk outside.

Where were the other children when your youngest, Guddu, was born?

My other children stayed at my mother's house. The barber's wife [came and] put oil on the baby's head and on me. And the next-door neighbors made food and tea and gave it to all of the friends who came over.

Do you have women friends?

Only women friends—Taka and Urmilla. We talk about our children, about the market. We talk about where to find fodder and firewood and how to do things in the house. We meet every day. We sit in my courtyard or at the door.

I go to their house or they come to my house. We sit together and sew, clean rice, and make hand fans.

Are your friends important to you?

They are important. They make me feel good.

Bachau, what would you like your children to become when they grow older?

Bachau Yadav (husband): I have three sons. I want one son to become a doctor, one to go into the army, and the third son should stay at home and take care of the house. I want one daughter to become a nurse, and the other one should be a good housewife. I want all my children to be educated, to study; and also, the girls have to learn how to maintain the house. They should learn how to cook and clean utensils and all that.

Whose responsibility is it to take care of your children?

Bachau: My wife's, but in the morning and evening when my wife is cooking food, I take care of the children.

Do you share any household duties with her?

Bachau: Once in a while I cook if she needs that help. If she's not well, I massage her head.

What is the role of women? What kind of things should they do?

Bachau: Women should work in the field. They should take care of the house, they should take care of the kids, and they should take care of their husbands.

What is the role of men?

Bachau: I'm the guardian of the house.

What was the last major decision you made?

Bachau: The decisions I have made in my life were to get married, to make a house with my own hands, and to buy land. What my wife [wanted to do] has not yet been done. What she wants is to learn how to have a well-run household.

Who makes the decisions about how money is spent?

Bachau: I do.

Do people in your village give equal standing to you and your wife?

Bachau: In the village, men have higher standing.

How about at home? Is your wife of equal standing with you there?

Bachau: At home I give her equal standing, because who is there to see?

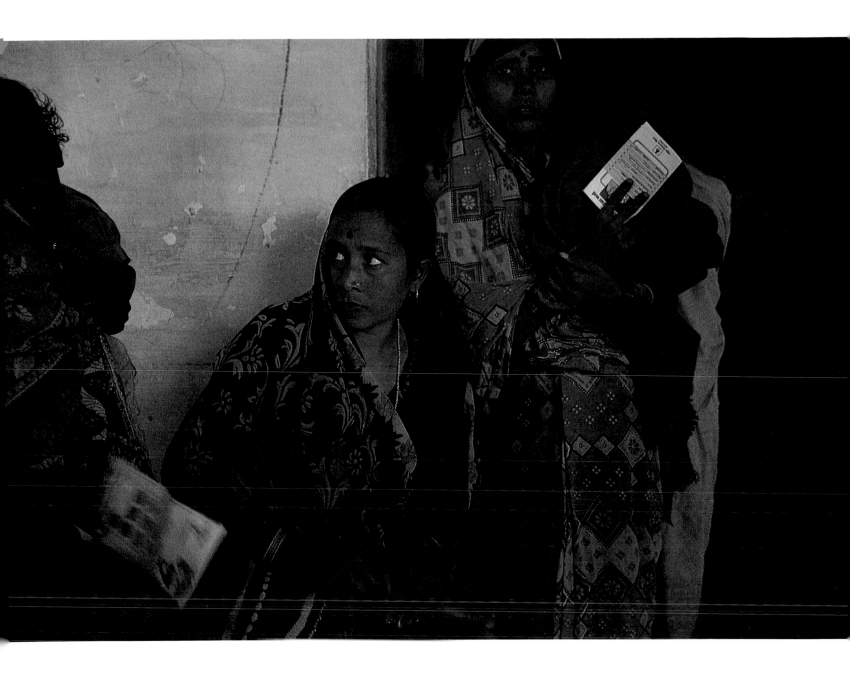

Field Journal

Every morning begins with—mist? dung-fire haze? whatever it is—hanging soft and chill in the air. It's quiet; the din and bustle, the press of people and vehicles and animals has not yet begun. A wonderful time of day, a needed break from being so nose-to-nose with life in India.

Mishri lives in a world bounded by the walls of the courtyard behind her house. Almost every activity takes place in this secluded outdoor space. When she ventures outside, she uses the gate set into the courtyard wall—I never saw her use the front door. To keep her public exposure to a minimum, Bachau sweeps the packed ground in front of the house. For her part, she won't speak Bachau's name, at least to me. When I asked her how to pronounce it, she got a neighbor in a bright yellow sari to say it for her.

I was struck by Guddi's ability to carry so much responsibility with so little protest. At 9—almost the age when her mother married her father—Guddi takes care of her baby brother, cooks and washes the dishes—completely her mother's right hand. There is not a spoiled bone in her body. I'd make any kind of fool of myself to win one of her smiles.

Both Mishri and Bachau have moments of vanity. When I take Bachau's portrait, he borrows Western-style clothes from neighbors, dons my sunglasses, and proudly shows himself to the camera in some self-inspired version of mod and macho, successful and sleek. Mishri loves her two delicate, airy saris, one of which she washes every day, changing and bathing in full view of the strangers who have invaded the courtyard. After I tell the family I would like to get them something as thanks for their hospitality, Mishri gets me alone and indicates what would please her. To my surprise, it's jewelry, make-up, a new sari, dye for her feet. Not something to make her life better, but beauty products and new clothes. After all, I reflect, she is only 27.

— SARAH LEEN
FEBRUARY

Her face partially concealed by her sari, Mishri (above) makes one of her relatively infrequent trips outside the home to take Guddu for his shots at the well-baby clinic. Like many Indian women, Mishri is Hindu but has adopted the Islamic custom of purdah, *in which women keep themselves apart from male gazes and male company. As she waits in line for the inoculations, the baby restlessly squirms in her lap, noisily tunneling into her clothing in the kind of exasperating behavior familiar to mothers everywhere.*

Israel
Ronit Zaks

"My marriage is a small fire which is always burning."

RONIT ZAKS SAYS SHE WOULD GIVE anything to have five minutes in the bathroom without one of her two children yelling, "Mom!" She's only half joking. Her husband Dany, 34, works long hours as the manager of a restaurant near their apartment on the outskirts of Tel Aviv, leaving Ronit with the bulk of the childcare and—equally dismaying to her—depriving the family of his presence. Although they don't consider themselves deeply religious, the Zaks adhere to the basic tenets of Judaism. But without Dany, the Sabbath meal is lonely unless Ronit and the children, Yariv, 6, and Noa, 3, eat at her parents' house or invite Dany's father to dinner.

One of five brothers and sisters from a bookish Moroccan family, Ronit, 31, types reports in her home for a private investigation firm. Now that Yariv is in school and Noa attends daycare, Ronit would like to have a full-time job outside her home. She would also like to be free to navigate around the city on her own. The only thing holding her back, she says, is the lack of a driver's license. She passed the written test but has failed the driving test seven times in eight years. "I feel bad," she says of the situation. "I'm in the 20th century with no driving license."

Photographs by LORI GRINKER Interviews by FAITH D'ALUISIO

Moments after a heated discussion about the long hours Ronit's husband, Dany, puts in at his job, the couple kiss and make up. "I don't like being alone every night when Dany's gone to work, but it's his job," Ronit says. "Managing a restaurant is night work and I knew it when I married him."

Conversation with Ronit Zaks

Faith D'Aluisio: Did you mind serving in the Army?

Ronit Zaks: You know in Israel they say, "When the girls are young, they play with dolls and the boys play with soldiers. When they grow up, the boys play with dolls and the girls play with soldiers." [Laughs] It's a good lesson in life, to be in the army. Even if you are just a secretary for two years for the same commander, it's a good lesson. You learn at the age of 18 to sleep without your mom. To sleep far away, to learn about your country, to do things that in many other countries nobody does at 18. For eight months I wore a bulletproof vest and had an M-16 rifle. I finished high school and after only four days, I went into the middle of the Lebanon War! They put the vest on you and you learn how to shoot and suddenly in the middle of the night, they jump at us and say, "Come on, make sandwiches for the soldiers that are going to Lebanon." We call it war... food.

I think you mean rations.

And after two months, they sent me to Tel Hashomer [a hospital in Tel Aviv], where I was a clerk for three months. My job was bad because every morning I had to write the names of the soldiers that died. Every morning, I got the black list and wrote. It was hard—I, personally, was in 11 funerals. I think that's a lot. And after that they told me, "Look, we need women to go to Lebanon." So I learned how to be a policewoman. I went to Lebanon to the big [refugee] camp. And I saw the terrible things that were happening there between the people that were in the camp. I really don't

know if I'm allowed to talk about it.

All right. So what did you do after the war?
I got married after a year and a half.

How did you and Dany meet?
It was a blind date. We went out together for a year. I didn't want to bring him home because my parents would say, "Why don't you marry?" So I told them I had no boyfriend. "I'm going out with my girlfriends," I said. When he came to my parents and told my father that he wanted to marry me, my father said, "She is my diamond, what do you have to offer her?" Dany said, "It's none of your fucking business." My father was so angry! "What?" he said. "Get out of here!" I was in shock! But my mother said, "That's good. That's the answer your father needs [to hear]."

You're kidding!
My father didn't want me to marry Dany but afterward he was convinced it was okay—a good *shiduch* [Yiddish for a "good match"—*Ed*].

What does Dany expect from you?
Dany never expects anything from me. He accepts me as I am. I told you what he wants me to be—a career woman. I will never be like that, but this is his ideal woman. But he will never ask me, "What did you cook today?" or "Why isn't my shirt ready?" or "Why isn't the house clean." Never! I wish he would ask me sometimes but he isn't like that.

Why do you wish that he would ask you?
It's very complicated. You touch on a very sensitive nerve. I think in marriage, two people are supposed to be together. You should talk about things together, do things together, even gossip together, but we never do things together. Never. He's in his own world. I'm over here talking, telling things, and I'm more open than he is and he is not like that, not at all. And I cannot change him because he's like that.

I think that's true in most relationships.
We are totally different people. Totally different, like two...what's the word?

Parallel lines?
Yes, nothing is the same. We don't like the same music or the same books, not the same friends, not the same political issues, not the same education for the children. Not even the same furniture in the house. Nothing is between us except for the children.

So how do you stay married?
Sometimes, when two people meet and they are very different, it is good. I can say my marriage is a small fire which is always burning

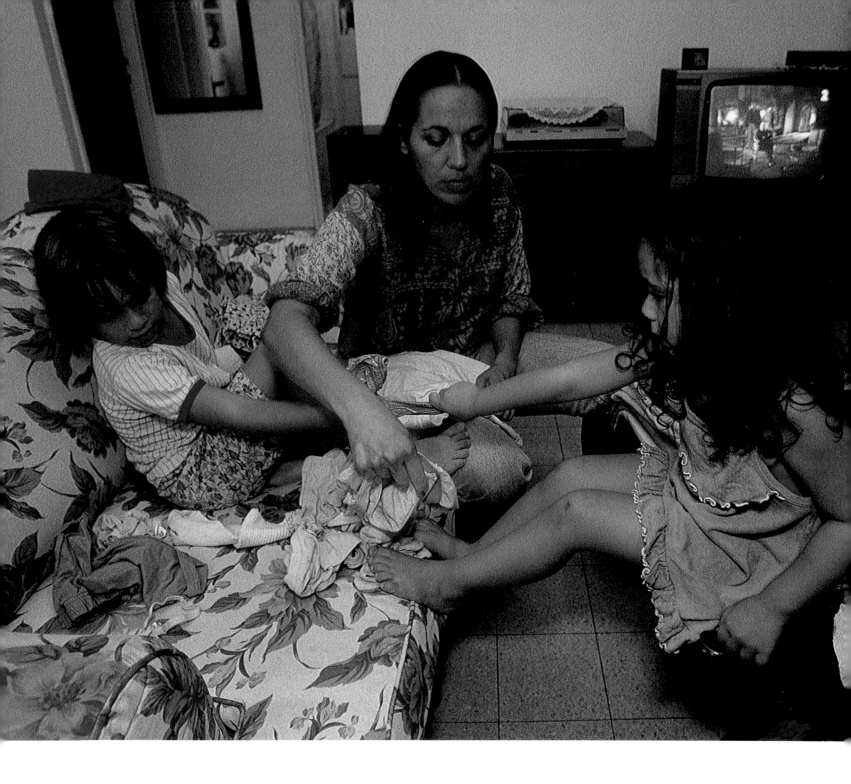

Three-year-old Noa squalls with rage (right, top) because she cannot use her favorite plastic cup, which was being used by one of the friends of her brother, Yariv, 6. After letting the ear-splitting shrieks wind down into whimpers, Ronit gives her daughter a soothing cuddle and kiss (right, bottom). Later that night the 10-minute task of folding the laundry (above) turns into a hour-long marathon after the freshly bathed children volunteer to "help."

Faith: What was growing up in your familiy like?

Ronit: Everybody reads. My father would give us books and say, "Read, read, read." I grew up in a house full of books. French books, Israeli books. We grew up—seven people in one and a half rooms. No furniture, but full of books.

Do your children like books?

My children love when I read them stories. All the time, they say, "Read a story, tell me a story."

Do you?

I don't like to read [the children] stories. I cannot stand it, I really don't know why. And when Noa was born, at first I was thinking, "Now I have to read two stories every night." I don't like it, but I am doing it for them. I really would like them to love reading [as much as I do]. My mother read me a story every day, why shouldn't I do it for them?

Did you always think you'd have kids?

Yes, I wanted children from wall to wall, but now we consider it not possible.

How were your parents able to raise five children and you don't feel like you can have more than two or three?

Because my mother didn't work, and they were living in a small house. There were no televisions and no gifts. I had one doll. I loved her so much. Her name was Rebecca and I had her from when I was 2 until I was 10. And now Noa has so much [more than that]. It's very difficult to raise children today because they

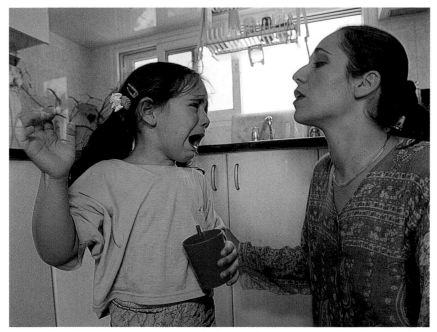

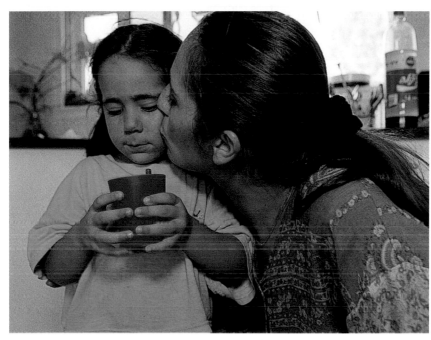

Because Jewish women in Israel must serve in the army alongside men, foreigners often assume they live in an egalitarian society. In fact, the military is a major roadblock to equality. Seventy percent of female soldiers are shunted into traditional women's roles, and since the military serves as an important training ground for many professions, women have fewer job options in the civilian labor market and a tougher time joining the ranks of political and economic elites. It's no surprise, then, that just 10 percent of Israel's legislators are women. And Israeli women dealing with divorce or marriage must wrestle with Orthodox Jewish rabbinical courts which govern such personal matters and often defer to men's wishes.

Religion, which has a powerful effect on women's lives, separates Israel's population into two major groups: Jews, and mostly Muslim Arabs, who make up nearly one-fifth of the population. Arab women live in a largely sex-segregated world that requires them to dress "modestly" and stay home to care for their families. Like other Israeli women, they also experience domestic violence: One women's group reports 200,000 victims per year.

Still, both Israeli and Palestinian women have defied traditional expectations, organizing grassroots development groups and forming alliances to protest the Israeli occupation and its accompanying violence. Change is slow, but women's public activism is helping to redefine traditional gender roles.

want things like judo classes and this costs money. Everything costs money. The children want to see a film—I have to take them. It's a lot of money for all of us to go. My parents took us to the sea and the zoo, where it didn't cost money. It was great. It's not the same now. Children today are sucking the money out of you, more and more.

But you would like to have more children?
Yes, one more. Even [though] it's a very bad world, another one.

How much time does your whole family have to spend together?
With Dany? Very little. He goes to work at 4 p.m., and he comes home at 2 or 3 a.m., and then he sleeps until 11 a.m. or noon, because he needs that. After that I'm waking him up to do shopping or look after the children while I am working or to be with Yariv for a bit, but it's not happening a lot. Dany's got to go out because he has the car and the [driver's] license.

Is it hard to work at home with the kids?
Yeah, I never work at home when my kids are at home. I don't want to do it—not to them, not to myself, and not to Dany. Because if everyone is here and I am working, it's the worst time of day for the Zaks family. I try to finish fast or just turn off the computer. I don't do it because Dany becomes nervous and the children are yelling and I cannot work. If I can't stop, I pay the babysitter to take them out.

"I wake up in the morning at 7 a.m. and wake the children," Ronit says. "I give them breakfast, help them brush their teeth, make something for them to eat at school. Then I dress them and take them to school. Sometimes Yariv takes Noa to daycare himself—he has only just started this. Coming home, I read the paper until 9 a.m., make my coffee, and then sit to work at my computer." (above) Sometimes the routine is varied by a driving lesson (right). "At 1 p.m.," she says, "I get up and make lunch. After that, the children come from school and daycare and we eat. Sometimes I have work to do so I finish it. I might call the babysitter to watch them while I work. At 4 p.m., we go downstairs to the grass." When they return, Noa races to the television (far right) to exercise with the trim host of a popular Israeli exercise show. "By 8 p.m.," Ronit says, "the children are washed, eating dinner, and going to sleep."

Faith: Is anything missing in your life?

Ronit: I know that it may sound very simple, but I know that if I have a license to drive everything will be different. To be independent, in my married life—in my life—I need a driver's license. It's my first thing to reach for. It would make me more independent. It would relieve 50 percent of the pressure from me and Dany. He really wants me to have the driving license because I'm driving him crazy. I passed the written test but I can't pass the driving test. I had to take the lessons again. Again I failed. Then again and again. After two years I had to take the written test again. It has been eight years now. I cry a lot because of every failure I have had. It's hard to say, "I failed again."

Dany, do you know what makes Ronit happy?

Dany Zaks (husband): Of course.

What?

Dany: A little romance, a little vacation. A little listening. That's what makes her happy.

Ronit says your job as a restaurant manager takes you away from the family a lot.

Dany: Of course it takes me away. If I could do it just eight hours a day, from 7 a.m. until 3 or 4 p.m., that would be wonderful. But sometimes you have to put yourself first.

What do you mean?

Dany: Before, I was a chef; I enjoyed it, but it was very dirty, tough work. You work with an oven in front of you and you sweat, and you sweat, and you sweat. So this job is a better job

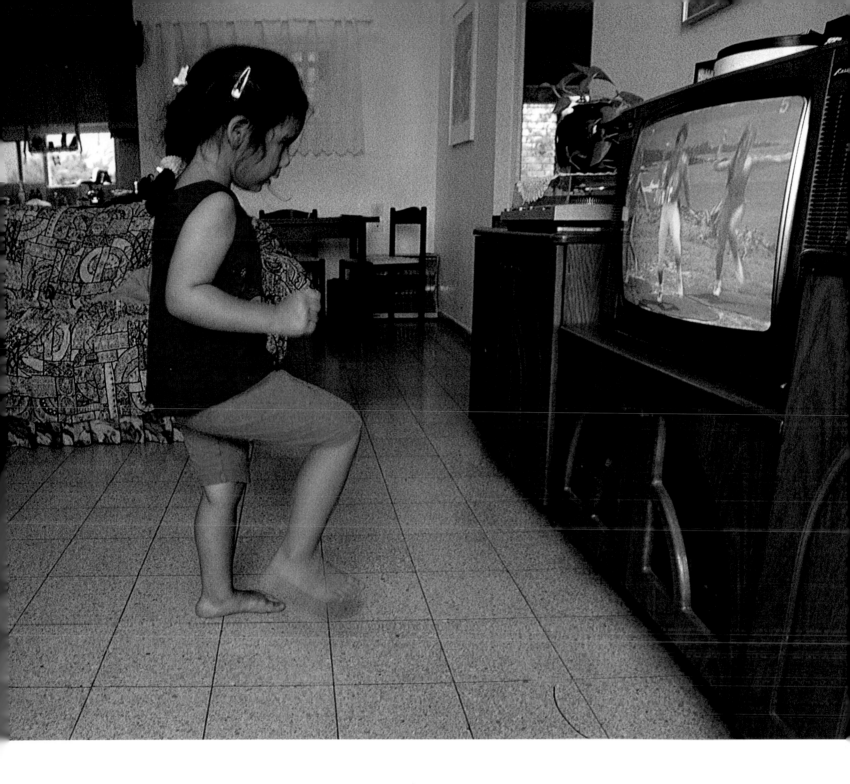

for me, but not for the family. But it's better money, and that's what is good for us now.

It's sort of an important trade-off.

Dany: Of course.

Ronit told me that after eight years of working at home, she would like to work outside the house. How do you feel about this?

Dany: Well, she had full support from me, starting maybe two or three years ago, to look for a job outside. It will open her mind, because she has become very closed off.

She thinks that the key to her independence is a driver's license.

Dany: Um, I don't think so. Because if you ever want something, you will do it. This is a reason why I'm not understanding why she doesn't get

it. There's a psychology book called Cinderella something, have you ever heard about it?

The *Cinderella Complex*, the one about women's hidden fears of independence?

Dany: Yeah, correct! She always comes back and finds a reason "why I don't do this" and "why I don't do that" and "because of my husband" and "because of this" and "because of that." Bullshit. If she wants it badly, she will get it.

Well, can you help Ronit with this?

Dany: I talk with her about it, but I'm a little aggressive, I think. I mean, I push people, but not with soft words. I don't push her slowly, slowly. I'm a difficult person.

Do you think it's because you're a man?

Dany: No. It's because that's my character.

FOLLOWING PAGES

The Zaks' favorite family outing is a day trip to the Mediterranean coast, a 20-minute drive from their apartment in Tel Aviv. "In the summer I'm always going to the sea with the children," Ronit says. "We have fun." So much fun, in fact, that the prospect of losing these pleasurable afternoons on the beach is one of the reasons she has not been looking for a job outside the home.

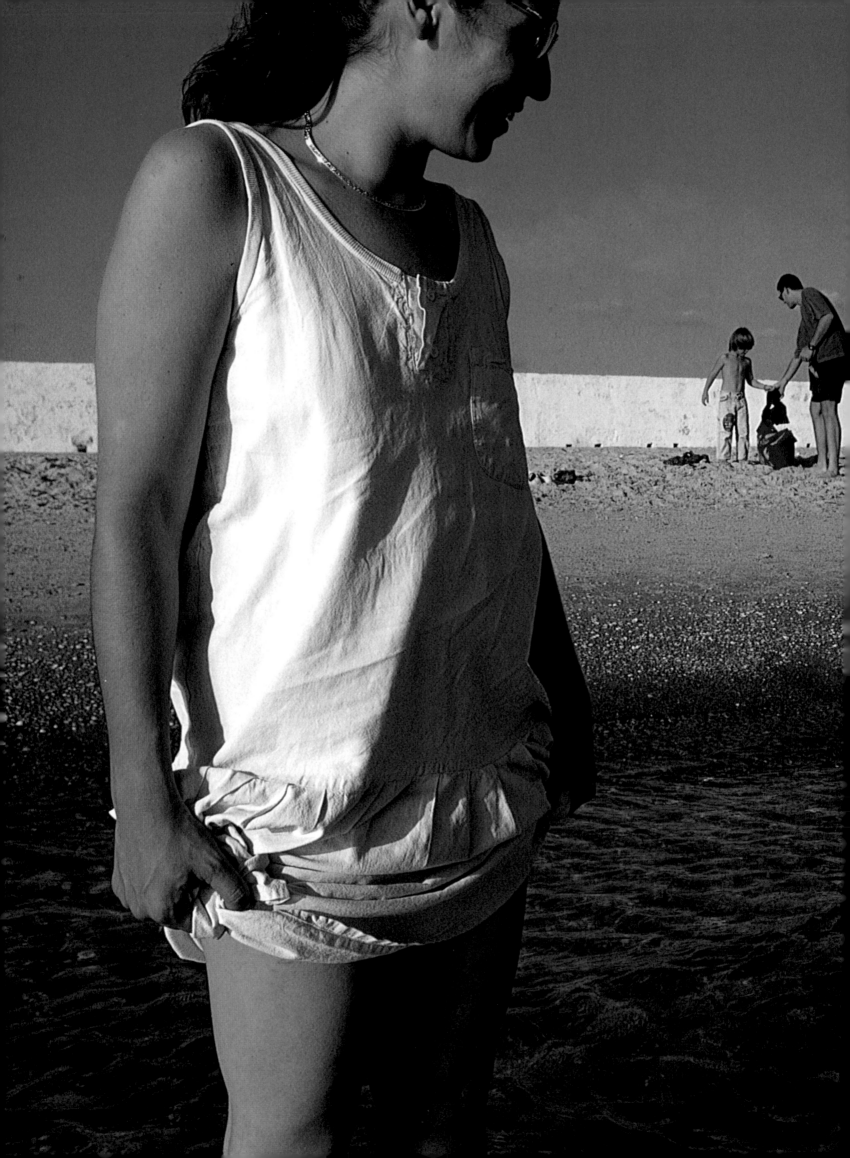

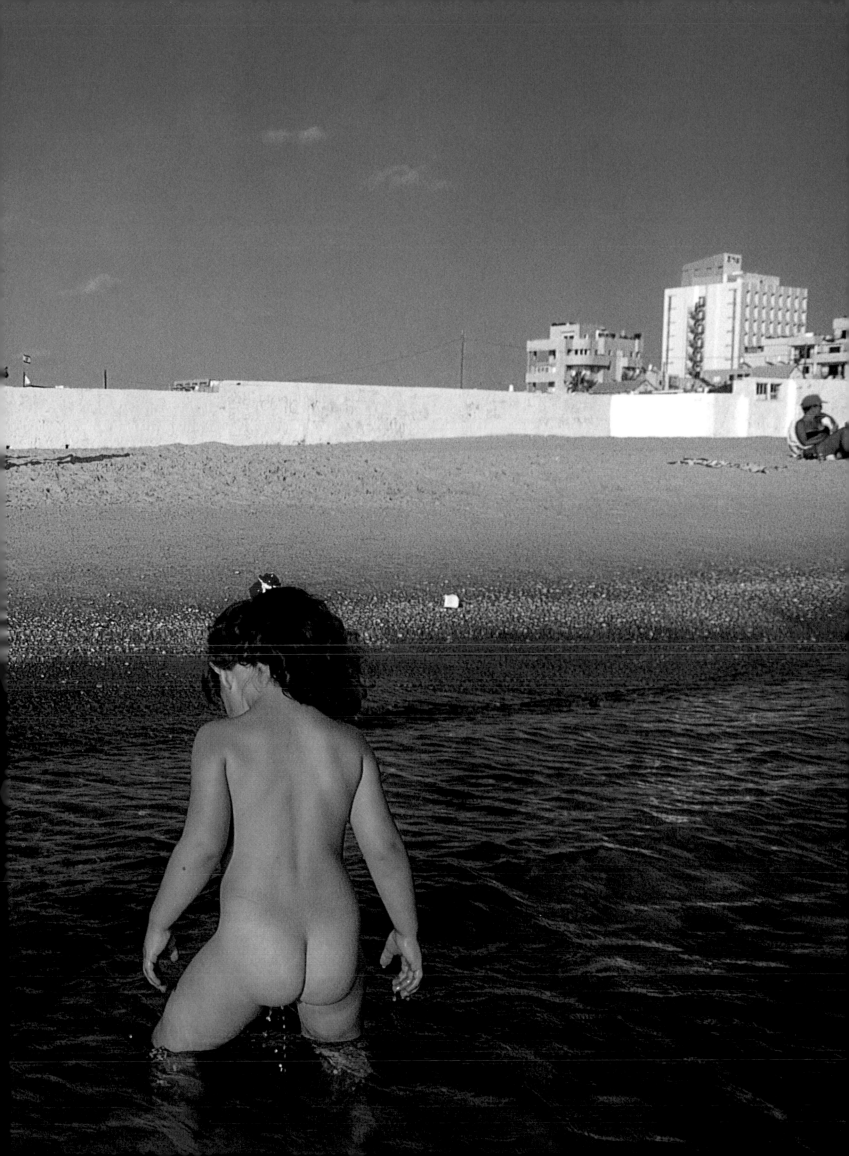

Field Journal

Ronit says she is torn about her life, but it seems being a mother is one of her true callings. Warm, attentive, good-humored, fairly patient—she's awfully good at it. But her dream is to work outside the home, which, for her, conflicts terribly with her love of raising the children. It's a difficult choice, so she has allowed herself to avoid it by spending endless time working toward getting her driver's license.

Obtaining the license is one of the little things that has to happen before the big thing—a job outside the home—can happen, but the big thing is too terrible to deal with, so she is stalled on the little thing. At the same time, she and Dany—who love each other deeply—are so different that it is hard for him to help her resolve this dilemma. Dany is a realist, a street-savvy guy, whereas she's a romantic, a dreamer. There's an inevitable conflict. For him, it's easy; he wants something, he goes out and gets it. So why won't she, he wonders. He admits it's easier for him to just go out and get what he wants, because Ronit—the infrastructure of the family—is at home making sure that it functions. They are the kind of people who readily express their feelings—they argue a lot but it seems good for them. And in a family whose members spend so much time trying to explain their desires, we came to believe that they are bound to work out Ronit's quandary.

— FAITH D'ALUISIO AND
LORI GRINKER
SEPTEMBER

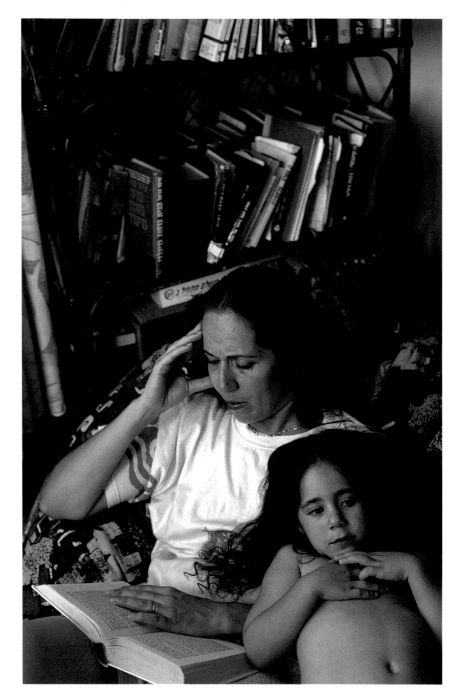

Faith: How important is religion to you?
Ronit: I'm not from a very religious family. I come from an ordinary family. We make first the *brit mila* [circumcision performed on 8-day-old boys], the *bar mitzvah*, we have religious weddings, and we have the *kiddush* on Fridays. The *kiddush* is when my father raises the wine and blesses the drink. Now after many years, my father is going to the synagogue. He and my mother are becoming a little bit more religious because my brother is very religious.

Would you ever convert to a different religion?
No, I never thought about it. I am Jewish, it's the best. It's the first religion in the world. I think that we are God's chosen religion.

Do you think that religions should be able to peacefully coexist?
First, I think that it's good that every person has something to believe in. This is very important. If you have nothing to believe, you are nothing. As a Jewish person, I know that my people suffered for 2,000 years, and I know that they will keep on suffering, but I don't think that it's a reason to make war. Why should we have war? I think we should live together side-by-side, but actually doing it has caused a lot of problems. You cannot ignore it. Muslims and Jews lived together with harmony and peacefully for 100 years in Jaffa, for example. Suddenly, a Jewish girl falls in love with a Muslim boy and, wow, there is a fight and killing between the families. I wish people could

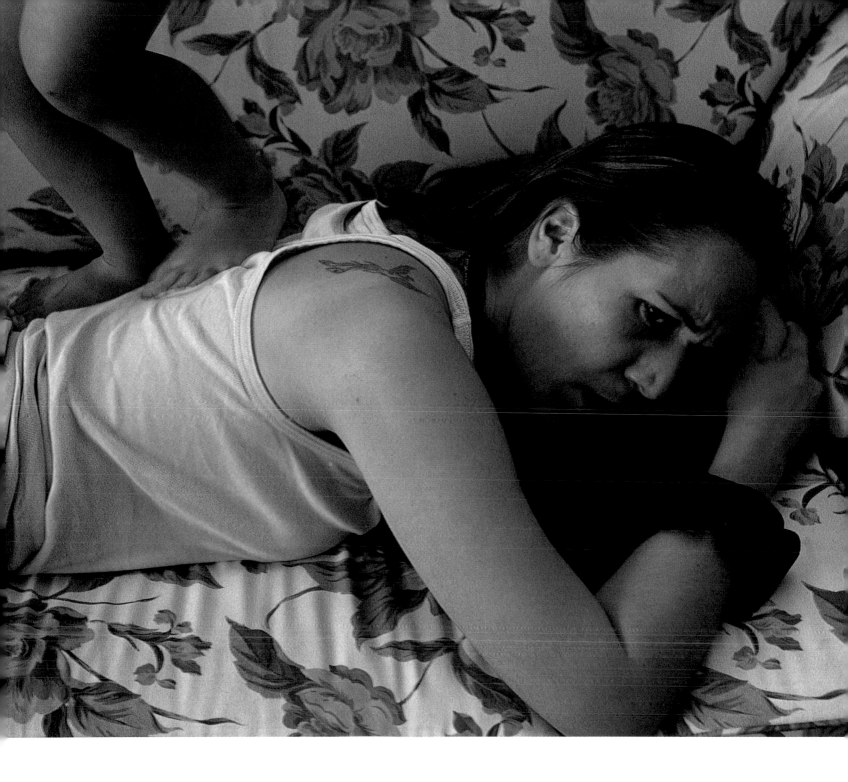

live together, but it's not possible because human beings have a problem with this.

Would you ever have married someone who was not Jewish?

No, because of my family, I cannot do this to them. I met a few boys that are not Jewish; I just accepted them as friends. I didn't think about them romantically, from the beginning.

How do you feel about Arab people?

First, they are our cousins; they are very close to us, physically and territorially. And even emotionally because we speak almost the same language as they do. I know from the movies that we see that they are very warm and nice people, the Arabs. But as an Israeli person, as a Jewish person, I don't think that now we can live with

[the Arab countries] together. By the law and by the Bible that even they believe in, this has been our territory for 2,000 years, and they know that and we know that. So it makes me feel bad that they're asking so much from Israel, just to do the peace. What'll we have left? Only Tel Aviv and Jerusalem? Even Jerusalem, they want even Jerusalem. And then what, will they also want Tel Aviv? And there won't be any country, no Israel.

Are you frightened for your children?

I am frightened for my children. I am frightened when I'm going on a bus. I'm frightened when I'm walking with my children and there are three or four Arabs coming next to me. I'm frightened because you never know what will happen.

A woman who loves to read, Ronit finds herself paradoxically disliking the act of reading to her children (left). She makes herself read aloud every night so that her children will learn to love books. Then she may endure a "backrub" from Noa (above), who shrieks with glee as she walks on Ronit's back. "I love silence," Ronit says wistfully. "I come from a very large family and when I married Dany, who is quiet and comes from a quiet family, I fell in love with the silence.

Childcare

In most of the world's families, women have the primary responsibility for childcare; it is one of the greatest joys in their lives, and one of the greatest burdens. Although many political activists, religious leaders, and social scientists have argued that men should be more directly involved with their children, the overall balance of domestic obligations has changed little. Indeed, according to the psychologist Dorothy Dinnerstein, dividing child-rearing equally among the sexes would require such profound social changes that it is unlikely to happen for decades, or even centuries.

RUSSIA: Mentally gritting her teeth, Zhanna Kapralova experiences a universal frustration—that of a parent trying to convince a finicky child to eat. Infuriatingly, Zhanna cannot even be self-righteous with Anastasia; according to Zhanna's mother, she was equally finicky as a child.

JAPAN: As her daughter stares in a sleepy daze, Sayo Ukita offers her a hot drink in the morning before school.

ETHIOPIA: Yowling in protest, Kebebe Getachew gets his face washed by his 10-year-old sister, Like.

SOUTH AFRICA: After Poppy Qampie's son, George, emerges from his bath, she puts moisturizer on the dry skin of his feet.

UNITED STATES: Putting the finishing touches on her son's hair in the morning before school, Pattie Skeen keeps an ear cocked as her daughter practices the piano.

MEXICO: Suppressing her amusement, Carmen Balderas de Castillo listens as her son, Cruz, tries to persuade her to give him some money to spend on sweets at the corner convenience store.

BRAZIL: As her housemate's son surveys the scene, Maria dos Anjos Ferreira bathes her giggling daughter, Priscila—using a bucket rather than a bathtub to ensure that casts on the baby's legs will stay dry.

HAITI: As the children drop off to sleep, Madame Delfoart sits by lantern-light with her son Soifette and nephew, Michelet, who is now living with her family.

MALI: Ankle-deep in the Niger River, Pama Kondo breaks off from washing dishes to wash the face of her son Mama.

JORDAN: Peering over Haifa Khaled Shobi's shoulder, her sons, Ra'ad and Khaled, insist on sharing their mother's moment of repose with the day-old newspaper. Because of housework and childcare, Haifa says, she is always reading yesterday's news.

ALBANIA: As Hanke Cakoni feeds her young, disabled son, Eli, her son Ardian eats a snack before going out to feed the animals.

ISRAEL: For the fifth time that day, Ronit Zaks reprimands her daughter, Noa, for walking on the furniture.

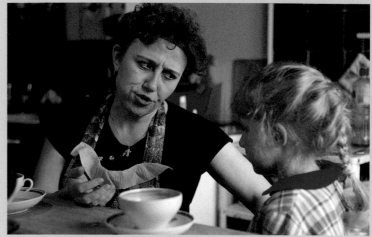

RUSSIA

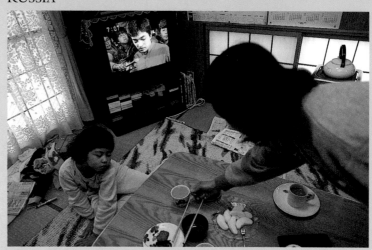

JAPAN

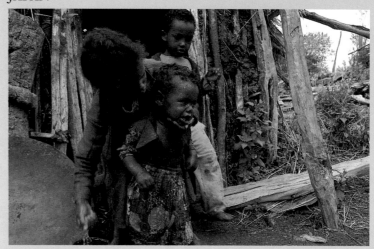

ETHIOPIA

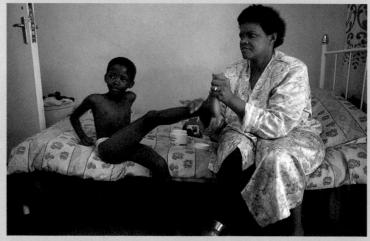

SOUTH AFRICA

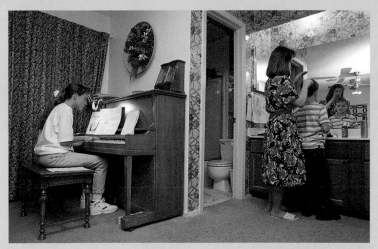

UNITED STATES

MALI

MEXICO

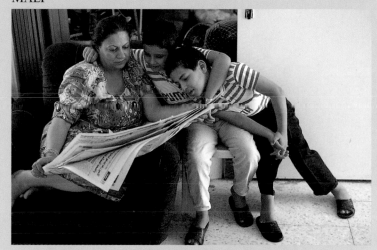

JORDAN

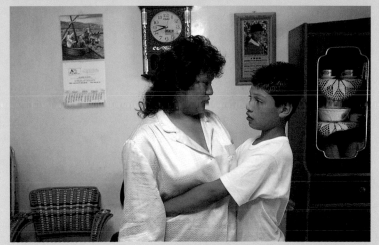

BRAZIL

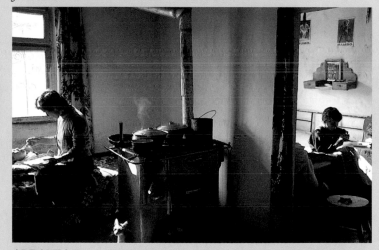

ALBANIA

HAITI

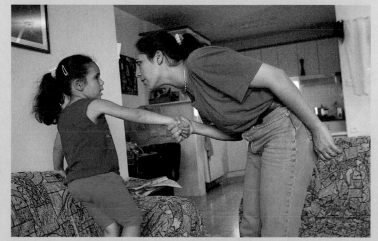

ISRAEL

Italy
Daniela Pellegrini

"We cannot talk about tradition nowadays because it is only a material world."

AFTER WORKING FOR 20 YEARS AS AN accountant in the small Tuscan city of Pienza, Daniela Ciolfi Pellegrini is out of work and angry about it. "Women are the first fired and last hired," she says. She lost her job when the company folded in 1994, and looking for another has proved fruitless.

Daniela, 42, now does most of the household tasks and childcare that she used to share with her husband, Fabio, 47, a high-school teacher. Like many Italians, Daniela was an only child. Her father died when she was a girl; her beloved mother died when Daniela was a first-year university student. Orphaned, Daniela had to leave school to support herself.

Although she knew Fabio as a child—his grandparents lived near her—they did not become a couple until they were in their twenties. After living together for many years they married, she says, to give a legal surname to their daughter.

The birth of Caterina, now 4 (*inset*), was a turning point in their lives. For years, Daniela and Fabio traveled in political circles and acted in a political theater troupe that toured the Tuscan countryside. They had a large group of friends that functioned as a kind of extended family. But as people grow older, Daniela says, their ideas change. "You look at your life and you want someone, a creature of your own. And so we had Caterina." Joblessness weighs Daniela down; without the consolation provided by her adored daughter, she says, she might give in to depression. While once her life revolved around herself and Fabio, now her life revolves around Caterina.

Photographs and Interviews by CATHERINE KARNOW

Family and Nation

Italy

Population: 57.7 million
Population Density: 496.5 per sq. mile
Urban/Rural: 68/32
Rank of Affluence among UN Members: 17 out of 185

Daniela Pellegrini

Age: 42

Age at marriage: 40 (lived with Fabio for 20 years before marriage)

Distance living from birthplace: 500 meters (Daniela's family name, Ciolfi, is found in the town archive dating to the 16th century)

Children: 1

Number of children desired: 2 (but now chooses not to have another child)

Occupation: Homemaker (formerly an accountant, laid off in 1994)

Religion: Roman Catholic (non-practicing)

Education: 1 year of university and 5 years of accounting school

Currently reading: Several newspapers daily

Favorite subject in school: Literature

Least favorite task: Ironing

Favorite activity: Reading local history, novels, and newspapers

Women admired: Rita Levi Montalcini, a Nobel prize-winner in medicine; Iris Origo, a humanitarian philanthropist who wrote about World War II.

Worst life event: The death of her parents

Best life event and proudest accomplishment: The birth of her daughter

Personal dream: "I hope for good health for all of us and work for me."

Conversation with Daniela Pellegrini

Catherine Karnow: Tell me about the best and worst events in your life.

Daniela Pellegrini: The negative things I remember were the deaths of my mother and my father. My father died of a heart attack on April 13, 1961. He was only 38. My mother died in December 1972. She was 49 years old and she died of cancer. The most positive event in my life was Caterina's birth, because after having such a hard life—at 37, I had waited for her and wanted her. When she was born, I was very, very happy.

You didn't mention your wedding day.
We think of it as only a contract, because we lived together for 20 years. When we went to sign a piece of paper, it didn't mean that we loved each other more or less. It was exactly the same as before. We did it only for Caterina, for the surname and some legal things.

Is the life you had together before getting married typical, or not typical?
It is much more frequent now—to live together and then to get married.

Are most of your friends married?
Ten or 15 years ago a lot of friends got married, and now they are divorced. But we and some of our friends in Siena who only lived together— we stayed in love.

Are there special traditions for marriage here?
We cannot talk about tradition nowadays because it is only a material world. When people who never go to church show up only for their wedding day to show off their wealth, that is not tradition. Church weddings have become occasions for people to show how much money they have. It is all strange, horrible.

Catherine: Fabio, Daniela told me you met as children but you didn't get interested in each other until you were much older. What was your courtship like?
Fabio Pellegrini (husband): I had to work very hard, because she wasn't interested in me at the beginning. But after a few months, I saw that she was gradually getting more interested in me.
How did you make her interested in you?
Fabio: When she thought that I was getting less interested in her, she got more interested in me.
How would you answer this—did you marry for love?

Fabio: We started to live together for love. It has endured. Because it had gone on for many years, we didn't need the wedding. It was only for convenience, only because when we created a family we also needed this institution. We needed it for the child, but we didn't need [it] for our feelings. The feeling was and is present. The real wedding day for me was the day when Daniela and I came to this home the first time and started to live together. The actual wedding day—it was only a formal thing. Only something to give a formal identity to a feeling that was always there.

A swirl of confetti rains down as Daniela attends a Carnevale *costume* festival for children (above). Although she loves to make her 4-year-old daughter, Caterina, happy and has dutifully sewn a special costume for this festival, she has never enjoyed big public festivities. A private, reflective woman, her favorite activity is reading. "I read newspapers every day," she says. "And I read novels, stories, and books about local history."

On the narrow street outside his home in the small city of Pienza, Daniela's husband, Fabio, exercises with his roller skis (left). An avid sportsman, he often travels to the northern mountains to ski. Daniela, who is not a skier, prefers to take daily walks in the Tuscan countryside. Both Daniela and Fabio come from families that have lived in the region for centuries. They live in the house that belonged to Fabio's grandparents.

In a basement jammed with old clothes and discarded furniture, Daniela (above) works at her least favorite domestic task: ironing. "I don't like ironing," she says. "But I do it two or three times a week, because Caterina goes to school and plays in the public park." Caterina loves to dress up and changes clothes frequently.

Catherine: When did you decide to have a child?

Daniela: When I was 34, I had an operation. There was a danger of death if I did not [have it]. They took one ovary and it was more difficult to become pregnant. I wanted Caterina before the operation. [When] she came, I was 37 and we were happy.

Did you know that you were going to have a Cesarean?

We discussed it for a long time but only decided for sure 15 days before Caterina was born. I was under anesthesia when I gave birth. When I woke up, they said to me, "You can't see her." Because of this problem she had with her blood,

she had two transfusions. I cried very, very much and after two days they took me to see her. And when I saw her, I thought she was beautiful, a beautiful face, a beautiful girl. Her weight was right and she was pink.

So you didn't see Caterina for two whole days?

No. She had this problem with her blood, and they could not take me to see her because she had to stay in intensive care. Fabio was furious, because he wanted me to see her, but it was impossible for me.

When did Fabio see her for the first time?

Immediately when she was born. With him was his sister, Anna, who lives in Siena, and the first

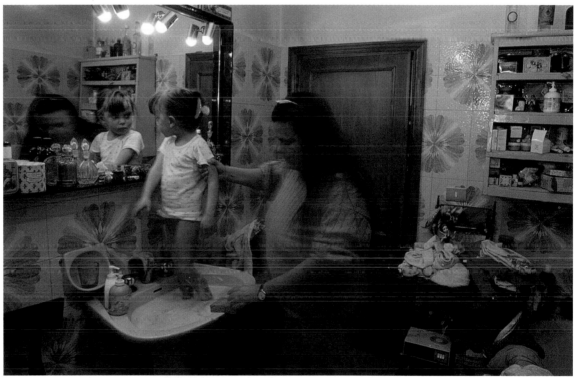

Although both parents try to share the chores and childcare, the brunt falls on Daniela, who lost her job as an accountant two years ago. After Caterina comes home from nursery school, she accompanies her mother on a shopping expedition (left, studying an assortment of Barbie dolls, of which Caterina prefers Wedding Barbie). When they arrive home, Fabio cooks dinner (bottom). Later, Daniela gives Caterina her bath (below), as the girl admires herself in the mirror.

words she said were, "*Che bellisima!*"

You were in the hospital for 21 days?

Yes. We stayed first [in a hospital] in the south of Siena and then in a children's hospital. We stayed there only because Caterina needed it.

Did insurance cover it?

We paid nothing.

If you got pregnant again, would you have the child?

Sure. To think of killing the baby—I could never do it. I am not against abortion, but I couldn't do it.

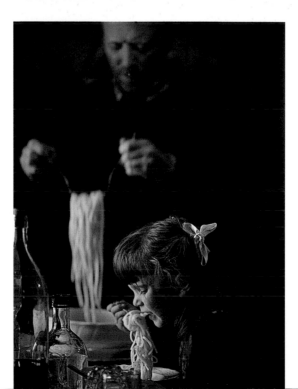

FOLLOWING PAGES

Surrounded by toys in the Pellegrinis' living room, Caterina twirls a Hula Hoop. Growing up as the adored only child of a middle-class family, she will have a childhood strikingly different from that of her mother. Although Daniela, too, was an only child, she was born into an extended household that included her aunt and grandparents. "They had little money and nothing in the kitchen," she recalls. "Everyone shared clothing. They had a winter coat, for example, and many people wore it. It was very hard."

Field Journal

I saw the conflict in Daniela on the afternoon we went to a children's *Carnevale* party. Caterina's costume was a "crazy clock"—a clock with no 12. It's because *Carnevale* is about the turning of the seasons, Fabio explains. Time, he says, is a man-made concept, which ultimately binds and represses. The number 12 closes the circle, but a clock with no 12 leaves time open, unleashed, unrepressed—a good kind of time.

The party was held in an old theater with wonderful molding on the stage. As the place filled with dozens of children dressed in nutty costumes, the din grew deafening. They were playing children's songs and the kids threw confetti at each other and bumped each other on the head with soft hammers. Afterwards, there was a sort of Punch and Judy show. The children stared transfixed or shouted back to the marionettes. Meanwhile, Daniela kept going out to have a cigarette and express how dull it was.

Clearly Caterina is Daniela's biggest joy. She loves her immensely, and Caterina in some sense returns her love. But since Daniela does not have the profession or job she wants, there is a void, an emptiness. No wonder the project of Caterina so overwhelms her. She must derive all her sense of self-worth from this child. When I asked what kinds of ideas were most important to her, she was unable to come up with one—and she is a thinking person! She could only reply, "Caterina."

— CATHERINE KARNOW
FEBRUARY

Catherine: What is the biggest difference you see between your life and your daughter's?

Daniela: I think there is no difference, because when I was a child I was as loved as Caterina is now. So there is no difference.

Are you glad that you gave birth to Caterina later in your life?

If I'd had Caterina when I was 20, it wouldn't have been good. I didn't want a baby at first, because Fabio and I both traveled a lot and we had political duties we believed in. Also the state of our families—neither Fabio nor I had parents who were alive, and it is very difficult without parents. But when you become an adult and you see what you have done and what you are going to do, you need someone. You look at your life and you want someone, a creature of your own. And so we had Caterina.

When did you go back to work?

I returned to work when Caterina was three months old. Fabio had only a week off.

Who is most responsible for caring for Caterina?

When I worked, Fabio had more free time, and he spent it with Caterina. Now that I do not work, I take care of her most of the time. Fabio takes care of her maybe 35 percent of the time and 5 percent of the time she is cared for by Angelina, our neighbor. I don't have to ask Fabio to help.

Would Fabio like you to work at a job outside your home again?

He would be very, very happy.

Would you say you and Fabio are equal partners in your home?

There is no one who gives orders and the other obeys. We decide together. My husband is very open-minded. He sees no difference between women or men. He thinks we have equal duties and equal rights.

What was the last major decision made in your home?

The last major, important decision we made was having Caterina—and we decided together.

Who handles the money in your family?

We make decisions together, Fabio and I. Neither of us has the last word.

Is there love in your relationship?

Sure, or we would not stay together.

Tell me what makes you happy.

I am satisfied seeing Caterina happy and enjoying herself.

What makes you angry?

The fact that as a 40-year-old woman I have real trouble finding a new job.

Is there anything that you want in life?

My parents. I miss them. It is hard to live without them.

But you have your friends.

We have many, many friends in our life, male and female. They are very important.

How often do you see your female friends?

In the summer we meet often. In the winter, just on the weekend. We walk together and talk about all sorts of things.

Do you talk with them about situations that women find themselves in?

My friends and I, we don't meet to speak especially about women. We don't moan about women's problems in the world. If we speak of them, we speak about women's problems in the working world and nothing else.

Are women involved in politics here?

Yes, women are elected to Parliament. The parties give them places on the ballot, but it is just the same with them as for men. It does not matter if those elected are intelligent or not.

Is it important that women be politically involved?

I do not care. When someone is involved, for me it's important that it is an intelligent person. Whether the official is a woman or a man—for me there is no difference. It does not guarantee me anything if the person elected is a woman. There is a law now in Italy that says that in a list of ten candidates, the party needs to give five seats to women, but I do not agree with this. Assuring women of positions puts them in an inferior position. It looks like men have to help women because we do not understand and need to be helped. I think that jobs and political positions should go to those who are qualified.

What are the problems that women have in the working world?

When we have to coordinate work and family, and work and children. And if someone has to lose their job because there is not enough work, women are the first to be sent home.

Do you have enough money to live on?

People never think they have enough money. For example, in our situation only Fabio is employed, but we cannot say that we are poor because there are a lot of people worse than us. Only Fabio works, but it is not a tragedy. My family lives with dignity on what Fabio is paid.

Women in Italy

Italian feudal customs, alive in some areas until the 19th century, allowed lords "first night" privileges when their peasant tenants married—that is, a lord maintained the right to have intercourse with a bride on her wedding night. Catholic doctrine and Italian custom required women to remain chaste and subordinate, but sexual double standards meant that even into the 1960s, women who were raped were expected to escape dishonor by marrying their rapists.

Under Mussolini's fascist regime (1921-45), women were exhorted to bear 12 children each, producing more soldiers for the state; a sign of women's resistance was the increased number of abortions during this period, although the practice was officially outlawed. Women were often summarily dismissed from their jobs, and the state ordered discrimination against women in favor of family men. Childless couples were taxed. But today, birthrates in Italy—once the highest in Western Europe—are the lowest in the world.

The contemporary feminist movement, which began in resistance to Mussolini, was revived in the late 1960s when women began pushing for—and winning—reforms such as the legalization of divorce and abortion, and the repeal of laws punishing unfaithful wives and forbidding birth control information. The state began subsidizing nursery schools and family health care clinics. But a law against sexual violence, debated for two decades, did not pass until 1995.

Italian women who wanted to highlight gender discrimination formed the National Housewives Federation in 1982, which demanded that salaries be paid to women who work in the home and raise children. After Italy's courts ruled that household work had as much economic value as work outside the home, the organization's 800,000 members voted to become a union. Still, while some Italian feminists argue that patriarchal ideas have been discredited, discrimination persists: Italian women earn just 80 percent of men's average wages, a disparity that increases with age and socioeconomic class.

Holding her photograph from days in a radical theater group, Daniela looks into the light flooding through the window. On the bed sits Caterina, home from nursery school with a cold. "Our time in the theater lasted only three years," she says, "because in that period [the late 1970s, when Italy was rife with youthful political protest] everything seemed to start and end so rapidly." When the hopes of that era faded in the 1980s, many Italians of Daniela's generation found themselves struggling to regain their feet in a society with one of the highest unemployment rates and costs of living in Europe.

Japan
Sayo Ukita

"I really would like women to be more independent, to talk with men as equals. Usually Japanese women don't want to obey, but they are forced to."

SAYO UKITA SPENDS THE DAY CLEANING her home and waiting for her husband, Kazuo, and two daughters to return from work and school. A meticulous homemaker, Sayo, 46, (*right*, straightening towels beneath her wedding photo) coordinates the complex family schedule. Both girls swim competitively and Maya, the younger one, takes piano lessons. And, of course, there is school five and a half days a week and Saturday afternoon *juku*, the cram school common in Japan.

Sayo bicycles to the market every day and, between errands, cooks all meals from scratch (*inset, bento* boxes). Because of her painstaking care, the house is spotless. The yard is not unlike the neatly manicured yards usually found in suburban Tokyo. It is the haven of the dog, Izu-maru, who is ignored by everyone in the family except Sayo, who feeds him.

Sayo and her husband, Kazuo, live in a house which is larger than they could afford to buy on their income. Kazuo, unlike his brother, chose not to study medicine, instead taking a job as a supervisor in a book wholesaler's warehouse. His father, an affluent doctor, bought the house for the couple when they were married. As the eldest son, Kazuo will inherit the family shrine which must be in a home that befits the Ukitas' status. A former bookstore clerk, Sayo left her job—which she loved—when she married. With a small inheritance from her own father, she hopes to someday start her own bookstore when her children are grown.

Photographs and Interviews by KAREN KASMAUSKI

Japan

Population:
125.2 million

Population Density:
857.9 per sq. mile

Urban/Rural: 77/32

Rank of Affluence among UN Members:
2 out of 185

Sayo Ukita

Age: 46

Age at marriage: 29

How Sayo met Kazuo:
He made deliveries to the bookstore where she worked in Okinawa

Distance living from birthplace: 3.5 hours by plane

Children: 2

Number of children desired: 4 (but not planning to have more)

Occupation:
Homemaker

Religion: Buddhism

Education: High school

Favorite subject in school: Math

Currently reading:
Daioojo by Ei Rokusuke—a best-selling how-to book about dying peacefully

Monthly family income:
¥476,250 [US $4,760]

Cost of a movie ticket:
¥1,800 [US $18]

Cost of 1 quart of milk:
¥198 [US $2]

Childhood chore:
Helping mother in her midwifery practice

Saddest life event:
Death of father

Happiest life event:
Birth of children

Personal dream:
Nothing special

Woman most admired:
Catherine Deneuve

Caught in a rare moment of repose, Sayo (right) is the center of the Ukita household. Raised in Okinawa, she hoped to run a bookstore—a plan that went unfulfilled after her father died, her brother and his wife took over the household, and Sayo found herself in a subordinate position. Now a frenetically over-scheduled Tokyo homemaker, she has so little time to herself that a visit to a neighbor who teaches flower arranging (above, Sayo on left) is a rare treat.

Conversation with Sayo Ukita

Karen Kasmauski: Is marriage what you expected?

Sayo Ukita: No, no, I thought it would be much merrier and happier. [Laughs] At one point I wanted us to have the same interests—to go to art galleries. I wanted him to go with me, but he was not interested, so we do not have any activities to do together. And my husband, he maybe feels the same way. I do not drink, I do not know about baseball, I do not do karaoke or bowl. I am not interested in these activities.

Does Kazuo help around the house?

He does nothing but go out to buy the food for the dog.

Do you think he would object to your working outside the home?

He would not object to me getting a job if I still did everything here.

Are you and Kazuo equal in the home?

I think it is quite different. If I caught a cold, he would say, "Please take care of the children and me."

So even if you were sick, you would still

have to take care of the children? You would have no rest?

[Laughs and nods]

What do you think your neighbors would think of that?

They might think it was quite natural. Husbands do not do any work in the home. In this neighborhood, there was one family where the wife fell down and [hurt herself and] the husband had to take care of the children. He found himself a father for the first time.

Who makes the decisions in your home?

Me. He says nothing. If the TV is broken he gets mad. Otherwise he says nothing. [Laughs]

This is kind of a sensitive question. Do you think that there is love in your marriage, between your husband and yourself?

There is anger, but there is love there—there has to be love, right? If there was no feeling, or if it was like, "Oh, well, whatever..."—it is not like that. Of course, my husband is the center. He is the main person in my life.

Do you think he feels the same way?

I have never asked him about this.

At dinnertime, the Ukita household (above) always has a guest—the television. Meals are consumed in a distracted reverie at the Japanese-style short-legged table which sits in the center of the living area. Afterward, Sayo cleans the dishes, organizes the children's bath, and—a particularly odious task—cleans up after the family dog, Izu-Maru (top). The family found Izu-maru, a stray mongrel, while on vacation and named him after the place where he showed up.

Karen: Were you treated differently than your brothers when you were growing up?
Sayo: It was so different! There is complete male domination [in my family] in Okinawa.
What do you mean?
My grandmother was a mistress. My grandfather had a first wife who only had girls, and then his mistress got pregnant and gave birth to my father. When my grandfather's real wife died, my father's mother had a right to inheritance because she had a son. My father got everything. The first wife had three daughters and they did not get anything. My grandmother had two girls and a boy. The girls got nothing.

My father got everything.
Girls had to marry to own property?
Yes.
How about in your generation—did you get anything from your parents?
Before I got married, my father died. Before he died, he had a talk with me and said it would be good if I had a little money for expenses. He gave me a little land in Okinawa which I own now. It was just a little, but I could inherit something from my father.
Did you all get equal shares?
No! [Laughs] My mother and the oldest son got most of the land. The second son and third son

got most of the rest. As for the [four] daughters, we got small pieces of land. The amount of land received by the sons depended on what they were going to do with it.

You had some other jobs and then worked in a bookstore for four years after you graduated from high school. Were you thinking then about getting married?

Before my father died, I didn't think about marriage. I wanted to have my own bookstore. But when my father died, my brother took over the family and that changed the circumstances; I thought I would have to leave the family because my brother was taking over. So I thought the best way out would be to get married.

Why did your brother taking over the family change the circumstances?

After my brother took over the house, my brother's wife would be in charge of the house. I would be the sister-in-law, which isn't a good position to be in—you know, when you're living in the same house. I was not forced to leave. I just thought that I should leave.

How long after your father died did you marry?

One year later.

Sayo cleans the bathtub (above) in the family's one-bathroom home. Before taking a bath, family members scrub down with the flexible shower hose at center rear; the water goes down a drain in the floor. Freshly clean, they remove the insulated bath cover (beneath plastic bucket) and soak themselves in the tub, which is constantly filled with hot water. Once a week, Sayo changes the water.

A swimmer in training, Sayo's younger daughter, Maya, 9 (above), takes lessons at the community pool several times a week. At home, when help is needed, Kazuo (above right) can be persuaded to put aside his baseball game to look over math problems which confound Mio, 12. Though they have a car, the Ukitas travel mostly by bicycle (bottom right, Sayo and Maya on a shopping run)—a preferred alternative in Tokyo traffic.

Karen: Sayo, why didn't you go to college?
Sayo: My parents did not allow me to go to university because I am a woman. In Japan, they used to think that girls do not need to go to university because they were only going to do housework.

But your mother worked as a midwife in a maternity clinic. Why didn't she think that education was important for her daughters?
My mother was brought up by my grand-mother, who believed that women should improve themselves, and should be strong, powerful people. But my mother married my father and when she did that, she entered his

household and had to do as he wished. My grandmother would say, "We are entering into an era of education now," but my father was brought up to believe that girls do not need a formal education. My father's family did not even allow the *boys* to go to university—it was really old-fashioned. In my father's family, most of the women cannot read. Even my father's mother cannot read or write.

Do you see any difference between your life and your daughters' lives?
Wow, my daughters are really, really free. I could not do things as freely as they can.

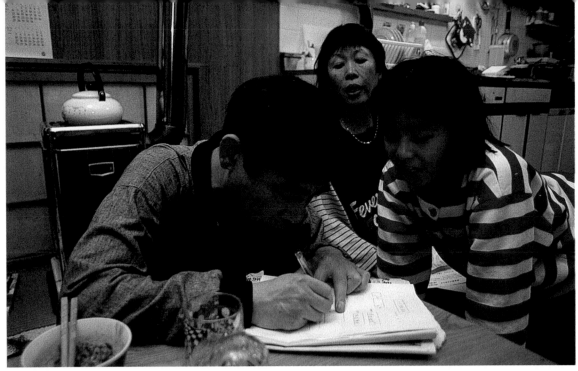

Women in Japan

FOLLOWING PAGES

In this child-centered society, many working women quit their jobs to raise children. They often re-enter the workforce later, but then earn less than men, taking part-time work or jobs with few benefits. Still, Japanese laws provide working mothers with flexible hours and 14 weeks of maternity leave.

But because women are seen primarily as wives and mothers, those trying to obtain secure jobs with seniority-based wages and benefits have it rough; despite equal opportunity laws, companies are still reluctant to hire, train or promote women, whom they expect to quit and get married.

Japanese women have the world's longest life expectancy, and as the population ages and nuclear families replace extended kin systems, working women need more support, like elder- and childcare, which the government provides on a limited basis. Domestic abuse is a problem, though its extent is uncertain, since Japanese culture discourages "airing one's dirty laundry" in public.

Largely because their role in rearing children was deemed crucial for the nation's develop-ment, women gained more access to education in the late 1800s. By 1994, nearly half of female high school graduates went on to colleges or universities. But this hasn't translated into better jobs or increased political power: Just 8 percent of managers and less than 15 percent of legislators are women. Still, women wield substantial clout in the environmental movement and in grassroots politics.

Asleep on their futon, Sayo and Kazuo drift off to opposite sides of the bed. As is often the case at night, Maya has clambered beneath the comforter for a snuggle with her mother.

Laughing with a friend at the local grocery store (right), Sayo seems the picture of contentment. But one of her favorite movies is Belle du Jour, *the story of an ordinary housewife who rebelliously moonlights as a prostitute. In Sayo's view, Catherine Deneuve, the star (above), "is so incredibly beautiful that I can't believe God is fair to other women. She has everything: blond hair, blue eyes, fabulous smile, and a beautiful body. It would be a superb thing for a woman to make full use of her endowment to enchant people, fascinate her audience, and then get swept up with admiration and compliments."*

Field Journal

Lina the interpreter and I took the train to get to Sayo's house on the outskirts of Tokyo. Not only did we wreck our backs and necks hauling two heavy suitcases and a bag of gifts up and down the many stairs we had to climb during three stop changes, we were also risking our lives. The Aum cult launched another subway gas attack—on the line we were riding. Fortunately for us, it went off just after we left. More than 300 people went to various hospitals.

On the surface, Sayo's neighborhood seems like a throwback to U.S. suburban neighborhoods of the 1950s. Moms with strollers, dogs in many yards. Children playing in the streets without adult supervision. The kids all have apple cheeks and all the babies are fat. I only see older men—

working age men don't get home until nightfall. When we arrived, the rainy morning had cleared into a warm, embracing afternoon. An overwhelming feeling of comfort and security filled the air—ironic of course with the gas attack just a couple of miles away.

Once Maya came back home at 2 p.m., the TV went on. Mrs. Ukita cooked dinner as Maya did her homework and Mio ate her snack before swimming. All the while, the TV blared about the horror of the rail line gassing. When Kazuo came home, he declared he'd rather watch baseball and found the only channel which was not carrying the attack.

Cooking, cleaning, swimming, salaryman work—it's all done with incredible intensity. Mio says she has no time to visit with friends and

Maya seems to have no desire to do so. The only other activity besides homework and TV is an occasional game of Donkey Kong. Dad doesn't even go out to karaoke anymore. He goes to work, comes home, eats dinner, has several drinks, and watches the TV.

Maya is told by her mother to jump rope each afternoon. I think Sayo does this to force the girl out of the house once a day for an activity which isn't school or swimming. Mio is obsessed with swimming. She swims after school and her one day off from school, Sunday, is spent at the pool. The strange thing is that she says she does not really enjoy swimming. She just does it because it is scheduled. Mom started her in that direction and Mio apparently has no motivation to change.

Although Sayo seems not to allow herself any time for hobbies, she admires people who do. She told me she admired her neighbor, Mrs. Manabe, who learned European-style flower arranging. She's good enough now that she's traveling to Germany for further study. When we visited her house, she was arranging a wedding bouquet with a student. I could see that I—the professional photographer

—was there as a favor to the neighbor, who was very proud of her work. Sayo stood back as if she were slightly intimidated by the whole thing and frequently looked out the window for Mio who was due home from school. Mio arrived and Sayo rushed back to feed her lunch.

— KAREN KASMAUSKI
APRIL

Karen: Kazuo, what do you think is the role of a wife?

Kazuo Ukita (husband): In my opinion, the wife perhaps should be controlling the husband and keeping her eye on what he is doing. And during the day, when the husband is away at work, as the mother of the children she has to look after the children, and she must be both their mother and sometimes their father.

How do you think women will fare in the next century?

Kazuo: Maybe they will have a higher position than men.

Why do you think that?

Kazuo: Women are more independent now and I think that young men aren't as strong as they used to be.

Sayo, do you think women will fare better in the next century?

Sayo: Not in the next generation, but maybe in about 100 years. [Laughs] Customs are not very easy to change in a few years. It will take a very long time. I really would like women to be more independent, to talk with men as equals. Usually Japanese women don't want to obey, but they are forced to.

Hair

Everywhere on Earth, daughters—and some sons—remember those tugs with the hairbrush or comb that couldn't or wouldn't be pulled through the tangles in their hair.

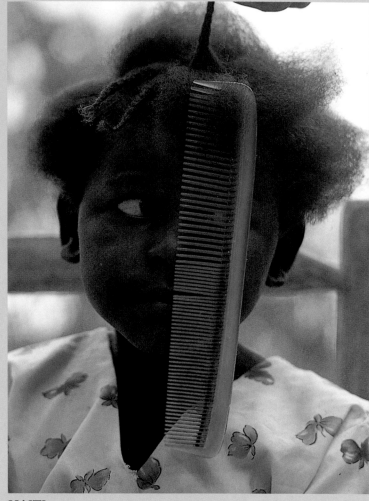

HAITI

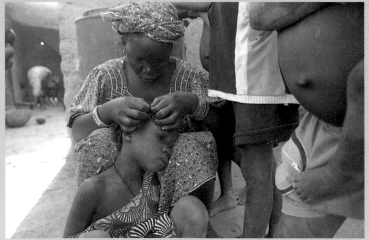

MEXICO

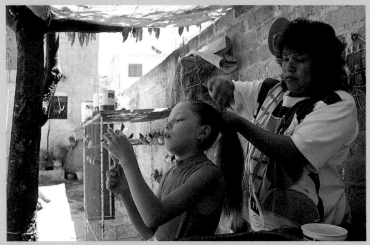

MALI

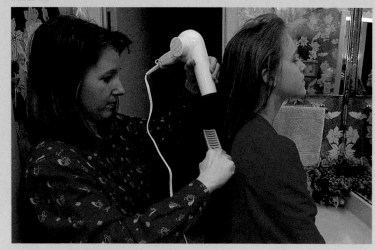

UNITED STATES

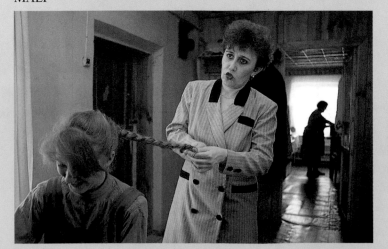

RUSSIA

JORDAN

BHUTAN

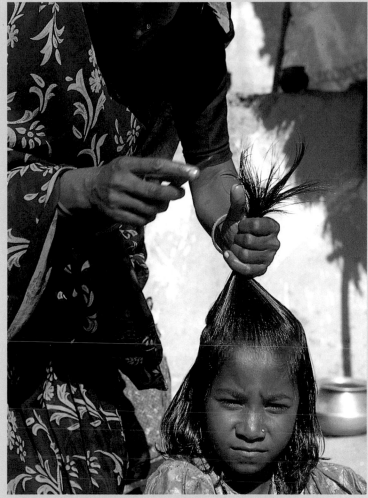

INDIA

GUATEMALA

THAILAND

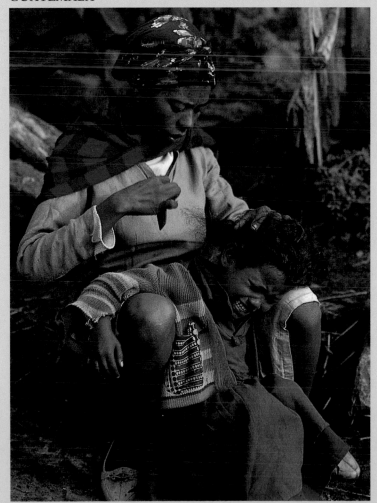

ETHIOPIA

ISRAEL

Jordan
Haifa Khaled Shobi

" When I was working, I thought I was living in a tornado—running, running, running around. "

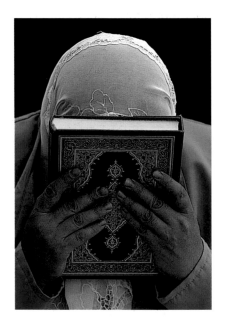

HAIFA KHALED SHOBI SAYS PROUDLY THAT SHE can count on one hand the number of times her children have talked back to her. "It is because I respect them," Haifa says, "and they respect me." One of ten children, Haifa, 42, was raised in a Palestinian household in the city of Nablus on the West Bank; her husband, Ali Nawafleh, 40, comes from a formerly nomadic Bedouin family of 12 children. According to Arabic custom, their marriage was permitted only after Haifa's brothers came to Amman, Jordan's capital, where she was working as a teacher, and they talked to people who knew Ali. After their wedding, Haifa continued to work as an Arabic teacher until she concluded that being with their five children was more important—and that her salary barely paid for childcare.

The center of the Nawaflehs' lives is their faith in Islam (*inset,* Haifa and her Koran). Deeply religious, they try to read the Koran daily; Haifa teaches her children to praise God when waking up in the morning, at the beginning and end of meals, and when entering the house. "That way," Haifa explains, "the devil doesn't come into the house with them." Haifa wears the traditional head covering when she is out in public but she does not keep to it as strictly as some. Her mother, who often visits from Nablus, covers herself even in the home. Not that all is sobriety—Haifa and her young daughter, Salam, 4, are fans of Bedouin soap operas and the cartoon antics of Tom and Jerry.

Photographs by LORI GRINKER Interviews by FAITH D'ALUISIO

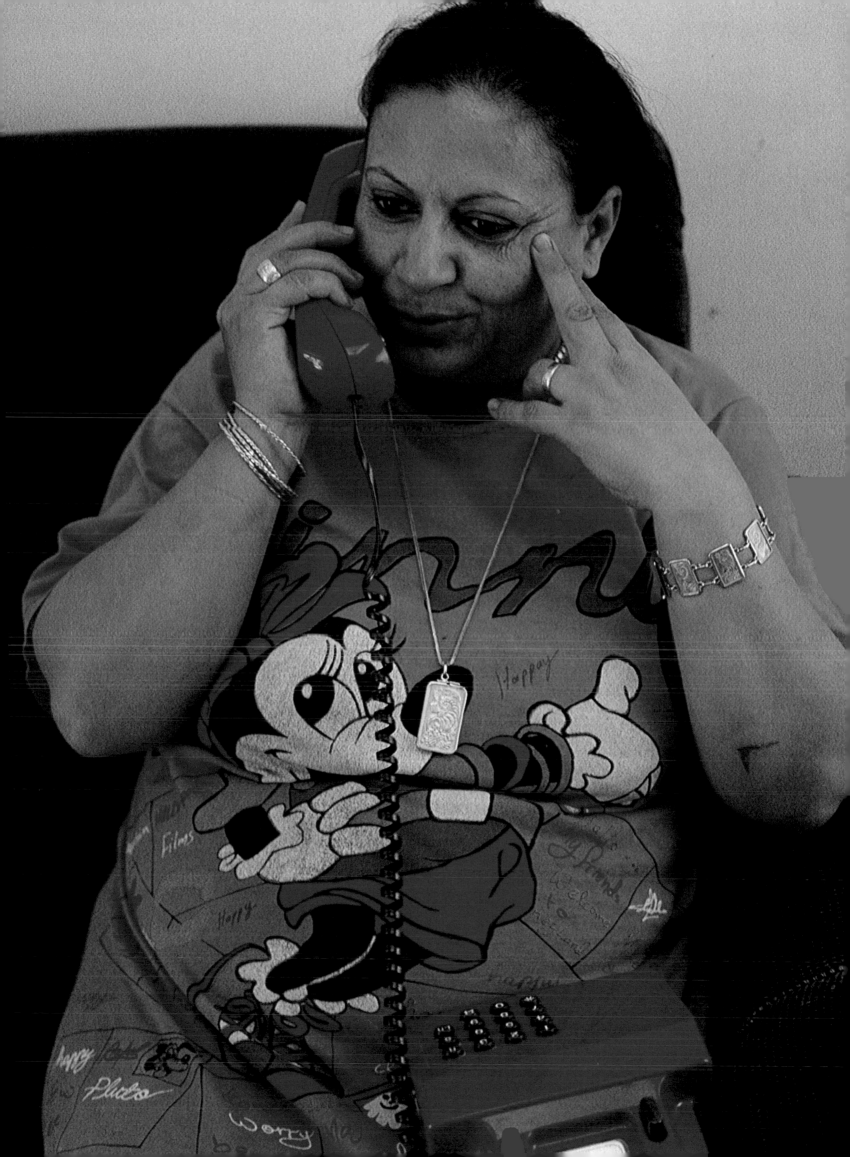

Family and Nation

Conversation with Haifa Khaled Shobi

Jordan

Population: 4.1 million

Population Density: 111.8 per sq. mile

Urban/Rural: 68/32

Rank of Affluence among UN Members: 94 out of 185

Haifa Khaled Shobi

Age: 42

Age at marriage: 28

Distance living from birthplace: 5-hour drive

Children: 5

Number of children desired: 4

Occupation: Homemaker, retired teacher

Religion: Islam

Education: 4 years of college (would have liked to obtain a further degree)

Favorite subject in school: Arabic

Literate: Yes. Ali is also literate

Currently reading: Yesterday's newspaper and the Koran

Monthly family income: 225 dinar [US $325]—85 dinar from Haifa's teaching pension and 125 dinar from Ali's work.

Cost of a canister vacuum cleaner: 125 dinar [US $180]

Least favorite task: "There is nothing."

Favorite task: Cooking

Woman most admired: Queen Noor

Best life events: Her marriage and King Hussein's return to Jordan after his cancer operation.

Worst life event: Her father's death

Hope for the future: "That God gives us life and health so we can see our kids happy."

Faith D'Aluisio: You live in Jordan now, but you were born in Nablus, on the West Bank.
Haifa Khaled Shobi: Yes. I was one of seven boys and three girls. I am number four. My mother, of course, was a housewife. And my father was a wholesale fruit merchant.

Would you say your mother's life was very different from yours?
Of course. It is a totally different life. There was no TV. There was no water. There was no stove. They used to wash everything on their hands and knees.

Did she always expect you to get married?
Of course. A woman—no matter how educated she is, no matter what she does—in the end, she wants to have a house and family.

Do you know what your father's expectations were of you?
My father wanted me to make my own home and have a husband. But one thing my parents did not expect was that I got married far away—I married someone not from Nablus. They wanted me to be close to them. Even after I put on my ring, [my father] wanted to withdraw his consent because it affected him so much that I would be so far away.

So why did you do it?
Love means everything. [Laughs]

What was your courtship like?
It was very beautiful. I spent the nicest parts of my life at this time. A woman always worries that during her courtship, the man is putting on airs and doing things for her just because he wants to impress her and he is just acting. And I was worried that when we got married all this will go. But thank God, until now, he is the same man who courted me. He still loves me as much as he did before.

That's so sweet! What was he like?
My husband from the start was very open-minded and understanding of my needs. He never restricted me in any way. He let me keep all of my freedom. Some of my friends' husbands will not even get their own glass of water—the women have to get it.

What do you think of these men?
It is a pity that they have wives.

Some Westerners say that this kind of domination of women is Islamic tradition.
The *shari'ah*, which is the way of life [the law] of Islam, gives a woman all the rights—at her parents' home, her rights with her husband, her rights with her kids, her rights in the society. No one can forbid something that God allowed. A girl, when her father dies, has the right to inherit as her brother does. Of course, it is only half as much as her brother inherits.

Why "of course"?
Because the man provides for the woman when she gets married.

Do you read the Koran often?
Every day, sometimes every other day. Even if we do not carry the Koran, open it and read it, we have memorized many things in the Koran by heart. My kids are used to reading the Koran. Ali and I read the Koran before we sleep.

You told me earlier that you don't pray as much as you would like.
It is not that I don't pray. I pray and then after a month or two, God grant him, the devil plays in my mind and I just stop. So it is not continuous. The devil is smart and conniving.

I'm curious. Your mother wears the scarf inside and outside the home, whereas you seem to do it only outside.
My mother did the *haj* [pilgrimage to Mecca]. After women make pilgrimage, they are not allowed to show their hair, their arms, or their legs.

When Ali's friends were here, you remained uncovered.
The Koran says the woman is not allowed to go out with her hair uncovered. I am covered when I go out. If I listened to Ali, I would not wear the head cover at all. He does not want it because he says religion is in your heart and in the way you conduct yourself and how you deal with people.

So you don't agree with Ali on this point?
People must do what God orders them to do.

Has this created conflict between you?
Ali never interferes in things like that.

How old were you when you started wearing the scarf?
Thirty-five. After I got married, I lived for two years with his parents. Before, I was like you, wearing slacks, my hair down, sleeveless. In the South, they hold onto tradition a lot and they were all covered. I used to feel naked when I would see how they were dressed, so I started wearing the veil. And it became a habit.

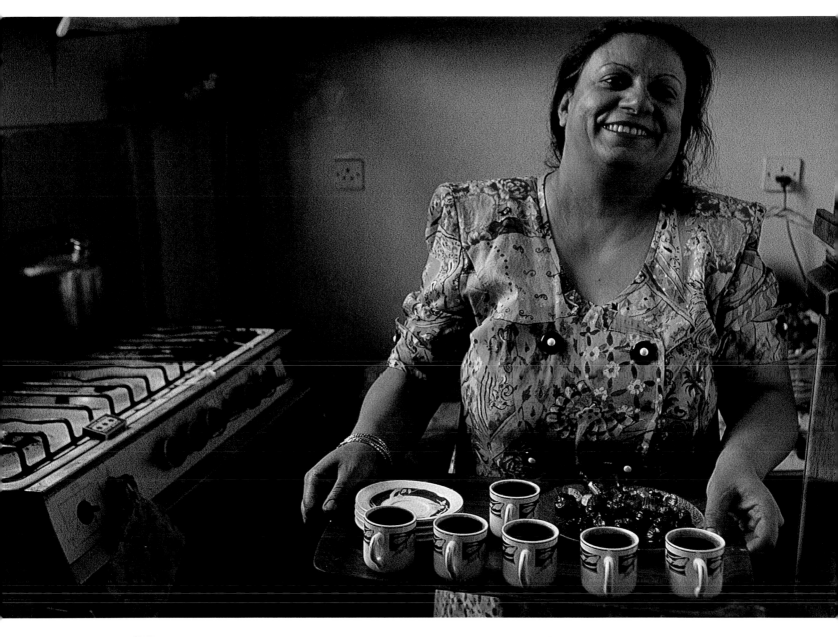

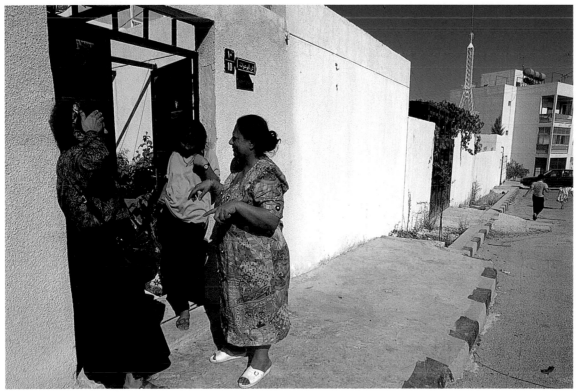

A woman imbued with the Arab tradition of hospitality, Haifa is constantly making the world welcome to her row house on the outskirts of Amman. When a friend stops by (left), Haifa and her oldest daughter, Lena, 14, immediately ask her to come in. Visitors are quickly presented with cups of Haifa's strong, sweet, cardamom-flavored coffee (above). Haifa brews coffee the Arab way, by spooning finely ground coffee into a long-handled ibrik (Arab coffee pot), letting the coffee boil over, adding sugar, and letting the coffee boil over again—a delicate but messy procedure that produces a distinctively strong brew.

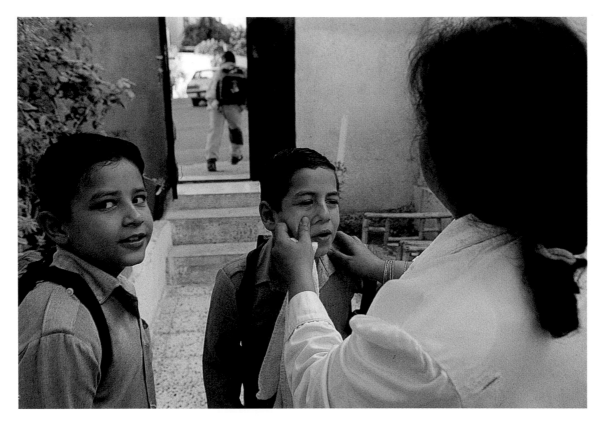

Having retired from her teaching job, Haifa is able to enjoy the luxury of spending time with her children. Like women the world over, she begins the morning with the ritual of getting the kids ready for school—a task that she finishes each morning with a physical scrutiny of the three boys and their school uniforms (top, giving Khaled, 8, a final onceover, as Ra'ad, 10, waits in line and the previously inspected Hmaid, 12, leaves for school). Older daughter Lena has already left for her school. [In Jordan, boys and girls are educated separately.] While the four older children are in school, Haifa gives her youngest, Salam, 4, her daily bath (right, middle). Haifa and her husband, Ali, originally intended to name the little girl by another name. But as Haifa was in labor, she recited verses from the Koran and the little girl came into the world as her mother said, "Salam"—peace. In the evening, Haifa helps the children with their homework (bottom right, assisting Lena while Salam chatters away into a play telephone).

Faith: What socio-economic level do you think describes your family?

Haifa: We're average, we're struggling. A person struggles to be better off, of course. But we also have an Arabic saying: "Stretch your legs as far as your bed." It means don't try to live a life that's more than you can afford.

If you could use the income, why did you stop working as a teacher?

It became too much. My kids demanded more. I started finding it difficult taking Salam out in the cold and the snow. I'd wake up at 6:30 a.m. to have Ali take me to work, and his work starts at 8 to 8:30 a.m. It became very inconvenient

and difficult. When I looked at the difference between the salary and the pension, I found out that I was working for only 40 JDs [US $58] extra and I was spending those 40 JDs on the daycare center and transport. It wasn't worth it.

How is life different for you now?

When I was working, I thought I was living in a tornado—running, running, running around. Trying to coordinate work and my house needs and my kids' needs and my husband's needs. After I left my work and my job, things were more relaxed. I have more peace of mind now.

After helping Haifa get the children ready for school, Ali (above) polishes his shoes and dresses for work. A driver for the Ministry of Youth, he is on call 24 hours a day—which means that he never knows his exact schedule, but also has more free time with his family. "The daily demands are all my responsibility," Haifa says. "When one of the children is sick, though, it's the opposite. 'You have the daily responsibilities,' Ali says. 'I'll stay up with them at night.'"

Women in Jordan

Women in Jordan spend their social lives almost entirely in the company of other women. The system of *hismah*, or modesty, keeps many from interacting with men outside their families. At the same time, ties between women are strong, and cross generational boundaries.

Muslim women often don't meet their fiances until the engagement, when the couple begins to get acquainted and prepare for the wedding. Customarily, the man's family provides the bride with a furnished house near the home of the husband's father, and agrees to a marriage contract which provides for a settlement payment in case of divorce.

Largely Islamic Jordan has few unmarried adults, and few people live alone, preferring to live near kin or remarry— sometimes two or three times—to find a stable relationship. Women do the bulk of the household work, though more are working outside the home as well.

Before the 1930s, few Jordanians were literate, but now most young women finish high school. And with an influx of Palestinians into the cities, Jordan has become increasingly urban. Although women have more opportunities now, they still experience discrimination: Compared to men, women have fewer inheritance rights, less legal grounds for divorce, and greater burdens of proof in court. Unequal standards of sexual conduct also apply: Men who commit "crimes of honor"—killing female relatives guilty of extramarital sex—face minimal punishment in a country governed by religious texts interpreted by men.

Faith: Haifa, what do you hope for your daughters' futures?

Haifa: Lena has her own ambitions. Now, she is saying, "I want to be become an orthodontist." And let us say she finishes high school at 18, she will study for four years. Then she wants to work two years, which she should. She would then be 24, 25. This is, I think, a good age for her to get married.

Would it be okay if she stayed single?

Not to marry, I will allow her that. But to live alone, no, because our culture does not allow [unmarried] women to live alone in a house.

But you were unmarried and left Nablus to work as a teacher in Jordan.

If it is for work reasons that she has to go and work abroad, then it is okay.

What happens to unmarried girls in this country who get pregnant?

In our society, a father can kill his daughter if this happens. It is honor killing.

Do you think that if Lena became pregnant that Ali could kill her?

Yes, because he is abiding by his culture and traditions.

Would you support your husband in this?

Yes, we would kill her. In our beliefs, this is something very forbidden, and it is not forbidden to kill a woman who does this.

Have you ever known of anyone being killed in this manner?

In my time it has never happened, but sometimes we hear gossip from our parents of people long ago to whom this happened.

Ali, are your hopes for your daughters different from your hopes for your sons?

Ali Nawafleh (husband): I want the girls to be educated as much as the boys. Both of them equal. I like to give my daughters freedom. But the restricted, the logical kind of freedom, the one that they keep their self-respect in.

I understand that in this country if a girl loses her honor she can be killed by her father. What do you think about this?

Ali: In Jordan now, anything that happens like this, you can seek the help of social educators and counselors who have degrees. The father should study the situation. He should not straight away kill her, because the girl might be innocent. It's *haram* [bad] in our religion for someone to kill a human being without judgment, without trial.

What do you think should happen to a father who would do this?

Ali: He shouldn't be forgiven, this father. Even if it was me, I should not be forgiven, because I did a wrong.

So you look down on a person who would do this?

Ali: Yes, they're sick. A person who will kill someone, especially if there's a possibility of innocence, is sick. Anyway, we have, thank God, conservative people in this country. This might happen in Europe, girls getting pregnant, but not here.

Sitting around a newspaper tablecloth, the Nawaflehs share a dinner of hummus, chicken casserole, tomato-and-cucumber salad. Eaten about 2 p.m., dinner (above) is the main meal of the day; the children are home from school and Ali tries to stop home for the meal. Cleaning up after the bunch keeps Haifa busy for much of the day (left). A Bedouin soap opera keeps her company as she sweeps the family room.

FOLLOWING PAGES

In the courtyard, Haifa and her mother, Mahasen, share a companionable smoke of the argilah (an Arab waterpipe). Since the death of Haifa's father two years ago, Mahasen says, a late-night bowl of tobacco has been a comfort. "Before he died," she says, "I watched 'Hawaii 5-0' and English movies and read the subtitles with the sound down. Now my eyes are bad and I can't see as well, so the argilah is my friend."

Field Journal

After meeting Haifa and Ali, we jokingly accused the people who helped us in Jordan of staging the family, because they were so amazingly warm and hospitable. "Stay!" Ali told us. "Forever, if you like!"

The Nawaflehs' faith is at the center of their lives—they read the Koran often and are always citing its proverbs—although they would not describe themselves as unusually devout. But whatever they are doing seems to work for them. The family may not have everything that Haifa and Ali would like to have, but they enjoy what they do have. And they surely know how to enjoy food! At one point the family spent a day making four different kinds of pastries. Everyone pitched in— Lena kneading the dough in a bowl balanced on her lap, Salam running to fetch different ingredients, Ali getting the ovens ready, the boys helping with this and that, and Haifa overseeing it all. The results were irresistible.

The kids were thrilled by our electronic gadgetry. In fact, when we opened up the laptop they said the one English word we heard from them: "Com-PU-ter!" They gave the trackball a workout. But, other than the cameras, we weren't nervous about letting them handle the equipment —Haifa, who knows everything about her kids, assured us that it would be all right, and it was.

— FAITH D'ALUISIO AND
LORI GRINKER
SEPTEMBER

Faith: Haifa, how many times were you pregnant?
Haifa: Seven. I have five [children] and I have been pregnant seven times. When I finished nursing my first son, Hmaid, I didn't get my period so I went to the doctor—she was western—and she told me I was not pregnant. She gave me medicine [to start my period] and I miscarried. And after Salam [my last child], I got pregnant and I was very weak. I went to the doctor and he confirmed it and I aborted it.

What are your feelings about abortion?
Islam forbids abortions and the government forbids it. But it is legal in hospitals and clinics if a pregnancy is dangerous for the mother, or if she has gotten sick with something that might affect the baby.

Were you sick?
When I knew I was pregnant after Salam, I was very depressed. I told Ali that I couldn't take another pregnancy anymore and I didn't want it. He told me, "Whatever you want to do, do. Go to the doctor, go." I said, "Let me see. I will try and do things alone and if it doesn't work, then I'll keep the baby." So I did all these things that would make the baby go down and it happened.

What did you do?
It was not at the doctor's clinic that I aborted. I took herbs. I had my kids stand on my back and I was jumping up and down and carrying heavy things.

How did you know about these herbs?
Women talk with each other.

You told me the other day that Salam was unplanned. Were the other children planned?
Lena, Hmaid, Ra'ad, and Khaled were all planned and we said that is enough and thank God. And then Salam happened. We got her, we were very happy, and we were very satisfied and thank God for what we have. Now I have had my IUD in for three and a half years.

Besides your children, what things do you most enjoy in your life?
When I go out with my husband alone. When I go out with him, I really feel the closeness and I realize how happy he makes me. When we are coming back, we might stop and buy a sandwich and a juice and stop the car and eat them. We will drive slowly to enjoy the time we have alone together. I feel as if he is giving me all of his time and all of his attention and he feels that I am giving him all of my time and all of my attention and we are alone and there are no interruptions from the kids and you really

feel closeness with no interruption.

On these trips, do you ever drive?
No. Before I was married, my brother started teaching me how to drive. The first time I tried to drive, I almost ran over my mother. My brother had to step on the brake and swerve the car and we hit a tree and damaged the car. And since then I haven't wanted to learn how to drive.

What kinds of things do you do for yourself?
I will leave my kids and after a hard day's work, I will go and take a bath and get dressed. I will put

a bit of makeup on. I might sit and read. Or make a pot of Turkish coffee and sit and enjoy it. In the morning if what I am cooking that day is easy, I will go and I will visit my friends.

Ronit, in Israel, told me she feels favorably toward peace with the other countries in the Middle East but that she doesn't think it will happen.

We just heard the word "peace" between us recently. Before that we were enemies and an enemy is an enemy. They used to consider the Palestinians their enemy, so there must be hate. That is what an enemy is. An Arab person is a human being and the Jew is also a human being. To be human is to have feelings. A person will be affected by things and will try to seek revenge for that reason.

Do you harbor any ill will toward Israelis?
For me, personally, no.

Do you understand when people do?
They must have reasons for it, for this bitterness and hate.

Before leaving for work, Ali gives his wife a kiss on the cheek; Haifa's mother (on left, in a rare moment without her scarf) looks on with indulgent amusement at the couple's display of affection, which briefly interrupts the task of washing the breakfast dishes.

Mali
Pama Kondo
Fatoumata Toure

" Besides fishing, men cannot do much. Most of the time, women are the harder workers. " — PAMA

" On the day of my wedding I wept, because the trip from youth to old age and responsibility did not attract me. " — FATOUMATA

FATOUMA KONDO—"PAMA," AS SHE IS KNOWN—IS THE FIRST OF SOUMANA Natomo's two wives; Fatoumata Toure is the second. Both families eat together, share domestic tasks, and spend most of the day at Pama's home. Fatoumata, 28, (*bottom right*) leaves in the evening with her children to sleep in her own house, which is a short walk away. Soumana, 41, alternates houses, spending the night with each woman in turn. The joint household is tranquil; Pama (*top right*) says she is glad Soumana has a second wife, and that she would welcome a third or even a fourth. Like Fatoumata, says Pama, the additional wives could help her with the children, the housework, and the family mango orchard.

As the first wife, Pama, 34, organizes the joint household, though the work is split equally between the women. More important to her, she regards herself as a partner in Soumana's business, which involves buying grain in their town of Kouakourou and selling it at the market in Mopti, a district center of commerce. Surrounded by sacks of grain, she often makes the overnight boat trip to Mopti; at the market there she excels in bargaining—a legacy, she says, of the mathematics she learned in school. Because Pama was a good student, her uncle wanted her to become a civil servant, but she always wanted to get married and she couldn't do both. Because Fatoumata, her co-wife, has an ulcer, she says she does not travel far; instead she stays home with the children and lets Pama do the traveling—an arrangement that seems to suit both women.

Photographs and Interviews by **MELISSA FARLOW**

Family and Nation

Mali

Population: 9.4 million

Population Density: 19.6 per sq. mile

Urban/Rural: 22/78

Rank of Affluence among UN Members: 165 out of 185

Pama Kondo

Age: 34

Age at marriage: 23

Distance living from birthplace: Same village

Children: 5

Number of children desired: 10

Occupation: Market seller and homemaker

Religion: Islam

Education: 9 years

Literate: Yes

Least favorite task: Pounding grain

Favorite task: Fetching water

Thoughts about having a co-wife: "I just want to have help with the work so I can do the selling."

Fatoumata Toure

Age: 28, but not sure

Age at marriage: Approximately 17

Distance living from birthplace: Same village

Children: 4 (but one died at age 3)

Number of children desired: "Whatever God gives me."

Occupation: Homemaker and embroiderer

Religion: Islam

Education: None

Literate: No

Least favorite task: Pounding millet and fetching wood

Favorite task: Embroidery

Hope for the future: For children to grow up and make money so they can take care of her

Conversations with Pama Kondo and Fatoumata Toure

Melissa Farlow: What do you think are the most important things that have happened in your life to this point?

Pama Kondo (first wife): Two years ago, my younger sister was about to deliver a baby when she had complications. She was taken to Mopti, where she died in an operation. It was her first child. She was 17 years old.

She was only 17? Oh, I'm so sorry.

Her body came here from Mopti and it was announced to the villagers that she had died. They buried her and they made sacrifices so that God would bless her body.

Where did they bury her?

In a burial place for all the village.

Do you ever go there to visit the grave?

I can't go to the cemetery.

Why not?

It frightens me.

Because there are dead people there?

Yes.

In my country, we go to the cemetery to sit by the graveside of a loved one and sometimes we feel that we can talk to them.

How can you talk with a body?

Well, sometimes we talk in our minds to their spirits.

We sometimes cannot even look at the dead. I have never seen a corpse—except when sleeping, when I see them in nightmares.

Is there a happy moment of equal importance that comes to mind?

The day [my son] Mamadou was circumcised. My husband then belonged to an association whose members brought a lot of music for the whole night. We cooked a big meal and prepared drinks.

When did that happen?

Five years ago. [My older sons] Kontie and Mama aren't circumcised yet because we don't have the money to do it. The great feast you have to organize requires money. You have to kill sheep or goats—even a cow—and invite people to drink and dance and sing songs.

I know in Mali that the girls are also circumcised. Have your daughters been cirumcised?

Yes, Pai and Tata have been circumcised.

At what age?

[At] six or seven years.

How old were you when you were circumcised?

Seven.

Was it frightening for you?

No.

Was it painful?

Yeah, it was painful.

Balancing a metal pail, Pama (left, at center) carries water from a community well. Despite the load, Pama enjoys the task, since the well is a gathering place for the village women. As she walks, the village streets buzz with a distinctive mix of human voices, the pounding of grain, and the calls of farm animals. But the ambiance of the village is rapidly changing—as a portrait session with the family (above) demonstrated when a moped sped by.

Knee-deep in the warm waters of the Niger, Pama's second daughter, Pai, 13, shakes out the family wash. Women line the shore during the day, doing laundry or washing dishes. When not helping with the chores, Pai attends a Medersa school, which combines instruction in the Koran with academic subjects like languages and mathematics. In fact, math is Pai's favorite subject—she hopes that her computational skills will help her become a trader.

Melissa Farlow: How old were you when you got married?
Pama Kondo (first wife): Twenty-three.
How did you and Soumana meet?
Sometimes the man doesn't even know the woman. But since we lived in the same village, we knew each other—our grandparents were relatives. It's the man's parents' duty to find him a wife, so Soumana's parents approached my parents.
What was your wedding like?
When I married, there was no big feast. We and my girlfriends and my husband's friends and the marriage broker just went to city hall. We were asked if we loved each other and we signed some papers.
Then did you go home to live in his house?
I lived there even before the marriage. It's the same house where we live now.
And your husband married a second wife as well—Fatoumata.
Yes, she helps me. We help each other.
So were you happy when your husband brought someone else into the family?
Yes. We were married in the same month, I and

my co-wife, because when Soumana's parents asked my parents to marry me, it took a long time [4 years] before my parents replied. He thought they would refuse and he went to seek another wife. Both families accepted at the same time.
Is that unusual?
It is not usual.
Did you know Fatoumata beforehand?
She knew me and I knew her.
For us, your kind of marriage is hard to understand because our traditions permit us only to marry one person at a time. What is your relationship to each other?
We help each other and Soumana.
Do you always get along?
If people live together, they can't help quarreling.
It would be tough if you didn't get along.
It would be difficult.
Do you think Soumana will take more wives?
Yes, to help me. Even if Soumana were married to four women [the maximum permitted by Islamic law—*Ed*], I would be lucky, because I would always be the first wife. That gives me a higher status. I would decide

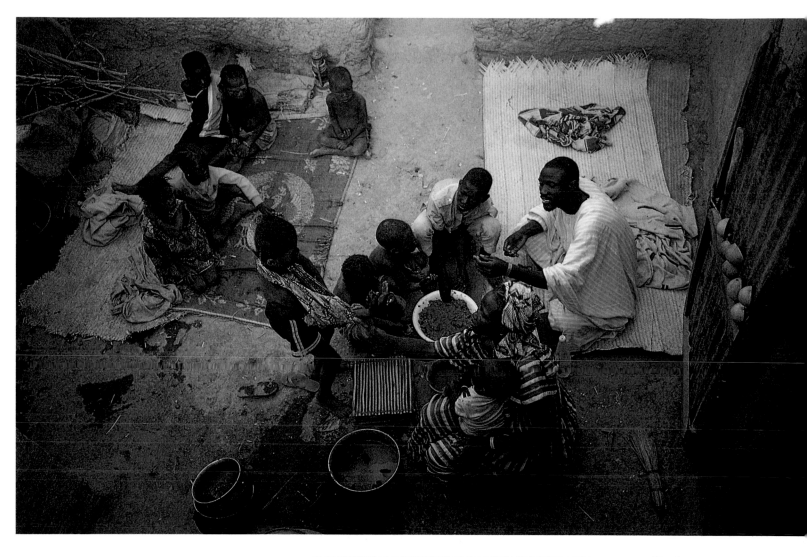

what everyone would do.

If Soumana were to take another wife, would he tell you before doing it?

He would tell me.

What if you didn't like her?

It's not [for me] to decide if I like her or not. Everything depends on Soumana.

So how does a family with two wives and one husband function?

He spends one evening with me and the next with her.

What do you do during the daytime? Do you go to fetch wood?

Yes, I do. I pound rice, too. Sometimes I buy unhusked rice, steam it [to loosen the husks], pound it to remove the husks, and then sell it. We use the profits to take care of the children—buying clothes for them, paying school fees, and feeding them.

Children are very expensive. Did you plan to have five of them?

I would love to have more.

How many?

Five more children, even. [Laughs]

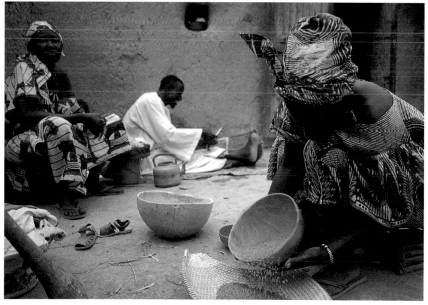

As Fatoumata looks on, Pama (above, on right) whose day it is to cook, pours rice from a gourd into a basket in the courtyard of the main house. Although Pama, the first wife, is in charge of organizing the household, she and the second wife, Fatoumata, split most of the work equally. An exception occurs when Pama travels to the larger town of Mopti to resell grain. In her absence, Fatoumata (top, sitting beside Soumana) cooks, cleans, and supervises the children as they take turns eating millet porridge from a communal pot.

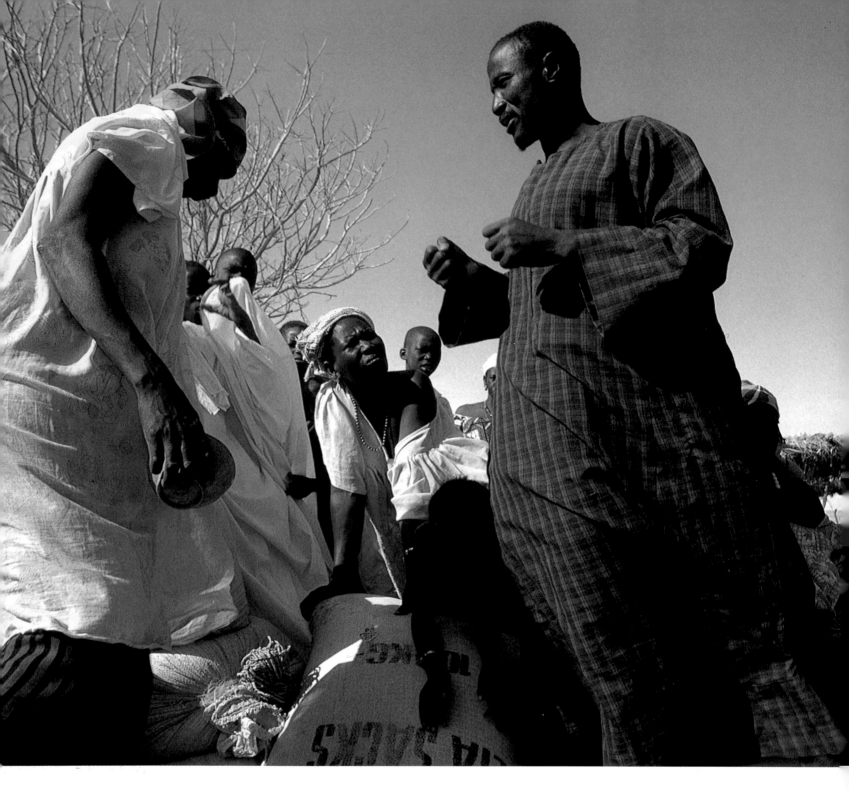

As Pama (center, in pink)
watches with interest,
Soumana bargains with a
woman selling grain in the
village market in
Kouakourou. A trader—
or, perhaps more accurately,
a wholesaler—like her
husband, Pama will take
the ten bags of grain
Soumana purchases, each in
its 120 kg (264 lb.) sack,
to the big market in Mopti
by overnight boat. There
she will resell it at a profit.

**Melissa Farlow: Fatoumata, what were your
mother's expectations of you?**
Fatoumata Toure (second wife): My mother
wanted me to be a dynamic person [active, less
shy]. She failed.
**What about your father—what did he
expect of you?**
I don't know much about my father because I
was little when he died. He had another wife
[besides my mother]. The other wife had four
children. I don't have older siblings from my
father and mother—they all died when they
were young. I have two younger siblings with
whom I have the same father and mother.
After my father died, my mother joined her

brothers' house and took me there.
What did your father do for a living?
He was a fisherman, like my mother.
[Fishing is the characteristic occupation of the
Bozo people, the ethnic group to which the
family belongs.—*Ed*]
They fished together?
Yes, we all fished. I spent eleven years working
the fishnet in the river.
Did you go to school?
No, we were nomadic, mainly traveling back and
forth from here to the east—the Gao region. We
barely spent two months of the year here.
**Did the boys and girls share all of the duties—
like cleaning the fish, taking them to market,**

FOLLOWING PAGES

As Pama seeks a moment of rest after a hot day over the fire, Soumana (left) draws a design on a piece of cloth that Fatoumata is about to make into a baby sling. "I take the material from a salesman," she says, "then I embroider it and sell it. With the money, I pay back the salesman his money and buy another piece of cloth." Her small profit is enough to buy soap and kerosene for the family. After executing the design, Soumana switches to accounting, figuring the cash flow for his grain business with a pocket calculator (below).

working on the boats, cleaning the house?

No, men do not clean house.

Only women do house cleaning?

Yes, and cook.

But everybody worked equally at fishing?

Yes.

Were there some extra things the boys had to do?

No, just the fishing.

Pama, is it true, men only fish?

Pama: Besides fishing, men cannot do much. Most of the time, women are the harder workers. When you went to the market, you saw my mother selling mangoes. That's the kind of activity that we do to get money to buy food.

Other than fishing, men just talk in the shade and wait for money from the women.

Has the treatment of women changed at all from your mother's generation to yours?

It's changed. During my mother's time, you could find many fish in the river to feed the family. So much of the family income came from men's fishing. Now fish are scarce and the women have to go to the market and work hard to sell things to feed their families.

Were you born here in the village?

Yes.

In a hospital?

I don't think I was born in a hospital. I don't think there was one [nearby] then.

Stolidly shouldering her burden, Pama carries firewood she has gathered near the family's mango orchard. Living in an area with little forest cover, wood is scarce; the search for fuel, correspondingly hard. Pama has been doing all the wood-gathering and other heavy work because her co-wife, Fatoumata, is suffering from an ulcer. "I would like Soumana to get some more co-wives," Pama says, "so I could get some rest."

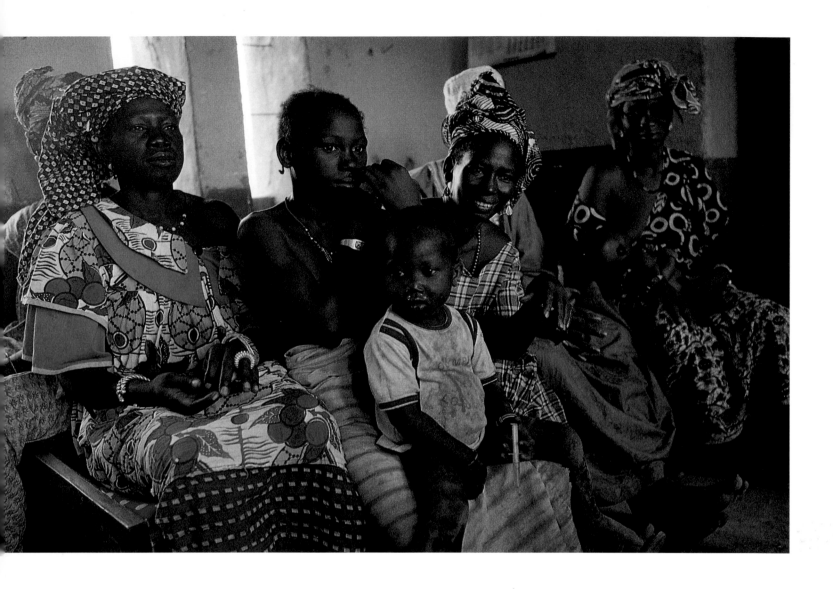

Women in Mali

Rural Malian women pound grain, gather wood, fetch water, plant crops, cook, care for children, and perform dozens of other tasks. Men fish, trade goods, and plow the fields, but women joke—with some accuracy—that their husbands just sit around and talk all day.

One out of three children die before age five, so women feel they must bear many sons and daughters—an average of seven—to make sure enough survive to help support them in their old age. But childbirth is risky for Malian women, who have the highest maternal mortality rate in the world. Most rural women have limited access to health care, clean water, and education. And as many

as three out of four adult women have undergone female circumcision, a practice many consider potentially harmful.

Tradition dictates that men take on the decision-making role in both the domestic and the public sphere. Malians elected the country's first democratic government in 1992, and ratified a new constitution prohibiting gender discrimination. Laws requiring women to obtain their husbands' permission before opening a bank account or starting a business were quietly repealed. Independent political organizations are springing up in the cities, including small business organizations and legal clinics for poor women. Women activists say Mali

has made great strides, but that democratic changes haven't yet made much concrete difference in women's lives.

And some conservative tenets remain virtually untouchable in this mostly Islamic country, where 45 percent of all married women live in polygamous households. For instance, one presidential candidate's proposal to outlaw polygamy met with no response; the practice is such a fact of life that it seems unthinkable to even discuss such a change. Still, the ranks of women journalists, business owners, lawyers, and other professionals are increasing, though only two Cabinet ministers and three of 116 legislators are women.

Melissa Farlow: Are your wives of equal standing with you in your home?

Soumana Natomo (husband): The husband, the father, is always at a higher level. I have more respect. I am the chief of the family, and I am superior. Men are superior in Muslim society. If you see women in a situation where they're higher, it's not a good situation.

How do you view the role of women in your culture?

Soumana: It's the men who give the women permission to do [what they do]. For example: It is always the responsibility of the man to say to the housewife that she has to be religious, to do the right things for their religion, and to explain religion to his kids.

What are your wives' proudest achievements?

Soumana: For women one of the [important] things is being able to do commerce and bring back money. And also having children is something that they can be proud of. It's very important, too, because if you are old and you don't have kids that will work in your place, you are poor and you are damned.

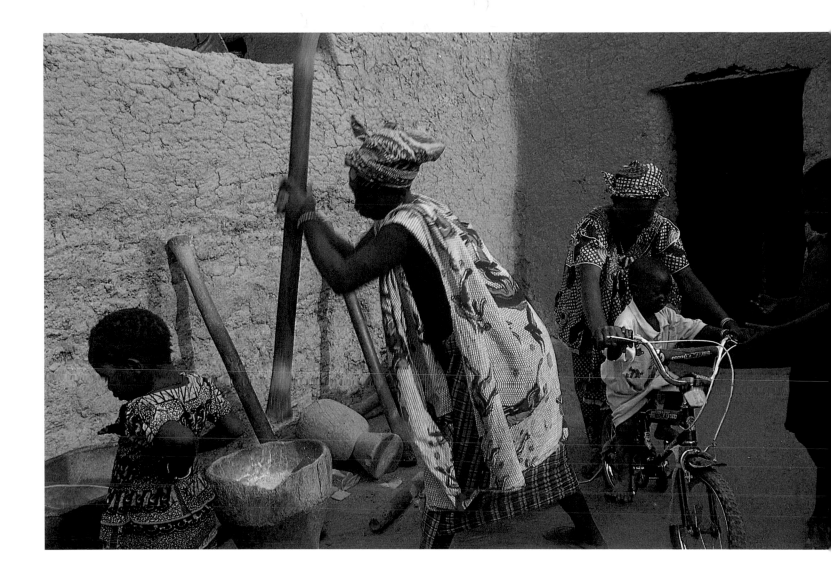

Is it okay for your daughters to stay single?
Soumana: No, it's not possible. It's very bad in the Muslim religion. People would look down on them.

How is it viewed if girls get pregnant before marriage?
Soumana: It happens and it is bad. I would be angry and I would throw [my daughter] out of my house.

In our country, women can stay single and men marry only one woman at a time. But there is also a lot of divorce. Do people divorce in Mali?
Soumana: There are some people who do it, but I would never consider it. Sometimes if the woman tries to get too much power, the man will just tell her to leave because in the family theater, the man has the power. He won't tolerate a wife who tries to get power for herself.

Your wives each have a house that you share with them. How do you spend your evenings?
Soumana: At night, generally, I will eat dinner with the whole family, and we will chat and hang out a little bit after dinner. Then I will go to the other house, and we have tea, and oftentimes my friends will come over and there will be a social gathering. And people talk, and the children will either play with other children, do homework, or tell stories to one another.

What do your wives do with their free time?
Soumana: They like to talk [with their friends] and watch television. Sometimes people set up a TV in the street, and they like to watch that when it is not their turn to stay with me. You pay ten cents to go in, and you get to watch on a big screen. Occasionally my kids will fall asleep in front of the TV, and I have to go and bring them back to the house.

They set up a big-screen TV in the road in Kouakourou and charge admission?
Soumana: There are people who travel around with the television. They go from village to village to earn money. It's like a traveling show kind of thing. There's only one big TV that travels around. There are also about ten TVs in town [with small screens], but only one has a VCR so you can watch videos.

As Pama pounds millet in the courtyard of her home (above), her oldest son, Kontie, 11, and her co-wife, Fatoumata, teach Fatoumata's son, Mama, 2, how to ride a bicycle. The two women easily share their joint lives, partly because each has her own separate domain—Pama in the main house, and Fatoumata in her small house down the street. Together but separate, the families intermingle with little evident tension. On a visit to Soumana's brother's house, Pama (above left, third from left), and Pai, her daughter, chat and listen to music with their relatives. Pai holds Fatoumata's son, Mama, who plays with a syringe casing taken from the trash heap at the local clinic.

Women in Mali work hard. As Soumana sat listening to the BBC on his radio, wives and daughters were all around him, preparing food, sweeping floors, grinding millet. The household operates pretty smoothly. Pama and Fatoumata understand each other well, though they spend little time socializing with each other and have their own separate circles of friends. The girls worked, too, as soon as they were judged capable. Still, Pai was never given direct orders. She was treated with respect and affection.

Pama and Soumana survey the market for low grain prices and after conferring with each other, he takes out a solar calculator to determine the best deal. After a price is set through bargaining, he buys sacks of millet and loads them onto a boat headed to the market in Mopti. Pama rides overnight on the boat with the grain, supervises unloading it, makes the rounds to different buyers, sells the grain, and takes the return boat the following night.

Although there is great respect and caring in the family, I never saw physical affection among adults in Mali. I was told that it was "for four eyes only."

— MELISSA FARLOW
JANUARY

The daily task of washing dishes in the river completed, Pama (right) begins the short walk back to her home. At times, such as when she is selling grain in Mopti or has other tasks, her daughter Pai or co-wife, Fatoumata, will do the chore.

Melissa Farlow: What's the name of your first-born child?
Fatoumata Toure (second wife): She died. Her name was Tena.
How did your child die?
She was about three years old. She had what we call "disease from the sky." [Chronic malaria—which causes convulsions violent enough that they are attributed to witchcraft. Fearful of incurring supernatural wrath, people refer to the sickness by the euphemism "disease from the sky."—Ed]
I am sure it was very sad for you.
Well, that was a long time ago. It's behind me now but I cried a lot then.
Was it a long time until your next child was born?
When the first one died, I already had my second one.
Who takes care of your children?
I do. [My] husband buys clothes for the children and buys them medicine.
Do the two families share responsibilities for the children? For example, did Pama care for your children when you were first so sick with your ulcer?
Yes.
Do you intend to send your children to school when they are old enough?
I prefer the Koranic school.
A religious education is what you want for them—not the modern school? [Secular schools in Mali are known as "modern" schools.—Ed]
Not everyone attends the modern school. I want to send the boys to the modern school because it prepares boys to go to other [towns]. The girls will stay home and get married.
I know that because there are two wives working together in this family, you take turns doing the cooking, so let's talk about a day when you cook. What's the first thing you do in the morning?
I pray before work, then I make breakfast.
You make breakfast for both your kids and Pama's kids?
I do it all myself.
For how many people?
Ten people.

What happens after breakfast?
I pound millet for lunch, then I wash my metal cooking pots. Afterwards I go to buy fish for dinner. When I buy fish or meat in the morning, I divide it up for lunch and dinner—I rarely go to the market twice a day. Then I do sewing. I never finish sewing. When it is time to do something else, I get up and go do that task. After dinner and cleaning the [main] house, I go to my house to drink tea. The days when my husband spends the night with me, or when my friends come, we drink tea and talk. If it's not my turn [with my husband], I just talk with my friends.
And then you pray again?
I pray five times a day.
What kind of a day would you have if it were not a cooking day?
If it's not a cooking day, I wake up in the morning, sweep my house and fill my jars with water. I go to Pama's house for meals and come back to my house.
How did you meet your husband?
We lived in the same village, and my mother and his mother are cousins.
Did you choose each other or did your parents choose?
Our fathers and mothers gave us to one another.
Once the marriage was arranged, how long was it before you actually got married?
It was between our parents. I have no idea how many years it was.
Did you love one another?
Yes, we did.
How did your husband know you loved him before you married him?
When I was asked to marry him, I didn't refuse.
Did you ever consider not getting married?
At the time of the wedding I wasn't happy. I thought a lot about the freedom of youth. On the day of my wedding I wept, because the trip from youth to old age and responsibility did not attract me.
What do you expect of your husband?
I want my husband to love me a lot.
And what does he expect you to do?
He wants me to do everything he asks me to.
What would you like to have more time to do? Working? Sleeping?
Working. Sleeping does not make anything happen.

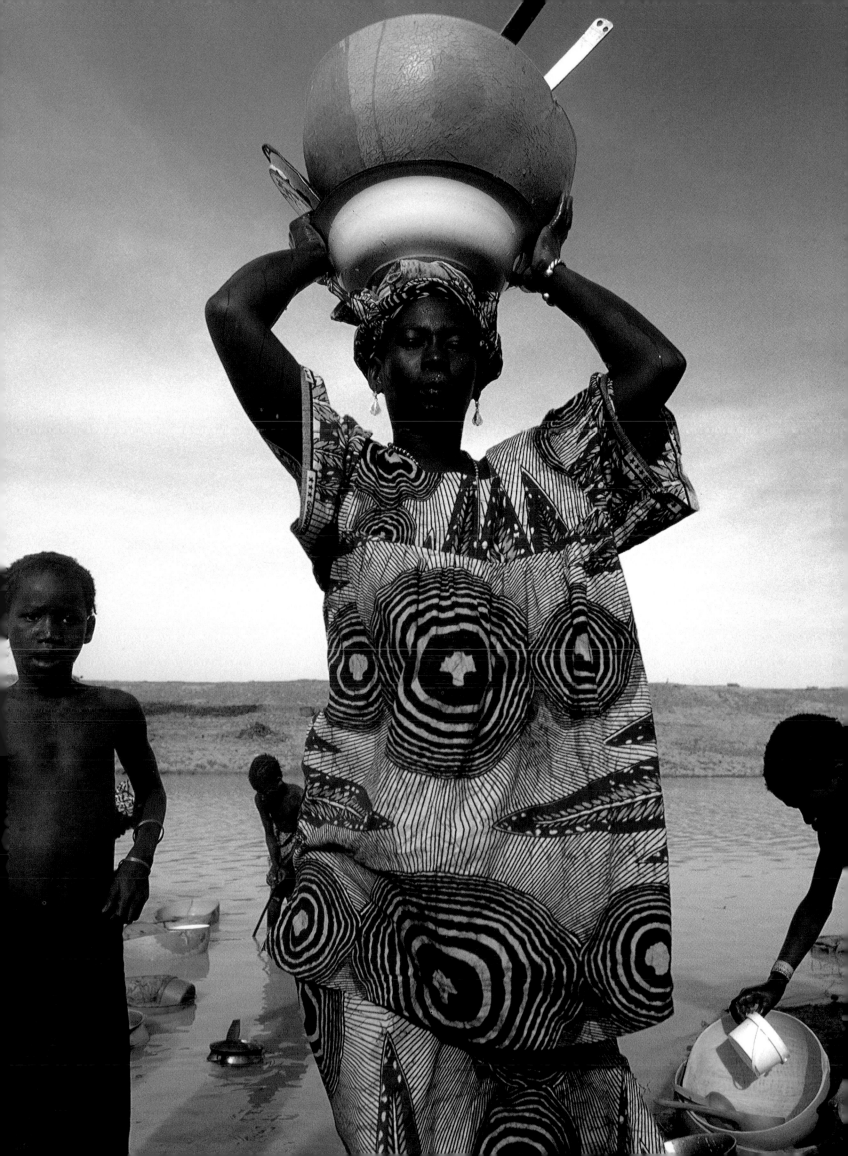

Food

ITALY

As the world's population rises, the number of malnourished people is greater than ever before. Every day, more than ten percent of the world's population eat fewer than 2,500 calories apiece—the amount an average person needs to have enough energy to thrive. Many of the hungry are children. In an apparent paradox, this sad situation is occurring at the same time that the advances of the Green Revolution have ensured that a greater percentage of the Earth's population is better fed than ever before. Indeed, the rise in global affluence has allowed hundreds of millions of people to transform their image of food from a bare necessity to a playful part of the day. As a result, the menu of the world's food ranges from handfuls of roasted grain in some poor regions to bountiful displays in others.

ITALY: Pasta with pesto sauce, lettuce and tomato salad, prosciutto, salami, bread, Chianti, and Coca-Cola.

ETHIOPIA: *Injera* bread and barley (one of the grains commonly used to make the spongy bread).

JORDAN: Fried eggs, *labaneh* (a yogurt-like spread), *falafel* (a fried patty of ground chickpeas and spices), *hummus* (pureed chickpeas, sesame oil, and herbs), olives, cheese, meat, and arugula.

MEXICO: Corn *tortillas*, chicken soup, avocados, onions, salt, and diced hot green chilis.

BHUTAN: Nalim takes a lunch break from the fields—sipping a cup of sweet tea with milk. The children snack on rice which has been puffed over the fire.

ETHIOPIA

Per Capita Average Calories Available
(as % of need), 1988-1990

Albania	107	**Italy**	139
Bhutan	128	Japan	125
Brazil	114	**Jordan**	110
China	112	Mali	96
Cuba	135	**Mexico**	131
Ethiopia	73	Mongolia	97
Guatemala	103	**Russian Fed.**	n.a.
Haiti	89	South Africa	128
India	101	**Thailand**	103
Israel	125	United States	138

Per Capita Average Calories Available (as % of need): Calories from all food sources: domestic production, international trade, stock draw-downs, and foreign aid. The quantity of food available for human consumption, as estimated by the Food and Agriculture Association of the United Nations (FAO), is the amount that reaches the consumer. The calories actually consumed may be lower than the figures shown, depending on how much is lost during home storage, preparation, and cooking, and how much is fed to pets and domestic animals or discarded. Estimates of daily caloric requirement vary for individual countries according to the population's age distribution and estimated level of activity.

Source: *World Resources, 1994-95,* World Resources Institute.

JORDAN

MEXICO

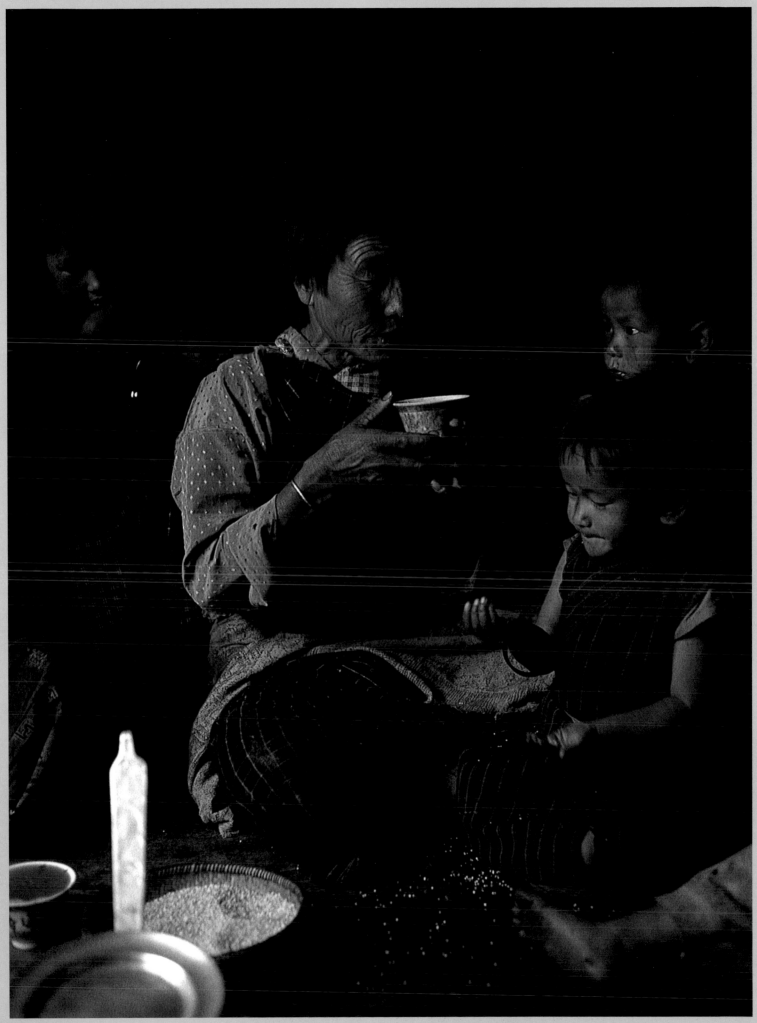

BHUTAN

Food

CHINA: The Wu family eats a lunch of pork chops, mixed greens, tofu with chilis, and kidney beans.

MALI: The two Natomo families share an early morning meal of cooked grain, eating out of the same bowl, as is traditional.

HAITI: Madame Dentes Delfoart prepares her family's sole meal of the day; a lunch of plaintains [a kind of banana] and tomatoes.

GUATEMALA: In a kitchen adjacent to their one-room house, the Calabay Sicay's eat a meal of *tortillas* and black beans prepared over the open fire.

JAPAN: Dinner-time at the Ukitas consists of *miso* soup, rice, vegetables, strawberries, and televised baseball.

RUSSIA: At lunch, Xenia Kapralova tries to feed rice pudding to an ailing Anastasia. Other food on the table: chocolates, cookies, hard sausage and cheese, and pancakes.

MONGOLIA: The Batsuur extended family shares soup with meat dumplings, sliced meat, bread, cucumbers, candy, tea, and soft drinks.

THAILAND: A weekend lunch of sticky rice, fresh vegetables and curries draws the Khuenkaew family together for a meal—one of the few activities that they share together.

UNITED STATES: The Skeens enjoy a Saturday lunch of homemade bread with butter, chicken, rice, and broccoli.

ITALY: Fabio and Daniela Pellegrini offer their daughter a taste of pasta.

BRAZIL: Maria dos Anjos Ferreira feeds her children sandwiches and glasses of milk for lunch.

MEXICO: The Castillo Balderas children eat a lunch of *chile rellenos*, avocados, corn *tortillas*, *tostadas*, and rice. They drink sodas from the corner market.

Share of Household Consumption Expenditure on Food (%), 1980/85

Albania	n.a.	**Italy**	19
Bhutan	n.a.	Japan	16
Brazil	35	**Jordan**	35
China	61 b	Mali	57
Cuba	n.a.	**Mexico**	35 b
Ethiopia	50	Mongolia	n.a.
Guatemala	36	**Russian Fed.**	n.a.
Haiti	n.a.	South Africa	34
India	52	**Thailand**	30
Israel	21	United States	13

b: World Bank estimate, includes beverages and tobacco.
Source: *World Resources, 1994-95,* World Resources Institute.

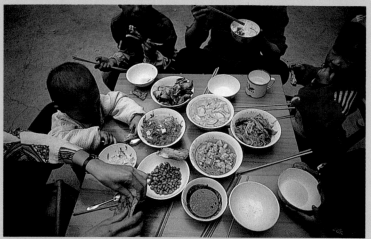
CHINA

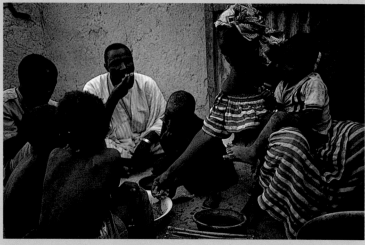
MALI

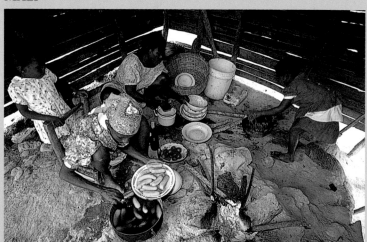
HAITI

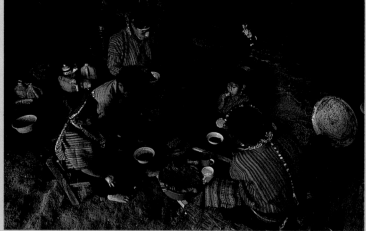
GUATEMALA

JAPAN

UNITED STATES

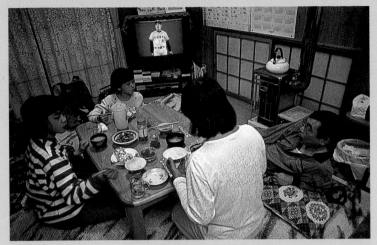

RUSSIA

ITALY

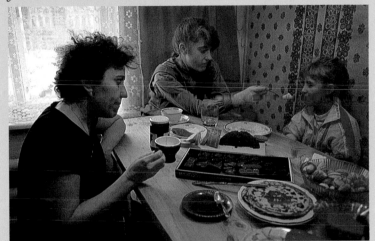

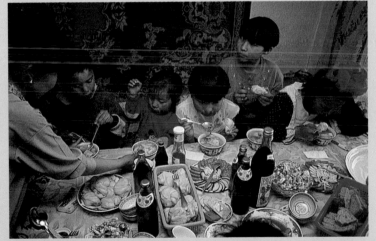

MONGOLIA

BRAZIL

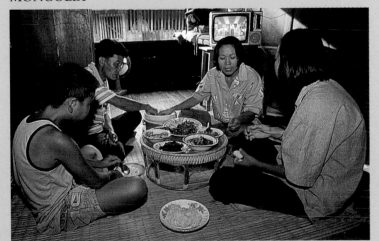

THAILAND

MEXICO

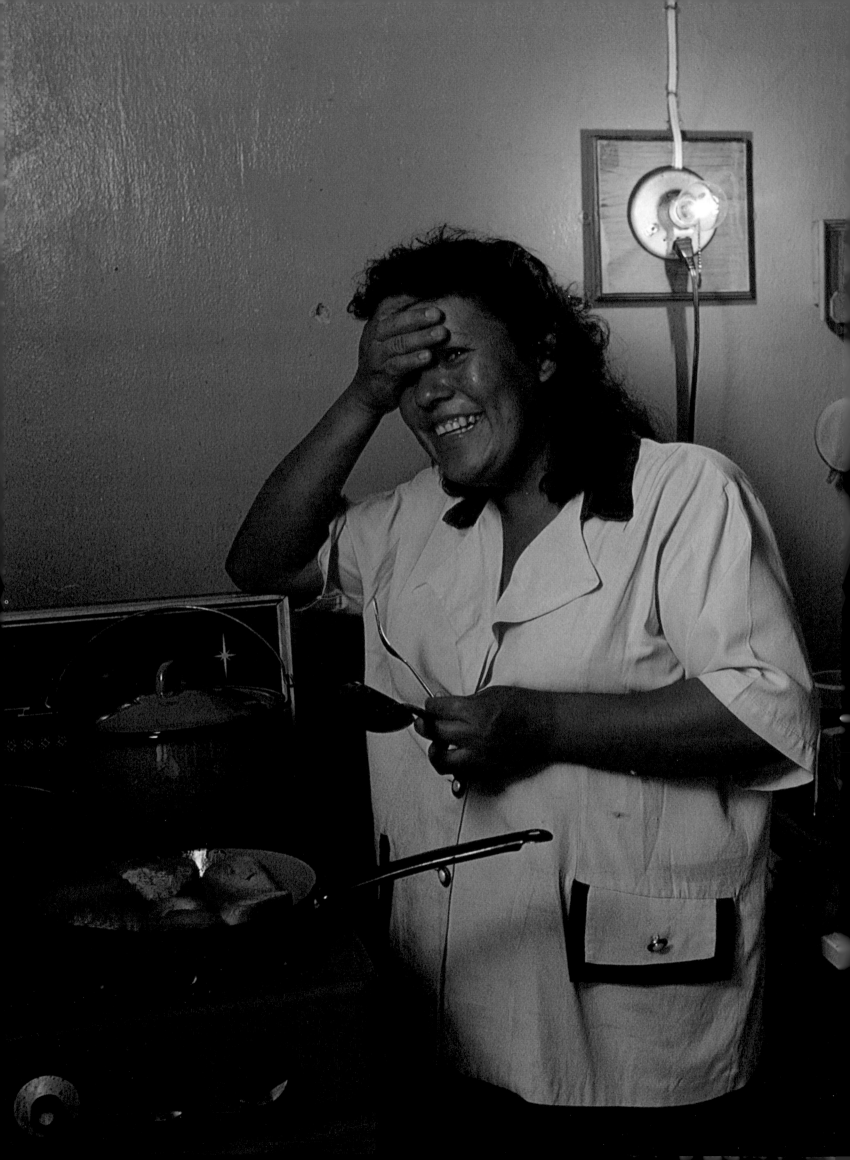

Mexico
Carmen Balderas de Castillo

" If I tell him I want to do something, he doesn't like it, so I don't tell him anymore. "

LIKE A RAPIDLY INCREASING NUMBER of Mexicans, Carmen Balderas de Castillo has given up the Roman Catholic faith of her parents and become a Jehovah's Witness. She studies the Bible every day and credits her faith with helping her cope with daily life. She and her children attend meetings in the Kingdom Hall close

to her home in the central Mexican city of Guadalajara. Her husband, Ambrosio Castillo Cerda, 31, is a non-practicing Catholic and does not approve of this or other interests that Carmen, 27, has outside their home.

Carmen, Ambrosio, and their four children, ages seven to 11, live in a small house next door to her in-laws. Ambrosio delivers produce during the weekdays and does freelance welding on weekends, earning enough to inch the family into the middle class. Over the last 12 years, he has converted their house from a one-room shanty to a six-room home with rudimentary plumbing.

While the rest of the family is away at school or work, Carmen keeps house—difficult because she must work hard to keep out dust from the unpaved streets. Sewing is among her favorite pastimes; she would like to take sewing classes and then use the skill to earn money for the family. But Ambrosio, who controls the finances, says the family can't afford the lessons. This is not the first time Carmen's ambitions have been frustrated—she says she left school at age 12 because her father could not afford for her to continue.

Photographs and Interviews by STEPHANIE MAZE

Mexico

Population: 93.7 million

Population Density: 123.9 per sq. mile

Urban/Rural: 71/29

Rank of Affluence among UN Members: 48 out of 185

Carmen Balderas de Castillo

Age: 27

Age at marriage: 15

Distance living from birthplace: 1 hour

Children: 4

Number of children desired: Fewer

Age at which Carmen would like her daughters to marry: 30 or 35

Hours of television watched by children daily: 6 or 7

Occupation: Homemaker

Religion: Jehovah's Witness

Education: Primary school

Literate: Yes. Ambrosio is also literate

Favorite subjects in school : Math and history

Currently reading: Her Bible

Monthly family income: 1600 pesos [US $290]

Drinking water supply: Bottled

Laundry: Buckets of water are carried inside to fill the washing machine

Favorite activity: Reading

Least favorite activity: Cooking

Worst life event: Not being able to continue in school

Carmen's wish: To work so she can afford to go back to school.

Off a ramshackle side street in a neighborhood in the hills of Guadalajara stands the home to which Carmen's husband, Ambrosio, has devoted more than a decade of labor (above, with the truck Ambrosio drives for a produce company). The evolution of the house, which began as a wooden shack, mirrors that of the neighborhood, which began as a shanty town and has been transforming itself into a lower-middle-class area. During that time, Carmen has cared for the couple's four children. A Jehovah's Witness, she takes them with her to worship every week (right, flanked by her tired daughters at an early-morning service).

Conversation with Carmen Balderas de Castillo

Stephanie Maze: Do you remember any special event in your life when you were growing up as a girl?

Carmen Balderas de Castillo: When I left primary school, that was the most important, and when I got married.

How old were you when you graduated primary school?

Twelve years old.

And how old were you when you married?

Fifteen. [Common law marriage until three years later—Ed]

When Ambrosio was your boyfriend, what was that time like?

Well, it was very nice, although we did not go out very much. He went to the house and we would speak about what interested us. We got along well.

You were 18 when you had your wedding ceremony? What was it like?

I had a civil marriage, in the civil registry. It was a simple wedding, with simple clothes. We had a dinner with my father.

Did you marry for love?

Yes.

Did you ever think about not getting married?

I always thought that I would get married.

Always?

Yes. My thoughts were to continue studying, but when I started going out with Ambrosio I ended up pregnant at 15.

Is marriage everything that you hoped for?

No. You could say I'm used to my life in the house, to attending to my husband and children and making sure they want for nothing. But what one hopes of marriage is not the way it is. I have always met his expectations of me, because I have always done what he said. But I have never been able to confide in him because he gets angry. If I tell him I want to do something, he doesn't like it, so I don't tell him anymore.

Do you consider yourself in love?

[Shrugs] Well...Who knows. In the times when we are together or talking...we get along fine. At times, if we have problems, he is very *machisto*.

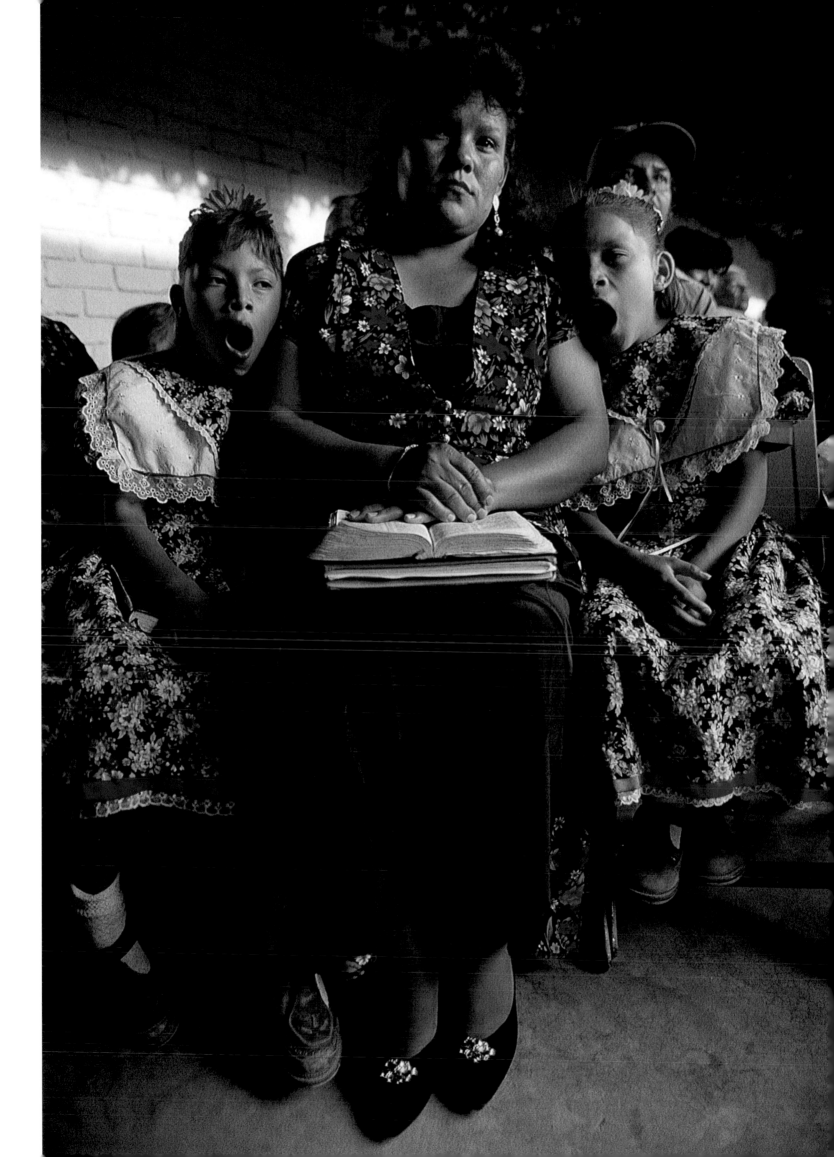

Shrieking with laughter, the Castillo children collapse on the floor (above) after the older children finish piggy-backing their younger siblings in a race around the kitchen table. Restive at the end of their spring vacation, the four children—Cruz, 11, Nayalit, 10, Brenda, 9, and Marco, 7—have been driving their mother crazy by playing noisy games and pestering her at every opportunity for money to buy candy and pan dulces (sweet Mexican bread) from the corner market.

Stephanie: Was your mother's life different from yours?
Carmen: Yes. I am always at home with my children, she was not. She left when I was two.

She left the family? Do you know where she went?
My father told us she went and worked outside the city. We never saw her.

So you grew up without a mother?
Yes, my father, sister, and brother all worked. I was in the house alone with my aunt. She was very good with me. She treated me like I was her daughter. My father was also very good to all of us. He always saw to it that we never lacked for anything.

What would you say is your most important accomplishment?
The most important ones were things that I did not accomplish. In addition to taking care of the household, I would like to work so that I could study.

How would you have changed your life?
First, I would not have gotten married so young. I would not have had kids so soon. I would have studied. And with my studies I would have been in a better position than I am now. I would make my own decisions, independent of my husband.

Married, but independent?
Yes.

Are you happy with your life as it is?
Well, no, I am fulfilling my role and nothing more.

Have you ever thought about divorce?
No. Before I started reading the Bible, perhaps I would have divorced but now, no. You should be thinking about the stability of the home and the children.

What do you expect from your daughters in the future?
I hope that they... [Begins to cry] I hope they get what I didn't—that they get an education and succeed on their own. That they do not get married so soon. I want them to be older before marriage, because that way they can finish their studies, think more about things and have more experiences.

The Castillos watch a TV wrestling match during a visit from Carmen's mother-in-law, Ambrosia (above, seated to the left of Carmen). As a treat, Ambrosia has come with her youngest child, Miguel, a 9-month-old baby. She gave birth to the little boy when she was 50, and the child is a great favorite with the rest of the family. On a less social afternoon, Nayalit hides under the table (left) as Carmen crouches over her sewing machine next to Brenda, who has just taken a bath. Carmen would like to take sewing lessons, which would train her to earn money at home doing piecework. But Ambrosio believes the family cannot afford the lessons. When Carmen suggests that she work outside the home to earn the money, her husband rejects that idea, too.

FOLLOWING PAGES

Leaning back in a chair on the patio, Carmen's boisterous father-in-law, José, entertains the Castillo family with a stream of jokes and stories. Carmen's in-laws live next door, and the families constantly wander in and out of each other's homes. Sometimes they share childcare— Nayalit has charge of her young uncle, Miguel.

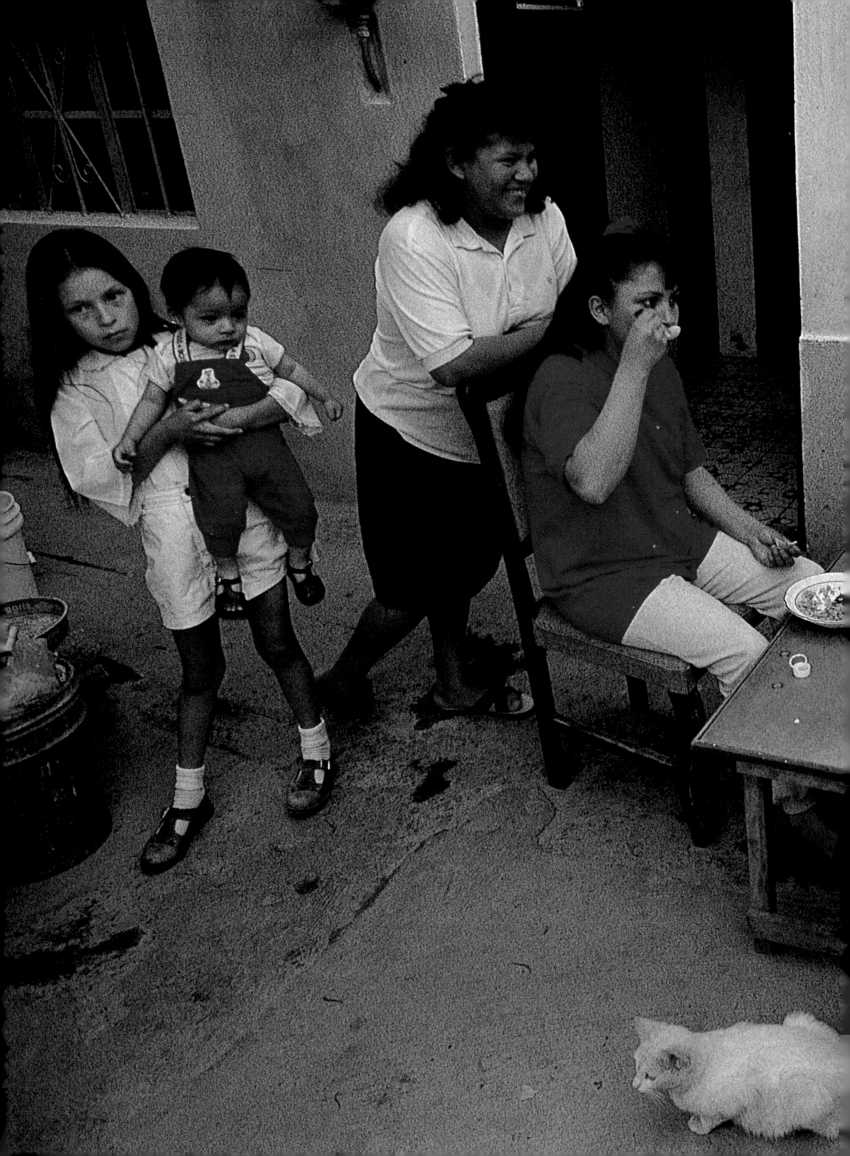

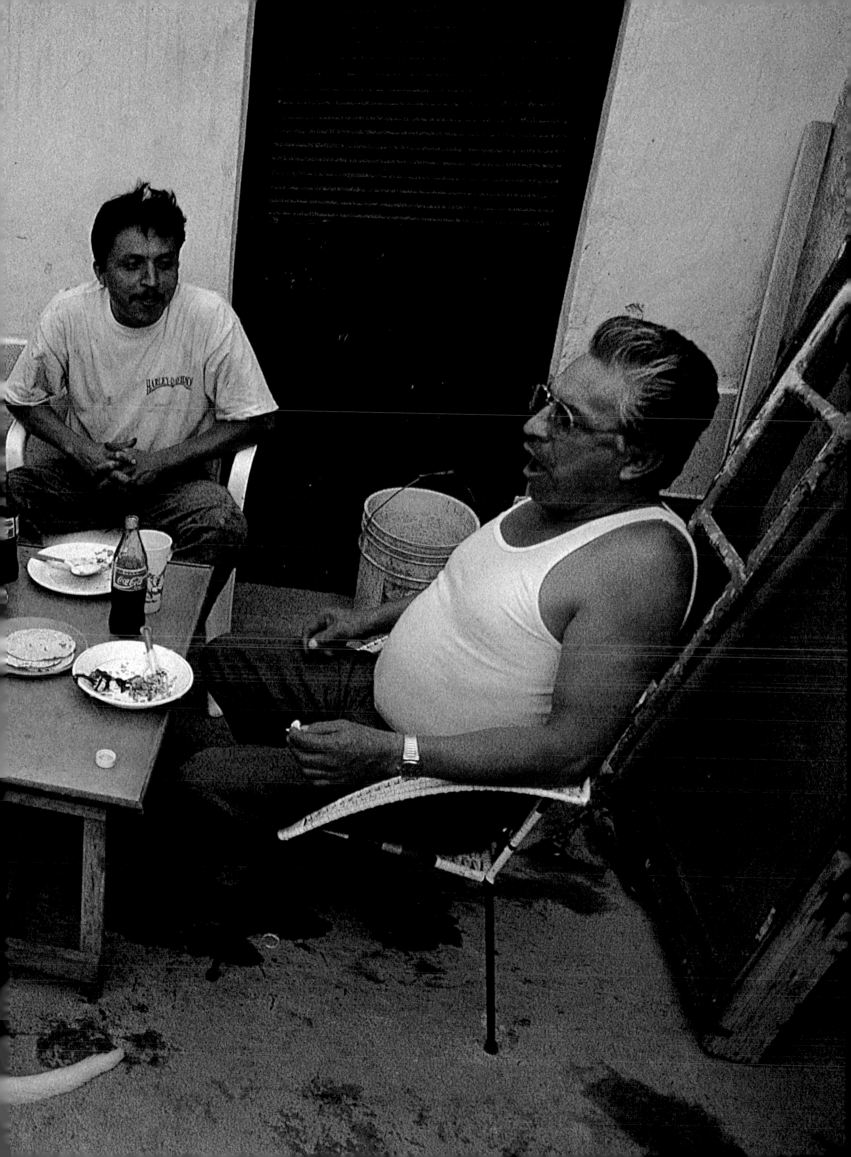

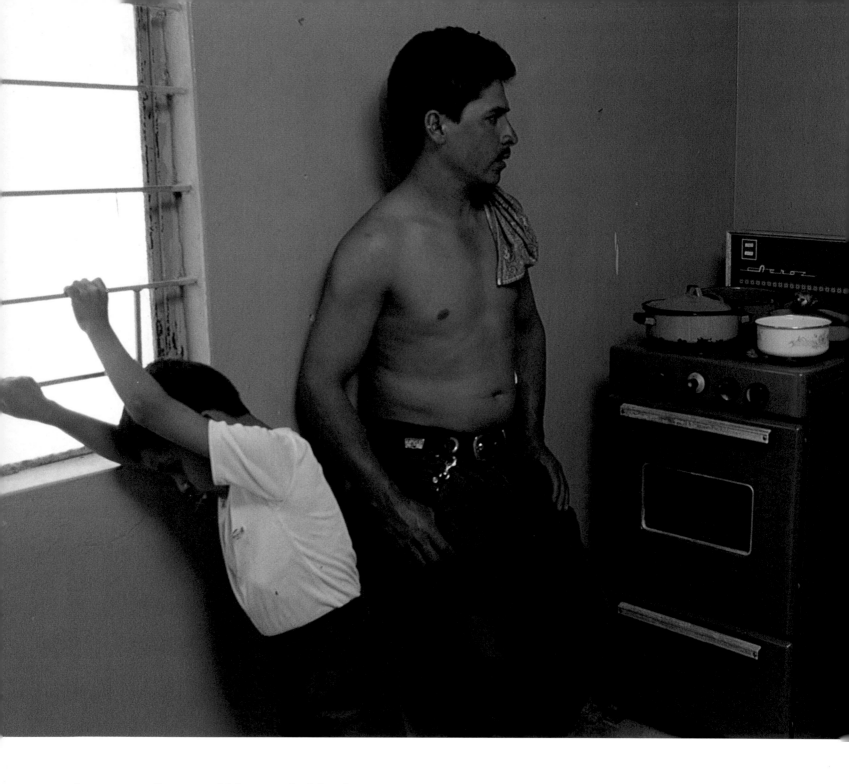

A tense moment. Carmen and Ambrosio have an anxious, quiet, heated discussion about a subject that is the bane of many couples: money. As Carmen shifts the pots on the propane stove, she and her husband dispute which bills they should pay quickly, and which can be left for a while. Marco Antonio, 7, patiently waits out the argument.

Women in Mexico

Women in black masks toting rifles and handmade guns comprised nearly a third of the Zapatista National Liberation Army, which revolted against Mexico's government in 1994— this in a country where colonial influences have long excluded women from politics and public life. The Zapatistas were protesting free trade policies and other economic changes that had devastating effects on many Mexicans, especially indigenous peoples and working women.

More than a million women lost their jobs during the economic restructuring of the 1980s; others worked without health benefits and where sexual harassment was rife. Although some found new jobs in *maquiladora* assembly plants, women's industrial wages, as a whole, fell from 80 percent of men's wages to only 57 percent. The financial crisis of 1995 left hundreds of thousands more Mexicans unemployed.

Such striking wage disparities might seem anomalous in a country where boys and girls get a nearly equal amount of education, but until this century, few Mexican women received any schooling. Even now, with widespread primary education, fewer girls than boys go to school, and in some southern states, illiteracy rates reach 40 percent.

Yet women have been politically active for years: from publishing radical newspapers during the 1910 Mexican revolution to starting feminist groups and women's studies programs in the 1960s. A decade later, the "mothers of the disappeared" staged protests against the government's practice of "disappearing" many suspected subversives. These women inspired other human rights activists in Latin America when they won freedom for more than 1,500 political prisoners.

Stephanie: How would you describe where your family is economically?

Carmen: We live fine—we are not lacking many things. Although there is not much to spend, what the children want they can always get.

Who has the final say about how the money is spent?

He decides. Because if I tell him something to the contrary, and he does not agree, he makes the decision anyway.

How do you mean?

I have been going to the dentist [to have some work done] and he told me I could pay for it little by little. The dentist is in dental school, but he is completing his studies and wants to finish with me before graduation. By the twenty-sixth of this month I have to finish paying so he can order the pieces. Ambrosio said that I did not tell him about this, but I did. When I told him, he said nothing, and so I continued going to the appointments. He knew how much it would cost (660 pesos [US $120]). Now he says it costs too much. He says he will give me only 200 pesos [US $36] the next time I go. I don't know what the dentist is going to say.

Are most of the arguments you have with Ambrosio about money?

Some of them, yes. Others are about religion. When it pertains to religion and my doing things with the congregation, I don't pay much attention to him. Because of that, there are problems.

He doesn't want you to leave the house?
Yes.

But you go out anyway?

Yes, but I do not leave without a reason. He gets mad when I tell him I am going out to meet with members of my congregation.

If you wanted to work outside the house, would your husband let you?
No.

Would you like to work outside the house?
Yes.

If you could, what would you like to do?
Well, there are many jobs.

What type of thing would you like to do?
Well, to have a good job you need to have schooling. So then it would be better if I worked in some store or factory.

Ambrosio, Carmen was telling me that she wanted to get a job. Would it be all right with you?

Ambrosio de Castillo (husband): No! If a woman works, I feel she loses her standing at home. It would conflict with the family. A woman who works feels more secure. I do not want her to be secure. All working women want to be independent and that conflicts with my concept of marriage. On top of that, I would not know how she would behave on the outside. She would be different and I do not want to have this happen to me.

Carmen, if you want to do something Ambrosio does not like, does he get angry?

Yes, and in order to keep the peace and so the children are content, I do not contradict him.

Field Journal

At first, I saw Carmen play the role of dutiful wife. She is sensitive to Ambosio's shifting moods, especially his anger—which erupted periodically but was never violent— she told me that she had decided to keep the peace at all costs. But toward the end of my stay, I saw her assert herself more and realized that she is the glue that keeps this family together.

She is a very affectionate mother; the children responded to her in kind, but were quite demanding as well.

I don't remember her sitting still for more than a few moments during my visit. When she was not cooking, she was cleaning, when she was not cleaning, she was washing, when she was not washing, she was tending to the children— she was like a machine in motion all day long. When Ambrosio wasn't at work—he would leave just after 4 a.m. and return at noon after eight hours of hard work delivering produce—he would collapse in front of the TV, a glass of beer in his hand, and wait while Carmen made lunch.

One night when Ambrosio was driving me to the cab stand—no taxi drivers would come to their neighborhood— I asked him why he didn't interact with his family. He assured me he loved them but said he was just too exhausted. But Carmen is exhausted, too. I left hoping they would make things work out.

— STEPHANIE MAZE
APRIL

Mongolia
Lkhamsuren Oyuntsetseg

" My mother lived in the time of the centrally planned economy, while I'm living in this free-market society. "

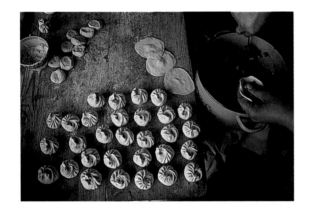

LIKE MOST MONGOLIANS, Lkhamsuren Oyuntsetseg and her family have been buffeted by the nation's transition to a market economy, which began in 1990. A licensed pharmacist, Oyuntsetseg, 33, was lucky enough recently to take over a former state pharmacy with a friend. Now she works long hours, so household tasks like cooking (*inset*, meat pastries) at times fall on her husband, Batsuur; their two children, Khorloo, 11, and Batbileg, 7 (right, with Oyuntsetseg); a niece; and their large extended family that lives with them.

The family lives at the outskirts of Ulaanbaatar, Mongolia's capital and biggest city. The quarter-acre plot has two homes: Oyuntsetseg's western-style house and a traditional Mongolian *ger*, a tent-like structure with heavy fabric walls and a frame of lattice and wooden poles, which houses Batsuur's younger sister and her family. Lacking running water, Oyuntsetseg sends a weekly flotilla of children to bathe at the better-equipped home of a relative downtown—a trip the kids treat as a chance to play video games.

After rejecting a government job, Batsuur, 39, tried to set up a business importing goods from China, but failed. "At the beginning of the market economy," he says, "I had big opportunities and I just lost them." A former master builder, he now resells goods on the open market and works as an on-call carpenter. Still, Batsuur—like Oyuntsetseg—believes that in the long run, prospects for their future are bright.

Photographs by **LYNN JOHNSON** Interviews by **MADRIG MASHBILEG**

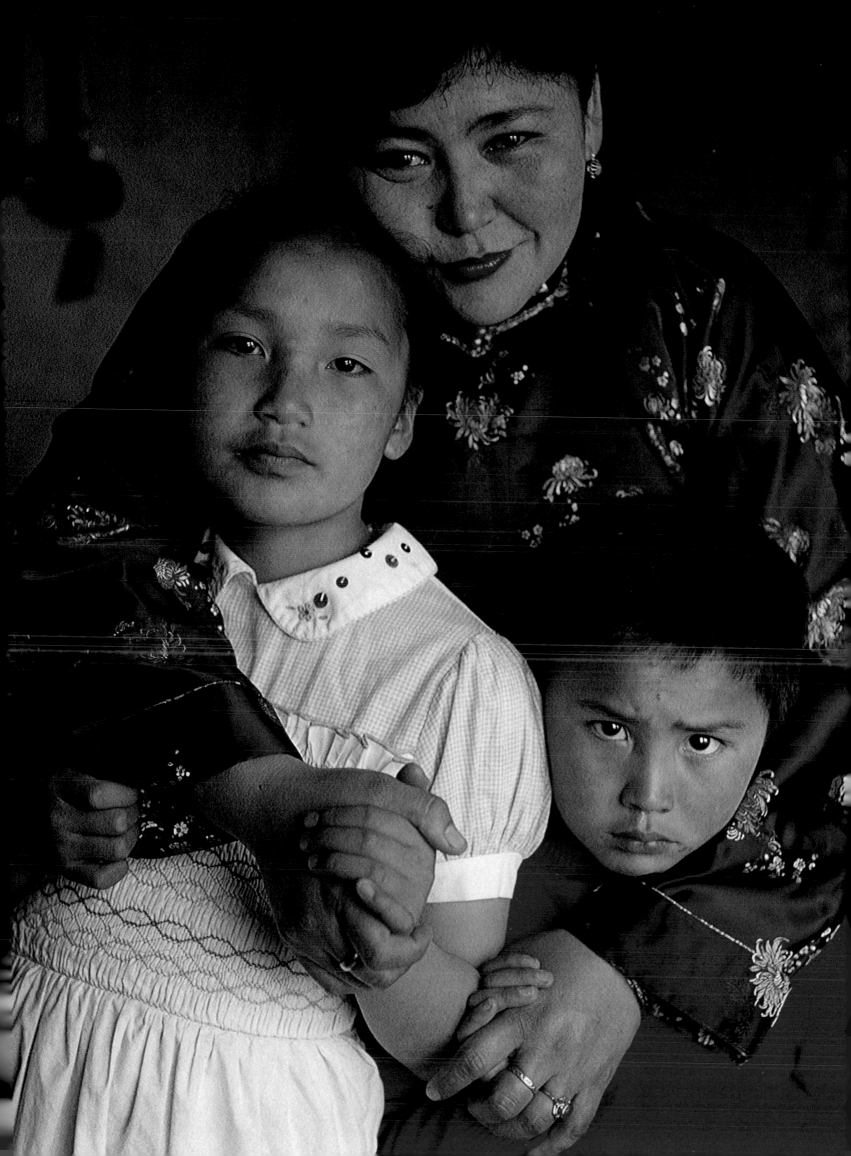

Family and Nation

Mongolia

Population: 2.3 million

Population Density: 3.8 per sq. mile

Urban/Rural: 55/45

Rank of Affluence among UN Members: 153 out of 185

Lkhamsuren Oyuntsetseg

Age: 33

Age at marriage: 21

Distance living from birthplace: Same city

Children: 2

Number of children desired: 2

Occupation: Pharmacist

Religion: Tibetan Buddhism

Education: Vocational training/medical school

Favorite subjects in school: Literature, history, and chemistry

Favorite task: Working at pharmacy

Least favorite task: Carrying water from the community water station

Monthly family income: Oyuntsetseg: 25,000 tugrik [US $55]. Batsuur: 150,000 tugrik on average [US $340]

Cost of 1 kilo of beef: 500 tugrik [US $1.15]

Cost of 1 kilo of camel meat: 400 tugrik [US $0.90]

Wish for her daughter: That she become a doctor

Wish for her son: That he become an engineer

Woman most admired: Miss Tsetsegma, a "nice, warm" Mongolian movie star whom Oyuntsetseg regards as a mother figure

Biggest dream: "To lose a little weight."

Conversation with Lkhamsuren Oyuntsetseg

Note: Oyuntsetseg and her husband, Batsuur, sat together during parts of this conversation. Because Mongolians' family names appear first, she is known as Oyuntsetseg, he as Batsuur, and the interviewer as Mashbileg.

Madrig Mashbileg: Was your mother's life different from yours?

Lkhamsuren Oyuntsetseg: I really don't know exactly what kind of life my mother led, because she passed away when I was very small. After I was born, I almost always lived with my grandparents. But I think [it was different], because when she was alive the economy and people's attitudes were very different. My mother lived in the time of the centrally planned economy, while I'm living in this free-market society—there's really been a lot of change. My mother worked for the state—she was a waitress on a train—and was paid by the government. I have to work very hard on my own to get a good salary to feed and clothe my children. But we are also able to do whatever we want to do.

How have things changed with the free-market economy, Batsuur?

Regzen Batsuur (husband): It truly changed our lives. We were not really ready for the free market and we didn't know anything about it.

Oyuntsetseg: I think that now we have a much better life. I prefer the free-market economy because you know that if you wish to have a very nice life you can have it, but to get it you have to be dedicated and have skills and knowledge. This economy gives you a lot of choices.

Oyuntsetseg, you live with a rather large extended family. Does this affect you financially?

Yes, it's difficult. We had Batsuur's sister and her two children living with us. She left just last month. And this year we've also had another one of my husband's sisters living here—she also has a child—and we have cousins living with us while they go to university. It's difficult, but what can we do? My husband has to take care of his family.

What do you think, Batsuur?

Batsuur: I don't think I would say that my family is leaning on our salary—because they usually contribute for their food and their electricity and everything else. We share all the payments together. So that's why it's good to live together—we can share all the expenses. On the

other hand, it would be good just to live alone, by ourselves with our two children. But it would be a bit more difficult, particularly in winter.

Do you have any savings?

Batsuur: Yes. From the first days of our marriage we saved some of our monthly income. At that time we thought it was a lot of money. But now we have such a high rate of inflation that all of our savings have turned to nothing.

Your new house is quite different from the *ger* [tent-like house] you had before. Was it hard to afford?

Oyuntsetseg: Batsuur did all the construction. We owned the land for seven years and had been saving our money and collecting building materials from our friends and other sources.

You've talked about wanting conveniences like indoor plumbing for toilets and bathtubs. Will you ever have them at your house?

I don't know. Sometime I will want to move from where I'm living now. Maybe go live in an apartment or have a bigger house—have better conditions. I would like running water and a central heating system. I think about getting an apartment and having a better future for my children—maybe in the center of the city.

I know you work in the city now. Tell me about your job.

My exact title is pharmacist, and I prepare all the medicines using the instructions given by the doctors ordering the prescriptions.

How did you decide to be a pharmacist?

From a young age I really wanted to be a doctor, but I could not pass the university examination, so I went to the medical college and got two years of training to become a pharmacist. Both of us, my husband and myself, we have vocational training education.

Do you want to get more education?

Yes, of course, I want more education, but now it is too late. You have to have time for this and I do not have the time. I would really like to see my children have more education than my husband and I have.

Do you think there will be a difference between your life and your daughter's?

I really would like to see a big difference. Now it is our time. It is not so difficult but it will be more difficult in the future. That is why we really have to work very hard and save some money for the future education of our children.

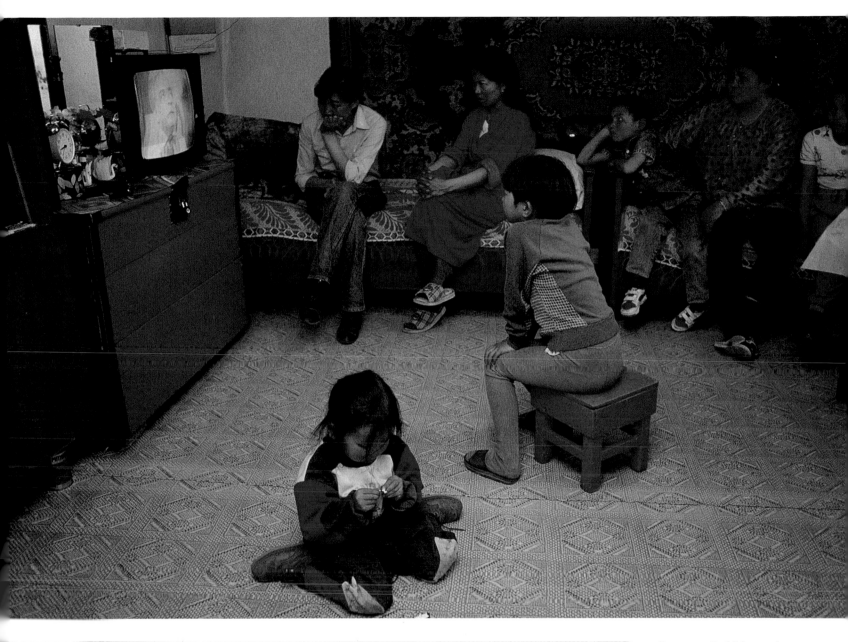

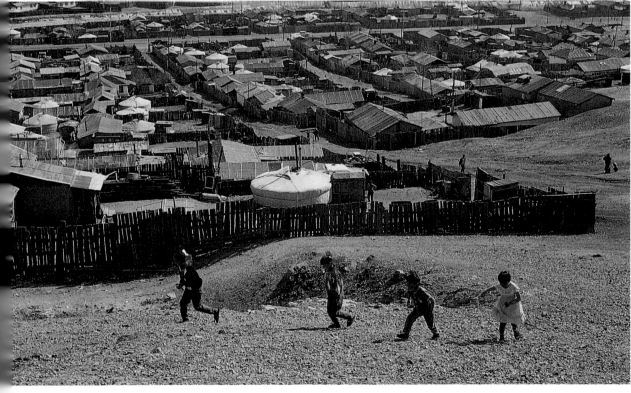

Oyuntsetseg's children and their cousins play on the slopes above the family compound (left, behind fence). The family lives in two residences: Oyuntsetseg's new, western-style house and her sister-in-law's traditionally styled ger—a round, tent-like structure with a design that dates back to Mongolia's nomadic traditions. Inside their houses the families gather on weekend evenings for a more modern tradition: watching the TV (above). They are not alone—the streets of Ulaanbaatar are deserted from 7 to 9 p.m. on Saturday and Sunday as the whole nation get its weekly dose of prime-time TV soap operas.

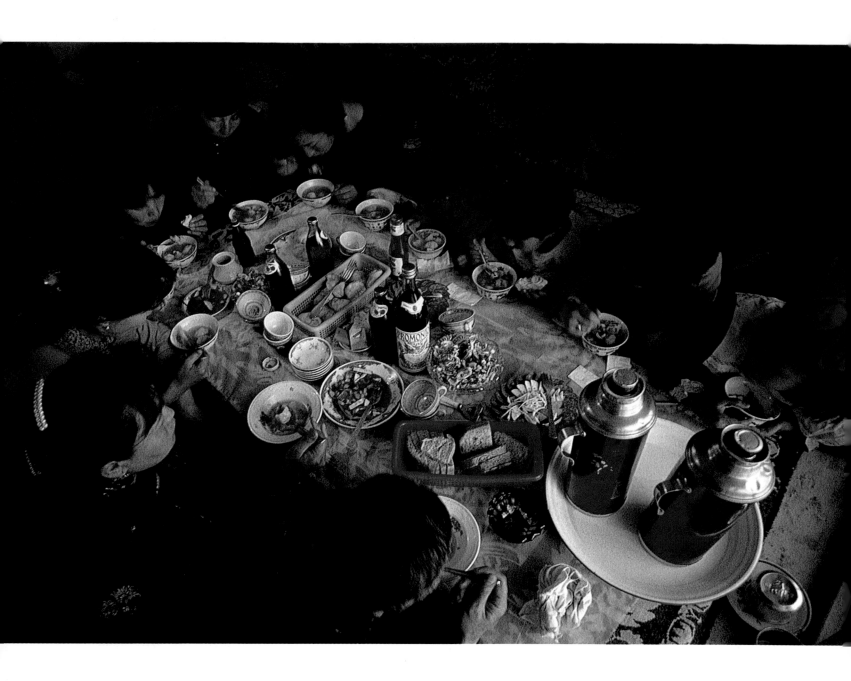

Oyuntsetseg and her extended family enjoy a lunch of soup and meat dumplings (above) at her home. Although the house is new—Oyuntsetseg's husband, Batsuur, built it a year ago—it lacks amenities like running water, much to her dismay. As a result, the children are periodically ferried over to a relative's apartment in downtown Ulaanbaatar for a hot bath (right). Shampooing themselves energetically are (left to right) Oyuntsetseg's niece Suvd-Erdene, 9; her son, Batbileg, 7; and her nephew Janerdunl, 4.

Mashbileg: What is your day like?
Oyuntsetseg: I usually get up early in the morning, at 7 a.m. I clean my home and prepare breakfast for the kids and for all the rest of the family. Then I go to the pharmacy and work until 6 p.m. I usually have lunch at the office and I come home around 7 p.m. There are a lot of people at home to help so dinner is usually almost ready. When my husband's not working, he takes care of the children and does some housework. We eat and then sometimes I rest for a while and maybe read the paper. Then I check my children's homework—I work with them—and then I sometimes wash clothes. My children go to bed at 10 p.m. and then around 11 p.m. I go to sleep.

How do you balance working in the pharmacy, your family, and your home?

Oh, I can tell you, I can manage it! I have experience!

What do you like to do for enjoyment?
Before, when I worked at my old job at the state pharmacy, I worked until 4 p.m. I had more time, so after work I liked to go shopping for clothes with my friends, or go to the cinema to see a new film. Now, starting only two months ago, I have a new job. [She runs her own pharmacy now with her colleagues from the old state pharmacy.—*Ed*] So at first I am hard working, but later I may have more hours to spend with my family and friends. Right now I am very busy.

How about your husband? What does he like to do for fun?
He likes to go to meet my friends with me, too.

Is there anything that you wish you could do more often?
Mostly have a rest at home because I work a lot.

Field Journal

Life can be a bit grim here. Finding a way to hold onto one's dreams, to occasionally lift oneself out of the daily drill is difficult. In the Batsuur family album, Oyuntsetseg (Oyuna for short) has pasted portraits of movie stars with uncles, cousins, and her mom, who died when she was only 8.

A surprise meeting we arranged was my favorite part of the shoot. We convinced Oyuna's "role model," a famous Mongolian actress, to meet us in the town square. Of course, I was acting the fool trying to entertain Oyuna across the language barrier —to hide the fact that the actress was walking toward us across the square. She was not deceived for long.

As soon as she recognized Miss Tsetsegma, she smiled. The two women immediately grasped each others hands, linked arms, and began to chat as if no one else in the world existed. They walked around the square talking all the while, stopping briefly for a photo. [p. 227] "I think of you as my mother," she told the stranger. The meeting was a gift for both women. Certainly the aging actress felt valued, and Oyuna was lifted from her daily routine by the experience—her dream came to life.

— LYNN JOHNSON
MAY

FOLLOWING PAGES

Suddenly losing his hat as a breeze gusts through the Soviet-style apartment blocks of Ulaanbaatar, Oyuntsetseg's nephew Janerdunl looks back in surprise as his mother, Ariunjargal, leads the family on the walk home from their relatives' house.

Women in Mongolia

In feudal, nomadic Mongolia, women milked the goats, cooked, cared for the family, and gathered dung for fuel. They sewed clothes, churned butter, made cheese, and preserved food for winter. Men herded the cattle and helped make felt for tent coverings.

These divisions of labor continued even after 1924, when a socialist government came to power with Soviet help and enacted a new constitution mandating gender equality. Although women were employed in the workforce in the same proportions as men, none became government ministers or high-ranking party officials, and because women dominated law, medicine, and teaching, these professions declined in status. Motherhood was encouraged: To raise the birthrate in sparsely populated Mongolia, the government offered women cash incentives for having numerous children.

In 1990, Mongolia became a free-market, multiparty democracy, and the transition has been painful. Unemployment, poverty, homelessness, and alcoholism have increased. Conservative notions about womanhood are gaining popularity, especially the idea that women should be concerned with the family rather than the political arena. The divorce rate is high, but many women get no alimony. Still, activists have begun organizing battered women's shelters and other women's groups, as well as pushing—with little success—for political changes like affirmative action for women.

Mashbileg: How did you meet Batsuur?
Oyuntsetseg: At work. His friend's car broke down and I was working until 10 p.m. He came into the pharmacy. It was cold outside, so he stayed inside for a while to be warmer. We talked and afterward went to the movies.
Batsuur: I was 28 years old, which is kind of late for a man not to be married. I remember that my parents were pushing me to marry, and that after I met Oyuntsetseg I told my parents that I had met a nice woman and that I was in love with her. They were pushing me to marry because they wanted to see their grandchildren. I got permission from my parents and after four months we married.
Oyuntsetseg: When I was to be married I had no one to give me advice. I had no parents so I just decided by myself. I was in love with my husband so I married him on January 15, 1983. I was 21. Everybody was happy that I married. They liked the match.

What was your wedding like?
We went to the place where marriages are registered and signed a paper. Then we came home and had a small party with Batsuur's parents.

Is marriage what you thought it would be?
Our marriage is fine. I am happy. I may be a little poorer than other people but I don't think about it. I am happy with my husband and my children. Right now, everything is okay in my life. Everything is as I want it.

Who makes the major decisions in your home?
We do it equally, but most of the time I make the decisions. Sometimes, if he makes good decisions, I will follow. [For example,] our refrigerator was damaged and we had to buy a new one. My husband wanted to buy a two-door refrigerator and I wanted a one-door refrigerator because it was cheaper. My husband insisted on the two-door refrigerator, but when we went to buy it, it was gone, so we bought the one-door model. It cost 165,000 tugrik [US $375]. I got what I desired anyway. [Laughs]

Do you think Batsuur sees you as an equal?
He's not really one to think that particular jobs are women's work. He helps me a lot and we usually share what we're doing in our home.

Is this true of all Mongolian men, Batsuur?
Batsuur: During my father's generation, women served men. The man was a very respected person in the family because he was the head of the family. But now it's really changing and sometimes I wonder who is the

leader—who is the head of the family. I think women's attitudes were really different then from women today. Over the last few years, I think relationships between men and women have changed everywhere, especially where there are a lot of people. Like, in shops or the black market, men and women usually fight a lot. They fight more than they used to.

Do men and women have equal rights now?
Batsuur: I think women have equal rights with men in this country on paper, but in reality conditions for women aren't really good, both in Mongolia and the rest of the world.

On a break from work at their pharmacy, Oyuntsetseg (left, on right) shares a chocolate bar with her co-worker, Gerelma, whom she calls "probably my closest friend." The two women worked together in the state-owned pharmacy that they now run as their own private business. They rent this space and sell drugs that they buy on the open market. Although only licensed pharmacists like Oyuntsetseg are supposed to sell prescription drugs, there is a black market for them—creating a risky situation for both pharmacist and patient.

Batsuur's amiability (above, being tested as his wife mischievously drenches him while he washes up in the sink) is one of the keys to what Oyuntsetseg thinks of as a happy, successful marriage.

Water

In affluent countries, safe drinking water is taken for granted —it is as simple as turning on a tap. But for much of the world, access to safe water can mean the difference between a family plagued by illness and one that thrives.

ETHIOPIA: Before leaving for school, Teshome Getachew washes his face with a cup of water as his sister Like ("*lee-kay*") pats mud and dung into the walls of their parents' house.

HAITI: Carrying a 5-gallon bucket of water, Madame Delfoart's oldest granddaughter, Lucemanne, and a friend make the daily 15-minute walk from the water hole to their home.

SOUTH AFRICA: In a nightly bedtime ritual, George Qampie is bathed before being tucked into bed by his mother, Poppy.

THAILAND: Standing just a few feet from the main road, Buaphet Khuenkaew pours well-water into a bucket. She will take the water into the enclosed family latrine and use it to take a standing bath—standard practice for the family, which does not have running water.

MONGOLIA: Because running water is not available in the Batsuur's neighborhood, Lkhamsuren Oyuntsetseg's cousins, who live with the family, make several trips a day to buy it at a public spigot. The woman at the window meters out the precious liquid.

JORDAN: One of the two toilets in Haifa Khaled Shobi's house is a Turkish toilet. The other is western-style.

BHUTAN: In a house with no bathroom or running water, Bangum and Choden try to make short work of bathing Bangum's little sister, Zekom, on the outside ledge of their house.

CHINA: Li Jianchun irrigates the family garden with water from the nearby fish pond.

INDIA: Mishri Yadav pumps water for cooking in the courtyard of her home.

MEXICO: Nayalit Castillo Balderas pours bottled drinking water as her brother, Marco Antonio, fetches a bucket of water from the cistern for the washing machine.

JAPAN: Under her mother's supervision, Maya Ukita takes her nightly bath.

Access to Safe Drinking Water
Percent of population, (urban / rural) 1990*

Albania	100 / 95		**Italy**	100 / 100
Bhutan	60 / 30		Japan	100 / 85
Brazil	95 / 61		**Jordan**	100 / 97
China	87 / 68		Mali	41 / 4
Cuba	100 / 91		**Mexico**	94 / 49
Ethiopia	70 / 11		Mongolia	100 / 58
Guatemala	92 / 43		**Russian Fed.**	n.a.
Haiti	56 / 35		South Africa	n.a.
India	86 / 69		**Thailand**	67 / 85
Israel	100 / 97		United States	n.a.

* Some reporting years vary. The World Health Organization defines reasonable access to safe drinking water in an urban area as access to piped water or a public standpipe within 200 meters of a dwelling or housing unit. In rural areas, reasonable access implies that a family member need not spend a disproportionate part of the day fetching water.

Source: *World Resources, 1994-95,* World Resources Institute.

ETHIOPIA

HAITI

SOUTH AFRICA

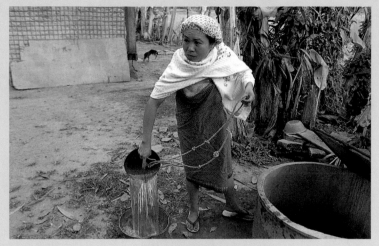

THAILAND

CHINA

MONGOLIA

INDIA

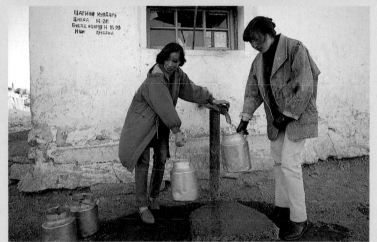

JORDAN

MEXICO

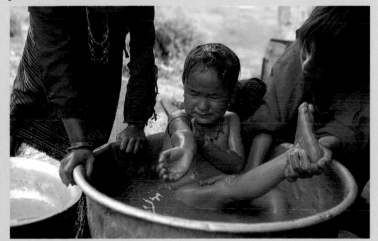

BHUTAN

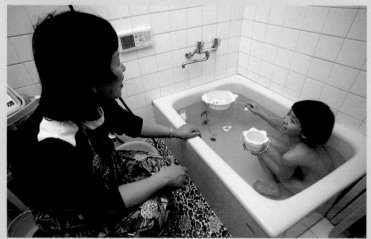

JAPAN

Russia
Zhanna Kapralova

*" I hope for a bright future, a really bright future.
I hope to stop being a working horse someday and
become a nice cat stretched out on the couch."*

ZHANNA KAPRALOVA'S HUSBAND, Evgeny, was murdered by unknown assailants on Christmas Eve of 1993. On top of the family's devastating loss, they suddenly had serious money worries. Without Evgeny's income, Zhanna, 38, and her daughters, Xenia, 15, and Anastasia, 8 (*right*, with Zhanna's visiting mother, whom the girls call *Babushka*—Russian for grandmother), must now live on a small monthly death benefit from the government and the meager salary—500,000 rubles [US $114] a month—Zhanna earns as a teacher of music and German in her town of Suzdal, 120 miles east of Moscow.

Still, Zhanna spends as much time with Xenia and Anastasia as she can spare from her work. A favorite family pastime is the kitchen garden; Zhanna and her daughters devote considerable time to raising strawberries, cucumbers, potatoes and other fruits and vegetables that provide vitamins they might not get otherwise. Though she has little free time, Zhanna recently joined a quilting circle, companionably meeting with friends once a month to talk and sew.

Both of Zhanna's daughters work hard at their studies—partly because of their mother's deep belief in the value of education. Learning is power, she tells them, especially for women. When she has a little extra money, she pays for extracurricular art and music classes for the girls. She hopes that education will ensure stable livelihoods for her daughters in the scary uncertainty of contemporary Russian life.

Photographs by LYNN JOHNSON Interviews by LUDMILLA MEKERTYCHEVA

Family and Nation

Russia

Population:
147.5 million

Population Density:
22.4 per sq. mile

Urban/Rural: 73/27

Rank of Affluence among UN Members:
64 out of 185

Zhanna Kapralova

Age: 38

Age at marriage: 21

Distance living from birthplace: 250 miles

Children: 2

Number of children desired: More, if life were better

Age at husband's death: 36

Occupation: Music and language teacher

Religion: Christian Orthodox

Education: College

Favorite subject in school: German and Russian literature

Monthly family income:
500,000 rubles [US $114], includes salary and death benefit

Cost of a kilo (2.2 lbs.) of sausage:
20,000 rubles [US $4.50]

Amount of income spent on food: 70%

Fervent desire: Work less, earn more, spend time with children

Greatest pleasure (and necessity): Kitchen garden

Biggest concern: Instability of Russian life

Least favorite activity: Trying to figure out how to make ends meet

How different parts of life are balanced: "By running from one to the other."

Conversation with Zhanna Kapralova

Ludmilla Mekertycheva: Tell me a little bit about your family, Zhanna.

Zhanna Kapralova: My mother was 30 when I was born. My father was 32. I was born in a village called Yar in the Kirov region [about 300 miles northeast of Moscow]. My mother is a librarian by training, but she did not work while she had kids. She only went back to work when we all grew up and went to school. My father was a railway engineer. I have two brothers.

Were you treated differently than your brothers?

Yes, of course. I was treated like an only daughter and beloved child. I was quite the spoiled child of the family, but I should say that my parents shed enough love on the boys, too. They were not deprived. My mother is a very loving person.

It sounds like you really love and admire your mother.

I think that Russian women like my mother have always been the real support of this country. She is such a resourceful, loving laborer, an industrious woman. She has enough love for everyone; she is prepared to work day and night to see her family happy. She is so energetic; she is so industrious; I really want to be like her.

What did your parents expect of you?

My parents' expectations for me were quite different from what I actually became. Since I was good at mathematics, my father hoped I would become an engineer. My mother wanted to see me become a doctor so I could take care of them when they were old and ill. But I became neither an engineer nor a doctor, I became what I myself wanted to become. I loved music and I decided to devote my life to teaching. I really love teaching and am happy with my profession. And my parents, even though their expectations did not come true, they still think that I am well-educated and have joined a noble profession. My parents were also very happy with my marriage. They liked my husband, Evgeny; and they love my family and they thought that it was quite a happy marriage, which it really was.

Did you always want to get married?

When I was 17, I thought I would never get married. It was not a major goal in my life.

How did you meet Evgeny?

I saw his photo once and liked his face. And

then, a year later, I actually met him. And three days after that, my husband was talking about love. When we got married we had a traditional feast—a two-day party.

Did you get pregnant soon after?

A year later. Actually, I was pregnant six times [altogether]. First Xenia. Then after Xenia came, I had two abortions. Then I had Nastia [Anastasia]—then two more abortions. So two children survived, and I had four abortions. My two kids were planned kids. The rest were...out of schedule, that is why they did not survive. Sorry, I think God will forgive me.

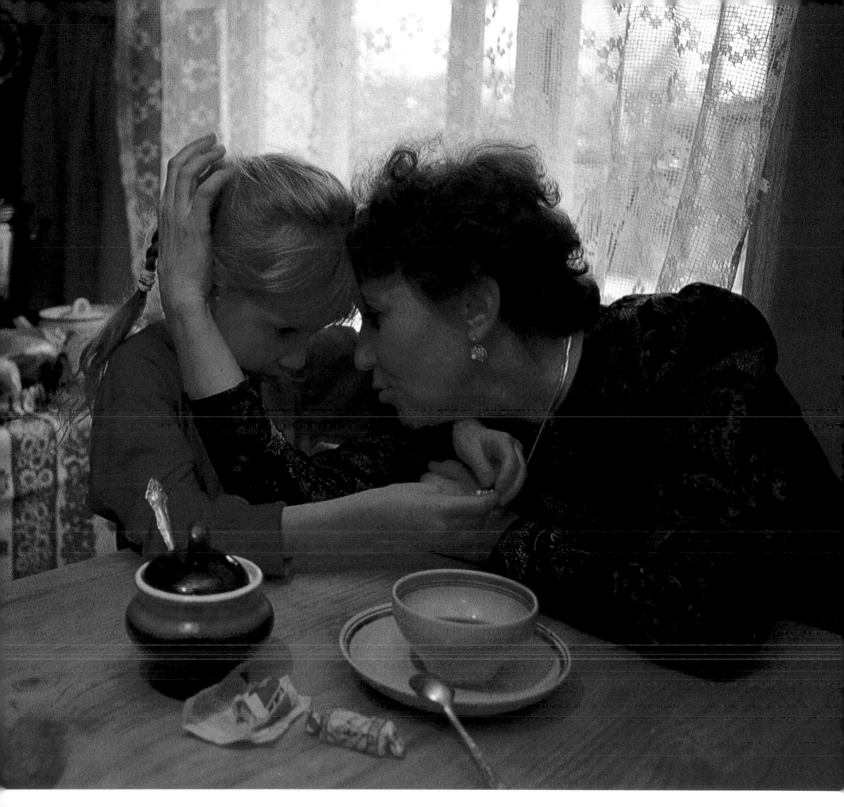

It's 7:05 in the morning, and Zhanna and Anastasia, 8, begin the day by exercising (left) to the instructions of a televised exercise show. Soon after, they will head in different directions: Anastasia and her sister, Xenia, 15, to the public schools in their town of Suzdal, and Zhanna to teach music at the Children's Music School, and German at Boarding School No. 1, a local institution for troubled children. The routine of exercise, breakfast, and school is broken only by vacations and childhood illnesses—as happens a few days later when Anastasia comes down with a cough and a mild fever. To comfort her, Zhanna stays home as late as she can (above). But eventually she has to race off to her job.

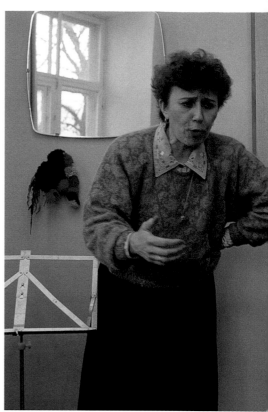

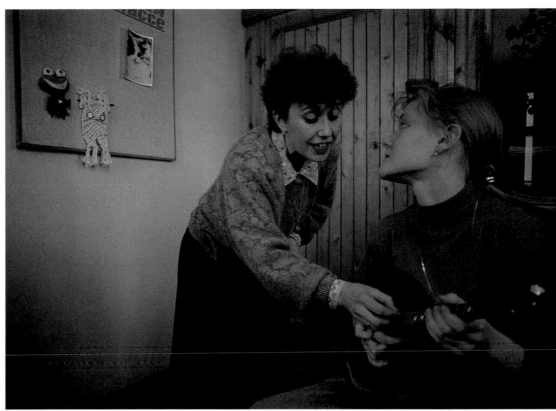

Ludmilla: Xenia, I know it must have been very hard for you to lose your father, but I would imagine it must have been equally difficult to see your mother lose her husband.

Xenia Kapralova (oldest daughter, 15): Mother had to become the head of the family when my father died. It has been really hard for us but she has been the one that must hold the whole household on her shoulders, and us, too. My mother is very attentive to me and we are good friends. Sometimes we quarrel, mainly about Nastia. [Laughs] My mother thinks that I do not spend enough time with my sister, and that I do not care about her as much as she thinks I should. The main thing that Mother does for me, she is my great friend and my great support. I can ask her any question, I can ask her for any advice, and every time I am sure that she will not scold me or say, "Get away with your questions, I have no time." She will listen to me and give me some wise advice. Also, she helps me with music and with my homework. Sometimes she helps me with mathematics, sometimes with other subjects.

So your mother helps you with everything, it seems? How do you help her?

Xenia: First of all, I help her with the household. I should say I am quite a conscientious daughter. My mother works at two schools. I realize that she does not really have a lot of time because of these two jobs, so I try to do whatever I can to ease her burden somehow. I have to wash the dishes, clean the house, and shovel the snow. I have a lot of work in the kitchen garden; I take care of Nastia, my sister. But the main thing I try to do for my mother is not to disturb her, not to make her unhappy by doing badly at school.

Your mother says you are quite a good student.

Xenia: [Laughs] At the moment I am reading Tolstoy's *War and Peace* for school. It is not really fun to read this book, but I have to read it anyway. Mathematics and subjects that are connected with it, like physics and chemistry, are not my favorite subjects and I do not get really good grades. But humanities, like literature and the English language, I get high marks in these subjects.

What are your plans for the future?

Xenia: I would like to enter some institute or university, though at the moment I am not sure I will be able to because the competition for free education is very tight. We have started to have to pay tuition these days but you also need to pass exams. I would love to study more history and the English language.

At the music school, Zhanna (above) teaches a student how to play a domra, the mandolin-like Russian instrument used in traditional folk songs. On another day, Xenia (left, typing) works on a different sort of instrument —a computer at the local community center. Along with reading, her weekly computer class is her favorite activity. Even though she doesn't own the computer, Xenia considers it her most prized possession.

FOLLOWING PAGES

On a crisp winter day, Anastasia (on right) and three of her friends rest at the side of her house after several hours of playing in the snow. The traditionally styled trim around the windows was made by Anastasia's father, Evgeny, before his death.

Ludmilla: Zhanna, is religion important to you?

Zhanna: There were times when I used to go to [the Russian Orthodox] church every Saturday. These days I cannot do this because I don't have the time. Sometimes, though, whenever I have a free hour during the week, like when I'm running from one school to the other, I drop by for a minute to light a candle and pray a little while for Evgeny. Religion is important for me, but I cannot say that I am a deeply religious person—someone who attends church regularly, prays regularly, and follows all the traditions and ceremonies and customs and so on. You have to bear in mind that we were brought up as atheists, and of course this has had some certain impact. Still, everyone in my family was baptized. We got Nastia baptized when she was 11 months old, at the same time my husband and Xenia also got baptized.

I know that as a teacher you place a lot of importance on education. How important is literacy to you—especially for your children?

Well, first of all, I should say I am really crazy on literacy. I think that all people should know their native languages well. This is why Xenia joined the club for young journalists. I think it is very important for her. Maybe she will not become a journalist in her life, I do not know, but I know this will help her to know her native language.

Do you have specific hopes for Xenia and Anastasia for the future?

It is very difficult to talk about this. They are young children. First of all, I want them to get a very good education. This is what I want for my children first of all. I would very much want them to find their own niche in this world. At the moment, I think that my oldest daughter is going to put her career first. She has a lot of ambition. As for my younger daughter, I think her career is going to be the career of homemaker. But let's see what happens. Maybe my youngest daughter will change radically, dramatically, by the age of 15 or 16. I would not like to see them occupy themselves solely with their families. I would like their interests and ambitions to be greater than simply getting married.

What about you? Are you earning enough money to support your family?

For existence, yes. For life, no. We are not starving. We have enough money for this kind of life; we spend exactly the amount of money I earn. I have money only for food. Sometimes I

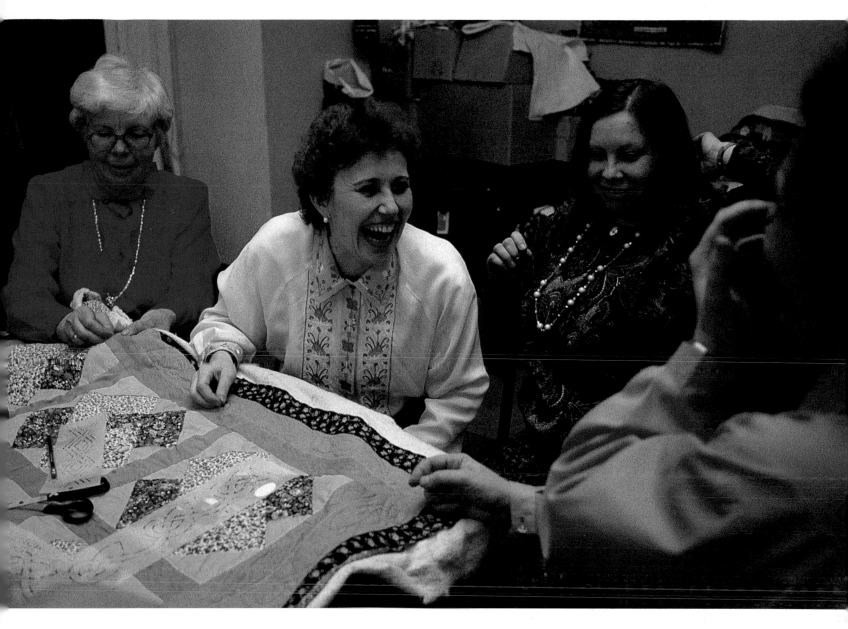

Part of Zhanna's precious free time is devoted to her close-knit quilting circle (above) which she has joined to help fill the void left by her husband, Evgeny's, death. Evgeny remains in the hearts of Zhanna and their daughters and they make time to visit his gravesite (top left). On their frequent visits to the site, the family lights a candle for Evgeny's spirit and places food on his grave. Each day, Zhanna says, brings reminders of his death, such as the repairs to the house that they were going to complete together (bottom left, Zhanna fixing her hair beneath a ceiling patched with magazine pages).

manage to save some money for the kids to buy some shoes or clothing. But if I want, say, a video camera or a new car to be able to take the kids to a picnic somewhere outside the city, I know that I do not have the money and that I will never have it. It would be nice to work a little bit less, and to be paid a little bit more, and to spend more time with my kids and friends.

What do you hope for yourself for the future?

I hope for a bright future, a really bright future. I hope to stop being a working horse someday and become a nice cat stretched out on the couch.

Field Journal

Everywhere Zhanna turns, she says she meets emptiness. The ache of Evgeny's loss just gets deeper. She is trying to be strong for the children and the children are trying to be strong for her.

The frenzy of the daily routine takes up most of her energy. This woman races through her days and the days are long. When I left the house one evening, it was almost 10 p.m. and she and the girls were still making cookies.

One evening we went to Zhanna's quilting club. It was difficult to get these women to speak generally about the condition of women in Russia today. Perhaps it is the old fear of speaking out or perhaps it is the depressing nature of the topic. But some of the women at the club did tell me that conditions in Russia are so difficult that they had to join together to give their souls a rest. One woman said, "Now the country is on the edge, and it is only the women of Russia that keep it from falling into the pit." As I watch Zhanna and other Russian women in their daily life, such sentiments ring absolutely true.

It is in the realm of family that these women seem to have remained strongest. Their roles as caretakers are of great importance to them. "A Russian woman is so resourceful," one adage goes, "that she can make candy from shit."

— LYNN JOHNSTON
FEBRUARY

"I don't really have time for leisure," says Zhanna, whose days are crammed with a full teaching load, the needs of her children, and a mountain of housework—all of which threaten to overwhelm her at times. Her girls help as they can, but ultimately, it's Zhanna who is responsible for making a life for her family. "By the end of the day," Zhanna says, "I am so exhausted."

Ludmilla: What do you do in the summer vacation, when you're not teaching?
Zhanna: In summer, we go to the river, which is very close to our house. Sometimes a couple of times a day, just to swim, to refresh ourselves. In the evening we take a long walk down to the Intourist Hotel, which last year started a new program for talented kids. Some kids are outstanding musicians, some kids are outstanding designers, and almost every evening they have a concert in the Intourist Hotel. My kids and I like to go there and listen to young

musicians. And sometimes we go to the forest to pick berries and mushrooms.

But these are all occasional things. A major part of my time is occupied by the kitchen garden. This is the place where I can combine pleasant things with useful things. I can put on my swimsuit and get tan while I weed or water vegetables. The size of my kitchen garden is 40 meters by 40 meters. I grow a lot of vegetables there as well as fruits and berries. I grow potatoes, tomatoes, onions, red beets, and carrots.

All these vegetables take a lot of care, of

hurry into the garden to take off all the blankets, and if it is balmy, open the doors of the greenhouse, and maybe even take off some plastic to expose the plants to the sun. My vegetables are normally protected by this plastic up 'til the middle of July. Watering and weeding take a lot of time. But in fact everything in the garden takes a lot of time. Only weeds grow everywhere without any care.

With your work and your garden and your music, do you feel like you've been able to fill up some of the empty places in your life?

Are you asking me if I would I like to get married again? My answer so far is no. I have not yet forgotten my poor husband and so far I do not want or really need anyone around, and I do not see any candidate—although a lot of people say that I have boyfriends. Oh my God, they should come and check for themselves! I do not really have anyone, and do not intend to, because it is a difficult situation. I have these two kids who have been spoiled too much by their father.

What do you mean?

Their father was such a loving man—I remember them crawling over him, you know, sitting on his knees. I remember him sitting with Xenia, helping her with mathematics. I think that one of the reasons why Xenia now sometimes gets bad grades in math is that her father used to help her a lot. Sometimes he would explain things to her again and again, but if he saw that she still did not understand, he would just solve all the problems and Xenia would copy what he wrote. I got really angry about this and tried everything to stop it. I kept trying to tell him that he was spoiling the child rotten, but he used to answer that Xenia needs some rest, and if she didn't understand something today, she would understand it tomorrow or when she grew up. You know, all four of us were together all the time—like working in the kitchen garden, even the little one, Nastia, would always be with us there, helping with something, maybe just picking up worms and giving them to the chicken. But anyway, the kids got accustomed to having a loving father, and I am not sure that I can find a substitute for them. As for my private life, it isn't easy. The kids are the main obstacle [to finding someone else], as well as my heart, which is not yet free.

Women in Russia

The transition to a market economy has been devastating for many Russian women. When factories closed and workers were laid off, women were first to lose their jobs, along with access to health care and benefits like maternity leave. State-sponsored daycare and high-quality education are no longer widely available. Women workers now earn just 40 percent of men's wages—down from 65 percent—and are much more likely to be unemployed. Formerly, 35 percent of legislators were women; now the figure is just 10 percent.

Under Communism, women had limited access to birth control, so to control their fertility, they often had multiple abortions—an average of four or five per woman. Millions of men were killed during Stalin's purges and World War II, leaving a huge number of widows, and a shortage of men that continues even today. As heads of households, women struggling to support themselves and their families may take any jobs available. One of the fastest-growing Russian businesses is schools for strip-tease artists, which women desperate to earn valuable foreign currency sometimes go into debt to attend.

There has been a resurgence of traditional gender roles at the same time that the women's movement, which began in the 1860s, has made a comeback. But this is not such a contradiction: In Russia, a "feminine" woman is not docile or passive; she's seen as someone who's strong and capable of shouldering the burden for her family. Women do most of the household work, but they also have the power in the home.

course. Growing vegetables in this climate is not easy. I normally start them in a small greenhouse. It's not a real greenhouse, this is just a small place that is sheltered with polyethylene film—like windows—and under this polyethylene I start growing tomatoes, cucumbers, and peppers. It's how I try to protect the young, weak vegetables from icy rain or snow, which can even happen at the end of May. Sometimes the night is so cold I have to put blankets or some other warm stuff on top of the greenhouse. Then in the morning I have to

South Africa
Poppy Qampie

"They did train me last year. I got a certificate — 'Introduction to the Computer.' But I took only that course. They ignored me when I asked to continue."

POPPY QAMPIE MAKES TEA, PREPARES lunch, runs errands, and does general cleaning (*right*) for the staff at a computer training center in Johannesburg. The job is frustrating, but she needs it; her husband, Simon (*inset*, in wedding photo), was a cashier at a discount store, but was fired more than a year ago because his employer believed he had deliberately undercharged a customer. While fighting this charge in court, Simon, 51, has a temporary job as a utility meter reader, but finances are still tight.

Just before Simon lost his job, the family moved from Soweto, where they lived with Poppy's mother, to a rented house in Thokoza, a suburb on the other side of Johannesburg. They spent a lot of money to furnish their new house—contracting a debt that now burdens them. Ultimately, Poppy, 37, was able to negotiate a deal in which her employer took over the credit payments, debiting Poppy's salary until the money is paid off. Although Poppy is happy with the arrangement, she and Simon are going further into debt to buy food and clothing for their children: Pearl, Irene, and George, and Judith, who is Simon's daughter from a previous relationship.

As uncertain as Poppy is about her own future, she is optimistic about the future of her country. A member of the African National Congress Women's League, she was excited to vote for the first time in her life in April 1994. Life, she thinks, will get better—slowly.

Photographs by MELISSA FARLOW Interviews by VIVIENNE WALT

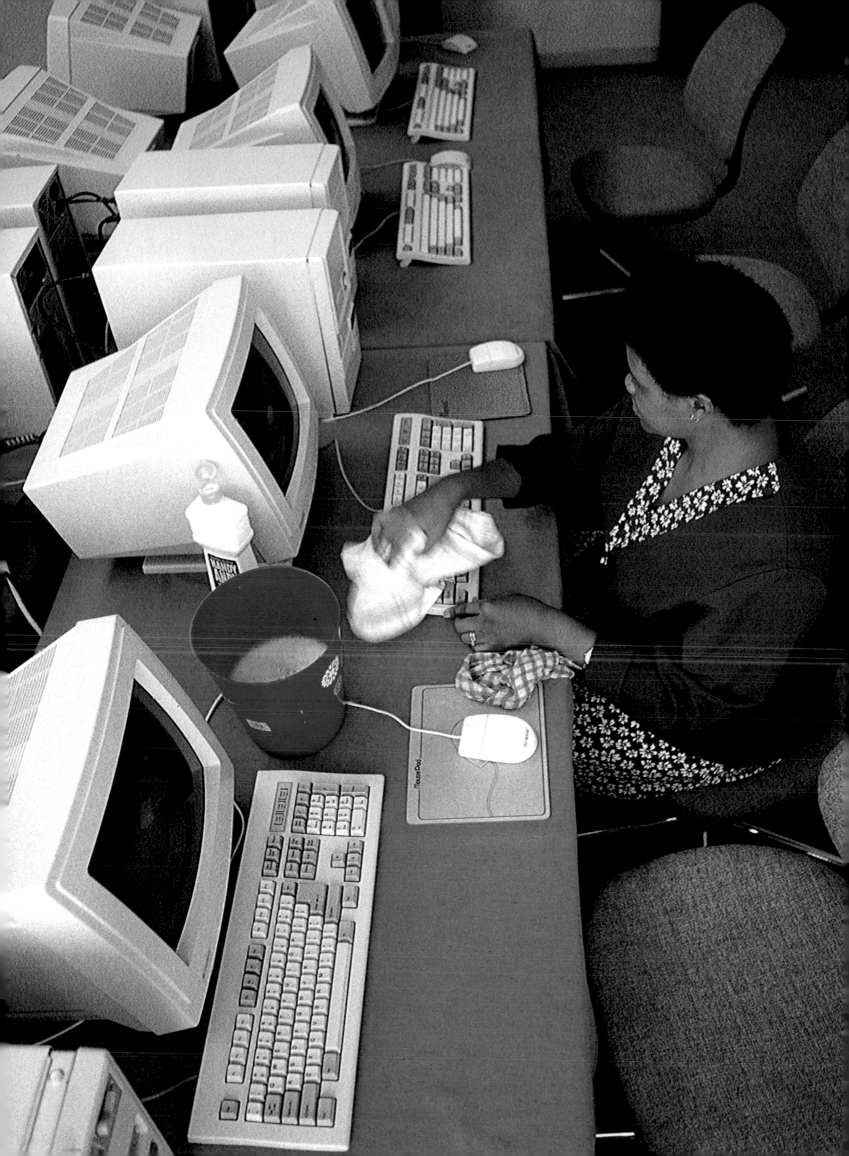

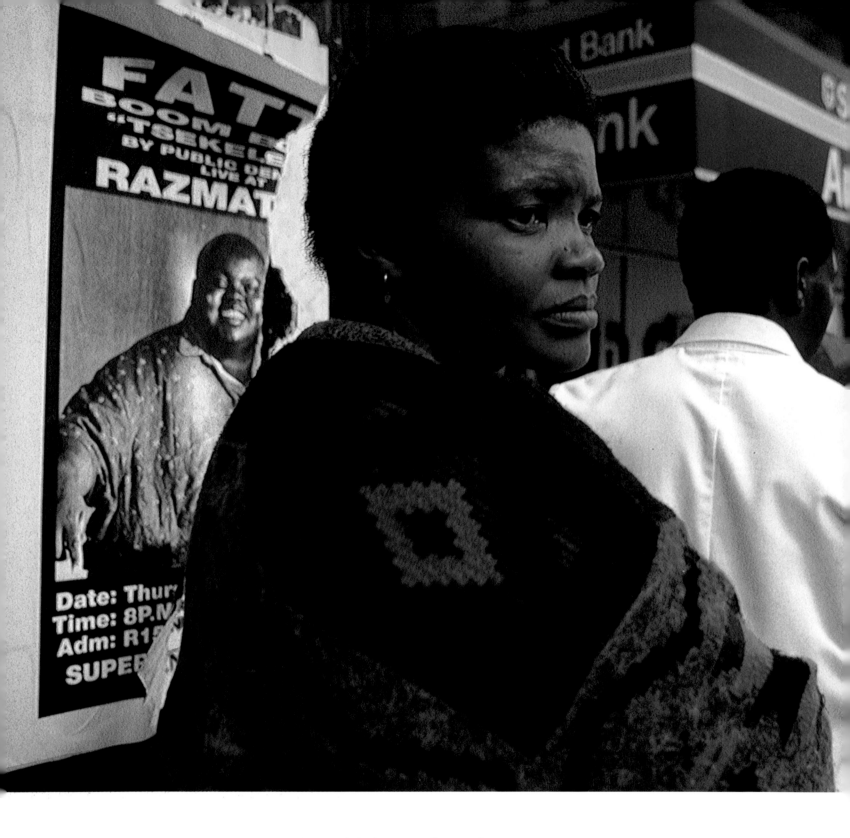

Conversation with Poppy Qampie

Waiting in line for the automated teller machine on a busy Johannesburg morning, Poppy takes care of the banking business for her employer, along with some personal financial transactions for her boss. When she returns to the office, she will make lunch for the rest of the staff— part of the myriad of small domestic tasks she performs as an office assistant.

Vivienne Walt: After you left school at the end of standard eight [equivalent to tenth grade in the United States], where did you go to work?

Poppy Qampie: My first job was as a cashier. When I started, I was earning 400 and sometimes 450 rand a month [US $120–135 at current rates], something like that. I worked there for five years, I think. I worked at a market for a year after that. I was a cashier there as well. By that time, my salary was about 700 rand [US

$210]. I left because I didn't like how they treated us. They were always sending out routine warnings because they said the money was short in the till, and I didn't know how that could be, because I gave people the correct change. I didn't know what was happening so I decided to leave. Then I worked at a chemist [pharmacy] in Johannesburg as a cashier for three years. It was a better job, but I left because I had to work Saturdays. I didn't get any chance to do anything. After that, I began work for a

Could they train you to work on computers?
Last year, they asked me if I wanted to do something else. They said I had to tell them what I wanted to do. I told them that it would be better for me to learn about computers, so I could help them train people.

What happened?
They did train me last year. I got a certificate—"Introduction to the Computer." But I took only that course. They ignored me when I asked to continue. And I started to think that they didn't really want to train me, because maybe I would use the training to leave them and get another job—a better job.

Well, would you?
If they would offer me a better job there, I wouldn't leave. But if I kept doing the same job, I'd have to leave because of the training I got.

After they ignored your request for more training, did you ask them again?
I didn't try to.

But why—were you worried that if you asked them too much, they'd think you were getting ready to quit?
Yeah, that's why.

You're looking for training—do you think you would like to go back to school?
I am thinking about that now. I want to go further to continue with my studies, if I can get afternoon classes. But I don't want to leave work. I want to work and do the studies.

Does it cost money?
Yes, it does cost money. I was willing to start this year, so I asked them to send me a brochure so I could see how much it cost. I couldn't afford it. Maybe I'll start next year.

So education is important to you. Does it bother you that Judith, Pearl, and Irene missed school because of the political upheavals?
They had to repeat one standard [grade] because there were riots. They were in school, but most of the time they weren't able to attend class, so they couldn't keep up their studies. They can't write well now because this happened.

Do you think now that there is a new government your children are going to get a better education?
We think so. We don't know. They told us that it will be better. They call meetings and then the teachers tell us that the education is going to change. But I don't know. We don't see any changing.

personnel company. I found the job through Simon. My boss, Anne, she was always going to the [discount store], and she knew Simon because he was a cashier there. Simon said to her, "My wife wants a job. Can you offer her something?" She said I had to come in for an interview. I did and they took me. They began [offering] computer training when I had been working there for three years, and Anne, she was in charge of the training department.

Family and Nation

South Africa

Population: 43.5 million

Population Density: 92.3 per sq. mile

Urban/Rural: 63/37

Rank of Affluence among UN Members: 58 out of 185

Poppy Qampie

Age: 37

Age at marriage: 22

Distance living from birthplace: 2 hours by taxi to Killarney (Soweto)

Children: 3 (and one stepchild)

Number of children desired: 2

Occupation: Office assistant

Religion: Dutch Reformed Church

Education: Standard eight (grade ten)

Literate: Yes. Simon is also literate

Currently reading: Daily newspaper—*The Sowetan*—and her Bible

House: Rented monthly for 300 rand [US $ 90], but hoping to buy it someday

Cost of a doctor's visit: 55 rand [US $16]

Favorite activity: Watching television

Favorite television show: A US soap opera, "The Bold and the Beautiful"

Proudest accomplishment: Staying married, having a family, and a better house for them to live in

Women most admired: Winnie Mandela and Albertine Sisulu

Dream for daughters: To be educated so they can look after themselves

Biggest hopes for future: To study and to own a car

Women in South Africa

When 20,000 women of all races took to the streets of Pretoria in 1956 to protest laws limiting black women's freedom of movement, the government backed down, waiting another seven years to make such laws compulsory for women. Though not always so successful, women were often at the forefront of the struggle against apartheid.

A coalition of women's groups formed in 1992 helped pressure the African National Congress to honor its promises to include women in the newly-elected democratic government. As a result, South Africa ranks 11th in the world in women's political representation, with women constituting a quarter of the new parliament. Laws which declared women legal minors, gave husbands sole property rights, and restricted inheritance for women have been repealed. Still, women experience job discrimination, income disparities, and inequalities in household divisions of labor.

Black women in particular are still reeling from the effects of apartheid, which forced many families to separate, and restricted most black women to employment in the informal sector, and as domestic workers—South Africa's second largest workforce.

Women make up as much as 45 percent of South Africa's labor force, and working women in trade unions have called attention to issues such as unequal pay, sexual harassment in the workplace, maternity and paternity leave, and the domestic division of labor. Nearly a third of black women earn less than 500 rand per month [US $150]; fewer than a quarter live in homes with running water, and not even a tenth have finished high school.

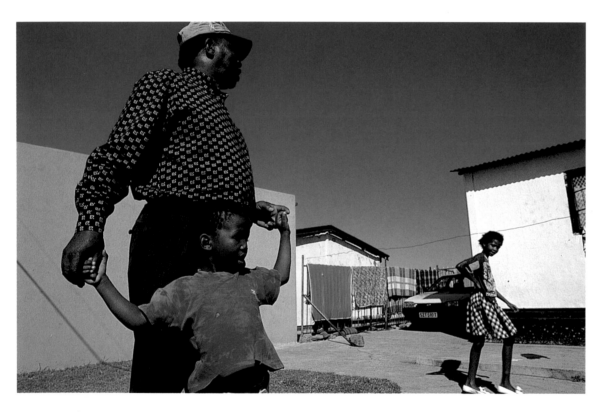

On Easter Sunday, the Qampies take a taxi to Poppy's mother's home in Soweto where the family lived until last year. While Poppy and her mother, Leah, cook in the kitchen, Poppy's husband, Simon, plays with his nephew Mateo, 4, whom he treats with great affection (top left). This Sunday, the family did not attend services, although Poppy was raised in the Dutch Reformed Church and considers herself religious (left, Poppy praying before bedtime).

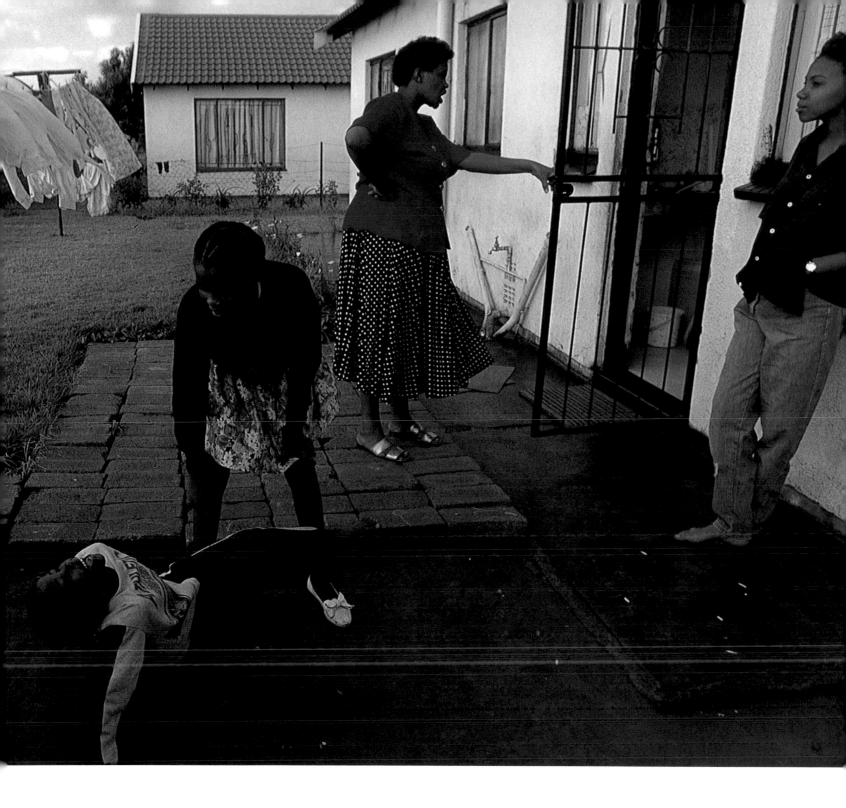

Vivienne: You were telling me that men are happier when a newborn baby is a boy than when it is a girl. What about women?

Poppy: They also feel happy, but men, if it's a boy—ooooh! They are more happy.

Is there a bigger party if it's a boy?

Yes, they will buy you a present and do better things for you than if it's a girl.

Does the extra regard for men continue on as people grow up?

Yes. The men are treated with more respect. The man is the head of the house so you have to get permission from him if you want something. [My husband] is the one people would first ask permission from before they come to me.

So, is Simon head of the house here, or do you share responsibility?

We normally share, but not everything. Mostly I must first ask for permission from him. It's difficult, because in our tradition men don't let you do things for yourself. Your husband must allow you to do something. There are things [Simon] says he doesn't want me to do. We've got a women's club so sometimes we go away and come back late. When we come back, he's mad. He says he doesn't want a woman to go around and come back late.

Is he worried about your safety, or because you've not cooked dinner?

He's worried about my safety.

Standing on the doorstep of their home, Poppy (above) organizes the family for a visit to the house of Simon's sister, which is a short distance away. As her mother issues instructions, Pearl, 16, leans against the house, ignoring the antics of her younger siblings, George, 6, and Irene, 12.

Coming into her boss's office (above left), Poppy offers a cup of tea. Her job at the personnel-training firm is to run errands and make meals for the staff.

On the weekend, Poppy prepares to serve a lunch of beans, rice, and chicken at a gathering at Simon's sister's house (above right). Poppy's family lives close by; however, they will return home before dark because, Simon says, the streets aren't safe at night.

Vivienne: Poppy, how old were you when you got married?

Poppy: When I got married, I was 22. I met Simon here in Johannesburg where we were working. We went out for a year.

Did Simon pay a bride price?

Yes. It was 1,500 rand [US $450], that went to my parents.

What was your wedding like?

We went to the church in the morning, and then after church we went to the park and took photos. After that we came home, and we invited our friends and everybody to come and join us at our home. We slaughtered a cow [for the party]. There were 100 people there. We just invited the neighbors, but the others— when they came down the street and saw there was a lot of people, they just came in. In our country we do that. If I know you and you didn't invite me, if I see that it's Poppy's wedding, I just go in.

Would it be okay if Pearl decides she doesn't ever want to get married?

If she decides that, it's fine. I wouldn't really mind because men—whoa, do they bring a lot of trouble! I wish I were single. I couldn't make it because I was pregnant already. I had to get married to this man.

How would you feel if Pearl got pregnant with no husband?

I don't know what I would do. I've told her I want her to stay in school to get educated. She can get married when she is 25, after she has finished everything. She must be educated. It's so important because I didn't get to do it. I wanted to get educated but I couldn't.

If Pearl did get pregnant, what would you say about her having an abortion?

I would not tell her to have an abortion. She must be responsible for the baby, because she wanted to play. That's the lesson—you run after the boys, you might get pregnant.

Vivienne: Simon, is there anything that you would like to change about the way men and women deal with each other?

Simon Qampie (husband): Yes, when you are talking with your wife, you must call [her] in your bedroom and sit down and talk together—not in front of your kids. That's bad. If I am angry, the best thing I can do is take my spade and do the gardening. And after that, come back and buy a cold drink and play with my kids.

What do you and Simon fight about, Poppy?

Poppy: Maybe we don't understand each other. Sometimes if I don't want him to do something, he does it anyway—like drinking. He does it, but I can't stop him.

Has there ever been a time when you thought that you would divorce?

No, I don't think so because the children, they want their father and their mother together.

Field Journal

When Poppy makes her office's morning bank deposit in downtown Johannesburg, she warily watches to the left, the right, behind her. Simply walking with her, I attract attention—any foreigner would. A woman who passes Poppy whispers that she better hide my camera for me or it will be gone. Poppy stops abruptly at the corner, demands I put the camera in her bag, and tells me to return to her office. Poppy herself slips easily into the crowd.

Poppy moved to Thokoza from Soweto last year because they thought the schools were better and the streets safer. They rented a much bigger three-bedroom ranch house with indoor plumbing and a modern kitchen. But they didn't get better schools or safer streets. The family reverted to old Soweto habits for safety. No one is allowed outside after 6 p.m. Locked inside with their TV, the home becomes a fortress for the night in a suburban neighborhood where burned-out homes are reminders of South Africa's history of racial tension.

On Easter Sunday, I shared a room in Thokoza with Poppy's two youngest children, George and Irene. Soft little child snores came from the single bed three feet away. It was so bright from the outside security lights that I could almost read a book in the "darkened" room.

Staying with them, it seemed to me that the strongest bond between Simon and Poppy is their children. Uncertain about South Africa's future, they ask me to take one of the children home. "Take any one of them," Simon urges while Poppy looks on. "Take them to America and educate them."

— MELISSA FARLOW
APRIL

Friends

Friends are often of special importance to women because they can be a source of comfort and solidarity in cultures that stack the deck against them. Almost every woman interviewed could come up with the name of a woman they were close to, and to whom, as Guo Yuxian in China put it, they could "show their heart."

HAITI: A happy visit for Mme. Delfoart—Mme. Akseus, her best friend, is paying a social call. The wife of the pastor of the Delfoart's church, Mme. Akseus (on left), is an energetic woman whom Mme. Delfoart admires.

RUSSIA: Zhanna Kapralova fills dumpling pastries with meat and enjoys a hug from her mother, Tamara Ivanovna Bannikova. Although they live too far apart to see each other as often as they would like, Zhanna counts her mother as her best friend.

BRAZIL: Returning to the *favela* (shantytown) where she used to live with the father of her three younger children, Maria dos Anjos Ferreira visits with two of the women she calls her colleagues—Beté and Deda (on the left and right of Maria, respectively).

ETHIOPIA: Birri Fayisso counts her great-grandson, Mamoosh Getachew, 8, as her best friend. The boy is somewhat neglected by the other members of his family because of undiagnosed disabilities and he often seeks solace in the arms of his dearest friend.

MONGOLIA: A surprise meeting in Ulaanbaatar's central square was arranged between Lkhamsuren Oyuntsetseg (on right) and Miss Tsetsegma, a Mongolian movie star, whom she has admired her entire life. Oyuntsetseg says that she thinks of the actress as a friend and mother figure, because her own mother died when she was 8.

MALI: At a community well where her neighbors draw water, Pama Kondo (at center) talks to a friend before filling her own bucket. This is Pama's favorite task because of the opportunity to see her friends. (And it's easier than pounding grain, she says.)

ITALY: Daniela Pellegrini (on left) and her neighbor Angelina Tani laugh over the latest antics of Daniela's daughter, Caterina.

UNITED STATES: Pattie Skeen breaks into laughter as her good friend Vivienne finally understands the subtleties of a bread recipe Pattie has shared with her.

BHUTAN: Sharing a glass of local wine at the only store in Gaselo—a village an hour's walk from their homes—Nalim and her best friend, Phangom (at center), take a rare moment of rest from their busy workdays.

MEXICO: Happily anticipating her favorite part of the week, Carmen Balderas de Castillo escorts her children and one of her good friends, Arciela (at center), to their Jehovah's Witness meeting.

SOUTH AFRICA: Poppy Qampie takes a moment from her errands to talk with her best friend, Anna (on right), who works in Poppy's building in downtown Johannesburg. The two friends have never visited with each other outside of work but consider themselves each other's best friend.

HAITI

RUSSIA

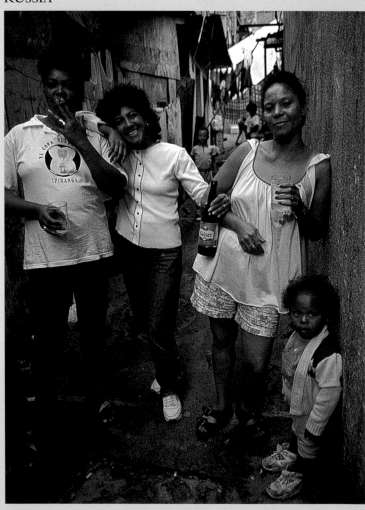

BRAZIL

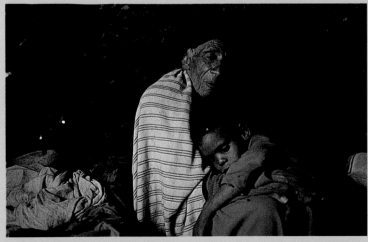

ETHIOPIA

UNITED STATES

MONGOLIA

BHUTAN

MALI

MEXICO

ITALY

SOUTH AFRICA

Thailand
Buaphet Khuenkaew

" I am not a sad person. I am always on the go. But actually, inside, I do feel sadness sometimes. "

SIX DAYS A WEEK, BUAPHET Khuenkaew sews buttonholes in men's shirts at a tailor shop in Chiang Mai, Thailand's second-biggest city. This is the first job she has had outside the home since the birth of her children, and she quickly seized the extra income and freedom it offered. It's hard though, she says, to spend long hours away from Ban Muang Wa, the village where her extended family lives and where she has lived since she was born. Before taking the job, Buaphet, 35, (*right*, washing before work) took care of her nephew for a year so that her sister-in-law could work as a teacher in a school for hill tribe people in the mountains. Now, she believes, it is her turn to have an income.

Back home, her husband, Boontham, 41, farms two plots of land and, between growing seasons, works whatever construction jobs he can find. Now that Buaphet has a job outside the home, the bulk of the weekday household chores fall into the lap of Buaphet's daughter, Jeeraporn, 17; her brother, Visith, 10, watches television and plays happily with his friends.

A popular, vivacious woman, Buaphet hopes that the tailoring job will be the next step toward a new life; later, she wants to start a shop of her own. With the income, she would like a car, a new house, and a color television (theirs is borrowed from her brother). The TV is especially important—watching the set is one of the few activities the family members, with their separate schedules, do together.

Photographs by JOANNA PINNEO Interviews by FAITH D'ALUISIO

One of the household chores that Buaphet likes the least is washing her family's laundry because it must be washed by hand, wrung out, and hung to dry. She expects her daughter, Jeeraporn, 17, to help with laundry and other tasks. While Jeeraporn hangs clothes, Buaphet (above) washes last night's dinner dishes, which were stacked in the kitchen after the meal at night.

Faith: Is marriage what you expected?

Buaphet: Sometimes it is not what I thought, but I have chosen this life, so I accept it. I am not that rich, not that poor. I have something in my stomach that makes me accept everything and be pleased with everything. Sometimes it is love that makes me stay with him. There are times that I think that I could find another man who is richer, but I could not leave Boontham because I love and pity him. If I left him, he would be alone. I see many unhappy families among my friends. I have a very good family.

So you've sometimes thought about divorce, but not seriously.

I've never thought of it seriously at all—but if I did divorce, I do not think I could live with anybody anymore. I would leave the children with him. I couldn't raise them by myself.

What have been the important events in your life?

No particular day or any particular event comes to mind. I am on the happy side all the time, and everything seems to be very okay and normal and nothing can make me sad. When my father and my grandfather died, I never got that upset because I am a lively person. I do not like being sad. Whenever people get sad, I think, "Just leave them alone." But I am not sad.

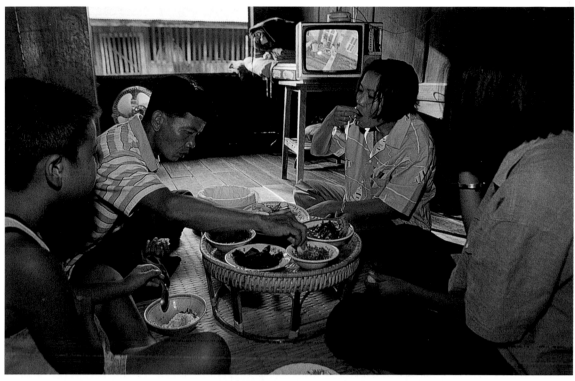

Every morning, Buaphet applies her makeup (bottom), whether she is commuting to work, or staying home with Boontham on Sunday to work in the fields, or to go to the village temple. After this morning ritual, she joins her husband, Boontham, and their children, Jeeraporn and Visith, 10, to eat breakfast (top), accompanied by the shrieks and bangs of TV cartoon characters. The family, seated around a low table, shares a meal composed of leftover food from last night's dinner— hung lei: a northern Thai dish made of pork, ginger, tamarind sauce, curry paste and onion; and gang phet: a dish made of coconut milk, onion, and meat, along with the usual rice and condiments.

Jeeraporn, goes to school on registration day to register and pay for books (middle, on left, Jeeraporn calculates the cost of books with a friend).

Buaphet gets doused by bucketfuls of water from playful monks near the village temple (above). During the Thai New Year, people sprinkle water on their friends as a blessing. Given human nature, the sprinkle has become a bucketful and people gleefully wait on roadsides to ambush all passersby. Later that afternoon, Buaphet shares beer and whiskey with friends (above right) on the bank of the creek that runs through the village. Her mother stands in the background watching.

Faith: What kind of a student is your daughter, Jeeraporn?

Buaphet: She is a good student. When she was younger, her grades were not good, but now she is picking up.

You said earlier that you think your son will go further in school than your daughter.

It is likely since he seems to have a better memory than his sister. Since he is a boy and is going to be the head of a family, it is more important for him to have further education so that he can bring up his family. As for Jeeraporn, whatever she accomplishes is fine; but because she doesn't have a good memory, I do not think she will go that far. If that is the case, I would not mind having my daughter stay at home with me.

Do you have any specific hopes for your children?

I would like both of them to be well educated, so they can get a good job and be white-collar workers instead of having to do manual labor like I do now.

Do you think it is because of your own experience—not going past sixth grade— that you want this for your children?

Yes. I left school because I could be a day laborer and get paid 6 to 8 baht a day [US $0.25-$0.34] and I liked the money. The teacher begged me to go back to school but I refused because I saw how good the money was. But if I could do it over again, I would try to get a bachelor's degree.

What would you do if you got a degree?

Get a good job. Anything good and respectable.

What would you change about your life if you could?

I would change the whole thing—my old life to a new life. I would like to create a whole new life and erase the whole old life.

Including your husband and kids and everything?

Yes.

That seems pretty radical. Does your husband know this?

No, but I do not like this life. I am not satisfied.

Pretend for a moment that you have the life that you want. What would it be like?

I would have everything in the house—television, washing machine, stereo, waterpump. I would be proud that I had everything that everybody else has. Then my life would go smoothly and I would be proud. I wouldn't have any problems.

So you don't talk to Boontham about your dissatisfactions. Do you ever talk about loving each other?

No, we never talk about it, but we can tell from the way we look at each other that it is there.

You never tell each other that you love each other?

Only when I get angry. I get upset and say, "If I did not love you, I would not stay."

FOLLOWING PAGES

With Buaphet in the lead, a crowd of New Year revelers dance from the village to a temple a mile and a half away. Farther back, men are carrying a paapa—a "money tree" made from sticks decorated with ribbons and Thai money (see inset, p. 228). Buaphet's husband, Boontham, a shy retiring man, rarely attends village festivities with her.

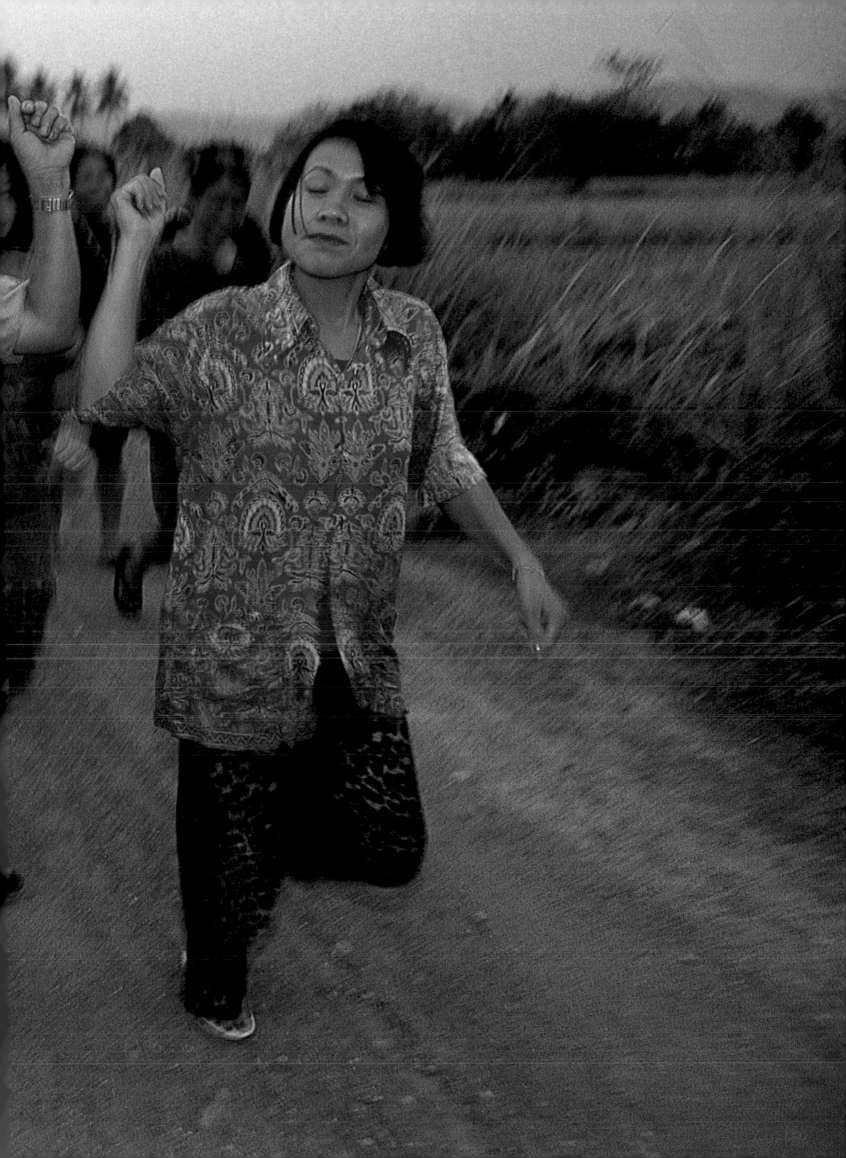

Women in Thailand

Ask a Thai man who controls the purse strings in his family and he's likely to reply: "My wife." In Thai society, women are traditionally known for their business acumen, especially in household matters. Now, as Thailand modernizes, many rural people feel economic pressure to sell their land or look for work in cities, so traditional gender roles are shifting. More women than men are moving to the cities, where they're more likely to be employed in lower-paying industries; two out of three female workers earn less than minimum wage.

Daughters, although valued, haven't always had as much access to higher education as sons, but now literacy levels for men and women are about equal. Successful family planning campaigns have dramatically lowered the birthrate—from five kids per family to about two. Women are also getting married later. With polygamy now outlawed, Thai men's yen for multiple sexual partners has been channeled into prostitution—a huge industry in Thailand, attracting thousands of tourists yearly. The country is estimated to have from 70,000 to 250,000 prostitutes, and has Asia's highest AIDS infection rate. Child prostitutes are particularly prized by patrons seeking HIV-free workers.

Historically, women's access to status and prestige has been limited by the fact that they can't become monks in this Theravada Buddhist society, but now hundreds of women are becoming involved in local politics, and a small but growing number serve in the National Assembly.

Faith: Buaphet, what is your biggest hope?
Buaphet: To have a nice life with everything that everyone else has in it—all the possessions.

Is having material possessions as important as being together as a family?
I would like to have what others have. And I think it is okay to want things like that. I separate my family and my possessions. Having possessions makes the family proud. Then all your friends and the children's friends can come and admire what you have. I think it is part of being happy. As for the family values, we have a good relationship and we are happy.

But you would need more possessions to be respected?
Yes, then I would be proud. Because many of my friends have everything they want.

They do? How?
They have rich husbands and rich parents, too, so they inherit. But for me and my husband, everything that we have, we had to earn it by ourselves.

Is there any one thing that you want personally?
Gold. [To Thais, gold is important as a symbol of wealth and status as well as an investment that retains its value and is easy to convert into cash in an emergency.—Ed]

Boontham, your wife tells me she wants more from life.
Boontham Khuenkaew (husband): I try to tell her to understand that sometimes I may not bring enough money for the family. I hope she understands. When I make more she is happy, which pleases me, but I tell her not to expect too much. And I hope she makes do with whatever we have in the house, and [she] will not be too hard on me.

Does she expect too much sometimes?
Boontham: Once in a while. I tell her, "You just can't have everything. You have to wait and be patient. We will eventually get things one at a time—it has to be like this."

Do you ever want things that aren't necessary?
Boontham: I have everything I need and I do not want anything else.

And Buaphet?
Boontham: She is proud of what she has. Though she has a job now, when it is harvest time she will probably ask the tailor if she can not go to work for a few days so she can help me.

She wants many things she doesn't have.
Boontham: It is fine, whatever she wants.

Do you think she feels that she needs these things for happiness?
Boontham: I know she would like to have all those things because we have talked about it. One day I hope I can provide some of these things. It is okay to let her have the dreams she wants to have.

Buaphet tells me she likes to spend her free time with her friends. What do you do for fun?
You have to look at the environment and the situation that I am in now. There's really nothing I can call fun, it's just things I have to do. Sometimes there are kids over and I watch them play and I enjoy that. And sometimes I go over to a friend's house and help in some ceremony or other occasion. Those are the things that I would say are fun.

Buaphet, have women's lives changed at all from your mother's generation to yours?
Buaphet: It is not the same. My mother had to go through more hardship in her life. She had to grind her own rice instead of having it done at the mill, and I can easily have it done. When my mother was my age, she would do everything by hand. She also had to give birth at home with the midwife instead of going to the hospital.

Has the treatment of women changed at all from your generation to your daughter's?
There is a big difference. All the circumstances changed. The society changed and people changed. When I was growing up, it was more conservative. But now people say if you do not control your daughter, she is going to follow the new way of life, and I do not like that.

What is that new way?
When I was growing up there were no clubs or discotheques that I could go to, but now there are plenty of them. I try to stop my daughter from being that type of person.

What do you like about the way women are treated in your country?
I like the Thai manners that women perform in different social functions. We all seem to know very well what we should do in different circumstances. For example, talking among friends, you can use certain kinds of words, but when you go visit the elderly, you cannot do that. That is what is good about Thai tradition. This is expected.

Is there anything you would change about the way women are treated in Thailand?
I think that it is impossible to change things because men are always superior to women in Thai society, and it is impossible to change that.

Field Journal

After Buaphet presented her offerings to the village temple, she met her mother, Ouan, on the road home. Although the two women were going in the same direction, they didn't walk together or converse—Ouan silently followed a few feet behind. At first we thought the lack of interaction was due to our camera. But as we got to know the family better, we realized that it was typical of them.

All of the Khuenkaews are like independently functioning units—working at different schedules, fulfilling different roles. Eating and watching TV are the only activities we saw them do together. Maybe they don't do more as a family because Buaphet and Boontham are such different people. Boontham is retiring, and sensitive. The only time we saw him upset was one afternoon when our interpreter was gone and he could not figure out how to give us what we wanted, which made it impossible for him to be his usual chivalrous self. To avoid inflicting him with such frustration, we agreed not to come back unless our interpreter was with us. Buaphet, on the other hand, could veer from being a dedicated mother to a party animal with a simple change of clothing. On New Year's weekend she kept us hopping, as she charged from one temple event to another—greeting friends, honoring neighbors, and taking time to comfort a friend whose mother had recently died.

Walking back from one event, she spotted a group of young men she knew sitting by an irrigation canal drinking beer. Buaphet bounded over and joined them for a sip. Her mother walked by and stopped and didn't say a word. We would have loved to know what she was thinking.

— FAITH D'ALUISIO AND JOANNA PINNEO

During the New Year's celebration, Buaphet observes the Buddhist custom of bringing a merit offering to someone whom she wishes to honor—in this case, an elderly neighbor. Carrying the gifts in a shiny aluminum bowl, she presents her neighbor with two small shopping bags full of fruit, fish sauce, powdered detergent, rice noodles, and other everyday necessities. Later that day, she and her children will honor Buaphet's mother in the same fashion.

United States
Pattie Skeen

"Women are the nurturers in a home, but women aren't always the nurturing people they need to be. The U.S.A. has kind of gotten away from that. It's coming back."

PATTIE SKEEN IS A LIST-MAKER— a stickler for schedules who keeps the family organized with notes on the refrigerator. Her organizational skills are needed, for the Skeens lead crowded lives that sometimes leave Pattie (*left*, with her wedding veil and daughter Julie) and her husband, Rick, wishing the world would stop

long enough for them to take a breath. A native Texan like his wife, Rick, 38, is a cable splicer for the local telephone company. Pattie, 36, teaches kindergarten at the private school operated by the Southern Baptist church the family attends in their suburban community outside Houston. Pattie loves teaching, although she says she has to be careful that the demands on her time don't conflict with the needs of her family (*inset*, home-cooked weekend meal).

Their two children—Julie and Michael—attend a public school in their district; Julie is in a program for gifted and talented children. Worried about crime, the Skeens make sure that their children don't go many places unaccompanied; weekdays after school are spent doing homework in the house and being shuttled about by their parents in the family cars. (Rick recently bought Pattie a cellular phone, just in case something happened to her on the road.) But the center of the Skeens' lives is always their unswerving faith. Born-again Christians, they credit Jesus with helping them to survive the tensions of an American life that sometimes seems to offer as much stress as material prosperity.

Photographs by ANNIE GRIFFITHS BELT Interviews by FAITH D'ALUISIO

Family and Nation

U.S.A.

Population:
263.2 million

Population Density:
72.7 per sq. mile

Urban/Rural: 75/25

Rank of Affluence among UN Members:
6 out of 185

Pattie Skeen

Age: 36

Age at marriage: 18

Distance living from birthplace: 14 miles

Children: 2

Number of children desired: 2

Occupation: Elementary school teacher

Religion: Southern Baptist

Education: College

Least favorite activity: Housecleaning

Favorite activity: Talking to family and shopping for groceries

Cost of a loaf of sliced bread: $2.08

Pattie's wish: To travel

Rick's wish: A camper

Treasured possession: Her wedding dress (as a symbol of the beginning of her marriage to Ricky) and the family Bible

Woman most admired: Barbara Bush

What makes Pattie happy: Good movies with happy endings and laughing with the family. Silly times, beautiful weather and scenery.

What makes Pattie sad: "Sad movies, people who are hurting, barriers between me and Ricky."

Conversation with Pattie Skeen

Faith D'Aluisio: Pattie, what have been the big events so far in your life—both good and bad?

Pattie Skeen: The good events? Each of our Christian birthdays, which are the days when each of us asked Jesus to be our savior; and my wedding day, of course. But then some other things were not so good—I remember when I was 16, I woke up expecting a great birthday. Nothing happened at breakfast. I thought they were going to surprise me. No one said a word. Finally my mother remembered. I thought she was kidding that she had forgotten. Mother was so horror-struck that she blurted out she wasn't kidding. You know, it gets my heart going pit-pat. Another big event was when Julie was born. That was the most wonderful thing. When Ricky was in high school he broke his neck playing football, and so he was in the hospital for two months in traction—anyway, he has this thing about doctors and hospitals. I wanted to do Lamaze [childbirth classes in the hospital] and he was not willing to do that. But when he found out that some other friend of ours had done it, he thought, "Well, if he can do it, I guess I can too." And so he was with me and he kept running back and forth outside telling [everyone] how much I had dilated and everything—back in and out. And then he was telling me, "She's crowning." He was just right in there and he did so good. When Michael was born, I couldn't have kept Ricky out if I had wanted.

How old were your parents when you were born?

My mother was 21. Father was 28. He was an accountant. There were five of us in the family—my parents, my two brothers and me. Mother did not work [outside the home]. She didn't start college until I was in fourth grade. I remember very clearly, because in third grade she was our Blue Bird leader, which is kind of like Girl Scouts. At the end of that year she made an announcement; she said, "I'm not going to be a leader next year because I am going to start college." I think that was an important time in my life, because when Mother started college, I started taking over a lot more of the housework and cooking. I got paid ten dollars a week, which to me was a huge sum, so I didn't mind doing it. When I was in the sixth grade, my mother got pregnant and had Sheri, my sister, and continued

on [in college] right after that and finished up, and then started teaching.

Why did she decide to go into teaching?
Because of the experiences my brother had in school. It was always very easy for me, but my older brother had a much more difficult time—partly because of the teachers he had. She thought, "This isn't right. Education has to be improved on." When she decided to go to college, my father's father said, "You better not let her do that because she'll start working, she'll start teaching, and think that she can just start ruling the roost."

In many societies that would be the end of it, but clearly not for your mom. Did your family impose any restrictions on you?
I never had any restrictions like that. They were always encouraging me to go and do and learn as far as I wanted to. Of course, we didn't come from a rich family. We were medium. We never lacked for anything, but the money for college was not always there. I had a scholarship that helped me. It was a full scholarship. My brothers had to help pay for part of theirs.

What similarities and differences do you see between your life and your mother's life?
I'm more involved in my church work than she was. We always went to church, but Mother was not a joiner. But she cooked dinner like I do and she was home for the family like I am. She didn't have a lot of outside interests, kind of like I don't either—I don't have time for it.

Were you treated differently than your brothers?
I always felt very special. I was 11 years old when [my sister] Sheri was born. I felt like I was the apple of my daddy's eye. I guess, if I was treated differently I thought it was because I was a girl and they were boys. They had to do the, you know, boy-type jobs like mow the grass and I didn't, although they did have to help on the inside also. They had to help clean and vacuum and wash dishes, but I didn't have to mow the grass and I didn't have to take out the trash. Those were boy jobs and they had to do them.

Did you ever feel like they could do things that you couldn't do, that you wanted to do?
No, I really didn't. Some girls might have, but I didn't. I felt like that if I wanted to do it, I could. I may not have wanted to in some cases.

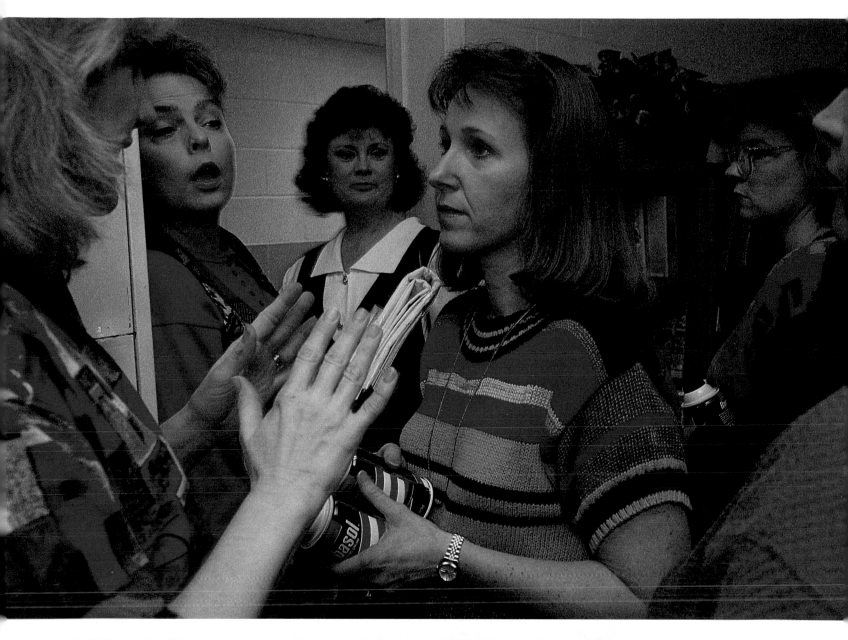

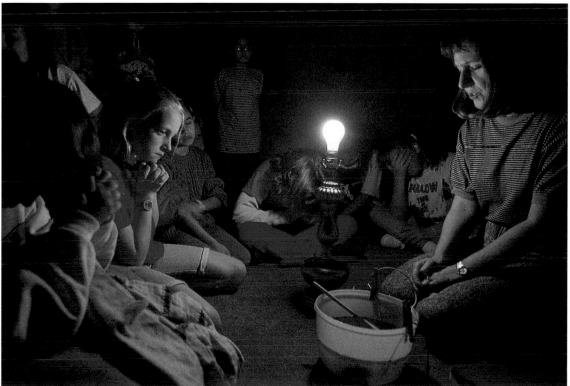

A conscientious teacher, Pattie meets before class with some of the staff at the private church school where she works (above). The shaving cream she holds will make "snow" for kindergarteners to play with at their desks. In addition to her teaching job, Pattie is a coordinator for Girls in Action, the church girls' group to which her daughter, Julie, 12, belongs. Among her duties is supervising the group's slumber party (left), at which Pattie illustrates a story about virtue with a lamp that suddenly glows when she puts the right chemical in the bowl of water, enabling it to conduct electricity.

As she waits in the family van for Julie to finish her piano lesson, Pattie (top) supervises the homework of her son, Michael, 9. Like many U.S. mothers, Pattie spends a lot of time driving her children to school, playmates' houses, and various lessons. Three days a week, for instance, she drives a carpool to Julie's school. An organized mom, Pattie guides the children through each morning, issuing last-minute instructions while they brush their teeth (far right) after a breakfast of fruit, milk, and glazed donuts. To make up for the family's hectic schedule, she and her husband, Rick, try to ensure that the family spends time together on the weekend. Rick likes to shoot baskets with the kids (bottom right), especially Julie, who wishes she had time to be on her school basketball team. Pattie, for her part, likes to cook with the children (middle right, making grilled cheese sandwiches). Although Julie thinks cooking isn't very interesting, she says, "Baking is fun." She and Pattie bake bread together most weekends.

Faith: Do you talk with your friends about women's issues?

Pattie: We do talk about that, yes. We talk about women in the workplace. I don't personally know women who are exploited but I know that there are. I think that women are overstepping their bounds a little bit—getting special favors that men don't get. Women are allowed to leave work when their children are sick. Men are not allowed to do that. In trying to make up for the past, the pendulum has almost swung to the opposite extreme. I think there are some women today who have it all wrong. They need to be the caretakers in the house. Women are the nurturers in a home, but women aren't always the nurturing people they need to be. The U.S.A. has kind of gotten away from that. It's coming back.

Have you been involved in trying to change the treatment of women in this country?
I have written letters to my congressmen on the subjects of abortion, economics, education, sex education, and abstinence. I think first of all that it should be taught in the home. Sex education without values is wrong. It needs to be taught with values. I like the "True Love Waits" program, but not the "Safe Sex" program.

FOLLOWING PAGES

Before school in the morning, Julie reflects on the writing assignment she is typing on the computer. Meanwhile, her brother, whose homework is safely completed, sleepily works on finishing his banana. When Julie finishes, Pattie will give the story a quick once-over.

Women in the United States

Swaying on a swing constructed by Rick's grandfather, the Skeens grab a little private time. Their children know that their parents want to be left alone for a little while when their parents are on the swing; it is here that Pattie and Rick talk about children, vacations, money, and their own relationship.

Ever since Abigail Adams demanded women be treated equally in the constitution her husband helped frame, American women have fought laws and traditions that kept them legally subordinate to men. Although the first woman entered medical school in the 1840s, it was 150 years before a woman became Surgeon General. Now women hold two seats on the Supreme Court and one-third of Cabinet positions—but they're still not specifically granted equal rights in the constitution.

While U.S. women have made great strides, gender inequalities still exist, and are worsened by race and class inequities. Women can become car mechanics and college presidents, but are more likely than men to live in poverty—partly because many must raise children with no paternal support. More women than men attend college, but they earn just 75 cents to a man's dollar. Although abortion has been legal for some 20 years, 83 percent of U.S. counties lack clinics where it's available.

Still, the fact that women began talking to one another about sexism and job discrimination in the 1970s meant they didn't confront these problems alone. They organized nationally to push for equal rights and address problems like sexual harassment, rape, and domestic abuse. Legal reforms have granted women more opportunities, but a conservative climate which holds women to blame for the decline of the nuclear family now threatens many of their gains.

Pattie: You know, if she says she wants to marry at 17, we will caution her that we think it is a little young and we think that she needs to wait until she gets out of high school. I'll encourage her to wait until she gets out of college because it's easier. It was hard to finish college, even when we weren't even paying for it. In fact, if I hadn't had the scholarship, I probably would have come very close to not finishing, because it got very difficult at the end to do that and still stay married and be happy in our relationship.

But you still want her to get married?
Oh, yes. Definitely.

And she wants to?
Yes, at this point.

Would it be necessary for her to marry someone from your church?
You don't have to be in our religion, but to be a Christian, to have the same belief about Jesus—that He is God's son and that He is the only way to Heaven.

Rick, this is a hard question, but I'm going to ask it anyway. How would you react if Julie became pregnant before she was married?

Rick: The first thing is that I would let her know that she is loved beyond measure, and that I am sorry that there was a situation, that there became this situation in her life. But it's like saying that you refuse to forgive somebody because the milk was spilt. Well, the milk cannot be unspilt again. Let's clean the milk up or let's do the best we can with what we have. And then let's go home.

Pattie, what would you do if Julie got pregnant before marriage?
Pattie: That's a real tough question. You never know exactly how you will react until that time comes. I know we would ache in our hearts because I know the trouble that it brings and the heartache that it brings and the problems that it brings to have pregnancy before you are married—to get things out of order. Abortion is not an option in our home, and so we would discourage that. But we would love her and support her and help her through, you know, having the baby. And after that, we'd see, as far as raising it. I don't foresee this happening because we try real hard to instill values in her right now. But that's not to say it doesn't happen. It happens all over.

Faith: Rick, how far do you expect your daughter to go in school?
Rick Skeen (husband): I want her to go as far as she'd like. If she wants to go to college, that's fine. If she wants to go to learn a trade, that's fine. I want it to be available to them if that's what they choose to do.

Pattie, you were married at 18, when you were in college. Would you want Julie to get married young?

Field Journal

On the day that I arrived, Pattie changed all of our plans because Michael had awakened with a sore throat. Actually, I was pleased at the changes—it would probably mean more picture opportunities because women usually have to drop everything and improvise when their children get sick. So off we went to doctor and pharmacy. I quickly learned how important religious faith is to this family. We prayed for courage, we prayed for a lost prescription, we prayed for a fun slumber party for Julie later that night. I also learned how much energy Pattie has. She was still going strong at the slumber party when I bailed out at 12:30 a.m.

Pattie hovered around Ricky, I suspect, because she knows how much he dreads being photographed. But after two days he loosened up. I think he realized I wouldn't push anything on him he didn't want to do. I was touched that he removed a red paint stain from my rental car when he noticed it, and insisted on cleaning my shoes when I muddied them in the backyard.

Although I don't agree with all of the Skeens' beliefs, I admire the quiet consistency with which they employ those beliefs in their everyday lives. They are kind to each other and grateful for all that they have. And I like the family's sense of fun—Pattie and Ricky never miss a chance to amuse their children. And a highlight of one day occurred when Michael and Julie performed a Christian rap routine.

— ANNIE GRIFFITHS BELT
JANUARY

Woman's World at a Glance

	POPULATION				EDUCATION		ECONOMICS		HEALTH	
	1995 millions	2025 proj % change from 1995	Density per sq mi	Distribution % urban	Adult Literacy %, f / m	Years of School mean years, ages 25+, f / m	Per Capita GNP US$	Female Economic Activity %, age 15+	Life Expectancy years, f / m	Doctors population per physician
Albania	3.5	34	312.6	37	99 / 99	5.0 / 7.0	360	59	73 / 68 b	585
Bhutan	0.8a	88	44.1	8.5	25 / 51	0.1 / 0.3	400	42	49 / 46	5,335
Brazil	157.8	42	48.0	77	80 / 83	3.8 / 4.0	3,370	31	68 / 62 c	848
China	1,218.8	25	329.8	28	62 / 84	3.6 / 6.0	530	70	71 / 67 b	648
Cuba	11.2	15	261.5	74	93 / 95	7.7 / 7.5	2,000	38	78 / 74 d	231
Ethiopia	56.0	132	118.7	15	16 / 33	0.7 / 1.5	130	50	49 / 45 b	30,195
Guatemala	10.6	105	251.9	38	47 / 63	3.8 / 4.4	1,190	18	64 / 60 c	2,356
Haiti	7.2	82	666.0	31	47 / 59	1.3 / 2.0	220	54	56 / 53 c	10,060
India	930.6	49	733.0	26	34 / 62	1.2 / 3.5	310	28	59 / 58 d	2,189
Israel	5.5	45	700.9	90	89 / 95	9.0 / 10.9	14,410	37	77 / 74 b	345
Italy	57.7	– 8	496.5	68	96 / 98	7.3 / 7.4	19,270	30	79 / 73 c	193
Japan	125.2	0.5	857.9	77	99 / 99	10.6 / 10.8	34,630	50	82 / 76 d	570
Jordan	4.1	102	111.8	68	70 / 89	4.0 / 6.0	1,390	10	71 / 69 d	574
Mali	9.4	152	19.6	22	24 / 41	0.1 / 0.5	250	15	57 / 55 c	67,789
Mexico	93.7	46	123.9	71	85 / 90	4.6 / 4.8	4,010	30	73 / 66 d	885
Mongolia	2.3	57	3.8	55	86 / 93	7.2 / 7.6	340	72	67 / 63 a	340
Russian Federation	147.5	4	22.4	73	98 / 100	n.a.	2,650	55	72 / 59	225
South Africa	43.5	61	92.3	63	75 / 78	3.7 / 4.1	3,010	41	68 / 63	1,264 a
Thailand	60.2	25	303.9	19	90 / 96	3.3 / 4.3	2,210	65	68 / 62 d	4,327
U.S.A.	263.2	29	72.7	75	95 / 96	12.4 / 12.2	25,860	50	78 / 72 c	391

n.a. = not available

SOURCES

Population, 1995: a = Bhutan's last census was in 1980. This newer estimate is based on recent figures resulting from the repudiation of the 1980 census by Bhutan's King and from the existence of a large number of Nepalese refugees. The actual population could range from 800,000 to 1,600,000. "World Population Data Sheet, 1995", Population Reference Bureau, 1995.

Population, 2025, projected percent change from 1995: Calculations based on data from Population Reference Bureau, 1995.

Population Density: Calculations based on population data from Population Reference Bureau, 1995.

Population Distribution, % urban: Population Reference Bureau, 1995. Exception: Bhutan from the Office of the Bhutan Mission to the United Nations.

Adult Literacy: *World Resources, 1994-95*, World Resources Institute (1990 data). Exceptions: Albania (1989), Japan (1989), Mongolia (1980), USA (1980) from *Britannica Book of the Year, 1990*, Encyclopedia Britannica, Inc.; Ethiopia, Israel, Russian Federation and South Africa from *State of the World's Children, 1995*, UNICEF (data for years or periods other than specified, differ from the standard definition, or refer to only part of a country).

Mean Years of School: *World Resources, 1994-1995* (1990 data).

Gross National Product, per capita: *World Data 1995*, The World Bank (1994 data). Exception: Cuba from *World Resources,1992-93*.

Female Economic Activity: Work for pay outside the home. *Human Development Report, 1995*, United Nations Development Programme (1994 data).

Life Expectancy: *WHO: Progress Towards Health for All, Statistics of Member States, 1994*, World Health Organization (data is for a = 1980-82, b = 1983-85, c = 1986-88, d = 1989-90). Exceptions: Russian Federation and S. Africa from Population Reference Bureau, 1995; Bhutan, from *Statistical Yearbook of Bhutan, 1993*, Ministry of Planning, Royal Government of Bhutan (1984 data).

Population per Physician: a = in South Africa: Transkei, Venda, Bophuthatswana, and Ciskei are not included. *Britannica Book of the Year, 1995*.

Fertility Rate: *World Resources, 1994-95* (1990-1995 data, except: a = 1985-90).

Maternal Mortality: *Human Development Report, 1995* (1980-1992 data, except: a = data refer to a different year or period, to only part of the country, or differ from the standard definition).

BIRTH					POLITICS		DEVELOPMENT		
Fertility Rate children per woman	**Maternal Mortality** per 100,000 live births	**Infant Mort.** per 1,000 live births	**Births Attended by Professional** %	**Contraception** %, married women, modern/ trad. methods	**Women's Suffrage**	**Women's Involvement** % parliament seats* / % ministerial level**	**Human Develop. Index Ranking**	**Gender Empower-ment Ranking**	**Data Reliability Grade***
2.7	n.a.	23	99.3 a	n.a.	1945	6 / 0 a	82	a	A
5.9	1,310	129	7	2 a	1953	0 / 22	160	a	D
2.8	200	57	73	57 / 9	1934	5 / 5	63	58	B
2.2	95	27	94.4	80 / 2 b	1949	21 / 6	111	23	B
1.9	39	14	99	67 / 2	1934	23 / 4	72	16	A
7.0	560 a	122	9	2.6 / 2	1955	1 / 10	171	105	B
5.4	200	48	51	19 / 4	1945	5 / 20	112	46	C
4.8	600	86	40	10.5 / 1	1950	3 / 13	148	63	B
	460	88	32	38 / 5	1950	7 / 3	134	101	B
2.9	3	9	99	n.a.	1948	9 / 9	21	a	A
1.3	4	8	100 a	32 / 46 c	1945	13 / 12	20	10	A
1.7	11	5	100	57 / 17 d	1945	7 / 6	3	27	A
5.7	48 a	36	86 b	28 / 8	1974	3 / 3	80	99	B
7.1	2,000	159	14	1.4 / 3	1956	2 / 10	172	97	B
3.2	110	35	41.9	45 / 8	1947	7 / 5	53	42	B
4.6	200	60	99.8	n.a.	1923	4 / 0	110	a	C
2.1 a	n.a.	19 a	100	n.a.	1917	8 / 0 a	52	a	B
4.	84 a	53	n.a.	48 / 1	1930 / 94 a	24 / 7	95	a	B
2.2	50	26	82	65 / 2	1932	4 / 0	58	54	B
2.1	8	8	99.3	70 / 5	1920	10 / 15	2	8	A

Infant Mortality: *World Resources, 1994-95* (1990-95 data, except: a = 1985-90).
Births Attended by Professional (Trained Personnel): *WHO: Progress Towards Health for All, 1994*, (1986-88 data, except: a = 1983-85, b = 1989-90).
Contraception: a = separate data not available for modern/traditional methods, b = includes condom use, c = used since last pregnancy or since marriage if no pregnancy, d = combination of methods in each category. *"World Contraceptive Use, 1994,"* Population Division of the Department for Economic and Social Information and Policy Analysis, United Nations (data is for various years). Exception: Bhutan from *State of the World's Children, 1995*; UNICEF (data for 1980-1993).
Women's Suffrage: a = 1930: suffrage for white women; 1994: universal suffrage. *World Resources, 1994-95*; Exceptions:

Russian Federation from *The Women's Desk Reference, 1993*, Franck, Irene & Brownstone, David; Japan and Mongolia from *Encyclopedia Americana, 1995*, Grolier, Inc.; Ethiopia from *Facts on File, 1955*, Facts on File Publications; South Africa from Institute for Research on Women, State University of New York.
Women's Political Involvement: * = as of 30/6/94; ** = as of 31/5/94, including elected heads of state and governors of central banks. a = no women ministers were reported by the United Nations Division for the Advancement of Women, the HDR Office says this information could not be reconfirmed. *Human Development Report, 1995*.
Human Development Index (HDI) Ranking: Assesses comparatively the progress of 174 countries with regard to basic human capabilities. *Human Development Report, 1995*.

Gender Empowerment Measure (GEM) Ranking: Assesses comparatively the progress of 116 countries with regard to gender equality. a = data for calculating the GEM was not available. *Human Development Report, 1995*.
***Data Reliability Grade**: The Population Reference Bureau assesses and grades the quality of population statistics available in a given country. *World Population Data Sheet, 1995*, Population Reference Bureau.

See Glossary, next page, for further information.

Statistics Glossary

Adult Literacy: Percentage of people over the age of 15 who can read and write. UNESCO defines illiterate as a person who cannot both read with understanding and write a short, simple statement about his or her everyday life. This concept is widely accepted, but its interpretation and application vary. It does not include people who, though familiar with the basics of reading and writing, do not have the skills to function at a reasonable level in their own society. Actual definitions of adult literacy are not strictly comparable among countries.

Births Attended by Professional (Trained Personnel): Calculated as the number of deliveries attended by trained personnel per 100 live births.

Contraceptive Use: Among currently married women of reproductive age (age 15-49), including, where possible, those in consensual unions. *Modern methods:* Sterilization (male and female), pill, IUD, condom, or other supply method (e.g., other methods requiring medical services, including injectibles, diaphragms, cervical caps, and spermicides). *Traditional methods:* Non-supply methods, including periodic abstinence or rhythm, withdrawal, douche, total sexual abstinence if practiced for contraceptive reasons, folk methods, and other methods not separately reported.

Data Reliability Grade: From the Population Reference Bureau—The Bureau's assessment of the quality of population statistics available in a given country. "A" = a country with both complete vital statistics (birth and death data) and a published national level census within 10 years or a continuous population register. "B" = country has one of those two sources plus either a census within 15 years or a usable national survey or sample registration system within 10 years, or both. "C" = at least a census, survey, or sample registration system is available. "D" = little or no reliable demographic information is available, estimates are based on fragmentary data or demographic models. There can be considerable variation in the quality of data even within the same category.

Female Economic Activity: Reflects supply of female labor for production of goods and services in public domain as defined by the UN System of National Accounts. (These figures reflect formal sector activity only, and do not take into account the large, albeit invisible, economic contributions of women in the informal sector—see also *Formal* and *Informal Sector Work*).

Fertility Rate: An estimate of the number of children an average woman would have if current age-specific fertility rates remained constant during her reproductive years.

Formal Sector Work: Work performed for pay in the market place.
Informal Sector Work: Work performed without remuneration in the market place, i.e.: subsistence agriculture; care for children, the elderly, and the disabled; provision of clothing and primary health care; cooking; cleaning; and sewing. Informal sector work is done overwhelmingly by women. Developing countries typically have larger informal sectors than industrial countries.

Gender Empowerment Measure (GEM) Ranking: From the *Human Development Report, 1995*—An instrument that measures the achievement of countries in providing equality of access for women and men to actively participate in economic and political life and take part in decision-making in the public domain. Although participation can take many forms, three variables are used to determine this indicator: share of parliamentary seats; share of jobs classified as professional, technical, administrative or managerial; and per capita income in PPP dollars (see *Purchasing Power Parity*). Although no country received a perfect score, Sweden was ranked number 1, thus the level of gender equality in political and economic participation in Sweden is the highest out of the pool of countries evaluated. Due to the unavailability of quality data, the Human Development Report commissioned by the UNDP was able to compute the GEM for 116 countries only.

Gross National Product (GNP), per capita: A country's GNP divided by its population. GNP is the total value of goods and services produced by a national economy before any deduction has been made for depreciation. The annual growth of the GNP is often taken as an indicator of the state of a country's economy, but its significance is limited because it does not take inflation into account. Its chief purpose is to indicate a nation's comparative national wealth. Although it is the most widely used measure of economic wealth, this figure is not a complete indicator of a country's development. See also the *Human Development Index (HDI) Ranking* which assesses the progress of countries with regard to basic human capabilities, and the *Gender Empowerment Measure (GEM) Ranking* which assesses the progress of countries with regard to gender equality.

Household Expenditure on Food (%): Except where noted, these data refer to either 1980 or 1985 (latest figures available). Consumption, as used here, refers to private (nongovernment) consumption as defined in the U.N.'s System of National Accounts. These data are collected through household censuses and surveys and therefore can suffer from sampling frame biases. In addition, the national accounting method used to estimate food expenditures may skew or distort these data.

Human Development Indicator (HDI) Ranking: From the *Human Development Report, 1995*—This indicator measures the average achievement of countries in basic human capabilities that people must have to participate in and contribute to society. These include the ability to lead a long and healthy life, access to education for all, and access to the resources needed for a decent standard of living. The HDI uses three variables: life expectancy at birth; educational attainment (adult literacy, with two-thirds weight; and combined primary, secondary, and tertiary enrollment ratio, with one-third weight); and income (GDP per capita in PPP—*Purchasing Power Parity,* see definition). The subsequent ranking of countries is relative. For example, Canada ranked number 1, so of countries evaluated, Canada has done the best in providing these three basic choices to all its people. Due to the unavailability of quality data, the Human Development Report commissioned by the UNDP was able to compute the HDI for 174 countries only. The index designers at the UNDP note that the concept of human development is more complex than any composite index—or even a detailed set of statistical indicators—can capture. It is however, useful for simplifying a complex reality, which is what the HDI sets out to do. The HDI's basic message should be supplemented by analyses to capture other important dimensions—many of which cannot be easily quantified—such as political freedom, environmental sustainability and intergenerational equity.

Infant Mortality: The probability of dying by exact age 1, multiplied by 1,000. From the UN Population Division.

Life Expectancy: Average number of years a newborn infant can expect to live under *current* mortality levels.

Maternal Mortality: Annual number of deaths of women from pregnancy-related causes per 100,000 live births.

Mean Years of School: Average number of years of schooling received for persons age 25 or over.

Per Capita Average Calories Available (as % of need): Calories from all food sources: domestic production, international trade, stock draw-downs, and foreign aid. The quantity of food available for human consumption, as estimated by the Food and Agriculture Association of the United Nations (FAO), is the amount that reaches the consumer. The calories actually consumed may be lower than the figures shown, depending on how much is lost during home storage, preparation, and cooking, and how much is fed to pets and domestic animals or discarded. Estimates of daily caloric requirement vary for individual countries according to the population's age distribution and estimated level of activity.

Population: Estimates based on recent census, official national data, or UN, U.S. Census Bureau, or World Bank projections. The effects of refugee movements, large numbers of foreign workers, and population shifts due to contemporary political events are taken into account to the extent possible. Such events can introduce a high degree of uncertainty into the estimates. *Urban Population:* Percentage of the total population living in areas termed "urban" by that country. Typically, the population living in towns of 2,000 or more or in national and provincial capitals are classified "urban."

Population Density: The number of inhabitants, on average, living within 1 square mile. Calculated by dividing the population of a country by that country's surface area.

Population 2025, projected % change: Population estimates for the year 2025 are based upon reasonable assumptions on the future course of fertility, mortality, and migration. The projected change from 1995 to 2025 was calculated as a percent.

Purchasing Power Parity: The number of units of a country's currency required to purchase the same representative basket of goods and services that a US dollar (the reference currency) would buy in the US (or a similar basket of goods and services).

Rank of Affluence: Ranking of the 185 UN members by most recent *Gross National Product (GNP) per capita* figures.

Contributors and Credits

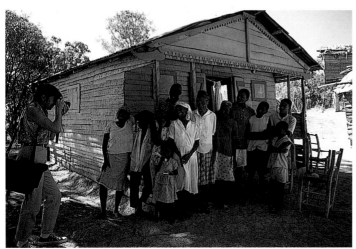

Photograph by Maggie Steber

Faith D'Aluisio is a former television news producer with a decade of experience covering stories for local and national television news organizations. She has received regional and national awards for documentary and news series pieces from The Headliners Foundation, United Press International, Associated Press, and Radio-Television News Director's Association. She has two sons, Josh, 16, and Adam, 14.

Claudia Glenn Dowling is a winner of several journalism awards, a fellow of the Explorers Club and has been a staff writer at LIFE for 13 years, covering everything from an assault on Mount Everest to new treatments for breast cancer. She lives in New York City and has a 14-year-old daughter, Hannah.

Melissa Farlow is a Pittsburgh-based freelance photographer and contract photographer for National Geographic. Among numerous regional and national awards, she earned a Pulitzer Prize—shared with the photography staff of the Courier-Journal and Louisville Times—for work done on coverage of desegregation in the public schools.

Annie Griffiths Belt is a freelance picture editor; a teacher; the mother of two children: Lily, 7, and Charlie, 3; and a contract photographer for National Geographic, where she has worked on more than two dozen magazine and book projects. She has received awards from the National Organization of Women, the White House News Photographers Association, and the Associated Press.

Lori Grinker is a New York City-based photographer and a member of Contact Press Images since 1988. Her award-winning photographs have been exhibited in museums and galleries in Paris, Amsterdam, Jerusalem, Chicago, and New York. Ms. Grinker has been published in the The New York Times, Newsweek, People, French Photo, and LIFE.

Lynn Johnson is an award-winning photographer known for her work in both color and black-and-white. A Black Star contract photographer since 1984, she has produced photo essays for such publications as National Geographic, LIFE, German GEO, Stern, Fortune, and Sports Illustrated. During her career, Ms. Johnson has received five World Press Awards, and a Robert F. Kennedy Journalism Award.

Catherine Karnow is a California-based photographer who specializes in people photography. Her work has appeared in such publications as GEO, Smithsonian, Island, and book projects including Passage to Vietnam, the Day in the Life series and several Insight Guides.

Karen Kasmauski is the mother of Will, 6, and Katie, 3, and is a contract photographer with National Geographic where her most recent stories have been pieces on Ho Chi Minh City, Vietnam and the Kobe earthquake. Based in Virginia, her work has also appeared in Fortune Magazine, Forbes, and GEO (Germany). Ms. Kasmauski has won many Picture of the Year awards, the White House News Photographers Competition, and a Robert F. Kennedy Award.

Sarah Leen is a Matrix International photographer whose work is primarily published in books and National Geographic, her assignments range from covering Lake Baikal in Siberia to Macedonia. Based in Maryland, she also teaches photography at the Missouri and the Maine Photo Workshops.

Madrig Mashbileg is the UNFPA liaison (United Nations Population Fund) to Mongolia. She lives and works in Ulaanbaatar, Mongolia.

Charles C. Mann is a contributing editor for The Atlantic Monthly and a contributing correspondent for Science. His work has also appeared in publications such as The New York Times, The Los Angeles Times, The Sciences, Smithsonian, GEO, Libération, and Panorama. Mr. Mann's most recent book, co-authored with Mark L. Plummer, is Noah's Choice, an examination of the human impact on biodiversity in North America. He has two sons: Sasha, 19, and Newell, 11.

Stephanie Maze's award-winning photographs have been published in National Geographic and books as well as in Newsweek, Time, the New York Times Magazine, Smithsonian, People, and Air and Space. In addition to raising her son, Tony, 8, she is currently the principal of Maze Productions, a Washington, D.C.-based multimedia communications group that develops photographic books, video programs, and interactive CD-ROMs for children.

Peter Menzel is a photographer known for his coverage of international feature stories on science and the environment. His award-winning photos have been published in LIFE, National Geographic, Smithsonian, The New York Times Magazine, Time, Paris Match, Stern, and GEO. He is the father of two sons: Jack, 16, and Evan, 13; and the creator, executive director, and principal photographer for the Material World Project, which produced Material World: A Global Family Portrait.

Ludmilla Mekertycheva was born in Russia and educated in Kazakhstan. She has been a Moscow-based translator, interpreter, and guide for National Geographic since 1991. Her son is a TV journalist with Reuters.

Maggie Steber is a documentary photographer whose professional career began in 1978. She has produced major projects on Zimbabwe, Cuba, and since 1986, on Haiti. Her award-winning work regularly appears in The New York Times Magazine, National Geographic, and LIFE. Ms. Steber lives in New York City and also teaches workshops at the International Center for Photography, The Maine Photographic Workshop, and the Woodstock Workshop.

Vivienne Walt is News Editor of the Wall Street Journal / Interactive Edition. She has written about Africa for several years, and was the former Johannesburg correspondent for Newsday.

PHOTOGRAPHY CREDITS

Annie Griffiths Belt: Guatemala (pages 86–93), USA (240–249), front cover (USA), 6 (Guatemala), 7 (USA), 36 (Guatemala), 39 (USA), 60 (Guatemala), 82 (Guatemala), 85 (USA), 104 (USA), 106 (Guatemala), 129 (USA), 152 (USA), 153 (Guatemala), 182 (Guatemala), 183 (USA), 227 (USA).

Melissa Farlow: Ethiopia (pages 70–81), Mali (166–179), South Africa (218–225), front cover (Ethiopia), 6 (Ethiopia, Mali), 7 (South Africa), 36 (Mali), 39 (Ethiopia, South Africa), 61 (Ethiopia, South Africa), 83, 84 (Mali), 85 (South Africa), 104 (Ethiopia), 106 (Mali), 128 (Ethiopia, Mali), 129 (Mali), 153 (Ethiopia), 180 (Ethiopia), 182 (Mali), 204 (Ethiopia, South Africa), 227 (Ethiopia, Mali, South Africa).

Lori Grinker: Israel (pages 116–127), Jordan (154–165), 6 (Israel, Jordan), 38 (Jordan), 39 (Israel), 61 (Israel), 85 (Israel, Jordan), 107 (Israel, Jordan), 129 (Israel, Jordan), 152 (Jordan), 153 (Israel), 180 (Jordan), 205 (Jordan).

Lynn Johnson: China (pages 50–57), Mongolia (194–203), Russia (206–217), 4–5, 6 (China), 7 (Mongolia, Russia), 37 (China), 61 (China, Mongolia, Russia), 82 (Mongolia), 84 (China, Russia), 104 (Russia), 105, 107 (Mongolia), 128 (Russia), 152 (Russia), 182 (China), 183 (Mongolia, Russia), 205 (China, Mongolia), 226 (Russia), 227 (Mongolia).

Catherine Karnow: Albania (pages 12–23), Italy (130–139), 6 (Albania, Italy), 39 (Albania, Italy), 82 (Albania), 106 (Italy), 107 (Albania), 129 (Albania), 180 (Italy), 183 (Italy), 227 (Italy).

Karen Kasmauski: Japan (pages 140–151). Other Japan photographs on pages: 6, 39, 61, 85, 107, 128, 183, 205.

Sarah Leen: India (pages 108–115). Other India photographs on pages: 6, 38, 153, 205.

Stephanie Maze: Brazil (pages 40–49), Mexico (184–193), 6 (Brazil), 7 (Mexico), 38 (Mexico), 60 (Mexico), 84 (Brazil), 85 (Mexico), 106 (Brazil), 107 (Mexico), 129 (Brazil, Mexico), 152 (Mexico), 180 (Mexico), 183 (Brazil, Mexico), 205 (Mexico), 226 (Brazil), 227 (Mexico).

Peter Menzel: Pages: 10, 93 (bottom).

Joanna Pinneo: Bhutan (pages 24–35), Thailand (228–239), 6 (Bhutan), 7 (Thailand), 11 (Bhutan), 36 (Thailand), 38 (Bhutan), 60 (Thailand), 82 (Bhutan), 104 (Bhutan), 153 (Bhutan, Thailand), 181, 183 (Thailand), 205 (Bhutan, Thailand), 227 (Bhutan), 254 (Bhutan), 256 (Thailand).

Maggie Steber: Cuba (pages 62–69), Haiti (94–103), 6 (Cuba, Haiti), 8, 36 (Haiti), 39 (Cuba), 61 (Haiti), 85 (Haiti), 107 (Cuba), 129 (Haiti), 152 (Haiti), 182 (Haiti), 204 (Haiti), 226 (Haiti), 255 (Haiti), back cover (Haiti).

Cartography by David Griffin.

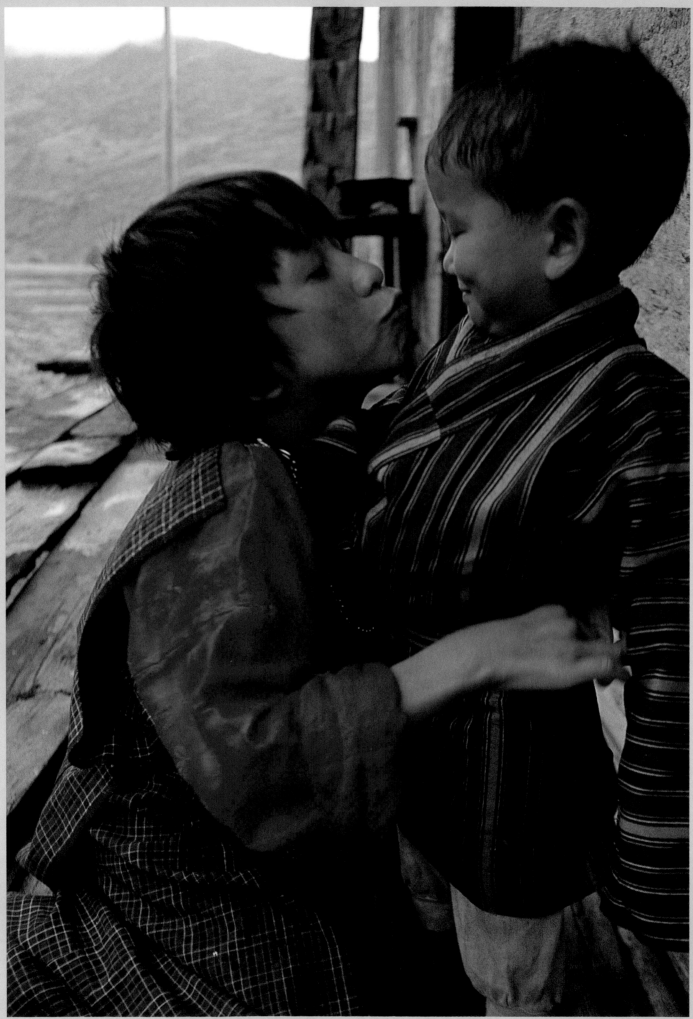

Bhutan: Four-year-old Gyeltshen giggles as his aunt Bangum ties his belt and offers him a kiss.

Photograph by Joanna Pinneo

Afterword

By FAITH D'ALUISIO and PETER MENZEL

DURING THE COURSE OF OUR VISITS FOR THIS BOOK, WE GAVE EACH WOMAN A COPY OF THE PROJECT'S previous book—*Material World: A Global Family Portrait*—and asked each woman how she thought her life compared to the other women's, and what she would like the others to know about her life. The answers were sometimes poignant, usually fatalistic, always compelling. It seemed to us that the best way to close this book was to let the women speak for themselves about what they saw in the others, what they would like to say to them if they could, and what they hoped that the others saw in them.

Eulina Aluis Costa/Cuba: Looking at the pictures, I see women that seem stone-dead. And I ask myself, how is it that they can be living like this, when we are at the end of this century and there is so much technology?

Madame Dentes Delfoart/Haiti: I cannot compare my life to the other women in the book. Our lives are too different.

Mishri Yadav/India: I don't understand their lives.

Haifa Khaled Shobi/Jordan: I consider myself a successful woman inside of my house. But outside, the society is what really judges you.
Faith: Does it matter?
Haifa: Of course it matters when someone calls me successful and I'm liked and I'm popular and they admire me.
Faith: What would you like the other women to know about you?
Haifa: Maybe that what is in them is in me, too. I don't consider myself a 100 percent successful woman and they may not either. There must be more successful people than me in this book.

Nalim/Bhutan: I like the life of the American family. They have very good property.

Carmen Balderas de Castillo/Mexico: Some [of the other women] have better positions from which they can raise themselves. I am better off than some, worse than others. I think these women realize that they should be able to accomplish their dreams.

Buaphet Khuenkaew/Thailand: Some of the women live well, but some have many children with very few possibilities. I really cannot say one woman's life is better than another. It's just that each woman's life suits each country.
Faith: How does your life compare to theirs?
Buaphet: I just have a different life. I'm a different person with a different mind and a different soul. I'd like to know more about every country. I want to know more about the food they eat—whether they bone the fish in Mali before the children eat it. And how can so many people dip into only one big bowl of food? I feel pity for them.
Faith: It's part of their way of life to eat out of one communal bowl.
Buaphet: I understand that. That's why it's different. And in Ethiopia, with the wind and the rain, how can they live under the kind of roof that they have? And the children have to work so hard, but they seem like a happy family.

Karen: What would you like the other women to know about you?
Sayo Ukita/Japan: I don't want them to know anything about me! [Laughter]
Karen: That's not fair!

Poppy Qampie/South Africa: Some of their lives are very difficult. To want water and have to go and carry it back and having to make a fire on the floor—it is very difficult.
Vivienne: Does any particular family strike you?
Poppy: I must mention Mali. I don't like how the Mali people live—the man with two women. One man with two women and a lot of children.
Vivienne: What is wrong with two wives?
Poppy: Two wives can't share one man. And the life—it wouldn't be good for a man to have two women. He might not like them equally.

Pattie Skeen/USA: It's fascinating to see how other people around the world live. Ethiopia is so poor. And they're a Christian family. How did they learn about God without the Bible to guide them? And Zhanna Kapralova's loss in Russia affected me deeply. Overall, I think that life for us [in the USA] is much easier. In a way though, we are the same. We're trying to bring up a family and we're fighting whatever troubles that come up against us as a family.

Ronit Zaks/Israel: [I would like the other women to know] that there is a country called Israel. It's very, very small and the people are warm and nice. And we have a lot of war, a lot of victims, a lot of violence in Israel, but the people are great, they are always together. We have a tough life of our own, but I'm a female just like you; I give children to the world and in the whole world it's nine months in the womb for everyone.

Lucia Sicay Choguaj/Guatemala: [I would like the other women to know] I am a good weaver and I have a good, tranquil family.

Hanke Cakoni/Albania: I would say to some of these women, "Watch what I could do if I had what you have in your life! But the possibility was never given to me to have the kind of life you are leading."

Fatoumata Toure/Mali: We are all the same. Women from elsewhere and women here are alike.

Acknowledgments

Photograph by Joanna Pinneo

The Material World Women's Project wishes to thank the twenty-one women who are the focus of this book, along with their families, friends, and neighbors.

These women courageously allowed us unlimited access to learn about their lives, their thoughts, their dreams. Without their cooperation, trust, and support, this book would not have been possible.

For their unswerving devotion to finishing a worthwhile project that often took them away from family and friends for the better part of a year, the Material World Women's Project offers a special thanks to sleep-deprived staffers: Sandy Sherwin, Karryn Olson-Ramanujan, Liz Enochs, Elizabeth Partch, and Carol Martinelli.

Thanks also to Peter Menzel's studio staff and others who provided office support: Mary Schoenthaler, Jane E. Lee, Todd Rogers, Tricia Rogers, and Nicky Shiflet.

The Material World Women's Project thanks the photojournalists and journalists who went above and beyond to gain a better understanding of the women in this book as people, rather than merely as subjects. The interviews were long—arduous at times— but fascinating.

As well, we are grateful to the translators in each country; **Albania:** Artan (Tony) Kadriu; **Bhutan:** Yangzom; **Brazil:** Stephanie Maze; **China:** A good friend; **Cuba:** Ana Margarita Gil; **Ethiopia:** Aberash Merid; **Guatemala:** Calixta Gabriel and Rick McArthu ; **Haiti:** Holner LaTendresse; **India:** Monica Narula; **Italy:** Anna Sagaria; **Japan:** Sanae-Lina Wang and Rina Tsuguchi; **Jordan:** Ranya Kadriu; **Mongolia:** Mashbileg Madrig and Darya; **Mexico:** Stephanie Maze; **Mali:** Kassim Kone and Blakeman B. Esselstyn; **Russian Federation:** Ludmilla Mekertycheva; and **Thailand:** Suwanna Tantayanusorn/Chiang Mai University.

We also thank the following people for providing further interview translations: Yangzom, Nilda Douma, Ana Marguerita Gil, Miguel Luis Fairbanks, Armando Hernandez, Kassim Kone, Mashbileg Madrig, Karim Rajani, Tad McNulty, and Suwanna Tantayanusorn.

Financial support for The Material World Women's Project was generously donated by the United Nations Population Fund. We are especially grateful to Hirofumi Ando and Stirling O. Scruggs, UNFPA. Moral support and field assistance was graciously provided by the United Nations Development Programme.

Many others helped to make the project a reality. We would like to thank the following people: The extremely patient Peter Beren, Erik Migdail, Susan Ristow, Janet Vail, and Nick Setka at Sierra Club Books; the long-suffering Ray Kinoshita, Angela Adams, Evan Angus, and Krishna Ramanujan; Djibril Diallo, Director, Division of Public Affairs, UNDP; facilitator extraordinaire, Sissi Marini, UNDP; Ruth Eichhorn, Joseph Hurban, Brigitte Barkley, Venita Kaleps, Sabina Wuensch, and Wilma Simon at *GEO Magazin*; Anna Sever Agency, Madrid; Alex Martínez Roig and José Manuel Navia at El Pais, Spain; Kathy Ryan/*New York Times Magazine*; Toyoo Ohta and Sanae-Lina Wang at Uniphoto Press International, Japan; Dick Lemon, Esq.; Ed Kashi; Eldonna Christie, M.D. and staff; Gene Rutkauskas; Marcia & Dana/Bayberry Travel; Audio-Video Center, Napa; Brent Olson/Geographic Expeditions; Miguel Luis Fairbanks; Woodfin Camp; Jose Azel/Aurora; Black Star; Peter Ginter; Guglielmo de'Micheli; Shawn G. Henry; Dana Wolf/Nightline; Betty Lou McClanahan; Andrew Clarke/Mandarin Press; Mary Jo Arnoldi/Smithsonian; Jay Harris, Jeffrey Klein, Kerry Tremain and Sarah Pollock at *Mother Jones*; Napa Public Library; Paul Kennedy; Don Belt; Randy Olson; Josh and Adam D'Aluisio Guerrieri; and Jack and Evan Menzel. And Brad, for letting go of it.

In each country we were helped by many people and organizations: **Albania:** Peter Schumann, Bengt Messing/UNDP; Fatos. **Bhutan:** Ugyen Rinzin/Yangphel Tours & Travels; Karma; Sangay Khandu and his pack horse; and Chato Namgay for holding the flashlight through dinner. **Brazil:** Bia Bansen; Frances and Marcelo Bicudo. **China:** Leong Ka Tai and our friends who helped in China. **Cuba:** Alberto de Perez and Sissi Marini/UNDP; Patrice Ariel Francais/UNFPA; Jose Ponce; Mrs. Estrin; Cuban Women's Federation; Vidalina Perez Martinez; Cesare Roque; Gustavo and Casanova. **Ethiopia:** Peter Simpkin/UNDP; Hapte-Selassie Tafesse; Worku Sharu. **Guatemala:** Sissi Marini/UNDP; Santos Peres Sicahán; Lars Franklin; Ingrid Melgar; Hans Peter Vuvollen/Ayuda Popular Norwega; and Ivan Choto. **Haiti:** Eric Swedberg/Save the Children. **India:** Hans von Sponeck/UNDP; Deepak Puri/*Time* magazine; Rati Shankar Tri Pathi; Jai Shankar Mishra and family; Dayanita Singh; the women of Ahraura village; Karuna Bahadur; Prof. Kali C. Bahl; Usha Jain/Southeast Asian Studies at UC Berkeley; and Amina and Karim Rajani. **Japan:** Toyoo Ohta and Sanae-Lina Wang/Uniphoto Press International. **Jordan:** Ed Kashi; Ranya Kadri and her mom; Mrs. Nouzat Shaker/Soldier's Welfare Society; Ali Khazáleh; Ali Nawafleh's friend, Mahmoud; Bayan Tadarra/ESQWA; and all the families in Amman that welcomed us into their homes. **Mali:** Neguest Mekommen; Tore Rose and M. Dysset/UNDP; Herves and Mariam Walet Mohamed/Le Bani Voyages, Bamako; Dramane Cisse/Le Bani Voyages, Mopti; Randy Olson; Jesse Dizard; Chief Kokena; and Abdoul Kader Toure. **Mongolia:** Mashbileg Madrig/UNFPA; Johannes W. Swietering and Mr. Tsend/UNDP; Sissi Marini/UNDP; Shun-ichi Murata; A. Stjarnerklint/UNFPA; Claudia Dowling; and G. Erdene. **Russia:** Ludmilla Mekertycheva; and Svetlana Chervonnaya. **South Africa:** John John and Vusi; John Moore/Associated Press; and Ethel and Alex Walt. **Thailand:** Serm Phenjati/Thai Airways International Ltd.; Brent Olson/Geographic Expeditions; Carol Goodman; Kamala Sukosol; Prof. Prachaval Sukumalanand/Chiang Mai University; and Pitaya Pongpaibul/Riverview Lodge.

Advisors for country summaries: Albania: Julie Mostov/Drexel University, PA. **Bhutan:** Fredrik Barth/Emory University, GA. **Brazil:** Kevin Neuhouser/University of Washington, WA. **China:** Lisa Rofel/University of California at Santa Cruz. **Cuba:** Helen Safa/University of Florida. **Ethiopia:** Tsehai Berhane-Selassie/Middlebury College, VT. **Guatemala:** Tracy Bachrach Ehlers/University of Denver, CO. **Israel:** Tamar Mayer/Middlebury College, VT. **Haiti:** Jeanine Coreil/University of South Florida. **India:** Pauline Kolenda/University of Houston, TX. **Israel:** Rutie Adler/Near Eastern Studies, University of California, Berkeley; Phillipa Strum, City University of New York. **Italy:** Lucia Chiavola Birnbaum/California Institute of Integral Studies. **Japan:** Glenda Roberts/University of Hawaii. **Jordan:** Sally Howell. **Mali:** Maria Grosz-Ngate/Central State University, OH. **Mexico:** Lynn Stephen/Northeastern University, MA. **Mongolia:** Judith Nordby/University of Leeds, U.K. **Russian Federation:** Patricia Kerig/Simon Fraser University, British Columbia. **South Africa:** Iris Berger/State University of New York. **Thailand:** Mary Grow/University of Wisconsin. **USA:** Winifred Mitchell/Mankato State University, MN.

Other expert assistance: Albania: Stephen Sampson/Institute of Anthropology, Copenhagen. **Bhutan:** Judith Justice/University of California at San Francisco. **Brazil:** Daphne Patai/University of Massachusetts. **Ethiopia:** John Hamer/University of the South, TN. **Guatemala:** Abigail Adams/Hollins College, VA. **Israel:** Tamar Mayer/Middlebury College, VT. **Japan:** Tomoko Hamada/College of William and Mary, VA. **Mali:** Sarah Castle/Brown University, RI, and Mary Curtin/U.S. State Department. **Mexico:** Rebeca Wong/Johns Hopkins University, MD. **South Africa:** Sean Redding /Amherst College, MA. **Thailand:** Herbert Phillips/University of California at Berkeley.

Statistical assistance: Nada Chaya, Population Action International; Alice Clague, editor, Demograpic Yearbook of the UN; Bill Cleveland, editor, Britannica World Data; Elizabeth Crayford and Cindy Alexis/World Bank International Economics Dept.; Moez Doraid, Human Develpment Report Office, UNDP; Chris Dove, World Resources Institute; UC Berkeley Government and Social Science Information; Sam Johnson, International Statistical Office; Zuali Malsawma, Population Reference Bureau; Felicia Shinnamon/Napa Valley College; Mary Beth Weinberger, UN Population Division; Alvin Zarate, National Center for Health Statistics.

Additional generous support was provided by

Alexander & Ishihara
Color Laboratories

Copy Centers

The Media
Laboratory, MIT

Palmer
Photographic

International
Airways

Visa Advisers

Geographic
EXPEDITIONS

Kodak
digital science

TheNewLab

United Nations
Population Fund

Xante